Cultural Studies
50 Years On

Cultural Studies 50 Years On

History, Practice and Politics

Edited by
Kieran Connell and Matthew Hilton

ROWMAN &
LITTLEFIELD
INTERNATIONAL

London • New York

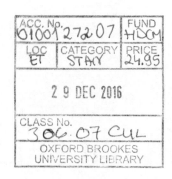
Published by Rowman & Littlefield International, Ltd.
Unit A, Whitacre Mews, 26-34 Stannary Street, London SE11 4AB
www.rowmaninternational.com

Rowman & Littlefield International, Ltd. is an affiliate of Rowman & Littlefield
4501 Forbes Boulevard, Suite 200, Lanham, Maryland 20706, USA
With additional offices in Boulder, New York, Toronto (Canada), and Plymouth (UK)
www.rowman.com

British Library Cataloguing in Publication Data
A catalogue record for this book is available from the British Library

ISBN: HB 978-1-78348-392-1
 PB 978-1-78348-393-8

Library of Congress Cataloging-in-Publication Data Available

ISBN: 978-1-78348-392-1 (cloth : alk. paper)
ISBN: 978-1-78348-393-8 (pbk. : alk. paper)
ISBN: 978-1-78348-394-5 (electronic)

∞ ™ The paper used in this publication meets the minimum requirements of American
National Standard for Information Sciences—Permanence of Paper for Printed Library
Materials, ANSI/NISO Z39.48-1992.

Printed in the United States of America

Contents

Acknowledgements

There are a great many people who have made critical contributions to the production of this volume and the conference on which it was based. We would like to thank each participant in the conference at Birmingham – both speakers and audience members – for creating such an intellectually charged, emotional occasion. We acknowledge the generous support of the Arts and Humanities Research Council (AH/K000500/1) which funded the wider project we undertook on the history and archives of the Centre for Contemporary Cultural Studies (CCCS), and the University of Birmingham's more recent management who paid for the conference. There are a number of people without whom the conference itself would not have been possible. These include Sally Baggott, a former CCCS student who helped us craft our ultimately successful bid for funds towards the conference and maintained a strong interest in the project throughout. Herjeet Marway, now a lecturer in philosophy, was at the time our administrator and essentially the foundation upon which the whole event rested. In the production of this volume we would like to express our gratitude to Jamie Perry for his assistance with proofreading, Bethan Strange for her work on the index and our editors at Rowman & Littlefield. Finally, we are profoundly grateful for the generosity of the late Michael Green and Stuart Hall. Without their guidance and support it is unlikely the entire project to mark cultural studies 50 years on would ever have been possible.

Introduction

Kieran Connell and Matthew Hilton

This book is the product of an event to mark the 50th anniversary of the establishment of the Birmingham Centre for Contemporary Cultural Studies (CCCS). The origins of this famous and influential academic experiment are well known. Having been appointed professor of English at the University of Birmingham in 1962, Richard Hoggart funded his new centre with an annual grant of £2,400 made available by Sir Allen Lane, the founder of Penguin Books. He could not have envisaged that the project would continue in different guises for almost four decades, or that the work that was produced there would remain influential well into the twenty-first century. What we know now is that the opening of the Centre's doors in the autumn of 1964 came to occupy a critical place in histories of cultural studies. It is widely regarded as representing the symbolic birth of a new kind of academic endeavour.

That these origins are so well known is in no small part due to the reflections of members of the CCCS itself. In spite of what was often a problematic relationship between the Centre and history as a discipline, the CCCS was always active in the narration of its own past. In the Centre's first annual report Hoggart and his then-deputy Stuart Hall set out their rationale for the CCCS. They explained its relationship to existing intellectual currents and what they saw as the Centre's core remit. But they also established an ongoing tradition of appraisal and re-appraisal that examined the Centre's present and future always in relation to its past.[1] Following the involvement of the CCCS in the student protest movement of the late 1960s, the interrogation of the Centre's past would for long periods become highly charged, particularly over the issues of class, gender, race and sexuality. This would to some extent continue all the way up to the Centre's controversial closure by the management of the University of Birmingham in 2002. And it is something that has also characterized cultural studies as it has been taken up

far away from Birmingham, in Northern Europe, North America, East Asia and beyond. Just as the Centre explored its own purpose and identity in its annual reports, journals and 'Stencilled Papers', those working in cultural studies today continue to stage conferences, give papers and write entire books on the subject of what cultural studies is, where it has come from, how it could be improved and where it should be going. 'What is cultural studies anyway?' was the question posed in 1983 by Hall's successor as CCCS director, Richard Johnson. It has seemingly never been answered.[2] Rather, it has simply been replaced by the variants *What's Become of Cultural Studies?* and *Why Cultural Studies?*[3]

In some respects, the predominance of such questions invokes the insecurity of what Stuart Hall himself continued to regard as a field of inquiry rather than a conventional academic discipline. There is undoubtedly a strength in the malleability of a field that has always been admirably open to revision. Yet, as questions on the nature of cultural studies proliferate in PhD theses, plenary lectures and special-issue journals, the field is in danger of becoming reduced to them. Alongside ongoing ethnographic or text-based analyses of the changing nature of 'contemporary culture', methodological self-reflections on 'what is cultural studies?' continue to thrive. It is for these reasons that we are to some extent reluctant editors of yet another contribution to what often appears as the indeterminacy of a discipline forever in its own making.

At the same time as this, however, we also feel a strong affinity to both the CCCS and cultural studies more generally. The CCCS has been a historical subject for us. As we were writing our history of its highly politicized working practices in the late 1960s and 1970s, it was hard not to contrast this with our own attempts at navigating the many constraints of the twenty-first-century university.[4] This work came out of our project to assemble an archive of CCCS material. The purpose of such a permanent documentary collection was to mark the importance of the CCCS, ensure its history would not be forgotten and to open its practices, proceedings, debates and dilemmas to new generations of scholars and students. The impending 50th anniversary of the establishment of the Centre in 2014 provided a sense of urgency for an archival project that had been under discussion for some time. The project began in February 2013 and the CCCS Archive comprising the donations of individual former staff and students is now fully open to the public at the Cadbury Research Library at the University of Birmingham.[5]

The genesis of this project is illustrative of the way in which the CCCS is for us also more than a straightforward historical subject. Both of us became friends with Michael Green, a member of staff at the Centre for almost its entire existence. Green had supervised Connell's parents as they undertook part-time MAs at CCCS in the late 1970s, and took an informal interest in his doctoral research undertaken under the supervision of Hilton. Having arrived

in Birmingham as a lecturer in history in 1997, Hilton was, in 2001, made an honorary member of what had become the Department of Cultural Studies and soon came to know Green, particularly during the campaign to prevent its closure. Green was a critical figure in helping to persuade Hall that the archive should be located – ironically, but also fittingly – at the University of Birmingham. Written into the heart of the archival project was a corresponding desire to communicate the significance of what had become famous around the world as the 'Birmingham School' to local audiences, where the Centre's reputation was paradoxically much less well known. This resulted in a major public exhibition that aimed to communicate the present-day significance of the Centre's work by bringing together a range of contemporary artists working on issues such as gender, race and youth cultures (the artwork on the front cover of this book, 'News in Briefs' by the artist Sarah Taylor Silverwood, was commissioned especially for this exhibition). The exhibition was co-curated by us and ran at the Midland Arts Centre in the summer of 2014.[6]

The work produced at the CCCS has also been a critical influence on our own scholarly work in areas such as consumption and race.[7] Moreover, we have been struck by its relevance to other historians with little or no connection to the CCCS as the 1970s and 1980s has come into historical view. For a generation of historians trained in the 1960s and 1970s, the Centre was a key sounding board for the exploration new theoretical innovations, not least through events such as the History Workshop which regularly brought historians and cultural studies practitioners into dialogue. But for younger generations trained in the 1980s, 1990s and beyond, the Centre's publications proved an important inspiration for an incredibly diverse body of work in social and cultural history. As we have witnessed the impact CCCS work continues to have in history, so we have become convinced of the ongoing need for a malleable field around which other, more traditionally static disciplines can pivot. It is well known that in the context of what Hall identified as a 'crisis of the humanities', cultural studies has had a similar impact on English, sociology and other disciplines.[8] This is itself a history that warrants proper attention. And it also raises questions about what role – if any – cultural studies will play in the shaping of future scholarly research in the humanities in a CCCS-less world.

These are the concerns that motivated our desire to stage 'The CCCS 50 Years On' (CCCS50), a two-day conference which took place at the University of Birmingham in June 2014, as close as we were able to get to the formal anniversary. Of course, many of these questions have also been discussed in what has become a global 'what is cultural studies?' publishing industry. But we felt that the regularity with which these questions were being asked was arguably indicative of a dissatisfaction with the answers that have emerged. Moreover, it is noticeable that the majority of work in this area has been

produced by single authors. Perhaps one of the clearest legacies of the CCCS is the fruitfulness that can be found in intellectual collaboration. As many of us within academia know all too well, in the present climate there are fewer and fewer spaces for the kind of experimental collaboration that allowed the CCCS to thrive. Our aim in the organization of the conference was therefore to find a format that, if not attempting to replicate the uniqueness of the famous 'subgroup' model adopted at the CCCS, could at least offer a platform for genuine dialogue. We decided at the very beginning that the conference would shun the convention of investing authority in a particular individual to deliver a plenary or keynote lecture. We of course invited speakers who had been at the CCCS at various points in its existence and who understandably had decidedly mixed feelings about, as one contribution puts it, 'a rather disturbing return to the scene of the crime'.[9] But we also invited people with little or no connection to the CCCS, cultural studies scholars and also scholars from history, other academic disciplines, artists and community activists who could offer entirely different perspectives. In total there were contributions from people who came from across four different continents. Speakers were asked to deliver ten-minute position papers that would act as provocations for wider discussion. Chairs were instructed to be as strict as possible in keeping speakers to time. In each panel as much time was given to comments from the floor as to speakers' own presentations. It was an approach that aimed to generate a collective dialogue that was greater than the sum of its individual parts.

It is also an approach we have attempted to replicate in the editing of this volume. The book begins with longer contributions that historicize the CCCS in its different guises from the genesis of its establishment all the way through to its eventual closure. In some ways this in keeping with the tradition of appraisal and re-appraisal established by Hoggart and Hall in the very first CCCS annual report. Rather than exploring cultural studies in terms of its intellectual development, however, these opening chapters are designed to show the myriad ways in which the CCCS was rooted in the peculiarities of what Stuart Hall would have called the historical conjuncture. One cause for the apparent insecurity of contemporary cultural studies is arguably the long shadow cast by the CCCS – the brilliance of the work produced there and the way in which much of this was seemingly imbued with a radical political agenda. Many working in cultural studies appear, as Ros Brunt puts it in relation to a different context, to be suffering from a 'guilt trip' from not being the CCCS.[10] In starting this book with historical explorations into the CCCS we want to make clear our view that the CCCS should manifestly not be seen as any kind of 'gold standard' that cultural studies scholars today should be expected to live up to, but was rather a particular product of highly distinct historical periods.

The following sections of the book explore the relationship between past and present in more detail. They consist of a series of interventions that

explore what are widely identified to be the key characteristics of cultural studies – innovation in pedagogical approaches, political engagements, regional variations and the relationship between cultural studies as an academic field and the world beyond the university campus. In each section, contributors, building on the ideas they set out at the conference, use the history of their own involvement in cultural studies to explore the lessons that can be learnt for its present and future incarnations. This is therefore far from a singular blueprint for what cultural studies should or should not be. Rather, it is a collection of many voices from which we hope readers will develop their own narrative of cultural studies 50 years on.

It is a source of great sadness that three of the most prominent figures in the development of cultural studies at Birmingham were not alive to witness a conference that explored its legacies. Michael Green died suddenly in 2011, without knowing of the eventual success of an Arts and Humanities Research Council grant application to which he had helped significantly and which enabled all of this to happen. Stuart Hall and Richard Hoggart died within months of each other in the first half of 2014, which added to an unavoidable sense of shifting conjunctures at the conference. Both men had been ill for many years prior to their deaths, but Hall had retained his intellectual prowess until the very end. He provided an invaluable source of guidance in deciding the format of and participants in the conference, inviting us to his North London home for updates over cups of tea. It was indicative of his dedication to the project of cultural studies that he was determined to himself play a part in the conference, even if he was aware that his health meant it was unlikely he would be there to participate in person. The solution reached was an extended interview between Hall and Connell in which Hall discussed some of the major themes of the conference and responded to material that had begun to emerge in the archival process (much of which he himself had not seen for over four decades). The interview was filmed with the intention that it could be shown to delegates at the conference.[11] It would be one of the last extended interviews that Hall ever gave. The atmosphere at the conference when the interview was shown for the first time, a matter of months since Hall's death, was highly poignant. The transcript of the interview is included at the end of this book.

Hall would undoubtedly have highlighted the fact that in many ways the title of this book is misleading. 'Cultural studies' existed before the Centre put a name to it in a range of locations, be it in the folk schools of 1930s Denmark, the attempts at developing an anthropology of the British working classes by Mass Observation in the same period or the writings of Raymond Williams and E. P. Thompson. Birmingham has rightly been 'de-centred' and the aim of this book is by no means to reassert its mythical status.[12] But we do feel that in order for cultural studies to move on it does need to come to

terms with the peculiarity of its past. The politics of cultural studies was made easier when it had a discernible canon against which to rebel: hegemonic understandings of the value of 'high' culture and the emphasis on 'the best that was thought and said'. In the early twenty-first century these culture wars are much less clear-cut. It is a paradox that today cultural studies seems both to be nowhere and everywhere. Nowhere in the sense that departments and centres, in Britain at least, are being closed and eaten up. But everywhere in the sense that much of the work that now goes on in traditional academic disciplines might be classed as versions of cultural studies. Serious analysis of television series, Hollywood cinema, subcultures and other forms of contemporary culture is happening everywhere in history, English and sociology – the very disciplines within which hostility to cultural studies originally appeared. But the cultural studies approach continues to thrive in a whole variety of disciplines across the arts and social sciences – in anthropology, social policy, religious studies, in departments of modern languages and across many of the subject areas found in modern business schools. Likewise, we have witnessed the concurrent emergence of micro-disciplines such as film studies, queer studies, porn studies and ever-more specialized fields devoted to particular areas of popular culture. Finally, as Jo Littler argues in her contribution to this volume, what might be seen as versions of cultural studies are now being played out in the popular cultural realm itself, in the pages of mainstream newspapers, online blogs and podcasts. This is arguably cultural studies' biggest achievement. The extent to which it can adapt to this new conjuncture is for others to now show.

NOTES

1. See CCCS, *First Report* (Birmingham, September 1964), pp. 1–7.

2. See Richard Johnson, 'What Is Cultural Studies Anyway?', CCCS Stencilled Occasional Paper 74, September 1983.

3. 'The Heart of Cultural Studies?' is the title of the opening chapter of Lawrence Grossberg, *Cultural Studies in the Future Tense* (London; Durham, NC: Duke University Press, 2010). See also Graeme Turner, *What's Become of Cultural Studies* (London: SAGE, 2012); Gilbert B. Rodman, *Why Cultural Studies* (New Jersey: Wiley-Blackwell, 2014).

4. See Kieran Connell & Matthew Hilton, 'The working practices of Birmingham's Centre for Contemporary Cultural Studies', *Social History* 40: 3 pp. 287–311.

5. The Archive is fully accessible via the Cadbury Research Library's website: http://www.birmingham.ac.uk/facilities/cadbury/search.aspx.

6. The artists involved were Trevor Appleson, Mahtab Hussain, louie+jesse, Sarah Maple, Sarah Taylor Silverwood and Nick Waplington. The exhibition also showed the work of CCCS alumnus David Batchelor and Janet Mendelsohn.

7. See our own work here, for example Kieran Connell, 'Photographing Handsworth: Photography, Meaning and Identity in a British Inner City', *Patterns of Prejudice* 46: 2 (2012), pp. 128–153; Matthew Hilton, *Smoking in British Popular Culture, 1800–2000* (Manchester: Manchester UP, 2000); Matthew Hilton, 'The banality of consumption', in Kate Soper & Frank Trentmann (eds.), *Citizenship and Consumption* (London: Palgrave, 2008), pp. 87–103.

8. See Stuart Hall, 'The emergence of cultural studies and the crisis of the humanities', *October* 53: (1990), pp. 11–23.

9. See Iain Chambers and Lidia Curti's contribution to this volume.

10. See Rosalind Brunt's contribution to this volume for an exploration of the political 'guilt-tripping' that occurred during her time at the CCCS.

11. The interview was filmed and edited by the photographer Alicia Field. See www.aliciafield.co.uk.

12. See Hendel K. Wright, 'Dare we de-centre Birmingham? Troubling the "origin" and trajectories of cultural studies', *European Journal of Cultural Studies* 1: 1 (1998), pp. 33–56.

Part I

SITUATING THE CENTRE

Chapter 1

The Lost World of Cultural Studies, 1956–1971

An Intellectual History

Dennis Dworkin

The best-known achievements of the Centre for Contemporary Cultural Studies (CCCS) at the University of Birmingham are from the 1970s and early 1980s. They draw on the cultural Marxist tradition of E. P. Thompson and Raymond Williams; the Western Marxism of Antonio Gramsci and Louis Althusser; and multiple strands of feminist and critical race theory. Yet, when the Centre was founded in 1964, these later developments were by no means preordained. Indeed, browsing through the annual reports and pamphlets that chart the Centre's early history, I am struck by just how distant the world in which the Centre originated now seems. Many of the intellectual sources on which it relied no longer inform current debates and discussions. Rather than names such as Foucault and Spivak, Said and Bhabha, Butler and Zizek, we encounter Leavis and Eliot (the latter not as a poet but as a cultural critic), Weber and Riesman, and Berger and Luckmann. Of the pioneering influences on cultural studies, perhaps only Raymond Williams is still cited in contemporary discussions.

The word 'lost' in the title of my essay therefore does not refer to the retrieval of a narrative that has been buried and recovered.[1] Rather, it seeks to recapture an intellectual and political world that has largely disappeared. The essay consists of three parts. First, I provide a rough sketch of the Centre's origins and early formation. I stress the ideas on which it was founded, emphasizing its connection to the milieu of adult education and the early New Left of the 1950s and early 1960s. Second, I discuss the founding of the Centre in 1964, its original goals and aspirations, and its early intellectual trajectory. Third, I analyse the transformation of the cultural studies project in the late-1960s and early-1970s, focusing on the impact of 1968 and its associated meanings on the Centre's students and faculty. Here, I draw on new sources that have recently emerged, including interviews. As a result

of the tumultuous experience of the late-1960s, and numerous contentious debates and internal struggles, Centre researchers acquired new theoretical vocabularies, thought about cultural practices in fresh ways and explored collective modes of work.

In 1964, Eric Hobsbawm reviewed Stuart Hall and Paddy Whannel's *The Popular Arts* (1964) for the *Times Literary Supplement*. He described what constituted cultural studies the year in which the Centre opened. 'British criticism in the field', wrote Hobsbawm, 'has long been the virtual monopoly of the local New Left: that is to say, it reflects a lot of Leavis (but without the Leavisite rejection of post-industrial culture), a much smaller quantity of Marx, a good deal of nostalgia for "working class culture", a pervasive passion for democracy, a strong pedagogic urge and an equally strong urge to do good'.[2]

Hobsbawm captured critical elements of early cultural studies: its debt to Leavisite criticism, its ambivalent relationship to Marx and Marxism, and its connection to the early New Left. His allusion to its 'nostalgia' for working-class culture and a 'strong pedagogic urge' was less straightforward. He was likely referring to texts such as Richard Hoggart's *The Uses of Literacy* (1957) and Raymond Williams's *Culture and Society* (1958) and *The Long Revolution* (1961), which portrayed working-class values nostalgically. They helped define the terrain of cultural studies and the cultural politics of the New Left, but their ideas developed in the older intellectual and political milieu of workers' and adult education.

Williams perhaps best summed up the dual influence of Leavis and Marxism for cultural studies: 'Leavis has never liked Marxists, which is in one way a pity, for they know more than he does about modern English society, and about its immediate history. He, on the other hand, knows more than any Marxist I have met about the real relations between art and experience'.[3] F. R. Leavis was an influential literary and cultural critic, particularly during the interwar years and the following decade. He viewed criticism as an aesthetic and moral practice based on the stringent training of one's sensibility and the close reading of texts. Critics were to bring the 'play of the free intelligence' to bear upon 'the underlying issues' of the modern world. He saw them as being in the avant-garde of cultural renewal, necessitated by a spreading and corrosive mass culture. Early contributors to cultural studies – including Hall, Hoggart and Williams – rejected Leavis's blanket dismissal of mass culture but embraced his wide-ranging interests and his reliance on the close reading of texts. Indeed, Hall's initial definition of socialist humanism in the New Left journal *Universities and Left Review* (*ULR*) appropriated a quote from Leavis: 'a vital capacity for experience, a kind of reverent openness before life, and a marked intensity'.[4]

As Hobsbawm implied and Williams reiterated, there is an ambivalent relationship between early cultural studies and Marxism. Marxism's contention

that the class relationships of modern capitalism provide the general context in which cultural practices are shaped was generally accepted. Deterministic versions of that relationship, notably mechanical and deterministic deployments of the base/superstructure model, were not. Here, Williams's influential chapter on 'Marxism and Culture' in *Culture and Society* is illustrative of this viewpoint. He accepted base/superstructure insofar as it meant viewing cultural practices in a wider context. Yet he found the model to be static and believed that it was incompatible with the totalizing and dynamic impulse of Marx's overall historical analysis. He argued that Engels's critique (in letters written in the latter part of his life) of its formulaic deployment by those calling themselves Marxists had long ago highlighted its limits. Williams did not reject Marxism: he viewed its existing form as inadequate to either grasp the specificity of cultural practices or grapple with culture's reciprocal impact on social and economic relations. In a now-famous formulation, Williams argued, 'It would seem that from their emphasis on the interdependence of all elements in social reality, and from their analytic emphasis on movement and change, Marxists should logically use "culture" in the sense of a whole way of life, a general social process'.[5]

Williams's thinking here is creative and innovative yet also a product of its time. First, it is symptomatic of the Cold War milieu in which he thought and wrote that when he did use Marxist concepts, he felt compelled to rework and disguise them, employing terms such as the 'system of economic life' rather than the 'mode of production'. Otherwise, he would have been summarily dismissed. Second, Williams's critique of Marxist cultural theory was largely aimed at English Communist critics, who, in his view, had failed to resolve the conflicts arising from their commitments to English romantic criticism, Marxist theory and Communist Party membership. In contrast with Williams's later, more memorable engagement with Western Marxist thinkers such as Antonio Gramsci, Lucien Goldman and György Lukács, his original encounter took place within a distinctly national intellectual milieu largely bereft of innovative Marxist cultural criticism. The same could be said for early cultural studies more generally.

When Hobsbawm wrote his review, cultural studies occupied a hazily defined space on the intellectual map, a product of debates and discussions that took place in and around the late 1950s and early 1960s New Left. The New Left emerged from the experience of the Suez and Hungary crises in 1956 and grew and expanded as a result of a shared commitment to the nuclear disarmament movement of the late-1950s and early-1960s. It consisted of two groups, although there was an overlap between them. The *Reasoner* group, creators of the *Reasoner* and subsequently the *New Reasoner*, was mostly composed of ex-Communists, predominantly from the interwar generation. *ULR* was created by a group of Oxford students who

wanted to create a discussion that would lead to a new kind of socialist poli-
tics, one that addressed the momentous transformations in post-war British
society. What was 'new' about the first New Left was that it represented a
third way: it rejected both the politics of the Labour and Communist parties
in their existing forms. In 1960, *New Left Review* (*NLR*) supplanted the two
journals. Despite their diverse origins and distinctive, sometime conflict-
ing, interests, the political perspectives of the two groups were converging.
'Culture' was central to their politics.

The New Left came into existence at a time of Cold War polarities, Conser-
vative Party triumph and widespread political apathy. The major question it
faced, like the Left more generally, was not only returning the Labour Party to
office but also re-energizing it with a socialist agenda in tune with the rapidly
changing times – the result of full employment, steadily growing income,
signs of class mobility and spreading mass culture. New Left activists were
critical of orthodox leftists who remained committed to traditional notions
of the class struggle and narrow views of politics. They also chided 'labor
revisionists', such as C. A. R. Crosland, for believing that the mixed economy
and the welfare state created the foundation of a post-capitalist society that
obsoleted class politics. Various New Left writers analysed the consequences
of the reshaping of working-class consciousness and culture, laying the
groundwork for the more academic discussions that took place later at the
Centre. Overall, they insisted upon the resilience of working-class culture,
while condemning the growing impact of Americanization. Indeed, New Left
activists were ambivalent about the United States. On the one hand, they
viewed the impact of American mass culture as a threat to working-class soli-
darity and community. On the other hand, some of them (especially among
those from the younger generation) were enthusiastic about American blues,
jazz and movies. They enthused over the evolving analysis and critique of
post-war transformations by American sociologists. C. Wright Mills's *White
Collar: The American Middle Classes* and *The Power Elite* (1956), David
Riesman's *The Lonely Crowd: A Study in the Changing American Character*
(1950) and William H. Whyte Jr's *The Organization Man* (1956) were among
the books that figured prominently in New Left discussions.

The original impetus of cultural studies at Birmingham developed more
along the lines of *ULR* and the original version of *NLR* than the *New
Reasoner* or the version of *NLR* edited by Perry Anderson beginning in 1962.
Hall was one of four *ULR* editors and *NLR*'s first. Hoggart was not a New
Left activist, but he published in *ULR*, and *The Uses of Literacy* was one of
the group's original inspirations. It was the subject of reflection and critique
by several writers in the Summer 1957 issue; and it was influential in the
debates on whether the working class was achieving 'classlessness' rather
than 'class consciousness' in the post-war world, triggered by Hall's 'A Sense

of Classlessness' in the Autumn 1958 issue. *ULR* socialists argued that the Left must acknowledge the profound impact of the new consumer society and welfare state on people's experiences rather than rely on outworn myths and slogans. The Centre's eclectic fusion of literary sensibility and sociological analysis in its early years was built on the earlier, more journalistic and less academic efforts found in *ULR* and the first two years of *NLR*, in part because Hall was one of the editors of the former and the sole editor of the latter.

In his often-cited analysis of the history of cultural studies, 'Cultural Studies: Two Paradigms' (1980), Hall linked the evolution of cultural studies to the politics of the New Left. He saw its development in terms of theoretical influences and paradigm shifts, a 'problematic' originally shaped by a series of 'culturalist' texts.[6] Hoggart's *The Uses of Literacy* used the close reading method of Leavis to 'read' an array of cultural practices beyond the pale of literature, recovering the 1930s working-class culture of his youth. Williams's *Culture and Society* delineated a mostly nineteenth-century tradition of English cultural criticism, existing on both sides of the political divide: it provided early cultural studies (and the Centre in particular) with a discourse on which to build and a tradition in which to historically locate itself. In *The Long Revolution*, Williams defined a method of cultural analysis founded on relationships between elements in a whole way of life and produced a series of case studies exemplifying his method. Thompson's *The Making of the English Working Class* (1963) conceived of class culturally and (in contrast to Williams) as 'a whole way of struggle'. He recovered the history of the early working class from the bottom up.

Given the centrality of cultural perspectives in the thought of the first New Left and early cultural studies, Richard Johnson in the late 1970s, following Hall, described this initial period as 'the moment of culture', contrasting it with the period in which he was writing – 'the moment of theory'.[7] Thompson rejected this representation. He viewed it as minimizing the arguments and debates that took place at the time and for depoliticizing the disagreements among the protagonists.[8] Nonetheless, it captures something important about the shared assumptions within the New Left milieu, notably the idea that the expressions of culture are produced through a protean and active process – created through human agency and manifestations of experience, not reducible to economic determinations.

In contrast to Hall's 'theoretical' history, Williams provided his own narrative. He emphasized that cultural studies developed as a radical theoretical and political practice within an alternative educational setting, namely the adult education milieu of the late 1940s and early 1950s – part of a long-standing tradition of British workers' education and adult education that provided a site in which a dialogue between intellectuals and workers could take place. For Williams, the classic texts of cultural studies did not so much embody

a theoretical paradigm shift as represent the most conspicuous expression of a much wider practice, shaped by numerous men and women who never expressed their ideas in a written form. Like Williams and Thompson during this period, Hoggart developed his approach from teaching adult working-class students. In his autobiography, he explained how such teaching shaped the contour of all three of their intellectual trajectories. 'We each had a sense of the special importance of our day-by-day work, a belief in the need for developed minds and imaginations – especially in wide-open, commercial, pyramidal societies – a sense of the many and major injustices in the lives of working people and so a deep suspicion of the power of class in Britain'.[9]

The origins of the CCSS reflect these political, pedagogical and theoretical influences. Initially, its research projects and theoretical vocabulary developed and extended perspectives originally voiced within the adult education milieu and in the New Left context. Although it catered to different students than those found in, say, the Oxford delegacy, it likewise occupied an ambiguous position in relationship to the established hierarchies of the university. One other precedent for the Centre worth mentioning is Mass Observation. Launched in 1937 (active until the mid-1960s and then revived in 1981), it sought to discover and preserve the views of ordinary people on their daily lives and the events of the time, as opposed to governmental and media representations of them. Founded by the South African poet, Communist and journalist Charles Madge (the first professor of sociology at the University of Birmingham and head of the department during the 1960s), the polymath Humphrey Jennings and the anthropologist Tom Harrisson, Mass Observation was funded by its founders and through contributions. It was sustained by hundreds of volunteer observers who kept diaries and responded to open-ended questionnaires.[10]

The Centre's origins are part of a world of higher education that has largely disappeared. In his autobiography, Hoggart recalled the establishment of the Centre and being hired at the University of Birmingham as professor of English. It came in the midst of what he characterized as an 'academic stroll'. Following lunch with several senior professors and the dean of the arts, the dean said to him, 'Well, they seem to want you. Are you prepared to come?' Later, when the vice-chancellor made the offer, one of Hoggart's three conditions for acceptance was the establishment of a postgraduate centre in contemporary cultural studies. The vice-chancellor replied, 'I cannot, of course, have a view on the precise subject. But you will be a professor and, if that is what you want to do, I do not think we would wish to dissuade you. But you would have to find the money for such a centre from outside'.[11] Thus, cultural studies was born at Birmingham.

Funding for the Centre was achieved equally informally. It came from Allen Lane, the founder of Penguin Books, who was grateful to Hoggart for

having testified in support of D. H. Lawrence's *Lady Chatterley's Lover* in
the face of obscenity charges following Penguin's 1960 publication of the
unexpurgated version. In a meeting between Lane and Hoggart at the office of
a mutual friend Bill Williams, Lane agreed to give £2,400 annually for seven
years. The publisher Chatto and the newspaper the *Observer* contributed as
well. When the Centre opened, it had a large enough annual budget to hire a
senior research fellow, a secretary, and some books and travelling expenses
for outside speakers. Stuart Hall was, of course, the research fellow.

Students in the early days of the Centre were admitted by written applica-
tion and an interview. Originally, there was only a PhD programme. There was
neither an application form nor research fellowships nor financial assistance.
Students financed themselves, either by scholarships from the Department of
Education and Science, specific awards from private sources, or by private
means. According to its first annual report, the Centre originally considered forty
applications, which it characterized as 'a surprisingly enthusiastic response'.
When it became fully operational in the fall of 1964 more than a dozen of these
had enrolled. The report noted that many of them had found it difficult to pursue
their interests 'within the established framework of disciplines in the universi-
ties, and welcome the opportunity to work here for this reason'.[12]

At the time that the Centre was founded, its faculty – Hall and Hoggart
– had already put their stamp on what was materializing as cultural studies.
Many readers of this essay know the rudiments of Hall's biography – his
migration from Jamaica to Britain in 1951 as a Rhodes scholar at Oxford, his
pioneering role in founding the New Left, and his editorship of the original
incarnation of NLR. Less well known perhaps is the fact that while being a
New Left activist, he was also a supply or substitute teacher in a secondary
school in south London. As he recalled it:

> So I thought well, what can you do? Practically, nothing! I couldn't then drive,
> so I couldn't drive a milk float. You can teach. So I got a job in a secondary
> school as a supply teacher, and you're sent round to different schools, but my
> school was unable to retain any of its supply teachers, or indeed, its teachers. So
> once I'd got in there they never let me go. I was a supply teacher in a school at
> the Kennington Oval, for quite a while, about three or four years, and, I used to
> leave there, get on a train, go to Soho, and edit the journal, and go back on the
> night bus – try to wake up in time to get to the Oval for the opening of class.[13]

Hall's experience as a teacher of working-class teenagers in a secondary
modern school and his enthusiasm about the new media and popular culture
were responsible for shaping his first book, co-authored with Paddy Whannel,
The Popular Arts. Whannel, like Hall, had been a schoolteacher. The British
Film Institute hired him in 1957 as an education officer; and he travelled the
country educating teachers about film. Their book was somewhere between

a theoretical and practical guide to understanding contemporary media and a handbook for teachers who wanted to use popular culture, and the issues that it raised, in their classes. Hall and Whannel rejected the rigid dichotomy between high and mass culture: a distinction that was not only based on an intellectual prejudice but also tended to fall apart under close scrutiny, particularly the analysis of movies and jazz. For them, popular and sophisticated art were not competing against each other: they had different aims and aspirations that were comprehensible only in their own terms.

An important element of *The Popular Arts* was its treatment of teenagers, who were often maligned as a social problem by pundits in the mainstream media. Hall and Whannel saw the younger generation as a 'creative minority, pioneering ahead of the puritan restraints so deeply built into English bourgeois morality, towards a code of behavior more humane and civilized'.[14] Equally important, youth culture had to be understood in the context of the new media and consumer capitalism. From this point of view, the music and fashion of teenagers was a contradictory synthesis of authentic and manufactured elements. This argument represented an early articulation, however embryonic, of the Centre's distinctive approach to subcultures.

The Uses of Literacy (mentioned previously) not only shaped early cultural studies but also represented the terrain that Hoggart imagined the Centre would explore. The book used the comparative method to analyse continuities and changes in the working-class way of life. Hoggart described both traditional working-class culture and the impact of the mass media on working-class experience and consciousness. From a working-class background himself, his account was overtly autobiographical, depending on childhood memories even when using the third person. He recreated the texture of working-class life in concrete and loving detail. The book was simultaneously anthropology, sociology and criticism. He contrasted the older forms of working-class popular entertainment as valid expressions of the 'full rich life' with the newer ones that he described as 'puffpastry literature, with nothing inside the pastry, the ceaseless exploitation of a hollow brightness'. For Hoggart, the debate on working-class affluence continued to be marred by seeing working-class life in socio-economic rather than cultural terms. While not underestimating the impact of mass culture on working-class consciousness and community, he insisted that working people were not blank slates, that they experienced the products of the new and expanded media from a distinctly cultural perspective.[15]

As director, Hoggart articulated the Centre's early aspirations in addresses, conference papers and essays. He used his 1963 inaugural address, 'Schools of English and Contemporary Society', to sketch out the landscape of cultural studies. It consisted of a defence of the literary imagination and argued for deploying it to analyse a wide range of cultural practices. Hoggart challenged

critics to be more open to the complexities of mass culture, while not avoiding critical evaluations. He located himself in the tradition of Leavis and the culture-and-society tradition articulated by Williams, which he contended needed further exploration. He cited several potential research projects, significantly because many were pursued at the Centre, although not necessarily as he imagined. They included (1) the study of the world of writers and artists, (2) an analysis of audience response, (3) the investigation of opinion formation, and (4) the examination of organizations that distribute the written and spoken word (in other words, the culture industries). Hoggart likewise imagined interactions between the various research strands: 'between writers and their audiences, and about their shared assumptions; about interrelations between writers and organs of opinions, between writers, politics, power, class, and cash; about interrelations between the sophisticated and the popular arts, interrelations which are both functional and imaginative; and how few foreign comparisons are made'.[16]

Elsewhere in the volume, Kieran Connell and Mathew Hilton explore the internal life of the Centre and its complicated relationship to the world beyond it. A related context in which to view its project is in terms of the growing movement in the humanities and the social sciences towards interdisciplinary analysis and scholarship, from the Annales School of historical writing in France and Marxist historians such as Hobsbawm and Thompson in Britain to American studies scholars in the United States. Hoggart's essay 'Literature and Society', an early effort at defining cultural studies, was published in the edited collection *A Guide to the Social Sciences* (1966), an inventory of recent work in the social sciences and the humanities. In the book's introduction, the editor, Norman Mackenzie, grouped Hoggart's essay with others in the book that were 'pushing out beyond the traditional boundaries of their disciplines and trying more satisfactory ways of describing what they find'.[17]

An early instance of the Centre's approach to cultural research is found in its first Occasional Paper, Rachel Powell's 'The Possibilities for Local Radio'. The fact that Powell's essay was the Centre's first publication is evidence enough of its importance. That Hall and Hoggart were the co-authors of the introduction further underscores its status, even if part of their purpose was to introduce the series. The essay was not an official Centre document, they suggested, as Powell was its author rather than its editor. Yet they enthusiastically endorsed it. They affirmed that the Centre was 'in general agreement with her arguments', and they commended Powell for producing a study that fleshed out the idea of local radio and showed 'what could be meant by the imaginative use of broadcasting within small communities'.[18]

'The Possibilities for Local Radio' contributed to the debate on the future of radio in Britain at a time when commercial expansion was being debated

in the public sphere. At first glance, Powell's essay did not seem to conform to the agenda proposed by Hoggart in his inaugural address: it did not explicitly perform close readings of texts, in this case radio programmes. In other respects, her analysis adhered to its spirit. She provided a wealth of empirical evidence regarding the mindset of the producers of commercial radio, the responses of audiences to their programming, the institutional outlook of commercial radio and its efforts to win the public debate. Most importantly, as stated in the inaugural address, the analysis of culture did not preclude cultural criticism. Powell's essay was simultaneously a spirited exposé of the consequences of commercial expansion at the local level and a detailed map of an alternative practice. It was closer to Leavis than to Dick Hebdige. On the one hand, she argued that the capitalist vision of radio's expansion was vacuous. She described local pop as 'meaningless and divisive': 'it will be merely another emptiness in the heart of our hollow cities'.[19] On the other hand, she proposed a model for local radio founded on 'culture', an ambiguous term, she admitted, but one (following Hoggart and Williams) that signified both a way of life and the practices that fostered and renewed it, in this case community relationships and democratic values.

In its first year, the Centre articulated a working procedure, cited in multiple reports, constituted by a three-part division of labour: the interpretation or critical reading of a text, the examination of its effect on an audience and the analysis of its social context and cultural significance. Initially, the Centre saw its methodology 'in co-operation with other relevant disciplines' as helping 'to set the phenomena of mass communications in a fuller social and historical context than any of us, working alone, have so far managed. It is not a substitute for social scientific analysis but a useful – an essential – adjunct'.[20] In practice, situating cultural texts in a wider context necessitated drawing on a theoretical understanding of culture and society beyond the scope of literary criticism, which Centre researchers soon realized either did not exist or existed in a form of limited value. Such was the case with the quantitative social-scientific work on mass communications being done in the United States, which Centre researchers viewed ambivalently. The third report praised American communications studies for producing generalizations that were subject to empirical verification, but viewed the cost of the achievement as suppressing questions 'not amenable to short-term verification'.[21]

Given the inadequacy of finding an existing theoretical foundation, the Centre was drawn into producing its own social and cultural theory; not in a systematic way, for there was really no clear path forward, but by exploring theoretical traditions of various kinds. In a 2011 interview, Hall described this period as a time of 'making it up': 'Anything that anybody thought might be relevant to making up cultural studies, because that's what we were doing. Making it up. Making it up week by week'.[22] An important part of

these explorations was the creation of a weekly seminar on 'selected texts', its purpose being 'to introduce students to some texts in fields of work adjacent to their own' and 'to build up our background reading, and to familiarize ourselves with methods and concepts drawn from other disciplines'.[23]

Alan Shuttleworth played an important role in helping the Centre broaden its 'universe of discourse'. He had read philosophy, politics and economics at Oxford and subsequently studied the writings of the American sociologist Talcott Parsons and Max Weber as a graduate student in sociology at Birmingham. He worked on the sociologist John Rex's important study of a poor West Indian immigrant Birmingham neighbourhood, *Race, Community, and Conflict: A Study of Sparkbrook* (1967). Being slightly older, Hall had known Shuttleworth since he (Shuttleworth) had been an Oxford undergraduate and a producer of the New Left student journal *New University*. According to Catherine Hall, Stuart had been a mentor to Shuttleworth, who for many years was a quasi-member of their family.[24]

Shuttleworth helped establish the text seminar and was responsible for the Centre's second Occasional Paper, its initial exploration of theoretical frameworks beyond its literary-critical foundation. In 'Two Working Papers in Cultural Studies', he reaffirmed the Centre's literary critical and humanist foundation (by analysing Leavis's writings), while arguing that its 'style and method' was inadequate to advance cultural studies' wider purposes. He advocated that the Centre broaden its approach by engaging with German idealism, particularly the writings of Max Weber, which he argued were part of a German culture-and-society tradition. The German critique of positivisms was analogous to literary criticism's critique of political economy and utilitarianism; it was founded on a conception of men and women as expressive, evaluative beings; and both traditions regarded human action as embodying subjective meaning and values. Yet, as Shuttleworth pointed out, there were also notable differences. Sociology, unlike criticism, was a generalizing mode, primarily concerned with groups, organizations and institutions. What it had to offer 'was not so much the "facts" – because the literary mind has its own ways of acquiring knowledge – but a classificatory, topological way of organizing'.[25]

Following Shuttleworth's lead, Centre researchers in the 1966–67 text seminar engaged with sociological theories that intersected with their aspiration to understand the connection between subjective meaning, objective social relations and individual and collective action. The 1966–67 report stressed, for instance, the Centre's affinity with Peter Berger and Thomas Luckmann's 'social construction of reality' perspective founded on the revival of Alfred Schutz's phenomenological sociology. The Centre saw this approach as a way of understanding how 'the subjective meanings of actors, who share a common social world, become expressed or "objectivated" in cultural artifacts,

in social gesture and interaction'. It provided an explanation of how mean-
ings were 'transposed from "subjective-meaning complex of action" into
the symbolic systems and language of a culture' and how consciousness and
subjectivity were turned into articulated social relationships, which in turn
bound individuals.[26]

Paper Voices (1970) was an early project manifesting these numerous
theoretical interests. The Centre's first group project was an analysis of two
newspapers, the *Mirror* and the *Express*, from the 1930s and 1940s to the
1960s. It was originally funded by the Joseph Rowntree Memorial Trust and
argued that in periods of rapid social change the press was a significant 'opin-
ion-former' and 'social educator'.[27] The research team of Anthony Smith,
Elizabeth Glass and Trevor Blackwell approached the newspapers as texts
containing embedded structures of meaning revealed through style, rhetoric,
form and language. *Paper Voices* was less interested in the newspapers'
explicit political views, and more in how their underlying linguistic, visual
and ideological assumptions, and their structures of feelings represented daily
events, constructed an ideal reader and reacted to and smoothed the way for
social change. *Paper Voices* crossed the ideas of thinkers like Hoggart and
Williams with theories drawn from semiotics and the social construction of
reality approach.

Britain was by no means in the vanguard of the cultural and political explo-
sion associated with '1968', but that remarkable blend of anti-establishment
student politics, youth subcultures, revolutionary sectarianism and experi-
mentation with alternative life styles was present. The revolutionary news-
paper *Black Dwarf*, the anti-University of London campaign, the Vietnam
Solidarity Campaign and political confrontations at the London School of
Economics and Hornsey College were all part of that tumultuous moment.
Looking back twenty years later, Hall (writing with Martin Jacques) char-
acterized the British version of 1968 as the most momentous radicalization
of its youth that had ever taken place, but one that was 'cultural' rather than
'political'. 'It was', in their words, 'through culture that political radical-
ism was generated and expressed. 1968 was the birth of the idea of cultural
politics as central to any hegemonic strategy'.[28]

Like so many other universities, the University of Birmingham experi-
enced upheaval. The Birmingham protest originated with 'The Student Role',
a moderate document produced by the Student Guild that made a case for
student participation in university affairs. Its demands were put forth dur-
ing a period of rising student self-confidence and in a growing institution
whose constitution had not been amended since 1927.[29] The administration
conceded much of what students wanted, but student leaders were frustrated
by (what they saw as) a strategy of continual delay in implementing a docu-
ment that increasingly seemed too timid in the first place. The tensions were

exacerbated by university policies regarding the admission of Czech students in the wake of the Prague Spring and student use of the rectory. In critical respects, it seems that the details of 'The Student Role' and other issues fought over were less pertinent than what they signified: intergenerational struggles, conflicts over modes of knowledge production, disputes pertaining to the university's relationship to the state, and differing views regarding the teacher/student relationship.

In late November, the Guild voted for direct action. It began with occupying the anteroom and office of the vice-chancellor, extended to many other administrative offices and ended up by occupying the Great Hall. It included a highly successful teach-in held over the weekend. In all, the sit-in lasted seven days. At a gigantic meeting of 4,500, students voted to end it. By the standards of the time, the Birmingham protest seems timid. There was no violence. Leaders of the Student Guild scrupulously adhered to constitutional procedures. The decision to launch a sit-in was more moderate than the shutdown that was considered but rejected. The militant Ad Hoc Group for University Reform, so-called because it in principle consisted of anyone who showed up, was undoubtedly important in pushing for more radical demands and shaping the discourse of protest, but ultimately was more important as a pressure group than as a representative body of the student majority. It certainly should not have been held responsible for the protest, as the administration seemed bent on accomplishing.

Faculty and students at the Centre were in the forefront of the protest. Hall edited an issue of the student magazine *Mermaid* on the experience of students at Birmingham several months before the protest. Paul Willis, having just entered the PhD programme, recalled that Hall addressed the sit-ins 'not as a professorial figure but a revolutionary and radical figure speaking to the masses of students'.[30] Michael Green, Trevor Blackwell and Trevor Millum, all attached to the Centre, and Catherine Hall were among *Mermaid's* contributors. The university named Larry Grossberg, who came to the Centre as a postgraduate student in 1968, and Chas Critcher, an undergraduate at the time but a postgraduate student the following year, to be part of the student negotiating team.

A fly-sheet circulating during the student protests called for a 'free university': the abolition of assessments, the democratization of relations between students and professors, the end of artificial barriers between disciplines, continual self-criticism and the creation of a curriculum based on 'felt needs'.[31] With very few changes, it describes the Centre in the years immediately following the protests. Changes originated as a result of both internal developments and interconnections with the wider intellectual and political environment. Most important was Hoggart's departure as director to take a position with UNESCO in Paris, first through a leave of absence,

then permanently. There were many reasons for his leaving: prominent among them was the difficult position he found himself in as director of the Centre and as a professor of English during the 1968 demonstrations. Although adroit in navigating the vicissitudes of university politics, during the student protests he felt the pressure, sometimes hostile, of mediating between the Centre's students, who were often participants, and the administration. Hall, who succeeded him as interim director, then director, was explicitly radical, enthusiastic about the cultural turn in politics, devoted to democratizing the Centre's structures and less committed to the kind of university politicking on which Hoggart thrived. The period of transition did not represent a total break with the past, as Hoggart did not relinquish the directorship immediately and the democratization of the Centre was already taking place while he was there. According to Rosalind Brunt, a postgraduate student in the thick of these changes, there emerged the 'little four' (Brunt, Chas Critcher, Richard Dyer and Trevor Millum), students who put forward proposals to the 'big four' (Hoggart, Hall, Shuttleworth and Andy Bear). 'It was sort of jokey', she recalled, 'but it is also indicative of some democratic inklings emerging in the Centre – which, despite its name certainly didn't start off really as any kind of collective enterprise'.[32]

The 'democratic inklings' were the beginning of a wide-ranging effort at redefining the Centre in the period 1969–71. These efforts took place when the Centre was in the midst of raising its profile through collective research projects and publishing, notably a cultural studies reader that never materialized and a journal that did – *Working Papers in Cultural Studies* (1971–77). They were part of a wider radical intellectual milieu in Britain where multiple experiments were taking place. The annual History Workshop conference, pioneered by the historian Raphael Samuel, one of *ULR*'s original editors, immediately comes to mind. The workshops represented a concerted effort to bridge the gap between historians and workers and played a critical role in launching the Women's Liberation Movement. More generally, debates within the Centre were part of the wider ferment that saw initiatives in workers' control, community organizing, alternative forms of education, communal living among youth, and the Women's Movement. Indeed, Hall expressed regret that Centre participants active in political causes on the outside did not bring the same commitment on the inside.[33]

Hall's visions for the Centre are contained in position papers never meant for external consumption, presented at weekly meetings attended by students and faculty alike, most importantly in the aptly titled 'The Missed Moment', originally given as a talk, later circulated in written form. Hall envisioned the Centre variously, as an 'advanced base', a kind of utopian enclave, and perhaps even as a 'red cell' (to be discussed further below). In the spirit of the 'third way' of the original New Left, he imagined the Centre as neither a

traditional research centre nor a self-sufficient political grouping, but occupying an in-between space. Organizationally, Hall anticipated a 'tight collective' evolving through democratization, solidarity, collective responsibility and self-criticism. Intellectually, he envisioned 'the production of work of a high and original quality, done from a sustained radical viewpoint, outside the dominant structures, values and modes of work current and prevailing in the surrounding academic environment'.[34]

In a 2013 interview included in this volume, Hall suggested that the transition from a 'tighter' to a 'looser' collective was a consequence of the increasing number of students coming to the Centre, but 'The Missed Moment' tells a different story.[35] At the time Hall was profoundly disenchanted at the failure of the 'tight collective' to emerge. He reaffirmed his commitment to the Centre, but for the first time since working there, he 'experienced it as a loss, as an absence, with resentment and unhappiness'.[36] Hall's understanding of what went wrong is difficult to summarize, but two lines of argumentation suggest themselves. First, he attributed failure resulting from the continued power of old structures, the lack of open debate, the absence of collective responsibility and the essentially 'unpolitical character' and political unsophistication of the Centre as a group. The Centre faced not 'a common dilemma but a set of serialized aggressive hostilities. Its direct consequence is pervasive bad feeling and bad faith which has marked our exchanges throughout the year.' Second, he believed that a major unsolved problem has been his dual role as an authority figure and as a participant, what he described as the classic 'double-bind'. As Hall stated it: 'Silence seemed to give as much offence as speech. I am not making a personal complaint here – though I cannot disguise how wretched and humiliating an experience this often was for me'.[37]

'The Missed Moment' reads like an ancient manuscript. Inside the world of today's neo-liberal university, it is hard to imagine such an undertaking being possible. Nor does it jive with the *Guardian* image of Hall as the 'godfather of multiculturalism' a sort of reassuring and kindly father figure who encourages the succeeding generations to think and act politically. Rather, it speaks to the era in which it was conceived, Hall's commitment to intellectual work as a political practice, the students that attended the Centre and some wishful thinking. It now seems remarkable that Hall imagined a group of postgraduate researchers in their mid-twenties could sustain his notion of a revolutionary collective, even if it was not to be specifically a party.

The fallout from 'The Missed Moment' is captured in Brunt's 'With Reference to the Moment Missed', a rejoinder to the talk rather than the paper (which was only written after Brunt's paper was circulated). It represents her response to Hall's paper as well as conveying her conversations with fellow students, thus offering a glimpse into the inner life of the Centre at the time. She portrayed his talk as 'presented to a weary and subdued meeting in a

weary and subdued way indicative of despair at low morale and seeing no
way out'.[38] Its audience felt that the project had neither been explicitly spelt
out until then, nor had Hall's representation of what transpired been entirely
accurate and nor was its seemingly total pessimism warranted. For Trevor
Fisher, Hall had never really 'pushed the intellectual line': he rather 'had
stood back as part of the crowd, which intellectually and politically, he
wasn't'.[39] Paul Willis believed that it was premature to judge the project, as it
had been a mere eighteen months, and that he himself had learnt a great deal
during that time and expected to go on learning.

For Brunt, Hall underestimated what had taken place at the Centre since
Hoggart's departure. Not only had there been work on research projects, plan-
ning for the reader and the publication of the first issue of the journal, but,
more generally, there was also a shift in orientation: from the moral critique
of the culture-and-society tradition associated with Hoggart 'towards a level
of critical theory at which people are prepared to engage "politics" seriously
for the first time'.[40] More generally, throughout the eighteen-month period,
she suggested, there was an 'implicit recognition' of the education process
experienced by students. In her words, 'it showed in the very language people
used to describe the intellectual debate and political orientation of the Cen-
tre'.[41] In short, where Hall had only seen failure, Brunt saw uneven develop-
ment and growth.

In the course of her critique, Brunt focused on Hall's portrayal of himself
as being in a 'double bind'. Brunt did not deny his representation so much as
suggest that he played an active role in creating it. He had a habit of attending
seminars with a pile of books in front of him on a table and remaining silent
only to intervene at the very end, so that people in the room, aware of his
prodigious intellect, anxiously waited for the other shoe to drop. Brunt argued
that the resentment felt by students was not about what points Hall was mak-
ing 'but how he said them – the all-or-nothing way he tended to intervene/
keep silent, rather than contributing along all the stages of the argument'. She
insisted that students accepted that Hall had a 'more worked-out theoretical-
political direction' but that he had a responsibility to educate others, although
it was not his alone.[42]

As evidence for Hall's underestimation of the growth of the Centre as a col-
lective and her contention that continued growth was possible, Brunt offered
the example of the admissions process. She observed that in the interviews
of applicants, the postgraduates of the interview team manifested increasing
cohesion in their portrayal of life at the Centre. In addition, she believed that
to build solidarity in the future, only applicants supportive of the Centre's
intellectual and political goals should be accepted. Not that she was literally
advocating that applicants have a political qualification: rather she supported
a 'cogent presentation' of the Centre's politics, the effect being that 'those

who felt threatened by it, or didn't see the point at all, would not wish to come anyway, nor would probably be invited'.[43]

Beyond the question that Brunt's proposal raised regarding what constituted an appropriate admissions policy for the Centre at the time, it also proved important because many years later, in his autobiography, Hoggart likely singled her out (although not by name) as representative of what had gone wrong with the Centre after his departure. He viewed her take on admissions as part of an effort at producing a 'red cell'.[44] Defending the Centre's practice under his directorship, he stated that neither he nor Hall used 'politics' as a criterion to accept students. This seems somewhat disingenuous given Hoggart's and Hall's politics: most applicants would have been left-wing in the first place. Most important, the question arises: Why would Hoggart pick on a student in the first place? Here, Brunt has recently suggested that while Hoggart had her in mind, she was likely serving as a proxy for Hall, for whom in the autobiography he has nothing but praise.[45] Her view makes sense insofar as Hoggart's broader intent seems to be a critique of the Centre's subsequent direction. It was Hall after all who had taken the Centre in a new direction and, in the process, undermined much that Hoggart had built.

A direction that Hoggart would certainly have opposed was any movement in the course of the Centre becoming a 'red base', a term that Hall used at the time, and, according to Brunt, introduced into Centre discussions.[46] How a red cell or base was imagined at the time would have been highly variable. The 1969 manifesto of the Revolutionary Socialist Students' Federation – a coalition including the International Socialists, the International Marxist Group, and *NLR* – gives an idea of the transformations it envisioned for university life.[47] Its action programme consisted of 'one man one vote' in a general assembly, no more exams and grading, an end to bourgeois ideology, the end of inequality between universities, and mass democracy. Hall's vision for the Centre at this time contained some of the same spirit, but (as we have seen) was less sweeping in its scope. As Geoff Eley has suggested elsewhere in this volume, Hall's advocacy of establishing a 'red cell' or 'red base' 'was less any concrete fantasy of plans for controlling the university (or some space within it) than the generic militancy keeping the political imagination at high levels of effervescence among students in 1967–71'.[48]

In 'The Missed Moment', Hall argued that addressing the 'crisis in Marxism' was critical to the politics of the Centre. On the one hand, he regarded Marxist theory as the only totalizing system capable of grappling with present conditions. On the other hand, he was well aware of its tendency towards narrowness and reductionism.[49] From the beginning, cultural studies was opposed to orthodox Marxism, and Marxism, although sporadically making an appearance in the Centre's early annual reports, was not going to be explored as long as Hoggart was director. In the late 1960s and early 1970s,

under Hall's leadership, Centre researchers entered into a new and closer relationship with it. Not in its orthodox guise, which had treated culture as a reflection or mechanical consequence of the base, nor in the socialist humanist version of the original New Left, which, though cognizant of the specificity and irreducibility of culture, had conceptualized it exclusively in terms of the category of 'experience'. Rather, cultural studies at the Centre drew on Western Marxism (most famously Louis Althusser and Antonio Gramsci), which, however heterogeneous, was unified by both its opposition to the orthodox formulation of the relationship between base and superstructure and its insistence that the model was indispensable. The 1969–71 annual report stated it this way: 'The major revival of Marxism, purged at last of its crude determinism, has proved to be a decisive development: above all for its rigorous attention to the complexly differentiated structures of a single formation, and its return to the problem of the social and economic determinations of culture. No single orthodoxy prevails here. . . . A hundred flowers contend'.[50]

The exploration of Marxism was not universally embraced. In the first issue of *Working Papers in Cultural Studies*, Alan Shuttleworth, who played such an important role in charting the Centre's early theoretical course, was entrusted with writing an essay articulating its distinctive framing of cultural studies. Rather than being an essay representative of where the Centre was at, his 'People and Culture' was more expressive of his own path. Shuttleworth was a self-proclaimed idealist, that is, he maintained that human activity, individual or collective, resulted from ideas. Accordingly, his view of what constituted cultural studies followed from this. 'Cultural studies', wrote Shuttleworth, 'should be to uncover the ideas embodied in all the various kinds of expressions in our society'.[51] Confronted with publishing an essay that did not reflect the Centre's current direction, Hall felt compelled to respond to it, and his essay 'A Response to People and Culture' was published following Shuttleworth's. He argued that 'People and Culture' was rooted in a 'methodological individualism' so thorough that it recreated all of the problems of positivism in reverse. Hall rejected the idea that culture originated with the individual actor: it was rooted in the reciprocal relationship between self and other. 'The question is', wrote Hall, 'how subjective meanings and intentions comes, under certain determinate conditions, to create and inform the "structures" of social life? And, how, in turn, the structures of social life shape and inform the interior spaces of individual consciousness'.[52] In his critique of Shuttleworth, Hall evoked an array of figures – R. E. Parks, Alfred Schutz, and Berger and Luckmann – all from the Centre's eclectic theoretical period, who were still very important to the Centre's conception of culture. There is no mistaking, however, the materialist thrust of Hall's thought and the direction in which it was moving.

In the early 1970s, the Centre underwent enormous changes. Allegiance to the culture-and-society tradition was being supplanted by commitment to

critical theory. The initial phase of grappling with Western Marxism, both its Gramscian and Althusserian versions, contributed to creating a theoretical synthesis that sought to bridge the gap between structuralism and humanism, structure and agency, theory and practice. Structuralism also was on the horizon of the Centre's interests. Between 1970 and 1972, a General Theory Seminar explored the relevance of Roland Barthes, Claude Levi-Strauss and Fernando Saussure for its project on the Western. What was noticeably absent was the collective exploration of women's issues. As Judith Scott, a student who enrolled in 1969 observed, 'the men produced the agenda: women were just beginning to mount a challenge to it'.[53]

While the idea of a tight collective was abandoned, its resonance was enormous. The General Theory Seminar and the working groups – the model of intellectual work for which the Centre is best known – seem to have emerged more as a compromise than as an initial ambition. They were somewhere in between the imagined utopian enclave and the realities of political pluralism and professional necessities. Hall concluded 'The Missed Moment' with the following observation: 'Our failure to grasp the opportunity to explore the contested territory outside the given routines of our normal intellectual life represents something more than a personal failure. It is a kind of collective set-back: and such defeats have more than personal consequences, and meanings. History tends, retrospectively, to be hard on them'.[54] Ironically, it was just the opposite. What followed was the beginning of the Centre's most productive intellectual period. Rather than history being hard on it, the Centre has been acknowledged worldwide for its role in putting cultural studies on the map.

I began this chapter by suggesting that the Centre's origins no longer seem contemporary, but I never meant to suggest that the Centre's early work was discontinuous with what followed. Many of the topics that surfaced in the mid-1960s were important to later cultural studies. The efforts to link cultural theory and empirical research characteristic of the cultural studies field as a whole were likewise part of the Centre's project from its origins. The multidirectional search for ways of thinking about culture is present from the beginning. Most importantly, as the quote from Eric Hobsbawm cited at the beginning suggests, cultural studies at the Centre was part of a tradition of cultural criticism that was not just about understanding contemporary culture. It was about transforming it.

NOTES AND REFERENCES

1. The foundation of my thinking on the history of cultural studies in this chapter is based on my book Dennis Dworkin, *Cultural Marxism in Postwar Britain: History,*

the New Left and the Origins of Cultural Studies (Durham: Duke University Press, 1997). I want to thank Gregory Merrill for transcribing Stuart Hall's 'The Missed Moment' from a photocopy of the original faded mimeographed pages into a readable form. Thanks also to Rosalind Brunt and Catherine Hall for taking the time to discussing the Centre with me.

2. Eric Hobsbawm (ed.), 'Pop Goes the Artist: Our Exploding Culture', in *Fractured Times: Culture and Society in the Twentieth Century* (New York: The New Press, 2014), p. 265.

3. Raymond Williams, 'Culture is Ordinary' in Robin Gable (ed.), *Resources of Hope: Culture, Democracy, Socialism* (London: Verso, 1989), p. 9.

4. Stuart Hall, 'In the No Man's Land', *Universities and Left Review*, 3 (Winter 1958), p. 87.

5. Raymond Williams, *Culture and Society, 1780–1950* (New York: Harper and Row, 1966), p. 282.

6. Stuart Hall, 'Cultural Studies: Two Paradigms', *Media, Culture and Society*, 2 (1980), pp. 57–72.

7. Richard Johnson, 'Against Absolutism', in Raphael Samuel (ed.), *People's History and Socialist Theory* (London: Routledge & Kegan Paul, 1981), p. 394.

8. E. P. Thompson, 'The Politics of Theory' in Raphael Samuel (ed.), *People's History and Socialist Theory* (London: Routledge & Kegan Paul, 1981), pp. 396–408.

9. Richard Hoggart, *A Measured Life: The Times and Places of an Orphaned Intellectual, vol. 2: A Sort of Clowning, 1940–1959* (New Brunswick: Transaction Publishers, 1994), p. 96.

10. Frank Mort made the point that the Centre is part of a wider history in which Mass Observation was a predecessor in response to my paper at the CCCS50 conference. See Charlotte Brunsdon, 'On Being Made History', *Cultural Studies*, 29, 1 (2015), p. 90.

11. Richard Hoggart, *A Measured Life: The Times and Places of an Orphaned Intellectual*, vol. 3: *An Imagined Life, 1959–1991* (New Brunswick: Transaction Publishers, 1994), p. 77.

12. CCCS, *First Report, 1964* (Birmingham: CCCS, 1964), p. 1.

13. Stuart Hall and Les Back, 'At Home and Not at Home', *Cultural Studies*, 23, 4 (2009), pp. 670-701.

14. Stuart Hall and Paddy Whannel, *The Popular Arts* (Boston: Beacon Press, 1967), p. 73.

15. Richard Hoggart, *The Uses of Literacy* (Harmondsworth: Penguin, 1958), p. 232.

16. Richard Hoggart (ed.), 'Schools of English and Contemporary Society', *Speaking to Each Other, vol. 2: About Literature* (London: Chatto & Windus, 1970), p. 257.

17. Introduction to Norman Mackenzie (ed.), *A Guide to the Social Sciences* (New York: A Mentor Book published by The New American Library, 1966), p. 33.

18. Richard Hoggart and Stuart Hall, Introduction to Rachel Powell, 'The Possibilities for Local Radio', *Occasional Papers in Cultural Studies* 1 (1965).

19. Powell, 'The Possibilities for Local Radio', p. 12.

20. Richard Hoggart (ed.), 'Literature and Society', in *Speaking to Each Other, vol. 2*, p. 34.

21. CCCS, *Annual Report 1965-66*, December 1966, p. 14.

22. Stuart Hall, 'Stuart Hall Interview, 2 June 2011' *Cultural Studies* 27, 5 (2013), p. 763.

23. CCCS, *Annual Report 1965-66*, p. 22.

24. Catherine Hall, interviewed by Dennis Dworkin, 11 July 2015.

25. Alan Shuttleworth, 'Two Working Papers in Cultural Studies', *Occasional Papers in Cultural Studies* 2 (1966), p. 24.

26. CCCS, *Annual Report 1966-67*, January 1968, p. 29.

27. A. C. H. Smith, Elizabeth Immirzi, and Trevor Blackwell, *Paper Voices* (Totowa, NJ: Rowman and Littlefield, 1975).

28. Stuart Hall and Martin Jacques, '1968', *Marxism Today* 27, (May 1988).

29. In 1927 there were 1550 students and 115 academic staff (39 being professors). In 1968 there were 6500 students, 117 professors and 836 non-professors. Eric Ives, 'The Events of 1968', Diane Drummond, and Leonard Schwartz (eds), *The First Civic University: Birmingham 1880-1980* (Birmingham: The University of Birmingham Press, 200), p. 356.

30. This paragraph is based on Kieran Connell and Matthew Hilton, 'The Working Practices of Birmingham's Centre for Contemporary Cultural Studies', *Social History* 40, 3 (2015), pp. 94-5.

31. Ives, 'The Events of 1968', pp. 362-3.

32. Christopher Pawling and Rosalind Brunt, 'Christopher Pawling and Rosalind Brunt Interview—6 June 2011', *Cultural Studies* 22, 5 (2013), p. 701.

33. Stuart Hall, 'Think Small but Hard' (1971), p. 3.

34. Stuart Hall, 'The Missed Moment' (1971), p. 9.

35. Stuart Hall, interviewed by Kieran Connell, 14 September 2013.

36. Stuart Hall, 'The Missed Moment', p. 16.

37. Ibid., p. 15.

38. Rosalind Brunt, 'With Reference to the Moment Missed' (1971), p. 3.

39. Ibid., p. 3.

40. Ibid., p. 7.

41. Ibid., p. 6.

42. Ibid., pp. 5-6; Rosalind Brunt, interviewed by Dennis Dworkin, 5 July 2015.

43. Ibid., p. 9.

44. Hoggart, *An Imagined Life*, p. 98.

45. Rosalind Brunt, e-mail message to author, August 23, 2015.

46. Ibid.

47. Revolutionary Socialist Students' Federation, 'Manifesto', *New Left Review,* 53 (January–February 1969), pp. 21-22.

48. Geoff Eley, Conjuncture and the Politics of Knowledge: The Center for Contemporary Cultural Studies (CCCS), 1968-1988.

49. Hall, 'The Missed Moment', p. 5.

50. CCCS, *Annual Report, 1969–70* (Birmingham: CCCS, 1971), p. 5.

51. Alan Shuttleworth, 'People and Culture', *Working Papers in Cultural* Studies 1 (1971), p. 93.

52. Hall, 'Response to "People and Culture"' *Working Papers in Cultural* Studies,1 (1971), p. 99.

53. Judith Scott, interviewed by Kieran Connell, 26 November, 2013.

54. Hall, 'The Missed Moment', p. 16.

Chapter 2

Conjuncture and the Politics of Knowledge

The Centre for Contemporary Cultural Studies (CCCS), 1968–1984

Geoff Eley

I want to begin by noting a discrepancy. On the one hand, the Birmingham CCCS has a salient and recognized place inside an important complex of cultural and intellectual histories of the last third of the twentieth century as the Left has come to conceive them. Those histories embrace definite objects of inquiry (classically: youth subcultures, popular cultural forms, ethnographies of working-class life); major new disciplinary and interdisciplinary areas of study (media, mass communications, cultural studies per se), long-evolving theories of language, ideology and subjectivity; entire dimensions of social and cultural analysis (gender, class, above all race); and last but not least, a particular reading of the course of British political history between the start of the twentieth century and its end. For the ferment of ideas in the 1970s and 1980s, the impact of the CCCS was indispensable – notably, for the debates inside Marxist theory and everything covered by the eight Hutchinson-published CCCS volumes, from *On Ideology* and *Women Take Issue* (each 1978), through *Working-Class Culture* (1979) to *The Empire Strikes Back* and *Making Histories* (each 1982), and finally *Crises in the British State* (1985).[1] This presence of the CCCS was also key for the history of the Left itself and the long-unresolved struggle to develop a politics adequate for the needs of the transformed capitalist society being created since the 1970s. Indeed, it is hard to imagine a history of the Left's debates and accomplishments in this period that holds no place for the multiform contributions of the Birmingham Centre and its members.

 Yet, on the other hand, you would never know this from the general accounts now being written by historians about these times. Neither the Centre as a particular institutional agency nor cultural studies as a body of

thought have any place whatsoever in the contents of those general British histories. The general narratives of the 1970s and 1980s, no less than the extensive literatures on Anglo-British national identity or for that matter very specific oeuvre like the cultural and intellectual commentaries of a centrally positioned, acutely perceptive and strongly left-of-centre intellectual historian like Stefan Collini, have nothing to say about this particularly interesting collective contribution.[2] To take another illustration, the CCCS proved an extremely fertile source of ideas around questions of Englishness/Britishness during the 1980s, particularly with respect to race, legacies of empire and the reshaping of the twentieth-century state. Yet Peter Mandler can track discussions of the 'English national character' between Edmund Burke and Tony Blair without even mentioning this body of work, except obliquely to confirm the 'perverse' wrongheadedness of 'left-wing intellectuals'.[3] Since the 1980s, as CCCS alumni dispersed across British higher education, an elaborate corpus has continued building around such questions, particularly on Englishness and empire, but it never registers on Mandler's radar.[4] These really are parallel streams of publication and discussion. So what is going on here? How do we make sense of such a discrepancy?

It calls our attention to one of the most basic of historiographical questions: namely, who writes history and how is it authorized? For when the past settles into the reliable patterns and normative stories deemed to describe how the present was produced, inequalities of power, audience and voice are usually in play. As I compose these words (at the climax of the process to elect a leader of the Labour Party in August 2015), British public discourse is saturated with references to '1983' and sometimes '1979', whose meanings evoke an especially well-established story about how the present came to be shaped, one whose elements have become so successfully naturalized as to constitute our contemporary political common sense. Facile though such claims can sometimes be, in other words, we are clearly dealing here with a type of victors' history: with complicated processes – some conscious, some not – that make some events and ideas useable for history and leave others on the cutting-room floor. How exactly the past gets recalled or forgotten, how it gets worked into arresting images and coherent stories, how it gets ordered into reliable explanations, how it gets celebrated and disavowed, suppressed and imagined, works in complicated ways to sanction the present as necessary, as the natural state of affairs, as an ending, against which 'there is no alternative'. Thus in pondering the significance of the conflicts of the 1970s and 1980s, we need to draw on some very basic questions. Which narratives get to organize the commonly accepted contours of a society's collective understanding? How do they get composed? What goes into their making? Who gets included, and who gets left out? What is it that confers a place in the story, even if merely a paragraph or a sentence or two? Which ideas deserve to

be noticed, and which can just be ignored? What is it that decides and how? If these are not exactly the questions of Brecht's worker who reads history, then the thrust is surely the same.[5]

Stuart Hall, who was director of the CCCS from 1968/69 to 1979, was by any criteria one of the most significant British intellectuals of the second half of the twentieth century. Yet, in contrast to his predecessor and CCCS founder Richard Hoggart, who *has* been written into the narrative, Hall finds no place in the currently materializing national histories. Hoggart authored *The Uses of Literacy*, to be sure, a book that captured the national imagination like few others when it was published in 1957 and whose resonance lasted for long thereafter.[6] Still more pertinently, though, as Rosalind Brunt observes, Hoggart's post-Birmingham influence had a very particular trajectory. He ceased being primarily a teacher-intellectual and preferred a career of high-level public administration instead, moving successively to UNESCO as assistant director general (1968/1971–75) and thence to Goldsmiths as warden (1976–84): 'Richard goes down the committee road, becomes one of the great and the good . . . and is very, very good at working behind the scenes, getting committees to take a progressive line on broadcasting, education, youth clubs, you name it, which did lead to substantial policy changes'.[7] He was the consummate outsider-turned-insider, experienced and adept at negotiating his way behind the scenes, joining the progressive establishment during a time when it enjoyed particular leeway in the conduct of cultural affairs.[8] But authorizing Hoggart's journey as part of the national story (rendering it visible), while effacing Hall's very different passage through the same period of strongly contested movements and ideas, is to write that history from a selective and highly particular vantage point, one that valorizes certain ideas and their emplacements over others. The genuine interest and importance of Hoggart's story – the place he holds in contemporary history – makes it no less partial and partisan in its assumptions about entitlement, given the structures of privilege and dominance – the institutionally secured concentrations of cultural capital – thereby involved.

What follows below is something of a counter-narrative, or at least a modest gesture in that direction. Why does this matter? From an earlier vantage point in the mid-1960s at the time of the Birmingham Centre's creation, on the cusp of the socio-political tumults that were about to launch its operative history, an official story seemed locked into place every bit as powerfully as the later neo-liberal mythology of the origins of the present in our own time. As it unfolded from the 1940s and 1950s, the post-war consensus celebrating the much-vaunted British genius for compromise and gradualism proposed a polite and complacent success story of British history based on parliamentary evolution, expanding citizenship and the creation of the welfare state. Certain intellectual interventions commonly taken as

foundational for cultural studies' inception – such as Edward Thompson's *Making of the English Working Class* (1963) and Raymond Williams's *Culture and Society* and *The Long Revolution* (1958, 1961) – then joined the surrounding momentum of the successive New Lefts in enabling a critique of that consensus, acquiring by the mid-1960s impressive breadth across British intellectual culture.[9] This had multiple dimensions, including its most overtly and directly political contribution: imaginatively reclaiming the past forms of popular democracy vitally helped in challenging the dominant ideas of the new and later time. The revelation that collective action, mass politics and insurrectionary resistance had been needed to dislodge the coercive and corrupt practices of a narrowly based political system in the earlier nineteenth century helped fuel the emergent radicalisms in this later twentieth-century present. But by attending to popular culture and popular beliefs, by exploring how ordinary people handled large-scale events by means of the ideas and practices accessible in everyday life and by developing his distinctive ethnographic methods, Thompson also delivered resources across a far wider set of fronts.

Thompson's social histories – always already cultural histories too – broadened out the space for thinking about politics, requiring new theories and techniques of study, while finding political meanings in all sorts of unexpected places. That already emerged powerfully from *The Making*, but was still more true of the subsequent work on the eighteenth-century 'moral economy' and the collaborative studies of criminality and the law pursued during Thompson's years at the University of Warwick (1965–71), which culminated in *Whigs and Hunters* and *Albion's Fatal Tree* (both 1975).[10] The freshly expanded conception of 'the political' emerging from these histories radically de-institutionalized its possible locations, shifting them away from the acknowledged arenas of parliaments, parties and associations towards other kinds of settings and practices, such as neighbourhoods and streets, workplaces and informal economies, riots and criminality, youthful rebelliousness, expressive stylistics, sexual dissidence and any of the ways in which a society's norms and behavioural rules might be challenged or flaunted, including even the meanings of 'apathy' or indifference to politics as such.[11] My point is that these were *precisely* the grounds where the CCCS began much of its own distinctive work after 1968. If some of the Birmingham Centre's early signature projects – on television and media more generally, on broadcast news, on soap operas, on magazine representations of women, even *Policing the Crisis* in its earliest provenance as a study of media panic around a local incident of 'mugging' – shared continuities with Hoggart's own characteristic concerns, then others definitely caught the Thompsonian momentum, including pre-eminently the new focus on subcultures, but also emerging interests in work and cultural history.[12]

A transition at the Centre could be glimpsed in this regard at the end of 1971 with the demise of the General Theory Seminar started in 1970 and its replacement with the famous and much-envied system of subgroups, which initially included both literature and society and media studies and was then rapidly extended towards subcultures. In this way, the Hoggartian origins crossed with the radicalized social histories and incipient Marxisms entering through ''68' and its surrounds. Yet, no sooner had Thompsonian social history made its imprint, than things were already moving on, driven intensely forward by a gathering commitment to theory as such – to linguistics and semiotics, to studies of ideology, to a wider range of European critical theory, above all to Marx.[13] This rapid movement beyond any ground connecting straightforwardly with Thompson quickened in response to the frenetic intensifying of wider Marxist debates of the time, compounded by the greater numbers of students including the influx arriving with the launch of the MA in October 1975. This passage from 1971–72 to the middle of the decade occurred through an extraordinary concentration of debate, experiment, creative disagreement and change, which has already been elaborately written about and formed the starting point for many of the trajectories taken to characterize the Centre's influence during the next decade. But in its particular relationship to Thompson – which was emblematic for the larger tensions pitting the Centre and its allies against an earlier New Left formation and *its* wider support – the Centre was undergoing a fascinating struggle with ambivalence. If certain Hutchinson volumes were heavily structured around a critical dialogue with Thompson's ideas (*Working Class Culture, Making Histories*), then from others he almost entirely disappeared (*Women Take Issue, Empire Strikes Back, Crises in the British State*). Aside from the migration of the Left's priorities to zones of political urgency where Thompson stayed mainly indifferent (notably, race and gender), strongly held differences also emerged over theory in general.[14] Though the CCCS always treated Thompson's ideas and standing in a spirit of constructive and respectful critique, by the mid-1970s fissures were clearly opening. Reacting initially against a 1976–77 Occasional Stencilled Paper, then against Richard Johnson's 1978 article in *History Workshop Journal*, Thompson unleashed his full polemical fury in a staged confrontation with Johnson and Hall at the 13th History Workshop at Ruskin in December 1979.[15]

Convening far wider disagreements inside the Left, whether among intellectuals or across movements at large, this seemed at the time a spectacular display of divisiveness, a severe crisis not just of civility, but of fundamental orientation and the relationship of debates in theory to possible forms of political practice, bringing to a head conflicts that were building over a number of years. As Kieran Connell and Matthew Hilton have argued, the Ruskin occasion was also prefigured in a variety of ways inside the CCCS

itself, where versions of the disagreements accompanied each of its major departures during the 1970s.[16] As it turned out, the December 1979 Ruskin confrontation proved cathartic: if the intellectual disagreements hardly melted immediately away, the changed political climate in Britain after Margaret Thatcher's election the previous May combined with the rebooting of the Cold War in the early 1980s to relativize the severity of those theoreticist battles and substantially contain their fallout. The details of the Ruskin debate have already been much written about, including by me.[17] The internal debates and trajectories of the CCCS itself during its heyday have also been explicated many, many times, whether by the participants themselves or by a small legion of commentators, probably exhaustively. Moreover, the relationship of those Birmingham histories to the wider universe of cultural studies as it coalesced during the 1980s and 1990s, intellectually and institutionally, whether in Britain or internationally, has been no less extensively treated. For my present purposes, therefore, I will make just a few further comments on the CCCS' relationship to the wider political and intellectual radicalism of the time. By pointing to a number of typicalities and convergences, my intention is not to lessen the Birmingham Centre's importance, but rather to deepen our sense of its context.

First, then, I want to stress the importance of the week-long student occupation of Birmingham University's Great Hall in November–December 1968 as a founding event. At one level it effected the transition of leadership from Hoggart to Hall. More searchingly, the experience of being involved in the sit-in and associated protests and debates clearly energized Hall and the Centre's students into re-imagining what the CCCS might be, leading 'to a concerted attempt to initiate a democratization of its working practices' embracing all 'decisions relating to the day-to-day management of the Centre, its intellectual scope, and its future direction'.[18] The resulting details of the democratic collectivism that came with growing intensity to shape the intellectual collaborations, production of knowledge, social relations and general everydayness of the Centre's collective institutional life have been well described elsewhere.[19] The *politics* of 1968–69 were vital in breaking the CCCS *out* of its Hoggartian cast and *into* a different frame of theoretically driven analysis of cultural phenomena in their broadest historical contexts of social life, a change traceable across the Centre's *Fifth* and *Sixth Annual Reports* (1968–69 and 1969–71), issued in October 1969 and December 1971 respectively.[20] One CCCS student active in the sit-in, Paul Willis, who later published an account of the experience, recalled a very direct relationship: it 'transformed how we would approach intellectual work'.[21] Hall was expansive in his hopes for what might come out: the CCCS could become a 'utopian enclave' capable of 'transcend[ing] the limits of what appears possible and natural within the existing limits of our situation'. It would 'challenge and modify

the prevailing modes of knowledge and authority'. The goal was 'nothing less than the creation, within . . . the existing system, of a *collective* – an intellectual *foco*: a sort of advanced base'.[22]

This was the rhetoric of the headiest hopes of a particular grouping of the student movements of the late 1960s, including the International Socialists (IS, future SWP), the International Marxist Group (IMG), and *NLR*, who in June 1968 formed the Revolutionary Socialist Students' Federation (RSFF) that flickered briefly across the map of student militancy in 1968–69. Lifting the neo-Maoist rhetoric of urban guerrillas and national liberation, along with a Marcusean sense of a de-radicalized working class, RSSF proposed the building of 'red bases' in the universities to act as the 'growing points of revolutionary power' for society at large.[23] But if Hall used a modified form of this language, it bespoke less any concrete fantasy of plans for controlling the university (or some space within it) than the generic militancy keeping the political imagination at high levels of effervescence among students in 1967–71. Some came to the CCCS already fired by experiences elsewhere – Rosalind Brunt from Essex, Christopher Pawling from time in Frankfurt, for example; others, including Chas Critcher, Paul Willis, Larry Grossberg and Pawling, were heavily involved in the Birmingham events per se. The compelling *eventfulness* of the sit-in – the exceptional intensity and perduring consequences of participating in a direct action of that kind, whose experiential charge came not just from the immediacy of the local events themselves, but also from their relationship to everything else happening in the wider radicalized worlds of politics – can never be exaggerated. The inflated sense of possibility was fuelled not just by events in other universities and colleges in Britain, Europe and across the world, but in countless other contexts of the late 1960s (socially, nationally, globally) where popular mobilizations and collective actions were occurring. In their concentrated unity of local and larger meanings, in the ramified directness of the relationship between immediate actions and wider realms of understanding and in the breathtaking existential dramas of personal change, such times are exceedingly powerful. They confer the rare privilege of learning one's politics – hectically, effectively, lastingly – in the laboratory of practice. What I still recall from my own experience of such a kind (from an occupation in Oxford in February–March 1970) is the sheer intellectual and political excitement of being *inside* the event – the rush of participating in direct action, the exhilarating novelty of so much collective discussion, the unprecedented ease of spontaneous communication, the rapidity of the political learning process and, of course, the temporary high of success.[24]

In other words, the seeming ultra-leftism of Hall's statements quoted above makes sense only in terms of these wider intensities and the imaginative release they permitted.[25] The interconnectedness across the many Left

intellectual initiatives of the time – field by field, discipline by discipline, and institution by institution, often reaching beyond the university precincts into wider settings of various kinds – was essential to the radicalism. There is a tendency to grant the CCCS greater originality, a uniquely vanguard-ist standing even than it actually possessed, and it takes nothing away from that history to find lots of equivalence elsewhere. Just as the sit-in's effects were replicated in many other places, so too was the drive to transform the interior relations and practices of the university, elements of which – in some version and degree, whether in a particular department or discipline or more widely across an institution – affected most of further and higher education in the late 1960s and early 1970s. Redefining the academic disciplines and their boundaries; rethinking the structure and contents of curricula; chal-lenging the given forms and methods of pedagogy; democratizing faculty-student-staff relations – these were the oxygen of student life for anyone with left-wing inclinations going to university in these years. Sometimes internal protests and pressures escalated into crises of an entire institution – at the London School of Economics (1967–69), Essex (1968–69), Hornsey (1968), Guildford (1968), Warwick (1968–70), Oxford (1970), and the Polytechnic of North London (1970–74).[26] More commonly, they energized particular departments and programmes in particular places or flared more passingly in discrete crises. My point here is that the *openness* to the possibility of radical change had become generalized across the student cohorts of the later 1960s along with the relatively small numbers of their teacher allies. Until we can grasp the rapidity and extent of this generalized generational shift – we will miss key lines of indebtedness, impact and affiliation.[27]

While the CCCS was certainly one of the key points of confluence, other groupings and networks had their own forms of democratic collectivism, with working practices that may not have matched Birmingham's for intensity, but marked no less of a vital departure in their respective fields. In fact, ideas and people travelled among these nodes incredibly easily. There were always wider connections radiating outwards from Birmingham as well as coming in from elsewhere. In the early years, there were two in particular. One came through the National Deviancy Conference founded in July 1968 by a group of young sociologists, each then in their twenties, as a Left breakaway from orthodox criminology in the interests of a theoretically driven social critique joined to political advocacy. Besides an array of monographs and three widely circulated volumes from their early conferences (1971, 1972, 1974), this group produced the programmatic *New Criminology* (1973) and a com-panion anthology (1975), along with an extremely ramified pattern of influ-ence across other parts of the intellectual Left before disbanding somewhere between 1977 and 1979.[28] But in conducting this work, they also developed a collective esprit and working practices based on intensive collaboration.

Ties with the CCCS were extremely close – Stanley Cohen published an early essay in the Centre's journal (1974); Stuart Hall co-edited *Situating Marx: Evaluations and Departures* (1973) with Paul Walton, another member of the group, from a conference on David McLellan's early selections from *Marx's Grundrisse* (1971) held at the CCCS and organized by Ian Taylor; both Phil Cohen's benchmark 'Sub-Cultural Conflict and Working Class Community' (1972) and *Resistance through Rituals* (1975/76) were heavily indebted to conceptual work by Stanley Cohen, Laurie Taylor and Jock Young; Hall gave a key paper on 'Reformism and the Legislation of Consent' to the last-but-one Deviancy conference in 1977, proceedings from which were co-edited by John Clarke (1980).[29] Partly through the shared concepts of 'media amplification' and 'moral panic', radical criminology was also linked with mass communications and media studies, which was the second early stream running through the CCCS. Connell and Hilton make this point very well on the example of the Centre for Mass Communication Research (CMCR) established in 1966 at Leicester University under James Halloran, whose background and career closely mirrored Hoggart's own (each was appointed at Leicester in 1957 and 1958, in adult education and English respectively). CMCR's signature study, an exhaustively rich analysis of the remarkably successful public de-legitimizing of the 27 October 1968 demonstration against the Vietnam War, converged with the Birmingham Centre's own emergent interests, but from differing grounds of politics, methodology and theory.[30] Later, these complicated but genuine links were especially apparent in two Open University anthologies on mass communication and society edited by James Curran, Michael Gurevich, Tony Bennett and Janet Woollacott (1977, 1982), which included magisterial commentaries by Hall on the re-theorizing of ideology in progress across very many sectors of the Left at the time.[31] Both patterns of wider cross-area and cross-institutional conversation (sociology of deviance, mass communications) came together in an anthology edited by Stanley Cohen and Jock Young in 1973, *The Manufacture of News: Social Problems, Deviance, and the Mass Media*, where the CCCS had a definite presence, including an excerpt from *Policing the Crisis* (1978) added subsequently for the second edition (1980).[32]

So how distinctive was the institutional culture at the CCCS? In comparison with the National Deviancy Conference, the CCCS had the advantage precisely of *being a centre* – of existing inside a single institutional location, in a freestanding physical space that for some time proved both autonomous and resilient, despite all the university's efforts to constrain and undermine it. But there were other examples. I will cite two from personal experience, neither of which exactly replicated CCCS circumstances – they were smaller, more dispersed, in a different relation with their surrounding institutional environs, lacking either the same all-consuming autonomies or

the longer-term theoretical legacies. But each showed very well the wider fields of intellectual and political influence and conversation. Some of these reached other universities and areas of inquiry, some articulated with larger theoretical debates and departures, but others extended beyond the seminar rooms and conference halls altogether, linking with non-academic settings in a more direct relationship to social movements, the arts and aesthetics, public culture and politics.

My first example comes from Cambridge in the 1970s, the centrepiece being the interdisciplinary 'Women in Society' course created under the auspices of the University's Social and Political Sciences Committee (SPS) in 1973. This was conceived and taught by a mixed collective of faculty, graduate students, non-academic professionals and community workers, some with formal university affiliation, others not. Avowedly interdisciplinary not just in the background and identity of its members , but also in its approach to knowledge and curriculum, and indeed its basic epistemology, the group called upon an entire array of disciplines, including anthropology, history, semiotics, psychology, medicine, genetics, history of science, economics, sociology, political theory and, of course, feminist theory. The collective esprit grew from the same intensity of reading/talking/writing characterizing CCCS working practices and their democratic elan. Moreover, if at one level this involved the same commitment to breaking down the hierarchies of status and authority between teachers and students, it was also far more than a working method or set of protocols for how to approach one's academic study. It involved an ethically driven and socially committed willingness to rethink what a democracy of knowledge might mean, whether in the micropolitics of pedagogy in the classroom or in any of the wider domains of political action in the university, the community and society at large. As at the CCCS, it encouraged 'an entire outlook, an ethos, a common acceptance that thinking, learning, writing, personal life, and politics all belonged axiomatically together', indeed that precisely those older separations could be refused.[33]

This certainly reflected the wider impact of the new Women's Movement, which was demonstrating insistently by example how teaching and learning practices might be remade. Widening the focus, a similar dynamic could be seen in another part of Cambridge SPS, namely the Marxism Seminar, also taught by a teacher-student collective largely beneath the radar of the tenured university faculty. We can keep extending this picture. The Cambridge Social History Seminar, begun in 1975, with support from neither the history faculty per se nor anyone appointed there, was another site of intensely engaged intellectual life, where the radicalism of changes in the discipline conjoined with other kinds of experience, from generational difference to a certain marginal or subaltern status: as graduate students, research fellows, part-time teachers

and non-tenured lecturers, all in our twenties and early thirties, we had no standing in the official eyes of the faculty. In speaking across these various milieus, we found the binding ties in politics – in the Tawney Society for example, the public face of a Left faculty group who sponsored occasional political lectures; or the Cambridge branch of the Communist Party, whose modest but energizing presence was the soil for a highly theoreticist Marxism. Not just overlapping, these contexts were porous to worlds beyond the university too. While weighted towards the metropolitan Oxbridge-London triangle, the thickening of the Left's public sphere was also important, with new journals, academic and professional networks, some access to national media and major annual gatherings like the Ruskin History Workshops in Oxford or the summertime Communist University of London (CUL).[34]

My second instance is from University College, Swansea, where I spent 1973–74 immediately before going to Cambridge. In the early stages of developing what eventually became a general critique of orthodoxies in German historiography, I tried out my arguments for the first time in spring 1974 before a freshly formed Radical Humanities group comprising barely half a dozen members, suggesting at first glance a very small and embattled outpost of Left intellectual life, the very opposite of the CCCS. Yet, tilting the angle reveals another picture and brings us to a different understanding. Swansea was also the home to the Coalfield History Project supported in 1971–74 by the Social Science Research Council (SSRC) and the South Wales Area of the National Union of Mineworkers (NUM), concerned with salvaging what remained of the old miners' institute libraries after the calamitous colliery closures of 1959–71. Out of that process came the creation of the South Wales Miners' Library, opened in October 1973. During its calendar of inaugural events, the library was the scene of intense interest and activity, drawing momentum from the coalfield radicalization accompanying the 1972 and 1974 national strikes. Here, in other words, the fulcrum of intellectual radicalism was much different from that in Birmingham, sustaining a pedagogy and a cultural politics more akin to the older thematics of working-class culture and community associated with Hoggart and Raymond Williams in the early CCCS years.[35] The *permeable* quality, the transfers back and forth between academic work and a politics beyond the university, becomes very apparent, although (as Connell and Hilton point out) the CCCS likewise encouraged projects that were community-based and involved with the cultural life of the city too. As it happens, 1973–74 also saw the climax of a three-year student campaign in Swansea to reform curriculum and pedagogy in the Philosophy Department, which escalated into a full-scale confrontation when the chair D. Z. Phillips sought the dismissal of sympathetic lecturers and caused mass student expulsions.[36] If Swansea lacked the same institutionally bounded continuity and 'red base' ethos as the CCCS, then a different set

of intellectual and cultural radicalisms could still be found, one with no less meaning for what ensued during the 1980s.[37]

In other words, in judging the place of CCCS in late twentieth-century British history, certainly in the terms that opened this essay, we should be careful of taking too internalist an approach, because once the perspective is widened in this way other insights start coming into view. The Centre's legacies have to be tracked not just in the development and diffusion of cultural studies as an academic field of knowledge, but in the wider domains I have been gesturing towards here. I have mentioned some other academic fields – sociology of deviance, mass communications, social history – where a very similar politics of knowledge was pursued, including both the working practices and the commitment to cross-disciplinary collaboration. Other examples would include the Conference of Socialist Economists (CSE) formed in January 1970, along with its *Bulletin* (December 1971) that became the journal *Capital and Class* (1977); the Radical Philosophy Group (January 1972), with its journal *Radical Philosophy* and extensive network of groups and meetings, including its Philosophy Festival held in Oxford in January 1976; and Radical Science Collective around Robert M. Young in Cambridge and London and its *Radical Science Journal* (founded 1974), which fed directly into Free Association Books and its journal *Free Associations* (1984).[38] These initiatives were always in mutual conversation together, varying by time and place. 'United by a recognition of the need to take an integrated approach' while marking 'the convergence of interests of Marxists working in a wide range of areas' (sociology of law, jurisprudence, industrial relations, political theory, social history and deviancy theory), for example, the National Deviancy Conference and CSE joined forces in January 1979 for a conference on 'Capitalist Discipline and the Rule of Law'.[39] The best-known coalescence of this kind – combining disciplinary insurgency, interdisciplinary desire and extramural ambition – was the History Workshop Movement and its journal (launched 1976), at its peak between the early 1970s and later 1980s. Whether in the pages of its journal, the annual meetings or the many other local and issue-oriented activities, it was here that each of the other networks most evidently converged.[40]

The mention of the History Workshop, as a ramified movement extending far outside the academic world, brings us directly to the extramural dimension. Raymond Williams, for one, had always found the deep provenance of cultural studies in a set of histories that preceded the CCCS, namely the experiments in adult education that went back to the later 1930s and bound the early careers of himself, Hoggart and Thompson together: 'That shift of perspective about the teaching of arts and literature and their relation to history and contemporary society began in Adult Education, it didn't happen anywhere else'.[41] If the South Wales Miners' Library offers one continuity

in this regard, then another runs through the Federation of Worker Writers and Community Publishers (FWWCP) founded in 1976, through which Ken Worpole brought together an array of initiatives in London, Manchester, Liverpool, Brighton, Bristol, Bradford, Birmingham, Edinburgh, Newcastle and elsewhere. FWWCP was further linked to Comedia (formerly the Minority Press Group) founded in 1978, where David Morley (then writing his dissertation attached to the CCCS) was an instigator.[42] Yet another link came from the forming of radical caucuses inside the teaching and social work professions, which exactly mirrored the initiatives in the academic disciplines mentioned above. Coalescing around journals, these included *Libertarian Education* (1973) and *Radical Education* (founded 1974) for teachers and *Hard Cheese, Humpty Dumpty* and *Case-Con* (all early-1970s) for psychologists and social workers.[43] On another important front, Counter Information Services (CIS) was formed by a collective of anti-capitalist journalists, who produced 36 'Anti-Reports' during 1970–84, providing critical analysis of particular companies and economic sectors, areas of economic and social policy, taxation, industrial relations and other aspects of British capitalism.[44]

These activities reflected the unity of theory and practice so essential to the excitements of the 'long '68' (say, 1967–75) and its aftermaths. At the CCCS that unity worked at several levels: in the democratic intensities of its own working practices; in its relationship to the politics and cultural life of the city; in its desire to produce methodologies, analyses and theories capable of making a difference to public policy (media and news, social policy and youth, crime and policing, schooling and education, racism and race, gender and the equality of women); and in its conviction that theory offered the best chance of producing really useful knowledge. As argued earlier above, this decisively recast the boundaries of politics. In David Morley's words, 'it was one of the key institutions that changed the definition of politics'. He continues: 'The invention of *cultural* politics, the fact that these days it's only commonsensical to think of the cultural dimension of politics, was a form of the remaking of common sense to which the Centre contributed enormously'.[45]

In concluding, I have three final observations. First, I want to contrast the *catholicity* of Left intellectual work in the earlier 1970s with the divisiveness later in the decade – an overall solidarity that only gradually acknowledged its differences. Partly, the new cohorts of students who came up through the higher education expansion were now testing their mettle: as they began writing dissertations and getting their first jobs, they formed Left caucuses discipline by discipline, field by field, institution by institution, profession by profession. During this same period, most of European Marxism and other parts of social theory, including Max Weber, were only then being brought into English translation, a great deal of it by New Left Books and Verso, for whom this was a systematic programme. One consequence was

that intellectual influences and emphases changed extraordinarily quickly: in the briefest of times, individuals passed through bewildering successions of thinkers and bodies of thought, eagerly devouring the latest 'ideas from France' (as it seemed), working them through, then invariably moving on.[46] This teeming profusion of access – Lukacs, Sartre and the Frankfurt School; Merleau-Ponty, Barthes and Goldmann; Althusser and Poulantzas; Gramsci of course; Kristeva, Irigary and Cixous; Lacanian psychoanalysis; Saussurian linguistics; the philosophy of science of Bachelard and Canguilhem; the aesthetics of Macherey; semiotics and theories of film; then Derrida and Foucault – made it hard at first to see where the places of tension and difficulty, the serious conflicts and downright incompatibilities were *inside* this broad front of critical thought. The divisiveness that exploded in various ways later in the 1970s was to that great degree already inscribed inside the manner of the early reception. Stuart Hall's retrospective on the Centre's intellectual trajectory from 1980 brilliantly recapitulates the CCCS version of this heady collective autodidacticism.[47]

Second, the discrepancy that opened my discussion comes glaringly through this account. I am arguing, clearly, that the intellectual and political intensities described above had a part in shaping not just the history of the Left but the national story in general. They deserve to be rescued, in other words, 'from the enormous condescension of posterity'.[48] Interestingly, while the reigning silence of historians remains remarkable and certainly deliberate, at the time itself, liberals and the Right found a good deal to say.[49] In September 1977, for example, the CCCS held a conference in Birmingham on 'Left Intellectual Work' to which several hundred representatives of the various journals and networks were invited. The closing plenary of this collective gathering was dominated by the hot-off-the-press publication of *The Attack on Higher Education: Marxist and Radical Penetration* (the so-called Gould Report), the latest in a series of 'Black Papers on Education' spearheading the counterattack against progressive education: a survey of Marxism in the universities, complete with lists of participants in the various networks and their meetings, *it* certainly found the ideas concerned very threateningly influential.[50] In that light, by contextualist protocols alone, it makes no sense to ignore the battles of ideas around which so many of the political shifts of the 1970s revolved. Too many accounts of what is taken to be '1968' or 'the New Left' seem concerned mainly to de-legitimize or dismiss – to present the actors as naïve and failed, as producing only a backlash or reaction formations, while at the same time enabling ultimately a set 'bourgeois' logics and values (individualism, hedonism, consumption, excess). Yet the point of revisiting the debates and departures of the 1970s less crudely is not to resurrect them as alternative histories, as the path not taken in some simple-minded counterfactual way, but to reconstruct the still open and unfinished fields of incompleteness, as the

more complicated ground from which the history of the present might then be written. Whatever careful arguments can then be made about the working through of effects and the laying down of positivities over the intervening decades, writing this process from the victor's perspective alone is simply bad history, the eerie sound of one hand clapping.[51]

How, finally, should we best summarize the CCCS contribution? From the beginnings of distance, in the *Cultural Studies* mega-volume of 1992, Stuart Hall called cultural studies 'a discursive formation, in Foucault's sense': 'we were trying to find an institutional practice . . . that might produce an organic intellectual' in the complicated sense intended by Gramsci.[52] My own summary would run something like this: after the years of inception in 1956–68, cultural studies came from a cross-disciplinary ferment of very self-conscious innovative ambition, at the core of which was serious theory work and its political applications, along with a collectivist ethos and an anti-hierarchical, collaborative method of working. Binding all of it together was the conviction that *culture* – both as theory and as life – is vital for the Left's practice of democracy. Culture matters, not just for how capitalism secures its stabilities, but for how critique and political resistance will need to be conducted too. The point of taking the forms of popular culture seriously, Hall had argued in *NLR*'s founding editorial in 1960, was that 'these are directly relevant to the imaginative resistance of people who have to live within capitalism – the growing points of social discontent, the projections of deeply felt needs'.[53] Together with the slightly older Raymond Williams, he insisted on bringing cultural questions into the centre ground of the Left's primary concerns – as questions of ideology, meaning, identity and subjectivity, whose pertinence for the chances of political change could then be made into objects of analysis and action. This unity of intellectual and political work was what captured the imagination in cultural studies of the classic CCCS years. Cultural studies tried to make a place where important intellectual work, matters of the highest public concern, the political common sense of ordinary people and the pressing political demands of the present conjuncture, in other words, ideas, politics, popular culture and the movements of history – could all come together. That was what Stuart intended by *conjuncture*: 'What joins together to make the big shifts in consciousness?'[54]

NOTES AND REFERENCES

1. Full citations, in each case published in London by Hutchinson: CCCS (ed.), *On Ideology* (1978); Women's Studies Group (ed.), *Women Take Isssue: Aspects of Women's Subordination* (1979); John Clarke, Chas Critcher, and Richard Johnson (eds.), *Working Class Culture: Studies in History and Theory* (1979); CCCS (ed.),

The Empire Strikes Back: Race and Racism in 70s Britain (1982); CCCS (ed.),
Making Histories: Studies in History-Writing and Politics (1982); Mary Langan
and Bill Schwarz (eds.), *Crises in the British State 1880–1930* (1985). These titles
were preceded by Stuart Hall and Tony Jefferson (eds.), *Resistance through Rituals:
Youth Subcultures in Postwar Britain* (1976), which was less central to the emerging
theoretical debates, as was CCCS (ed.), *Unpopular Education: Schooling and Social
Democracy since 1944* (1981). Another book, co-authored by Stuart Hall, Chas
Critcher, Tony Jefferson, John Clarke, and Brian Roberts, *Policing the Crisis: Mug-
ging, the State, and Law and Order* (London: Macmillan, 1978), was a freestanding
intervention. The final volume in the Hutchinson series, Sarah Franklin, Celia Lury,
and Jackie Stacey (eds.), *Off Centre: Feminism and Cultural Studies* (1991), dates
from a later moment. An anthology, Stuart Hall, Dorothy Hobson, Andrew Lowe and
Paul Willis (eds.), *Culture, Media, Language* (1980), contains additional work while
providing an overall introduction.

 2. Examples of popular histories include Dominic Sandbrook, *Seasons in the
Sun: The Battle for Britain, 1974–1979* (London: Allen Lane, 2012); Andrew Marr,
A History of Modern Britain (London: Pan Books, 2007); and Andy Beckett's supe-
rior *When the Lights Went Out: What Really Happened to Britain in the Seventies*
(London: Faber and Faber, 2009). None contains references to Stuart Hall, cultural
studies or the Birmingham Centre. At the high end of academic accounts, neither
Peter Clarke's *Hope and Glory: Britain 1900–2000* (London: Penguin, 2004) nor
Brian Harrison's *Finding a Role? The United Kingdom, 1970–1990* (Oxford: Oxford
University Press, 2010) pays any attention either. In a brief subsection ('University
Growing Pains') of a chapter on 'Intellect and Culture' (pp. 371–432), Harrison does
refer in scare quotes to 'cultural studies' (399). In Stefan Collini's case, Hall and
cultural studies register in neither of his most substantial volumes, *Absent Minds:
Intellectuals in Britain* and *Common Reading: Critics, Historians, Publics* (each
Oxford: Oxford University Press, 2006 and 2008). Cultural studies does get a chapter
in *English Pasts: Essays in History and Culture* (Oxford: Oxford University Press,
1999), 'Grievance Studies: How Not to Do Cultural Criticism' (pp. 233–51), but in
dismissive and supercilious tones. In another example, Laurence Black's *Redefining
British Politics: Culture, Consumerism and Participation, 1954–70* (Houndmills:
Palgrave Macmillan, 2010) mounts a sustained but oblique attack on the CCCS ver-
sion without ever naming it, invoking only a caricatured rendition of 'New Left' ideas
as 'an unofficial foil to several [of his] arguments' (p. 209).

 3. See Peter Mandler, *The English National Character: The History of an Idea
from Edmund Burke to Tony Blair* (New Haven: Yale University Press, 2006), 234; also
Mandler, 'The Consciousness of Modernity? Liberalism and the English "National
Character," 1870–1940', in Martin Daunton and Bernhard Rieger (eds.), *Meanings of
Modernity: Britain from the Late-Victorian Era to World War II* (Oxford: Berg, 2001),
pp. 119–44. A range of pertinent work makes no appearance in Mandler's bibliogra-
phy: for example. CCCS (ed.), *Empire Strikes Back* and *Making Histories*; Langan
and Schwarz (eds.), *Crises in the British State*; Paul Gilroy, *'There Ain't No Black
in the Union Jack': The Cultural Politics of Race and Nation* (London: Hutchinson,
1987), and *The Black Atlantic: Modernity and Double Consciousness* (Cambridge,

MA: Harvard University Press, 1993); Stuart Hall, *The Hard Road to Renewal: Thatcherism and the Crisis of the Left* (London: Verso, 1988). Patrick Wright, whose *On Living in an Old Country: The National Past in Contemporary Britain* (Oxford: Oxford University Press, 2009; orig. London: Verso, 1985) is the object of Mandler's attack, was affiliated with CCCS in 1979–80.

4. Here Bill Schwarz has been especially prolific: for example. 'Englishness and the Paradox of Modernity', *New Formations*, 1 (Spring 1987), pp. 147–53; 'Night Battles: Hooligan and Citizen' and 'Black Metropolis, White England', in Mica Nava and Alan O'Shea (eds.), *Modern Times: Reflections on a Century of English Modernity* (London: Routledge, 1996), pp. 101–29 and pp. 176–207; Bill Schwarz (ed.), *The Expansion of England: Race, Ethnicity, and Cultural History* (London: Routledge, 1996); 'Not even Past', *History Workshop Journal*, 57 (Spring 2004), pp. 101–15. *Memories of Empire, Vol. I: The White Man's World* (Oxford: Oxford University Press, 2011) postdates the appearance of Mandler's *English National Character*, but builds on many other essays published earlier. For a helpful anthology of latter-day reflections, see Mark Perryman (ed.), *Imagined Britain: England after Britain* (London: Lawrence & Wishart, 2008).

5. See 'Questions from a Worker Who Reads' by Bertolt Brecht, *Bertolt Brecht Poems*, (eds.) John Willett and Ralph Mannheim with the cooperation of Erich Fried (London: Eyre Methuen, 1976), pp. 252–53. Beginning with 'Who built Thebes of the seven gates?' the poem unfolds a litany of such questions. It ends: 'Every page a victory./Who cooked the feast for the victors?/Every ten years a great man./Who paid the bill? / So many reports./So many questions.'

6. See Richard Hoggart, *The Uses of Literacy: Aspects of Working Class Life with Special Reference to Publications and Entertainments* (London: Chatto and Windus, 1957); Hoggart, *An Imagined Life: Life and Times, Vol. III: 1959–91* (Oxford: Oxford University Press, 1992); Sue Owen (ed.), *Richard Hoggart and Cultural Studies* (Houndmills: Palgrave Macmillan, 2008).

7. Christopher Pawling and Rosalind Brunt, interviewed by Hudson Vincent, 6 June 2011, *Cultural Studies*, 27, 5 (2013), 702. Having famously testified as an expert witness at the landmark *Lady Chatterley's Lover* obscenity trial in 1960, Hoggart served on the Pilkington Committee on Broadcasting (1960–62) and the Arts Council (1976–81), as well as earlier on the Albemarle Committee on Youth Services (1958–60). He was Chairman of the Advisory Council for Adult and Continuing Education (1977–83) and the Broadcasting Research Unit (1981–91), and a Governor of the Royal Shakespeare Company (1962–88).

8. The urtext for this kind of history – both as reportage and affirmation – remains Noel Annan, 'The Intellectual Aristocracy', in John H. Plumb (ed.), *Studies in Social History: A Tribute to G. M. Trevelyan* (London: Longman, 1955), pp. 243–87, along with his latter-day elaborations in *The Dons: Mentors, Eccentrics and Geniuses* (Chicago: University of Chicago Press, 1999), and *Our Age: English Intellectuals between the World Wars – A Group Portrait* (New York: Random House, 1990).

9. Edward P. Thompson, *The Making of the English Working Class* (London: Gollancz, 1963); Raymond Williams, *Culture and Society, 1780–1950* (London: Hogarth Press, 1958) and *The Long Revolution* (Harmondsworth: Penguin, 1961).

10. See Edward P. Thompson, *Whigs and Hunters: The Origin of the Black Act* and Douglas Hay, Peter Linebaugh, John G. Rule, Edward P. Thompson, and Cal Winslow, *Albion's Fatal Tree: Crime and Society in Eighteenth-Century England* (each Harmondsworth: Penguin, 1975).

11. See Edward P. Thompson (ed.), *Out of Apathy* (London: Stevens, 1960); also Robin Archer, Diemut Bubeck, Hanjo Gluck, Lesley Jacobs, Seth Moglen, Adam Steinhouse, and Daniel Weinstock (eds.), *Out of Apathy: Voices of the New Left Thirty Years On* (London: Verso, 1989).

12. In some continuity with Hoggart's purposes were e.g. Dorothy Hobson, *Crossroads: Drama of a Soap Opera* (London: Methuen, 1982) and the later *Soap Opera* (Cambridge: Polity Press, 2003); David Morley, *The 'Nationwide' Audience: Structure and Decoding* (London: BFI, 1980), and *Family Television: Cultural Power and Domestic Leisure* (London: Comedia, 1986); Charlotte Brunsdon, *Screen Tastes: Soap Opera to Satellite Dishes* (London: Routledge, 1997); Angela McRobbie, *Feminism and Youth Culture: From 'Jackie' to 'Just Seventeen'* (London: Routledge, 1990). Stuart Hall's classic text from these early years was 'Encoding and Decoding in the Television Discourse' (Occasional Stencilled Paper 7), extracted as 'Encoding/Decoding', in Hall et al. (eds.), *Culture, Media, Language*, pp. 128–38. Other early interests from the mid-1960s mainly fizzled out, including popular sports and 'the western', D. H. Lawrence and related modes of literary study shaped around Matthew Arnold and F. R. Leavis, and even the Frankfurt School as such. For the emerging interests, see especially Hall and Jefferson (eds.), *Resistance through Rituals*; Phil Cohen, *Rethinking the Youth Question: Education, Labour, and Cultural Studies* (Durham: Duke University Press, 1999); Paul E. Willis, *Learning to Labor: How Working Class Kids Get Working Class Jobs* (New York: Columbia University Press, 1981), originally published in 1977. Most of Cohen's book originated in the 1970s, including the foundational 'Sub-Cultural Conflict and Working-Class Community', *Working Papers in Cultural Studies*, 2 (Spring 1972). Willis's book was one of the earliest CCCS-originated works to gain widespread attention, preceded by Stencilled Occasional Paper 43, 'How Working Class Kids Get Working Class Jobs' (1975).

13. See the editorial Introduction to *Cultural Studies 6* (Autumn 1974), where 'a theoretical shift in our approach to cultural studies' is signalled 'retrospectively, from an emerging Marxist perspective'. That shift entailed recognizing 'the theoretical and political limitations of the liberal radicalism from which "cultural studies" and the Centre emerged in the early '60s, and trying to clarify, in a preliminary way, the contemporary forces which shape us, and within which what we produce is to be taken into account' (p. 1). Thus if this issue opened with a critique of Hoggart (Colin Sparks), a brief manifesto on 'The Politics of Popular Culture' (Bryn Jones), and an appreciation of Raymond Williams (Michael Green), it continued with a critique of 'Roland Barthes: Structuralism/Semiotics' (Iain Chambers), a three-way exchange on Louis Althusser's theory of ideology (Robin Rusher, John Mepham, Steve Butters), an exegesis of 'Marx's Notes on Method: A "Reading" of the "1857 Introduction"' (Stuart Hall), a critique of 'The Aesthetic Theory of the Frankfurt School' (Phil Slater), and a brief guide to the Frankfurt School's writings (Chris Pawling).

14. These arrived with a vengeance in 'The Poverty of Theory: or an Orrery of Errors', the principal essay (204 pages, roughly half the book) in Thompson's *The*

Poverty of Theory and Other Essays (London: Merlin Press, 1978), which was an extraordinarily polemical, tendentious and intentionally divisive intervention.

15. The original paper, Richard Johnson, Gregor McLennan, and Bill Schwarz, 'Economy, Culture, and Concept: Three Approaches to Marxist History' (Occasional Stencilled Paper 50), considered the thought of respectively Thompson and Eugene Genovese, Maurice Dobb, and Barry Hindess and Paul Q. Hirst, engaging full-on with a range of approaches then in quite bitterly divided contention across the wider intellectual Left in Britain. Johnson then published a revised version of his part of that paper as 'Edward Thompson, Eugene Genovese, and Socialist-Humanist History', *History Workshop Journal*, 9 (Autumn 1978), pp. 79–100, to similarly divided response. See articles by Keith McClelland and Gavin Williams, letters by Tim Putnam, Robert Shenton, and Tim Mason (7, Spring 1979); articles by Simon Clarke and Gregor McLennan, letters by Richard Johnson and Gareth Stedman Jones (8, Autumn 1979). For the December 1979 debate between Hall, Johnson, and Thompson, see Raphael Samuel (ed.), *People's History and Socialist Theory* (London: Routledge, 1981), pp. 376–408.

16. See Kieran Connell and Matthew Hilton, 'The Working Practices of Birmingham's Centre for Contemporary Cultural Studies', *Social History*, 40, 3 (2015), pp. 302–10, along with their essay in this volume.

17. For the wider intellectual context, see Geoff Eley, *A Crooked Line: From Cultural History to the History of Society* (Ann Arbor: University of Michigan Press, 2005), pp. 48–60, 90–113, 115–33; and for the relevant political developments, Eley, *Forging Democracy: The History of the Left in Europe, 1850–2000* (New York: Oxford University Press, 2002), pp. 405–8, 384–404, 375–83. Among the many reflections on the Ruskin drama, see especially Susan Magarey, 'That Hoary Old Chestnut, Free Will and Determinism, Culture vs. Structure, or History vs. Theory in Britain', *Comparative Studies in Society and History*, 29, 3 (1987), pp. 626–39.

18. Connell and Hilton, 'Working Practices', p. 296.

19. In addition to Connell and Hilton, 'Working Practices', see the interviews by Hudson Vincent collected in *Cultural Studies*, 27, 5 (2013), including Lucy Bland; Christopher Pawling and Rosalind Brunt; John Clarke; Paul Gilroy; Stuart Hall; Stuart Hanson, Andrew Tolson, and Helen Wood; Richard Johnson; Gregor McLennan; Angela McRobbie; and David Morley.

20. Printed ibid., pp. 880–86 and pp. 887–95.

21. Connell and Hilton, 'Working Practices', p. 296. See Paul E. Willis, 'What is News – A Case Study', *Working Papers in Cultural Studies*, 1 (1971), pp. 9–36.

22. These sentences are taken from an internal CSSS document written by Hall in the summer of 1971 called 'The Missed Moment', quoted by Connell and Hilton, 'Working Practices', pp. 296–97.

23. In the Manifesto adopted at its second conference in November 1968, RSSF envisaged building 'red bases in our colleges and universities'. The Manifesto was published in *NLR*, I/53 (January–February 1969), pp. 21–22, along with a dossier of articles by James Wilcox (Robin Blackburn), David Triesman, David Fernbach, and Anthony Barnett (pp. 23–53). 'Growing points of revolutionary power' was a phrase used by Wilcox/Blackburn (p. 26).

24. The distribution of student activism across Britain is hard to summarize. The 1968–69 National Union of Students President Trevor Fisk counted 26 instances of

large-scale direct action in 1967–68, but this certainly understates the degree of fer-
ment, which in any case grew during 1969–70, See Trevor Fisk, 'The Nature and
Causes of Student Unrest'. in Bernard Crick and Willaim A. Robson (eds.), *Protest
and Discontent* (Harmondsworth: Penguin, 1970), p. 82. Major sit-ins occurred dur-
ing 1968–70 in LSE, Hull, Essex, Leicester, Aston, Bristol, Keele, Leeds, Manchester,
Birmingham, Warwick, Oxford, and elsewhere, including art colleges in Hornsey and
Guildford, for example. But beneath the more spectacular mass events was a thinner,
spasmodic and more dispersed, but no less constant current of activism, whose effects
travelled through most campuses in the country. For vivid instances of reportage at
the time, see Paul Hoch and Vic Schoenbach, *The Natives Are Restless: A Report
on Student Power in Action* (London: Sheed and Ward, 1969); Students and Staff
of Hornsey College of Art, *The Hornsey Affair* (Harmondsworth: Penguin, 1969);
Edward P. Thompson, *Warwick University Ltd: Industry, Management and the Uni-
versities* (Harmondsworth: Penguin, 1970; new edn. Nottingham: Spokesman, 2014).
Lisa Tickner, *Hornsey 1968: The Art School Revolution* (London: Frances Lincoln,
2008), provides a fascinating, archivally grounded retrospective. In many ways the
flavour is still conveyed best by Ronald Fraser (ed.), *1968: A Student Generation in
Revolt* (New York: Pantheon, 1988), esp. pp. 261–84.

25. See Christopher Pawling's remark in Pawling and Brunt, interviewed by
Hudson Vincent, p. 708: 'There was a sense where Stuart suggests, retrospectively . .
. that we were trying to make the Center into a place for revolutionaries in the univer-
sity, when in actual fact there wasn't a basis for it at the time. He, maybe, thought the
moment had been missed.' Pawling refers here to Colin McCabe, 'An Interview with
Stuart Hall, December 2007', *Critical Quarterly*, 50, 1–2 (2008), esp. pp. 21–27.

26. In addition to the works cited in note 24, see F. J. Campbell, *High Command:
The Making of an Oligarchy at the Polytechnic of North London, 1970–74* (London:
Time Out, 1975). Colin Crouch, *The Student Revolt* (London: Bodley Head, 1970), is
still a helpful overview.

27. All but one of the thirteen contributors to *Student Power* were in their twenties
(Tom Nairn, fired from Hornsey in 1968, was 31) and only 3 others were older than
25. As it happens, the four slightly older contributors (Nairn, Perry Anderson, Robin
Blackburn, and Alexander Cockburn) all came from the 'second New Left' in control
of *NLR* from the early-1960s. See Alexander Cockburn and Robin Blackburn (eds.),
Student Power: Problems, Diagnosis, Action (Harmondsworth: Penguin, 1969). The
other emblematic books were Trevor Pateman (ed.), *Counter Course: A Handbook
for Course Criticism* (Harmondsworth: Penguin, 1972), and Robin Blackburn (ed.),
Ideology in Social Science: Readings in Critical Social Theory (London: Fontana,
1972). Two later interventions that strikingly reflected the intervening CCCS influence
were AnnMarie Wolpe and James Donald (eds.), *Is There Anyone Here from Educa-
tion?* (London: Pluto Press, 1983), four of whose contributors came from CCCS; and
Janet Finch and Michael Rustin (eds.), *A Degree of Choice? Higher Education and
the Right to Learn* (Harmondsworth: Penguin, 1986), which included an essay by Bill
Schwarz on 'Cultural Studies: The Case for the Humanities' (pp. 165–91).

28. The seven founders were Kit Carson, Stanley Cohen, David Downes,
Mary McIntosh, Paul Rock, Ian Taylor, and Jock Young. See Stanley Cohen (ed.),

Images of Deviance (Harmondsworth: Penguin, 1971); Ian Taylor and Laurie Taylor (eds.), *Politics and Deviance* (Harmondsworth: Penguin, 1973); Paul Rock and Mary McIntosh (eds.), *Deviancy and Social Control* (London: Tavistock, 1974); Ian Taylor, Paul Walton, and Jock Young, *The New Criminology: For a Social Theory of Deviance* and *Critical Criminology* (each London: Routledge and Kegan Paul, 1973 and 1975). Key monographs included: Jock Young, *The Drugtakers: The Social Meaning of Drug Use* (London: Paladin, 1972), and Stanley Cohen, *Folk Devils and Moral Panics* (London: Paladin, 1973).

29. See Stanley Cohen, 'Breaking Out, Smashing Up, and the Social Context of Aspiration', *Working Papers*, 5 (Spring 1974), pp. 37–63; Paul Walton and Stuart Hall (ed.), *Situating Marx: Evaluations and Departures* (London: Human Context Books, 1973); Stuart Hall, 'Reformism and the Legislation of Consent', in John Clarke et al. (eds.), *Permissiveness and Control: The Fate of the Sixties Legislation* (London: Macmillan, 1980), pp. 1–43. Interestingly, direct citations to this sociology of deviancy no longer accompanied *Resistance through Rituals*.

30. See James D. Halloran, Philip Elliott, and Graham Murdock, *Demonstrations and Communication: A Case Study* (Harmondsworth: Penguin, 1970).

31. Stuart Hall, 'Culture, the Media, and the "Ideological Effect"', in James Curran et al. (eds.), *Mass Communication and Society* (London: Edward Arnold, 1977), pp. 315–48; Hall, 'The Rediscovery of "Ideology": The Return of the Repressed in Media Studies', in Michael Gurevich et al. (eds.), *Culture, Society, and the Media* (London: Methuen, 1982), pp. 56–90.

32. Stanley Cohen and Jock Young (eds.), *The Manufacture of News: Social Problems, Deviance, and the Mass Media* (London: Constable, 1973). New criminology also converged with the Thompson-influenced social histories of crime produced at the Warwick Centre for Social History, culminating in *Whigs and Hunters* and *Albion's Fatal Tree* (each 1975).

33. Geoff Eley, 'Stuart Hall, 1932–2014', *History Workshop Journal*, 79 (Spring 2015), p. 313. See The Cambridge Women's Studies Group (ed.), *Women in Society: Interdisciplinary Essays* (London: Virago Press, 1981).

34. In 1976–79 the Cambridge branch of the CPGB produced at least five issues of an interesting journal called *Red Shift*. The annual CULs in the 1970s can be tracked through Geoff Andrews, *End Games and New Times: The Final Years of British Communism, 1964–1991* (London: Lawrence and Wishart, 2004).

35. Williams of course had close affinities with the South Wales project. See for instance Raymond Williams, 'The Social Significance of 1926', *Llafur*, 2, 2 (Spring 1977), pp. 5–8, and more generally Williams, *Who Speaks for Wales? Nation, Culture, Identity*, ed. Daniel Williams (Cardiff: University of Wales Press, 2003); also Dai Smith, *Raymond Williams: A Warrior's Tale* (Cardigan: Parthian, 2008). For the Coalfield History Project, which received a second period of SSRC funding in 1980–83, see Hywel Francis, 'The Origins of the South Wales Miners' Library,' *History Workshop Journal*, 2 (Autumn 1976), pp. 183–205. The Library became a major archive depository, research centre, and hub of adult education.

36. See 'The Swansea Affair,' *Radical Philosophy*, 9 (Winter 1974), 1–3; 'Threat to Swansea Students,' *Radical Philosophy*, 10 (Spring 1975), pp. 1–2. The events

involved bizarrely manipulative and authoritarian behaviour on the part of Phillips and the College administration. An Industrial Relations Court eventually ruled that the treatment of the senior lecturer targeted for dismissal was unfair.

37. One exemplar, in a trajectory nicely linking various nodes in my discussion, was Kim Howells. Born 1946, from a South Walian working-class Communist background, he was prominent in the 1968 Hornsey occupation, received a B.A. from Cambridge College of Arts and Technology (1971–74) and Ph.D. from Warwick (1979) for a dissertation on the South Wales coalfield 1937–57. While living in Cambridge he regularly attended the Social History Seminar. Back in South Wales he helped run the 1980–83 SSRC Coalfield History project, worked for the NUM, and coordinated the 1984–85 strike in South Wales. He was elected to Parliament for Labour in 1989, serving in various junior posts in the New Labour governments during 1997–2008.

38. Other examples would include the network around *Critique: Journal of Marxist Theory and Soviet Studies*, founded by Hillel Ticktin in Glasgow in 1973; and *Review of African Political Economy* founded in 1974. For the Radical Science Collective, see Les Levidow and Bob Young (eds.), *Science, Technology and the Labour Process: Marxist Studies*, 2 vols (London: Free Association Books, 1981/84 and 1985). Bill Schwarz contributed to Vol. 2: 'Re-Assessing Braverman: Socialization and Dispossession in the History of Technology,' pp. 189–205.

39. The conference proceedings were published as Bob Fine, Richard Kinsey, John Lea, Sol Picciotto, and Jock Young (eds.), *Capitalism and the Rule of Law: From Deviancy Theory to Marxism* (London: Hutchinson, 1979), 7, including an essay by Phil Cohen, 'Policing the Working-Class City', pp. 118–36.

40. See now the unpublished dissertation by Ian Gwinn, *'A Different Kind of History is Possible': The History Workshop Movement and the Politics of British and West German Historical Practice* (University of Liverpool Ph.D., 2015); also Raphael Samuel (ed.), *History Workshop: A Collectanea, 1967–1991; Documents, Memoirs, Critique, and Cumulative Index to 'History Workshop Journal'* (Oxford: History Workshop, 1991); Eley, *Crooked Line*, pp. 51–53, 124–25.

41. Raymond Williams (ed.), 'The Future of Cultural Studies', in Williams, *The Politics of Modernism: Against the New Conformists* (London: Verso, 1989), 162. See also John McIlroy and Sallie Westwood (eds.), *Border Country: Raymond Williams in Adult Education* (Leicester: National Institute of Adult Continuing Education, 1993); W. John Morgan and Peter Preston (eds.), *Raymond Williams: Politics, Education, Letters* (Houndmills: Macmillan, 1993); and more generally, Tom Steele, *The Emergence of Cultural Studies 1945–65: Cultural Politics, Adult Education and the English Question* (London: Lawrence and Wishart, 1997).

42. See Dave Morley and Ken Worpole (eds.), *The Republic of Letters: Working Class Writing and Local Publishing* (London: Comedia Publishing Group, 1982). Stephen Yeo, centrally active in QueenSpark, FWWCP's Brighton affiliate, chaired the famous Ruskin panel in December 1979.

43. See here Mike Smith, *The Underground and Education: A Guide to the Alternative Press* (London: Methuen, 1977).

44. For details of CIS and the *Anti-Reports*, see http://www.anti-report.com/home/4559018053, accessed 1 September 2015. An excellent sense of the density of organized activity of the kind I am describing may be had by leafing through the 'Noticeboard' section of *History Workshop Journal*, issue by issue from 1976 to the early-1990s, when the feature began petering out.

45. David Morley, interviewed by Hudson Vincent, 6 June 2011, *Cultural Studies*, 27, 5 (2013), p. 836.

46. The reference is to Lisa Appignanesi (ed.), *Ideas from France: The Legacy of French Theory. ICA Documents* (London: Free Association Books, 1989). During the 1980s, the Institute of Contemporary Arts (ICA) became another key node of inter-disciplinary activity oriented towards cultural studies. Erica Carter, at CCCS in the late-1970s, worked as an events coordinator at ICA.

47. Stuart Hall, 'Cultural Studies and the Centre: Some Problematics and Problems', in Hall et al. (eds.), *Culture, Media, Language*, pp. 15–47.

48. Thompson, *Making*, p. 12.

49. Another striking illustration: Anthony Seldon and Stuart Ball (eds.), *Conservative Century: The Conservative Party since 1900* (Oxford: Oxford University Press, 1994), an 842-page all-but-official history of its subject, contains no mention of Stuart Hall in the otherwise full bibliographical guide to Thatcherism (766–67) or indeed any reference to CCCS contributions more generally, including most notably Bill Schwarz's work on Baldwinian Conservatism (pp. 758–62).

50. The report became known by its editor, conservative sociologist Julius Gould of the University of Nottingham. See *The Attack on Higher Education: Marxist and Radical Penetration* (London: Institute for the Study of Conflict, 1977). The Birmingham conference met on 17 September 1977.

51. See McCabe, 'Interview with Stuart Hall', pp. 22–27.

52. Stuart Hall, 'Cultural Studies and its Theoretical Legacies', in Larry Grossberg, Cary Nelson, and Paula Treichler (eds.), *Cultural Studies* (New York: Routledge, 1992), pp. 278, 281.

53. Stuart Hall, 'Editorial', *New Left Review*, 1, 1 (January–February 1960), 1. A decade later, the idea of 'growing points' remained an active referent. See note 23 above.

54. Suzanne Moore, 'Stuart Hall Was a Voice for Misfits Everywhere. That's His Real Legacy', *Guardian*, February 13, 2014.

Chapter 3

Cultural Studies at Birmingham 1985–2002 – The Last Decades

Ann Gray

The event that took place at the University of Birmingham on 24–25 June 2014 was both a celebration of the 50th anniversary of the founding of the Centre for Contemporary Cultural Studies (CCCS) and the well-timed launch of the CCCS archive now housed at the Cadbury Research Library at the University of Birmingham. Most of the reflections and critical memories from former members of the CCCS, which are included in this collection, focus, quite rightly, on the three decades from the 1960s to the 1980s as the key years of the development of cultural studies at Birmingham. However, while the CCCS effectively ceased to be when the unit was renamed the Department of Cultural Studies in 1984, cultural studies at Birmingham did continue, albeit within a very different institutional context, until its closure in 2002.[1] My contribution, therefore, to this collection seeks to not only ensure that both the closure itself and the circumstances leading to it are noted here but also that the nature of the work, topics, politics and pedagogy, carried out not only by faculty but also and especially by undergraduate and postgraduate students of the department during that period will not disappear completely from the CCCS 'story'.

One primary bearer of this historical narrative is now the CCCS archive and its future role will, in part, be to furnish and enable the construction and shaping of, hopefully, multiple narratives of cultural studies at Birmingham. Readers will be acutely aware of the partial nature of all archives despite their pull towards neutrality and objectivity. The materiality and now the institutional context which has been offered by the University of Birmingham for the housing of the archive makes powerful claims to be the definitive story of the complexity of the practice of an academic scholarly, socially and politically active grouping within its own institutional context. One earlier, and much more limited, attempt to document the work of the CCCS at Birmingham

was that mounted by me and a number of colleagues after the closure of the Department of Cultural Studies and Sociology (DCSS) in 2002. This project had been a long time in reaching fruition beginning in the mid-1990s but becoming urgently necessary as the department was being physically dismantled in the summer of 2002.[2] What became the two volumes published by Routledge in 2007 as *CCCS Selected Working Papers* pulled together a wide range of papers produced between 1964 and 1982.[3] Our selection included many familiar papers but also those that were less well known. Thus the volumes were our attempt to make a contribution to the 'much contested and still unsettled history' of the CCCS in its early years and we wheeled copies of stencilled papers out of the Muirhead Tower in 2002, before, as Stuart Hall reminded us of Marx's memorable remark, being abandoned 'to the gnawing criticism of the mice'. In the early stages of the project we had asked postgraduate students to select a range of working papers that had relevance to them as contemporary cultural studies students. Our aim was, through the selection of the working papers, to identify the early formations of the Centre and the key influences, its 'project', its political engagement and its working practice. In doing this we were keen to publish less well-known papers and those which, in retrospect, prepared the ground for later important developments in the field. There is no doubt that the closure of the department which was, after all, the continuing material legacy of the Centre at Birmingham, sharpened peoples' minds as to how, in what ways and by whom this version of the Centre's 'archive' was to be crafted. Stuart Hall himself became involved and he, along with other former members of the CCCS, played a large part in redefining the aims, structure and form of the volumes.

The subject of a broader archive emerged during some meetings. As early as 2006 I had e-mail and face-to-face discussions with Stuart Hall and Larry Grossberg about, among other things, where the CCCS archive – working papers and other documents – could appropriately be housed. I have to say that Birmingham was at the bottom of our list. However, several years later, when Matthew Hilton, Michael Green and Kieran Connell began discussing the possibility of a Birmingham archive and continued their work with Stuart's blessing, I was pleased that Birmingham had, if very late in the day, recognized the significance of cultural studies. But it is a source of great sadness that neither Stuart nor Michael could be there to be part of the subsequent CCCS50 conference that took place in Birmingham in June 2014.

Of course, what was not reflected in the Routledge volumes and as yet in the new archive was the Centre's work over the 1980s and 1990s, and the institutional vicissitudes that ended with its closure in 2002. This period also saw the expansion of cultural studies as a critical intellectual project and field of research based in the main on work done in the CCCS, initially in other places in the United Kingdom, but then as a global, transnational intellectual

movement. Indeed, Stuart made this observation at the 2000 Crossroads in Cultural Studies conference hosted at the University of Birmingham by the DCSS and it has continued in that vein.

Thus my aim here is to interrupt the continuous narrative that might be understood from the title of the conference and the archive itself. In seeking to represent the nature of the presence of cultural studies at Birmingham from 1985 to 2002, I will focus on two specific elements of the context within which the Centre continued to operate in this institution. They are the developments in higher education in the United Kingdom at the time that shaped the institutional setting and the strategies that were adopted by the university, which in turn had an impact on the continuing presence of cultural studies. In order to remedy the weight of managerialism and bureaucracy that inevitably looms large in my story (and all our stories now), I will attempt to retrieve evidence of the continuing practice of a vibrant cultural studies grounded in Birmingham produced by a politically informed pedagogy, an enlightened admissions policy and an openness to new developments in research which engendered challenging and critical work from students at all levels, especially in the period between 1991 and 1997 in the Department of Cultural Studies.

When considering the period from the 1980s and beyond, it is important to identify the key continuities from work at the Centre that underpinned the later work and practice of the surviving department in its various guises. The already established subjects of study, such as gender, race and ethnicity, media and representation, and cultures of everyday life, continued through into research and teaching; and approaches such as the importance of location and place, development of appropriate research methods, collaborative work – all of which were firmly enmeshed within and enabled by a politics of education. A powerful discourse of the latter provided the paradigm for the department's continuing work, mainly due to Michael Green's influence and leadership. All of these continuing themes that informed our practice created space for development, for student participation and, to be sure, for challenge and contestation.

The period of time under consideration here covers a number of transitions from the CCCS as a small research unit into an established teaching and research department. I will now briefly discuss the key earlier developments in those transitions, which are:

1. 1980–84: CCCS continues.
2. 1984: Department of Cultural Studies established.
3. 1997: renamed DCSS.

Between 1980 and 1984 the three-strong CCCS staff of Michael Green, Richard Johnson and Maureen McNeil, whose post replaced Stuart Hall's

after his departure in 1979, increased their offering of undergraduate courses in order to create an income stream, but also maintained the Centre in its established working practice. For example, there were a number of active research subgroups. Between 1982 and 1983 the Centre records some 11 working subgroups including class, education, English studies, food, media, popular memory, politics and culture, race and politics, sexuality and visual pleasures and the women's forum. Graduate student numbers increased and they were all invited to be involved in the running and direction of the Centre.[4] This was the transitional period from the CCCS practice, project and ethos into a full teaching and research department.

1984–1997

As economic pressures on universities began to bite, the CCCS was required to consider rationalization by becoming a larger unit in the university. After lengthy discussions it was agreed that the unit should join two members of the former Sociology Department, John Gabriel who specialized in race and society and Jorge Larrain specializing in Marxism and theories of ideology, to create a new department. The unit was to create a new undergraduate degree programme, in addition to continuing the taught master's and thesis work in cultural studies, race and education all reorganized within the larger cultural studies programme. The new department was relocated from the Faculty of Arts to the Faculty of Commerce and Social Science in the School of Social Science, which included economics, economic history, political science and international relations, Russian and East European studies and social policy and social work. In 1989 the single honours degree programme in media culture and society was launched and several joint honours sociology programmes continued.

The pressures brought on the CCCS were, of course, exerted on financial grounds, and, tellingly, the creation of the Department of Cultural Studies at Birmingham and especially the foundation of its undergraduate programme, coincided with the accelerated expansion of higher education in the United Kingdom which has continued ever since. Between 1989 and 2002, student numbers in the United Kingdom increased by 88%.[5] From its first intake the programme at Birmingham attracted large numbers of applications from excellent candidates. Throughout the nineties the department was encouraged to increase its student numbers, especially as resources began to shrink, but with delayed recruitment of additional staff. To give examples, funding overall in universities from 1989 to 2002 decreased by 37% with the result that staff-student ratios were worse than some sixth form colleges.[6] Within the universities, competition for resources was hard fought and when members

of the department attempted to secure more staff to cope with increased numbers, our teaching practices were called into question by the administration. We were told that we could no longer offer the luxury of 'Rolls Royce' teaching and should face up to the impact of mass teaching, which was to be the future. However, our arguments about the importance of high-quality teaching and commitment to students were supported, to a certain extent, by the introduction of teaching quality assessment in UK universities. In 1995 the team assessing the Department of Cultural Studies awarded maximum points but, as is the way in British universities, this attracted no investment in resources.

Indeed, the relatively low status given to teaching within universities was already reflected in the new funding structure established since the 1980s that separates funding for teaching and research. Universities therefore were becoming increasingly dependent on external income generation to fund research and other income streams were considered necessary for economic health. In this climate of reduced resources, universities in the United Kingdom cut academic staffing levels, changed the nature of some academic contracts and axed 'unprofitable' programmes. The separation of teaching and research, which has uniquely run in tandem in British universities, is, perhaps, the most insidious consequence of these funding arrangements and is becoming formalized in routine practices. The period in question also saw the increasing importance in the United Kingdom of the national Research Assessment Exercise, which sets the targets for quality research funding. And individual and department success are crucial to status and funding for research in the increasingly important league tables.

The department clung on with some difficulty to its commitment to critical pedagogy and some sustained collaborative work also survived. The appointment of Maureen McNeil in 1981 for what was advertised as a women's studies post within cultural studies had maintained and strengthened feminism's place within the core of the unit and this is reflected in outputs from the 1991 *Off-Centre* collection – edited by Sarah Franklin, Celia Lury and Jackie Stacey.[7] Furthermore, in designing the new single honours course, 'Gender', 'Race' as well as 'Media' were compulsory second-level courses. Throughout the 1980s, other subgroups continued; for example, the 'Race', Education Group and the Popular Memory Groups.

By 1991, the department had expanded to seven full-time staff whose specialisms were as follows:

John Gabriel: theories of 'race' and ethnicity; contemporary forms of racism.

Ann Gray: women and domestic leisure; media; popular culture; politics of research; methods and practice.

Michael Green: media and photography; culture and cities; arts, media and cultural institutions and policies.

Richard Johnson: social identity; popular memory and historiography; contemporary education policy; New Right theory.

Jorge Larrain: Marxism and ideology; development theory.

Maureen McNeil: science, technology and gender; science, technology and popular culture; work and sexuality.

Sadie Plant: cultural theory; post-structuralism; postmodernism; avant-garde cultural practice; the history of ideas.

Members of this expanded staff group brought their own research agendas to the existing mix. In 1991 they formulated a number of 'shared intentions' for the department, which included notably a particular commitment in admissions policy, especially given the under-representation of some groups who should have access to higher education, and a desire to work with institutions and groups outside higher education – often outside education altogether – in research and other projects. This period focused on undergraduate provision both in terms of delivering the new programme but also establishing tutors, staff/student groups, a group for mature students and always a number of social events. In addition, the department looked outwards and joined a large Erasmus Network between 1990 and 1995, which included the universities of Aarhus, Amsterdam, Barcelona, Copenhagen, Dublin, Goldsmiths, Middlesex, Paris 8 and 10, Roskilde and Tubingen. Some student exchanges were established but the highlight of the network's annual activities was a summer school for staff and students. These were held at Amsterdam, Paris, Copenhagen, Barcelona and Tubingen and were greatly appreciated and enjoyed by the students and staff who attended them. Some collaborative work emerged from this network and friendships were established which long outlived the period of the formal agreement.

Within the University of Birmingham, the department, often perceived as isolationist, reached out to and worked with other departments and centres – in particular the centres for Russian and East European studies; urban and regional development; West African studies; and the departments of history and American studies; English; geography; social policy and social work; and economic and social history – a number of which offered modules on the undergraduate programmes. In addition, a cross-faculty Women's Staff Support group met regularly in the 1990s and a cross-faculty Theory Group met regularly in the same period. Each of these informal groups resulted in formal postgraduate programmes.

TURNING TO OUR STUDENTS AND CONTINUING THREADS

Postgraduate students were, of course, at the heart of the work of the Centre and, indeed, students should be the life-blood of all university departments.

We were fortunate enough to have some outstanding students, undergraduate and postgraduate, who passed through the department, and their engagement in and contributions to the final decade or so of cultural studies at Birmingham should be noted.

By 1989, the first year of the single honours degree, work produced by the CCCS postgraduates in the 1970s and 1980s had received wide circulation. This was the case in relation to the publications on youth subcultures,[8] feminism[9] and media analysis,[10] some of which had found their way onto A-level syllabi and Access courses.[11] In addition there appeared to be an increasing student interest in new degree programmes, including those looking at contemporary questions of media, gender and race. Also in this period the public interest in cultural industries, in particular, the shift from public provision to the market set in place by the Thatcher government and continued by the New Labour administration furthered staff interest in local cultural industries, cultural politics and urban development.

Work on race and ethnicity continued through the undergraduate programme, and as new members of staff were appointed in areas of sexualities (Gargi Bhattacharrya), social and cultural identities (David Parker), cinema and cultural policy (Stuart Hanson), and postcolonial theory and feminism (Malika Mehdid), the programme developed these areas of study. Sociology teaching continued with further appointments: science and technology (Mark Erikson), sociology of the family (Jo Van Every) and anthropology (Susan Wright and Beth Edginton).

Most postgraduates came with established interests and agendas, often lying between disciplines and subjects. They researched topics about which they were passionate with growing intellectual confidence. A gradually increasing number of international students came to the department to pursue postgraduate studies in this period; many of whom, although keen to study in Birmingham, challenged the 'British' focus of the Birmingham version of cultural studies. Similarly, the theoretical frameworks that had been developed in the earlier periods of the CCCS were interrogated by students coming from, for example, Korea, Latin America and Taiwan, and reflected in student dissertations and theses.[12]

In addition to developing an undergraduate infrastructure, the department established a 'work in progress' journal. With support from the School of Social Science, *Cultural Studies at Birmingham* 1 was published in 1991 as the first of what was to be an annual collection of papers written predominantly by graduate students and visiting speakers to the new department. It aimed to replace the series of stencilled working papers which had been such an important part of the postgraduate community in earlier days. The department continued to make available the existing working papers which were advertised in the new journal and steady sales continued until long after the department's demise. In addition to publishable postgraduate work, some

undergraduate work was also included in the new journal. In the event it published only in four issues and what turned out to be the final issue covered the two years 1996–97.[13] The editors' preface to the final issue explains that the costs of publishing hard copy exceeded the sales and that they were pursuing the possibility of switching to an online version in the future. The preface also announces the change in title of the department to the DCSS.

Below are the topics of the papers published in each issue of *Cultural Studies at Birmingham*

No. 1 (1991): HIV AIDS representation; Indian video films and Asian British Identities; *The Sun* and its readers; cultural industries.

No. 2 (1993): Race and gender; working class and the arts; male bodies; narratives of racism.

No. 3 (1994): 'Middle England' and cultural studies; nationalism; Latin America and modernity; changing vocabulary of blackness.

No. 4 (1996/7): Music and education; global corporate culture; Birmingham and European reconstruction; men's fitness magazines; black popular culture.

The editorial collective felt strongly that, in addition to featured articles, student 'works in progress' from doctoral, master's and undergraduate dissertations should be recorded in each issue. Thus, names of all students and the titles of their theses were included each year. This typically egalitarian decision leaves within the pages of the short-lived journal the footprint of the intellectual and political concerns of those who made up the department during those years. These are poignant traces of those whose work was, in the main, responding to and often challenging the taught modules on undergraduate and master's programmes, which otherwise would be lost.

The authors in the two previous chapters of this section relate the work of the Centre in the 1960s and 1970s to the prevailing political and intellectual climates. As my approach here to the last decades of cultural studies at Birmingham has been to emphasize the productivity of the department, I have identified the major themes and topics across the work produced by these students during this period: sexualities, race and ethnicity, identities, new social movements, feminisms, masculinities, working-class cultures, politics of education, media and representation, urban studies, public culture, globalization, youth subcultures, cultural industries. This list of topics and themes mobilized and investigated by the student body is, I would argue, evidence of an engagement, not only with the already established areas of interest in cultural studies, familiar to readers of this volume, but also with what were then emerging subjects of study. Many of the dissertations were acute, insightful and exploratory focusing on subjects introduced by students themselves and

examined through conceptual and methodological frameworks. Students often surprised and, indeed, disturbed us in their desired research avenues. A significant proportion of the work was empirically based in the city and the region and some innovative methods were applied. In addition to the 'final' or culminating piece of work on each programme, students at undergraduate and postgraduate levels carried out group work as part of their assessment which, as in the CCCS days, was often difficult, rarely disastrous but occasionally brilliant. The spaces constructed within the courses and the ethos of the department itself encouraged student engagement, which reflected social, political and intellectual developments during the period.

The completions of postgraduate studies during the period up to the late 1990s numbered some 20 to 30 PhDs, covering topics such as cultural identity; sexualities; feminist issues; globalization; education/anti-racism; technologies of reproduction; community arts. In each year there were some 10 to 15 MSocSci completions and an average of 50 single honours graduates.

In the middle of this period the department's submission to the 1996 Research Assessment Exercise was awarded a grade of 4 out of a possible 5. On this basis the head of department requested the establishment of a chair in cultural studies which was turned down by the university.

1997–1998

The imposition of tuition fees had an impact on our student applications. In 1996, provoked by a perceived crisis in UK higher education, Prime Minister John Major set up an inquiry into the issue, chaired by Sir Ron Dearing. The 'crisis' was considered to be the result of a period of very fast growth in student numbers, which were financed by a severely reduced unit of resource per undergraduate student. Dearing's Committee reported in 1997 and the incoming Labour government the same year, under Tony Blair, introduced a £1,000 per annum student fee which began in 1998. The charging of tuition fees and the gradual erosion of support for 'non-conventional' students had an impact on the range of applications for the degree programmes and many students struggled to stay on their courses.

In common with the majority of UK universities, Birmingham sought to make economies and where possible to rationalize smaller units. This heralded another period of uncertainty for the department which was, in part, caused by the desire in some quarters of the university to reintroduce sociology within the School of Social Sciences. To those outside Birmingham this must have looked rather strange as the university had closed its Department of Sociology in the 1980s. Initially the University attempted to resituate those staff specializing in cultural studies subjects, which the school executive committee

defined as 'race, media and gender', within the Faculty of Arts leaving staff specializing in sociology in the School of Social Science to develop the new programme. All of the by then 10 departmental staff whose research interests did not necessarily conform to disciplinary boundaries, resisted this split and won the day. Thus, the department was renamed Cultural Studies and Sociology and launched a single honours sociology programme. Undaunted and determined to pursue their plan for a revived sociology, the university appointed an external professor to advise on the future of the department. The resulting recommendation that a chair in sociology be established was acted upon and Frank Webster was appointed in 1999. Of course these kinds of management demands for rationalization through restructuring take individual and collective tolls on time, energy and morale and, in the middle of a research assessment period, can have profound consequences.

It was, however, a shock to the department, school and university when in 2001 the submission to the Research Assessment Exercise failed to meet the university target. The university refused to appeal the decision and members of the department spent more time and energy on fighting for survival and livelihoods. Despite efforts to persuade the university of our contribution to the school, not least of which were viable programmes and a large number of domestic and international postgraduate students, the department was eventually closed in July 2002. Notice was given to staff on 20 June of that year, by e-mail, that each had six weeks to either re-apply for one of the four posts that were to remain, with research interests in European Studies or English, accept 'voluntary severance' or be subject to compulsory redundancy. All but two of the eleven full-time and one part-time member of staff accepted voluntary severance because they believed the existing degree programmes were neither viable nor credible on just four posts to service two degree programmes (250 undergraduates) and 50 research students. The closure announcement came after most of the undergraduates had left the campus fully expecting to see us in September and incoming students were sent letters from the head of the School of Social Sciences reassuring them that 'your degree programme will continue as advertised'.[14]

When news of the closure spread the vice-chancellor's office was inundated by letters and e-mails from scholars all over the world, many of whom were alumni of the Centre and department, expressing their profound objections to the closure. At the same time a remarkably energetic and committed campaign group spearheaded by students was formed in the summer of 2002, which comprised representatives from staff, alumni, parents, undergraduate and postgraduate students, colleagues from other universities and three local members of Parliament, Gisela Stuart (Edgbaston), Lynne Jones (Selly Oak) and Richard Burton (Northfield). A public meeting was held on 1 August 2002 addressed by Jones and representatives of undergraduate and

postgraduate students and staff affected by the closure. The student group also held regular meetings through that period and sought to inform returning and new students of the situation. The campaign's overall aim was to take the university to task over the closure and to protect student interests. Our two professional bodies – the British Sociological Association and Media, Communication and Cultural Studies Association – also wrote to the vice-chancellor expressing their concern at the closure and furthermore refused later requests from the university to advise on the appointment of replacement supervisors for the abandoned PhD students.

The campaign group appealed to the head of the Higher Education Funding Council and the minister of state for higher education, both of whom, while expressing their concern, declared that they could not intervene in the inner workings of institutions. Many continuing research students were severely affected by the closure and their work disrupted. New undergraduates commencing their studies in September 2002 found little signs left of the department to which they had been recruited and existing courses were, in the most part, run by graduate teaching assistants. The majority of the departing staff secured posts in other universities but those who have been interviewed as part of the CCCS 50 project speak of the devastating effect of the sudden closure on their personal and professional lives.[15]

Much has changed at Birmingham since the department's closure, but institutions, if they have any memory at all, are usually highly selective and can often demonstrate acute amnesia. The then vice-chancellor, after being congratulated by the University Council on his first year of 'organising for success', speaking of the closure of the department declared: 'the unit which has been reorganized in this process is not the internationally renowned CCCS created by Professor Stuart Hall and others: this in fact ceased to exist several years ago'.[16] He described the DCSS as 'a small unit in the School of Social Sciences'.

The new management had conveniently forgotten that only two years earlier the pro-vice-chancellor Michael Clarke, in welcoming delegates to the Crossroads Conference, declared that 'here was evidence of the continuity of a tradition at Birmingham'. What delegates found at the conference was the manifestation of a truly international field of inquiry. There is little doubt that people came to Birmingham because the then department was held in high regard and not considered to be some 'small unit in the School of Social Sciences'.

In his immediate response to the announced closure of the DCSS in an article for the *Chronicle of Higher Education*, Paul Gilroy reminded us that

cultural studies, for good or ill, is everywhere. Its worldwide popularity marks out a deeper realignment in the constellation of disciplines and scholarly

interests. The mythic wellspring amid Birmingham's red brick is no longer needed. The current closures will be fought, but what is at stake in that confrontation is the future of British higher education, not the future of cultural studies.[17]

The gathering of scholars past and present at the CCCS 50 event clearly demonstrate his point. However, the University of Birmingham's attempt to airbrush the DCSS, its staff and its students from history reminds us of the tenuous grip we have within our institutions, how institutions have the power to remember and forget and deny what is often the most obvious of its assets. This cavalier attitude to the truth and the callous dismissal of responsibility to staff and students is and should remain a dark and lasting stain on the University of Birmingham's record and be reflected in the archive.

NOTES AND REFERENCES

1. A full account of the closure can be found in Ann Gray, 'Cultural studies at Birmingham: the impossibility of critical pedagogy?' *Cultural Studies*, 17, 6 (2003), pp. 767–782.

2. The department was approached by a number of publishers during the 1990s who were keen to see the Working Papers published in edited collections. Initial work began in 1998 as a collaborative staff/student project and was then pursued in earnest from 2002.

3. Ann Gray, Jan Campbell, Mark Erickson, Stuart Hanson, and Helen Wood, *CCCS Selected Working Papers*, vols. 1 & 2 (London: Routledge, 2007).

4. Maureen McNeil speaks of this time in her interview on the CCCS 50 Website: http://www.birmingham.ac.uk/schools/historycultures/departments/history/research/projects/cccs/interviews/audio-interviews.aspx 10 May 2015.

5. In a series of articles about the state of UK universities, Will Woodward, then education editor of *the Guardian* referred explicitly to the University of Birmingham. W. Woodward 'Never mind the quality, feel the quantity' *The Guardian*, 20 May 2002.

6. Ibid.

7. Sarah Franklin, Celia Lury, Jackie Stacey, Off-Centre: feminism and cultural studies (London: Harper Collins, 1991).

8. Paul Willis, Learning to Labour: How Working-Class Kids Get Working-Class Jobs (Farnborough: Saxon House 1977); Tony Jefferson (ed.), Resistance through Rituals (Birmingham: CCCS 1975).

9. Angela McRobbie, Feminism and Youth Culture (London: Macmillan 1991).

10. Stuart Hall 'Encoding/decoding', in Stuart Hall, Dorothy Hobson and Paul Willis (eds.), *Culture Media, Language* (London: Hutchinson, 1980), p. 129; Charlotte Brunsdon and David Morley, *Everyday Television—'Nationwide'* (London: British Film Institute, 1978).

11. Access to Higher Education Diploma. A one-year course usually taken by mature students which enable them to apply to a UK university.

12. Daeho Kim, Inha University, Republic of Korea; Cristobal Marin, Santiago, Chile; Ting-Hue Chao, FuJen Catholic University, Taiwan.

13. *Cultural Studies* from Birmingham 1991; 1993; 1994; 1996/7.

14. Letter from Professor Stuart Croft, Head of School of Social Sciences, 22 August 2002.

15. A full list of the interviews conducted is available here: http://www.birmingham.ac.uk/schools/historycultures/departments/history/research/projects/cccs/interviews/audio-interviews.aspx 10 May 2015.

16. Press release University of Birmingham, 26 September 2002.

17. Paul Gilroy, 'Cultural studies and the battle for British higher education', *The Chronicle of Higher Education*, 15 July 2002.

Chapter 4

Cultural Studies on the Margins

The CCCS in Birmingham and Beyond

Kieran Connell and Matthew Hilton

Cultural studies has undoubtedly been the outsider of the academy. As seen in the chapters by Dworkin, Eley and Gray, whether because of their subject matter, use of theory or emphasis on the importance of political engagements, practitioners of cultural studies have posed a challenge to mainstream higher education. The ongoing attention given to the history of the Centre for Contemporary Cultural Studies (CCCS) means that it is easy to see where this sense of marginality comes from. Marginality is a recurring theme in the Centre's history. It was there in its 'inter' or 'un' disciplinary approach to its subject, for instance, and its subsequent embrace of various strands of Marxist theory. It was there in the increasingly political approach to academic work adopted at the CCCS, and its corresponding emphasis on collective decision-making and the development of links with external political movements.[1] And it was there in its initial affiliation with Birmingham's English department, where the Centre's focus on 'mass' or popular culture did not chime well with scholars of the traditional canon. This initiated a mode of operation within the university that, all the way through to its closure in 2002, was often at odds with senior faculty members and university management. All of this explains why cultural studies has so often felt itself under siege, outside of disciplinary norms, both at Birmingham and beyond.

To some extent this understanding is rooted at the very beginnings of cultural studies' 'myth of origin'.[2] Soon after Richard Hoggart established the Centre in the autumn of 1964, a letter appeared in the student newspaper *Redbrick* from three social scientists at Birmingham (A. D. Chambers, C. R. Hinings and J. M. Innes) who objected to the idea of cultural studies as a new field of academic research. For Larry Grossberg, writing in part two of this volume, the letter posed a clear 'challenge' to the CCCS. As Stuart Hall remembered it in 1980, it was a 'sort of warning' as to the 'reprisals' the

Centre could expect to face if its work was seen to 'illegitimately' encroach onto the existing remit of the social sciences.[3] Indeed, the authors of the letter expressed their concern at what they described as the Centre's 'complete lack of precise research proposals'. They pointed to existing work in the field of the mass media which had already suggested that 'broadcasting has little or no effect on people's attitudes'. Finally, the letter's authors derided what they saw as the 'fallacy' that 'the complex phenomena of human social behaviour can be investigated quickly and with a simple and direct approach'. The Centre's methodology was likened to that of 'popular journalism'.[4] Like the Centre's initial location in a series of temporary huts on the edge of campus, Hall saw this letter as evidence that the humanities were 'relentlessly hostile' to the CCCS, 'deeply suspicious' and 'anxious to strangle . . . the cuckoo that had appeared in its nest'.[5]

This chapter complicates this view of the development of cultural studies at Birmingham. The CCCS was of course the subject of considerable hostility throughout its existence, whether in its original guise as a postgraduate research centre or in its later formation as a more conventional department following a merger with sociology. As will be shown, attacks increasingly came not only from senior colleagues at the university and those in the established disciplines, but also from previously sympathetic comrades on the intellectual Left. Yet at the same time, the Centre was also able to draw on a much broader range of engagements, both within the academy and in the world beyond its institutional confines.

In the first instance, the perception of the CCCS as a marginal institution was at times itself a significant driver behind the cultural studies project. Hall and his colleagues were often energized by the notion that they were involved in an 'illicit' endeavour and that more established disciplines – particularly sociology – were in a state of 'profound disarray'.[6] For Hall, interdisciplinary work necessarily meant cultural studies mounting its own attacks on disciplines such as sociology and, as he put it in 1990, telling 'professional sociologists that what they say sociology is, is not what it is'.[7] In a 1971 internal memo to all Centre members Hall characterized its work as a process of engaging '"the enemy" in open confrontation'.[8] At times, these attacks were at least as vociferous as those to which the CCCS was regularly subjected. After the publication of the infamous letter of 'warning' to the CCCS in 1964, for example, Ian Jackson – a PhD student at the Centre – wrote to _Redbrick_ to complain about the 'extraordinarily generalised' argument put forward by the sociologists who, it was suggested, could have avoided 'the labour of their irrelevant diatribe' if they had 'simply consulted the individual members of the Centre about their respective projects'.[9] And when a later generation of CCCS students established the 'race and politics' research group at the Centre, their public criticisms of John Rex and other white sociologists of 'race relations' were such that Rex likened it to a form of academic 'warfare'.[10]

But the Centre's engagements were not all hostile, and went beyond the kind of generational shifts that to some extent characterize intellectual work across the arts and humanities as younger scholars seek to put their mark on a particular field of inquiry.[11] Cultural studies has had its fair share of advocates as well as detractors. Almost from the moment it opened its doors the CCCS drew on a broad network of supporters that began with key figures in the New Left but soon expanded to include other academics, commentators and institutions. This is not to downplay the extent to which the CCCS was both treading new ground and the victim of considerable hostility. As will be shown, their experiences in this regard were a precursor to more recent political – if not perennial – attacks on what has been labelled 'mickey mouse' studies. But we do wish to move the discussion beyond the Centre's enduring 'myth of the margins'.[12] The Centre, it will be argued, oscillated between, on the one hand, being something of a lightning rod for anxieties about culture, Marxism and 'theory', and, on the other, being a key part of an expanding network with a shared stake in the cultural studies project.

Although it may seem counter-intuitive in a volume that marks the half-century of the establishment of the CCCS, this chapter reiterates one of the key points made by Hall in his interpretation of the history of cultural studies – that its arrival should not be reduced to the story of a single institution or individual.[13] Rather, cultural studies emerged out of a particular milieu or 'conjuncture', in which a diverse range of actors played significant roles in its development in Birmingham, Britain, and beyond. It is this conjuncture that provides the focus of what follows. We begin with a discussion of the early history of the Centre, placing it in the context of other turns to popular culture within universities, especially a parallel initiative at Leicester University. We then move to the more overtly political stage of the Centre's work in the 1970s and examine how this proved an inspiration to a whole variety of practitioners beyond the academy working, especially, in the arts and cultural sectors. Finally, we return to some of the key attacks made on the Centre and on cultural studies more broadly that have reinforced the notion of its outsider status.

EARLY DEVELOPMENTS

Hoggart and Hall both highlighted the hostility that the CCCS initially faced from colleagues within the university. In Hoggart's autobiography, for example, he places his memories of his ultimately successful approach to Penguin Books for funds towards the Centre in the context of the refusal of Sir Robert Aitken, the incumbent vice-chancellor at Birmingham, to make any sort of financial contribution towards the endeavour.[14] Likewise, Hoggart recalled a later incident in the Senior Common Room when a colleague openly mocked the scholarly rigour of the Centre and described it as 'a nice

line in cheap hats'.[15] For all that the English department was home to the up
and coming writers David Lodge and Malcolm Bradbury, its main special-
isms remained the resolutely orthodox Victorian literature, the Romantics
and Shakespeare. Its head of department Terence Spencer was an expert in
the plays of Shakespeare and also headed the affiliated Shakespeare Institute
in Stratford.[16] Lodge reported that Hoggart and Spencer 'did not get on' and
'had nothing in common, personally or intellectually'.[17]

Yet there was more to the Centre's origins than hostility and mockery.
Publicly at least, Spencer was enthusiastic about Hoggart's emphasis on the
importance of contemporary culture. In June 1963, he praised Hoggart's
plans for the Centre in an interview with the *Times*. It was orthodox practice
for scholars to investigate the 'artistic and aesthetic experience' of the past,
Spencer remarked, 'yet aesthetic experiences today have a greater impact on
human beings than ever before'. That these experiences were now largely
conducted in what Spencer called the '"pop" area' was, he reflected, 'one
reason why it should be investigated'.[18]

Spencer may simply have been attempting to capitalize on the publicity
that Hoggart's move from Leicester University to Birmingham generated.
Hoggart was riding the crest of a 'wave of celebrity' following the publi-
cation of *The Uses of Literacy* in 1957 and, three years later, his role as a
witness for the defence in the 1960 obscenity trial that was brought against
Penguin Books following the release of an uncensored version of D. H.
Lawrence's *Lady Chatterley's Lover*.[19] Shortly after his appointment one
local newspaper ran a profile of Hoggart that described his career as the
'continuing diverse, rich, complex and utterly absorbing story of society,
its language, its communications and its shifting, growing, and always
extraordinary culture'.[20]

But the media's interest in the Centre went beyond a focus on the person-
ality of an increasingly prominent public intellectual. Sections of the press
were also intrigued by the founding rationale of Hoggart's cultural studies
project, and often displayed an unexpected feel for what it was setting out to
do. Reporting on Hoggart's inaugural lecture at Birmingham, for example,
in which he explained what he envisaged as the scope of 'Literature and
Contemporary Cultural Studies', a journalist for the *Guardian* felt that the
CCCS could do for the field of 'contemporary cultural studies' what the
'Shakespeare Institute has done for Renaissance Studies'.[21] Others were
drawn to the Centre's interest in taking seriously what Hoggart summarized
as the everyday 'mud of life'.[22] One report remarked that while Birmingham
boasted cultural 'show pieces' such as the Rep Theatre and the Symphony
Hall, it was the city's 'pubs and clubs . . . beat groups, striptease and football
teams' that made it the 'obvious locale' for what was understood as 'the first
scientific study of mass culture'.[23]

Furthermore, praise for the project of contemporary cultural studies could also be found in those publications that would later become some of the most hostile critics of so-called 'mickey mouse' studies. In 1996, for instance, the *Daily Express* would run a front-page feature under the headline 'The Farce of Useless Degrees', which criticized the use of taxpayers' money for what was described as a 'laughable inflation of subjects' such as media studies.[24] Yet three decades earlier the same newspaper's columnist Robert Pitman was intrigued by the prospect of a new research centre that would uncover the 'moral values' of the popular press. 'There is a streak of exhibitionism in all journalists', he remarked. 'It will do us the power of good to know that . . . the University of Birmingham [is] keeping a watchful eye on us'.[25] There was an exoticness to the Centre's focus on popular culture which makes it easy to see why newspaper editors in the 1960s were attracted to it, however wryly. Shortly before the CCCS opened its doors the *Daily Herald* ran a cartoon depicting a group of students dancing to a new band, 'the Dean Masters and the Dons'. Its members were dressed in mortars and academic gowns and, an onlooker explained, were research fellows in 'pop culture' at the University of Birmingham.[26]

Journalistic interest in the Centre coincided with the presence of intellectual networks that Hoggart, Hall and others at the CCCS were able to draw upon in the early development of cultural studies. Through projects focusing on the local press, 'pop music and adolescent culture' and 'the meaning of sport', they cultivated connections that went far beyond the academy.[27] Importantly, the CCCS's famous 'Tuesday seminars' welcomed faculty members from across campus and invited outside speakers from across the wider academic community as well as the arts and cultural sector more generally. The aim was to encourage interdisciplinary dialogue and 'give every student an opportunity to confront the general social and cultural issues which lie at the heart of this work'.[28] It was a practice that the Centre would attempt to maintain up until its later reconstitution as a formal academic department.[29]

The speakers during the Tuesday seminars' first years are particularly illustrative both of the Centre's innovative networks and its absence of any formal disciplinary heritage. The Centre was open to the input of non-academics who had practical experience in specific areas of popular culture but little or no formal scholarly expertise. In 1965, for instance, George Melly, the jazz critic who had previously been associated with a group of surrealist artists in Birmingham, spoke on 'jazz and pop clubs'. In 1966 Spencer Davis talked to the CCCS about 'pop music', having formed the R&B band the Spencer Davis Group two years earlier. John English spoke about his founding of the 'Cannon Hill Arts Collective', the aim of which was to provide local working-class and immigrant communities with access to the arts. And in 1970 Charles Parker, then a producer at the BBC who had made his name making radio

documentaries about working-class life and who would later establish his own theatre company in the city, was invited.[30]

More conventionally, the Tuesday seminar also featured other academics. Many of these had their own stake in the development of cultural studies as a fledging field of academic inquiry. Unsurprisingly, these included fellow travellers in the New Left, including Hall's successor as editor of the *New Left Review* Perry Anderson, the social historian E. P. Thompson and the literary scholar, Raymond Williams. Hall saw the early work of Thompson and Williams as constituting 'the original "curriculum" in the field', and both were regular visitors to the Centre in its early years.[31] Williams was the inaugural external speaker at the Tuesday seminar series when he presented a paper titled 'Problems of a Common Culture' in autumn 1964, while Thompson spoke formally at the CCCS three times in the first ten years of its existence. The last of these occasions was a precursor to Thompson's famous falling out with the Centre over the issue of continental theory: the title was, 'A Critique of Althusserian Modes of Thought in Historical Work'. Yet the regard with which he was held within the CCCS prior to this was demonstrated by his invitation in spring 1965 to provide a 'critical survey' of the entire first year of the Tuesday seminar programme.[32]

Alongside this, the Centre was also able to utilize the expertise of scholars who were much less associated with the development of cultural studies but were nevertheless working in fields closely connected to the early interests of the CCCS. Regardless of his later conflict with a younger generation at the Centre, for example, John Rex spoke at the CCCS in its inaugural year and would later recruit one of its students, Alan Shuttleworth, as a research assistant on his study of immigration and the inner city, *Race, Community and Conflict* (1969).[33] Other speakers included Hilde Himmelweit, the professor of psychology at the London School of Economics whose work looked at the impact of television on young people; the professor of music Wilfrid Mellers who spoke at the CCCS on 'popular music'; and the sociologist Edward Shils who spoke on 'mass society and mass culture'.[34]

These speakers often acted as a spur to the intellectual rigour of the Centre's evolving work. In the aftermath of a talk by the sociologist Jock Young in the early 1970s, for instance, Hall circulated a document to all CCCS members in which he complained that Young had displayed 'more original thoughts about the media and deviancy than I have heard or read from anyone in the Centre for many months'.[35] Furthermore, although cultural studies as a formal field of inquiry began to spread around the world in a much later period, many of the academic networks that contributed to its earlier development were also international in breadth.[36] For example, as she discusses in the penultimate section of this volume, Lidia Curti left Italy to become a part-time research student at the CCCS in its first year and would contribute to the Centre's

subsequent turn to Gramscian theory.[37] The inaugural visiting research fellow at the Centre was Benjamin DeMott, the American lecturer in English, while the CCCS also maintained regular contact with the French intellectual Robert Escarpit.[38] Escarpit was a commentator for the French newspaper *Le Monde* and in 1965 had founded his own centre for the study of popular culture, the Bordeaux *Institut Littéraire des techniques artistiques de masse*. As a result of his ties with Hoggart, Escarpit is said to have referred to the CCCS as the 'Lady Chatterley Institute'.[39]

In these formative years, therefore, the CCCS was both peripheral and not. It drew on the input of pop stars, journalists and others who are rarely asked to contribute to academic debate, yet at the same time it could count on the support of academics many of whom, even in this early period, already enjoyed prominent scholarly reputations. The Centre occupied a liminal position between marginality and respectability, something illustrated further by a comparison with another newly formed centre for the research of mass culture in the British Midlands: the CMCR at Leicester University.

THE CENTRE FOR MASS COMMUNICATION RESEARCH

The CMCR was established in 1966 by James Halloran, a lecturer in adult education who was appointed at Leicester in 1958, a year before Hoggart joined as a lecturer in Leicester's English Department. Halloran's interest in the mass media was developed during his time in extramural education and set out in *Control or Consent* (1963), a collection of essays on the 'sociology of mass communications'.[40] The CCCS and the CMCR were thus established within two years of each other and shared a number of links, though the existence of the Leicester Centre is insufficiently acknowledged either in accounts of the CCCS or of cultural studies more generally.[41] Halloran was a speaker at the CCCS in the first year of the Tuesday seminars, while Hoggart and Hall visited the CMCR in 1966 before each giving formal papers the following year.[42] Both centres began to examine broadly similar subjects. Local radio was an early shared subject, with the CCCS arguing against the commercialization of local radio in order to avoid producing 'lowest-common denominator programmes' and the CMCR exploring the way in which audiences used local radio in their daily lives.[43] Similarly, in 1970 a team led by Halloran produced an investigation into the way in which the media represented the anti-Vietnam War protestors of 1968, while Paul Willis – then a student at the CCCS – published an analysis of the local media's portrayal of the 1968 student sit-in at the University of Birmingham.[44]

An important shared reference point was the contemporaneous debate on the impact of sex and violence as portrayed on television. This was partly

initiated by the campaign to 'clean up' television led by the activist Mary Whitehouse.[45] Both the CCCS and the CMCR attempted to counter the argument made by Whitehouse and others that there was a direct link between what people saw on television and their behaviour. In the academic year 1965–66, for example, the CCCS obtained funds from the Gulbenkian Foundation for a project to examine the relationship between television companies and audiences. It was an early precursor to work on the media undertaken in the 1970s at the CCCS by figures including Ian Connell, Dorothy Hobson and David Morley. The aim was to show how audiences were active rather than passive consumers of television, and could shape the programmes they watched through 'correspondence, complaints, "talk-back" programmes and the press'.[46] The CMCR ran similar projects in this period, including a comparative exploration of the viewing habits of working-class and middle-class adolescents and a survey, undertaken in collaboration with the BBC, to 'assess the nature and extent of public concern about television and violence'.[47]

Both centres also attempted to influence debate through public interventions in the media. In 1967 Halloran wrote an article for the *Guardian* in which he complained that 'the public debate on the effects of the mass media does not take place at a very high level' and argued that the 'media must be studied in a wider social setting'.[48] A year earlier Rachel Powell, a research fellow at the CCCS, gave an interview on the subject to the *Birmingham Post*. 'What people like Mrs Mary Whitehouse and the Clean Up TV Campaign do not take into account', Powell remarked, 'is that people react to television far more subtly than just noting how much sex and violence they see'.[49] In 1966 Hoggart even wrote to Whitehouse to invite her to 'put your point of view' and 'say exactly what you felt' at a CCCS Tuesday seminar.[50]

The CCCS and the CMCR shared more than a common desire to counter the panic generated by those Halloran described as 'grass-root moralizers'.[51] Hoggart and Halloran were the product of similar formations. Both grew up in working-class households in Yorkshire, developed social-democratic-political outlooks and began their academic careers in adult education.[52] Hoggart would deliver his inaugural lecture at Birmingham in 1963, a decade before Halloran gave his at Leicester. Yet the content of the lectures do reveal some convergences in their ideas for the need for the study of mass media and culture. Given the subsequent emphasis at the CCCS on exploring ethnographic 'lived experience', the extent to which Hoggart focused on the impact of 'modern communications' in his inaugural has arguably been under-acknowledged.[53] Similarly, although by the 1970s 'communications studies' had developed a distinct disciplinary identity in Britain, Halloran nevertheless stressed the importance of not studying the mass media in a vacuum and of including the broader contexts of 'family, school, social class [and] neighbourhood'.[54] Hoggart and Halloran both critiqued the slowness

of disciplines such as sociology and philosophy to engage with changes in society and stressed the need for an approach that would, Halloran explained in the first CMCR annual report, 'cut across traditional disciplinary boundaries'.[55] The CMCR would even develop a set of working practices that resembled that of the CCCS, including the production of annual reports that situated its work in relation to broader developments in the field.

The distance between the two centres' research interests widened from the 1970s onwards, particularly as cultural studies embraced the continental theory of Althusser, Gramsci and others. Halloran was sceptical of this development, complaining that the assent of theory had resulted in scholars 'eschewing any discipline or systematic inquiry and never allowing an inconvenient fact to disturb a firmly held, unsubstantiated opinion'.[56] But hostility towards theory was something that was also shared by Hoggart. In his 1993 autobiography, for example, Hoggart wrote of his 'mistrust' for people who 'use theory as . . . substitutes for thought' and frequently bemoaned the supposed moral relativism he believed endemic to the subject.[57]

The point of the comparison, however, is not necessarily to argue for a similar celebration of the Leicester initiative. Rather, it is to emphasize a more general turn towards popular culture and the mass media in which the CCCS was joined by many fellow travellers. Where the greater marginality of the CCCS holds up in such a comparison, though, is in reference to the resources devoted to the two centres. The CMCR enjoyed far greater financial assistance than the CCCS was ever able to access. Whereas the CCCS had to rely on a grant of just £2,400 from Penguin and had no university support in its early years, the CMCR received financial support from Leicester University from the outset, as well as an annual grant of £20,000 from the Television Research Committee. The committee had been set up by the Home Office in 1963 in order to initiate 'research into the part which television plays . . . as a medium of communication and in fostering attitudes' among the general public.[58] Halloran acted as secretary of the committee and its financial backing enabled the CMCR to employ six full-time members of staff in its first year compared to the two full time and one part time member of staff at the CCCS, as well as invite speakers as prominent as David Attenborough (then controller of BBC 2), Charles Curran (director general of the BBC) and Donald Edwards (managing director of ITN).

The CMCR was far closer to the establishment than the CCCS ever was. Yet, the very fact that the CMCR was able to attract substantial investment from the state-funded Television Research Committee demonstrates that the broad subject area of popular culture was not in itself beyond mainstream societal interests. Although the committee was far closer to the Leicester Centre, the CCCS was also the beneficiary of some limited support – in its first year one of its research assistants David Chaney maintained a formal

attachment to the Home Office body.[59] Moreover, as the CCCS began to
achieve national and international prominence in the 1970s, it did so at a
time when cultural studies as a field spread through the polytechnics and new
universities, keen to distinguish themselves from the established academic
institutions, either through new programmes or innovative curricula design.
For instance, one of the earliest undergraduate courses in cultural studies ran
at Portsmouth Polytechnic in autumn 1975, the same year that the CCCS first
ran its taught MA in cultural studies.[60] A key marker would be the appear-
ance in 1982 of the Open University's U203 module Popular Culture, which
was convened by Tony Bennett with input from a range of figures – including
Stuart Hall, after his departure from the CCCS in 1979 to become professor
of sociology at the Open University.[61] To understand the CCCS's ongoing
liminal status it is therefore necessary to turn other factors. Primary among
these was its embrace of theory and a more overtly political project in the
years following the student rebellions of 1968.

ESTABLISHMENT AND ATTACKS: A RADICAL HEGEMONY?

The 1970s was the decade in which many of the Centre's most celebrated
publications were produced. The first edition of *Working Papers in Cultural
Studies* appeared in spring 1971, while the famous 'Stencilled Occasional
Papers', often the product of the Centre 'subgroups', began to attract signifi-
cant interest.[62] By the mid-1970s a contract with the publisher Hutchinson
meant that the *Working Papers* could reach a much wider audience than was
possible through the earlier Gestetner-enabled self-publishing ventures.[63]
It meant the CCCS became an incredibly popular place to study – particularly
among those who came from working-class backgrounds who were keen to
examine their own formative experiences in the political and popular cultures
of 1960s and 1970s Britain. Christine Hardy, for instance, had left higher
education in the mid-1970s to join an International Marxist Group squat
in London. She came across an issue of *Working Papers* and subsequently
undertook a PhD at the CCCS on 'arts interventions in working class areas'.[64]
Similarly, in the late-1970s David Batchelor had dropped out of art school in
Nottingham and was faced with a choice between a period of unemployment,
or retraining to become a teacher. He had an interest in 'politics . . . culture
and art' and one of his teachers suggested a third option – 'this new place in
Birmingham called Cultural Studies'. Batchelor subsequently undertook the
taught MA at the CCCS.[65] By the end of the 1970s the number of students
attached to the CCCS rose to more than 60.[66]

This expansion contributed to a growing stress within the Centre on
the importance of moving the discussion beyond traditional sites of

academic discourse. The involvement of CCCS members in a major sit-in at Birmingham in autumn 1968 was critical here, as students were subsequently encouraged to attempt to make connections between their intellectual practice and their outside interests and political commitments – particularly once Hall had succeeded Hoggart as CCCS director in 1969. Students embarked on what Charlotte Brunsdon has described as 'small-scale, short-lived, local' projects that took place away from the CCCS but were not seen as entirely separate from the cultural studies project.[67] The variety of these engagements provides an illustration of not only the eclectic interests of the CCCS at this time but also the more general uptake of cultural studies around the country. Moreover, the positive reception of many of these initiatives, once students had begun to live and settle in Birmingham, is indicative of the wider support non-academic communities had for many of the ideas being developed at the CCCS.

One of the better-known initiatives is the work that was undertaken at Forty Hall Road, a community action centre in Handsworth, one of the most ethnically diverse districts of Birmingham. Hall Road was co-established in the late-1960s by Chas Critcher, who combined his work in Handsworth with postgraduate study at the CCCS and had been an active player in the 1968 sit-in at Birmingham. Critcher reflects on his work in Handsworth in the final section of this volume, but its central aim was to 'do good' in the community through the provision of services while simultaneously attempting to 'raise the consciousness of the people' through the distribution of pamphlets and other literature – including a leaflet that attempted to highlight the media's role in what was seen as a developing 'moral panic' around street crime and 'mugging' in 1972.[68]

Critcher's work in Handsworth provided the genesis for *Policing the Crisis*, and there were other connections between the CCCS and Hall Road. Critcher and two other members of the Hall Road initiative, Ranjit Sondhi and Margaret Parker, were recruited by the CCCS to work on a UNESCO-funded project examining the printed media's representation of race and immigration.[69] Critcher is sceptical about the connections between cultural studies and Hall Road, describing the process of dealing with social security issues in the morning and structuralism in the afternoon as like living 'two lives in parallel'.[70] But for Sondhi, who was never formally a student at the CCCS, the Centre's work was an important point of reference for his subsequent work with Birmingham's Asian community, including the establishment of a long-standing advice centre for south-Asian immigrants in Handsworth.[71] The importance of the Centre's work, Sondhi reflected, was that it did not 'impose ideological straightjackets' on this kind of community work. Rather, he argued, it provided activists with the 'analytical tools to make sense of the contemporary issues that matter to us'.[72]

The link with Hall Road was certainly valued within the Centre and not just for the academic results it would eventually yield. In another internal memo circulated in 1971 – prior to the mugging incident that would make Handsworth a formal subject of study at the CCCS – Hall praised the 'enormous political activity' of CCCS members and argued for the need for this to be more closely connected to the Centre's intellectual project.[73] According to one local activist, Hall regularly held conversations with local black power groups in the 1970s, including the African-Caribbean Self-Help Organisation.[74] Another project – undertaken by Richard Dyer and Judith Scott, two students at the CCCS, and Michael Green, then the Centre's part time lecturer – was *Birmingham Free Press*. This was to be a fortnightly newspaper that would 'report and explore those aspects of Birmingham life that the national and local press cannot or will not deal with'. A distrust of the mainstream media was one motivation for the newspaper; another was the desire to foreground and take seriously people's everyday experiences. Prior to the first issue of *Free Press* Dyer, Scott and Green wrote to local community organizations including Women's Liberation, Gay Liberation and the Indian Workers' Association to ask for articles of 800 to 1,000 words. There was to be no editorial censorship – the only criterion was that articles should be about 'things that have happened, situations [and] people', and use accessible language written 'as it is said'.[75]

As with many of these initiatives, *Free Press* was a short-lived venture. Other local magazines, including *Birmingham Street Press* and *Grapevine*, soon superseded it. *Street Press* was an avant-garde publication closely connected to the Birmingham 'Arts Lab', part of a network of collectives that attempted to use art as a means of embracing the experimentalism of the student protest movement.[76] *Grapevine* was an alternative listings publication and was established by Trevor Fisher, who had been a student at the CCCS between 1971 and 1973. Fisher's motivations in starting the magazine stemmed in part from the fact that he had had become 'pissed off' with the increasing centrality of theory at the CCCS.[77] Yet a dialogue remained – *Grapevine* aimed to 'challenge the existing media' in a manner similar to the earlier *Free Press* initiative, and when *Grapevine* later ran into financial difficulties, a fund was set up by CCCS members to support it.[78] For Brian Homer, who helped produce *Grapevine* with Fisher while working full-time as an electrician, this was his first point of contact with the work of the CCCS. He 'became influenced by that kind of discourse' and that 'way [of] talk[ing] about culture', and would later draw on the Centre's ideas when he co-established the photographic journal *Ten.8*.[79]

For Homer, it was in this way that the Centre had 'a big impact' on the alternative cultures of 1970s Birmingham. *Ten.8* began as a platform for local photographers to showcase their work but soon evolved into a journal on the theory of visual cultures that featured contributions from CCCS figures

including Paul Gilroy, Hall and Dick Hebdige. There were numerous other initiatives. In 1972, for instance, feminists in the CCCS worked with local women's groups to support a playgroup and later reflected on the experience both practically and theoretically.[80] In the late-1970s those in the Women's Studies subgroup organized writing groups in collaboration with the Workers' Education Association (WEA), the aim of which was to enable working-class women to develop their writing skills in order to 'challenge the notion that literature was irredeemably elitist and bourgeois'.[81] Concurrently, members of the English Studies subgroup developed an interest in film and helped establish the Birmingham Film and Video Workshop. This was part of a nationwide network of film 'workshops' which also emphasized the importance of increasing working-class participation in the arts and providing a counterpoint to existing orthodoxy in filmmaking in the run-up to the birth of a fourth television channel in 1982.[82] For Roger Shannon, who after the completion of his MA at the CCCS worked for the Birmingham Workshop, it represented an attempt at using the specific 'conceptual and political tools' he had developed at the Centre in order to make a broader intervention in the cultural life of the city.[83]

Many of these initiatives preceded the formal take-up of cultural studies at Britain's polytechnics and new universities from the mid-1970s onwards. Likewise, the establishment of cultural studies modules and undergraduate degrees in Britain was also prefigured by a much more informal form of pedagogic practice undertaken with the involvement of CCCS students in further education colleges, art schools and other less overtly academic institutions throughout the 1970s. These institutions required a pool of casual tutors to run classes in 'general' or 'complementary' studies, which were seen as a means of giving students enrolled in practical training a more rounded education.[84] The CCCS was quick to develop links with local colleges in order to give those who did not have full scholarships at the Centre a regular source of income. Just as Hoggart, Hall and other members of the New Left cut their teeth in adult education in the 1950s and 1960s, then, so too were younger generations of cultural studies scholars able to experiment with teaching practices in an attempt, as Dick Hebdige put it, 'to understand where knowledge fits with people who are not in the same game as you'.[85] The courses CCCS members were involved in teaching were indeed general enough for them to be able to attempt to structure them – however crudely – around ideas about cultural studies. John Clarke remembers teaching a group about 'participation in the arts', for example, while in 1975 Paul Willis ran a complimentary studies course at Aston University. His syllabus included 'pop music', 'Tommy vs. Quadrophenia' and 'mass media and advertising'.[86]

By the time universities across Britain began offering courses in cultural studies, therefore, they were responding to shifts in ideas about culture that

were already underway. The CCCS was one early voice in this shift, but it operated alongside institutions such as the WEA and the CMCR, individuals such as E. P. Thompson and George Melly, and 'small-scale' projects such as the *Free Press* and Hall Road. By the early-1980s the demand for cultural studies was such that when the Open University introduced its U203 course in popular culture it attracted over 1,000 students in its first year. More than 5,000 students took U203 between 1982 and 1987,[87] the 'largest undergraduate take up for any cultural studies course in the United Kingdom'.[88] By the mid-1990s there were 40 universities and colleges offering courses in cultural studies in Britain and, as Part Four of this volume explores, an upsurge in interest in across Europe, the United States and beyond.[89]

CRITICS OF CULTURAL STUDIES, CRITICS OF THE CCCS

The institutionalization of cultural studies within the academy did not signal the end of the Centre's own liminal position between marginality and respectability. It is an irony that it was at the very moment that cultural studies was becoming a feature of university campuses across the country that the CCCS began to be subject to increasingly stringent attacks. To some extent, these were the products of the shifting political climate that Hall and his colleagues identified in *Policing the Crisis* and that Hall subsequently developed in his later analyses of 'Thatcherism'.[90] An early marker was the 1977 publication of *The Attack on Higher Education*, a pamphlet co-researched by nine social scientists and authored by the professor of sociology Julius Gould on behalf of the right-wing think tank, the Institute for the Study of Conflict. In one sense, the report could be taken as the extension of the culture wars signalled by the letter the CCCS received from the three social scientists at Birmingham in 1964. Unlike that letter, however, Gould's focus was not solely on the CCCS or the 'undisciplined' nature of cultural studies, but on the entire higher education sector in Britain and the threat supposedly posed to it by 'Marxist and radical penetration'.

Gould hoped his report would act as a wake-up call for the 'moderates' who managed universities and, in his account, had been culpably blind to the threat posed by the radical presence on British campuses. He pitched this threat as an ideological conflict between those who remained committed to an 'open, plural society' on the one hand and, on the other, particular 'groups and individuals' who had 'shown by their theory and – more importantly – by their practice that they reject . . . such freedoms'.[91] This division was expanded on in the opening section of *The Attack*. Where 'we stand', Gould wrote, was encapsulated by a commitment to 'intellectual diversity', 'pluralism' and a 'genuine liberalism'; where 'they stand', by contrast, meant 'a deep dislike of

a liberal/tolerant society' and ultimately 'a desire to destroy it' by any means possible – including a 'long march through the institutions'.[92] In the second camp Gould included members of the New Left, academic journals such as the *History Workshop Journal* and *Race and Class* and, because of their willingness to publish Marxist or 'radical' material, publishers including Penguin and Macmillan.[93] For the *Daily Telegraph*, Gould's report had uncovered a 'map of hell'; for the editorial collective of *History Workshop Journal*, it was 'a deliberate attempt to inject a virus of suspicion into intellectual life in Britain' and an 'invitation for blacklisting'.[94]

To some extent, after a brief period of media interest, Gould's report faded into relative obscurity.[95] As was the case with other perceived attacks on the Centre, some within the CCCS viewed *The Attack* as a badge of honour and a reaffirmation of their way of working. As Hazel Chowcott recalled, 'those who had been named [by Gould] were expressing outrage but you knew that if they hadn't been named they'd be even more outraged'.[96] Cultural studies had spread far beyond the confines of the CCCS by the end of the 1970s. Gould's report in many ways symbolized the beginning of broader hostility towards new fields in the arts and humanities as the higher education policies of successive governments took on the neo-liberal agenda – particularly once Keith Joseph had become secretary of state for education in 1981.[97] As the *History Workshop* editors presciently argued in 1977, the radical tradition within disciplines such as history was too well established to be threatened by Gould's polemics, but this was not the case in fields such as 'sociology, criminology [and] cultural studies'.[98] *The Attack* was a precursor to the instability that affected many cultural studies courses from the late-1980s onwards, not least at Birmingham. For Frank Webster, who was appointed to Birmingham's Department of Cultural Studies and Sociology in 1999, it was the long-standing perception among managers at Birmingham that the Centre was a 'red base' for 'left-wing troublemakers' that led to the ending of the CCCS as a postgraduate unit and the ultimate demise of cultural studies at Birmingham in 2002.[99]

It was Gould's naming of those individuals and institutions he saw as forming part of a radical conspiracy in Britain that led to him resigning his membership of the British Sociological Association, rather than face a disciplinary hearing.[100] What is revealing about these names, however, is the limited extent to which the CCCS was itself on Gould's radar. The period in which Gould conducted his research coincided with the growing visibility of the CCCS, yet Gould named only one person with a direct connection to the Centre – Gregor McLennan, a postgraduate at the Centre who was listed along with the other attendees of the 1976 Communist University of London.[101] Aside from this Gould mentioned institutions or people with much looser associations to the CCCS – from members of the New Left such as Thompson and Williams, for

example, to the Russell Press publishers, which produced the early issues of *Working Papers in Cultural Studies*.[102] Much greater focus was given to the Open University and the 'ideological attack on capitalism' that was seen as being present in many of its courses.[103] It was this element of *The Attack* that the media focused on, largely because of the close connection between the Open University and the BBC.[104]

This may simply be a reflection of the nature of Gould's prioritization of polemic over nuance and his reluctance even to distinguish between different strands of Marxist theory.[105] Yet it is also a reminder that for the Centre – in this period, at least – some of the most stringent attacks it faced did not come from the Right. While the CCCS had its admirers in Ranjit Sondhi, Brian Homer and others in Birmingham's cultural and political milieu, by the late-1970s it was increasingly the object of attacks from those who had previously been comrades on the intellectual Left – and it was the issue of Marxist theory that was again the key driver. While in Gould's hyperbole Marxist theory posed a threat to 'liberal' values, for many on the Left, theory was perceived as a barrier to the wider socialist struggle. The situation reached its nadir in December 1979 at the History Workshop conference at Ruskin in Oxford where E. P. Thompson's association with the CCCS project was spectacularly ruptured. Thompson had already detailed his hostility through his final paper at the Centre in the academic year 1974–75, and subsequently in private correspondence with the Centre's newly appointed lecturer Richard Johnson.[106] At the Ruskin debate, speaking on a panel alongside Johnson and Hall in the context of the recent publication of *The Poverty of Theory*, Thompson embarked on a tirade against his fellow panellists, the work of the CCCS and anyone else, it seemed, who argued for the use of theory in historical work. For the journalist Martin Kettle, who was there to cover the event for *New Society* magazine, Thompson's performance represented a 'demolition job'.[107]

For Kettle, looking back at the significance of the Ruskin conference, Thompson was speaking for those students who felt that 'their event had somehow been taken away from them by people who only spoke in theory, rather than talked about wages and hours and conditions and work and gender'.[108] The issue was that by the later-1970s the Centre's embrace of theory – and willingness to defend it – meant that it had become a lightning rod for those on the Left who shared Thompson's hostility. In 1978, for example, following the publication of *Women Take Issue* by the Women's Studies Group at the CCCS, one reviewer decided that she could not recommend a '"general reader" to struggle through it. The jargon is ponderous and on the whole unpolished. And, more importantly, it is very narrow: only Marxist writings are dealt with and, like it or not, some of the most interesting feminist work is not Marxist'.[109] Likewise, an article in *Revolutionary Socialism* argued that while the Centre had undertaken valuable work in areas such as youth

culture it was 'often in so inaccessible a way as to make it useless', whether to 'left-wing activists . . . [or] anyone else'.[110] And in the aftermath of Ruskin the *Morning Star* reported that the majority of the audience had sided with Thompson. There was a desire among the attendees for 'history to be made accessible', the paper reported, 'and show[n] how it is relevant to their lives'.[111]

The network of support that the CCCS was able to draw upon in its early years was therefore beginning to dissipate by the late-1970s, the very moment that cultural studies was being taken up at other institutions around the country. That the attacks that the CCCS increasingly fell victim to came not from the 'new' Right but from those who had previously been fellow travellers with the Centre was undoubtedly traumatic for those involved. In 1980, for example, Simon Frith – the cultural critic who had contributed to *Resistance through Rituals* and attended CCCS seminars throughout the 1970s – published for *New Society* a hostile review of the latest CCCS edited collection, *Culture, Media, Language*.[112] He argued the book was overly defensive and suggested that its use of theory had become outdated – 'these days', he wrote, 'it is so easy to sound like a Marxist intellectual that people are beginning to assume that anyone using these words has nothing new to say'.[113] Frith's review was followed by an angry response from Hall. He accused *New Society* of publishing only two favourable references to the Centre in sixteen years. But more irksome for Hall was the fact that the review had been written by 'so sympathetic a critic' as Frith. Hall accused Frith of underestimating 'the real and palpable pressures on the centre [*sic*] which may have produced an over-defensiveness' in its work. For Hall, the Centre's use of theory was far from fashionable – in fact, he argued, 'the revolt against theory . . . is the trendiest intellectual fashion on the current scene'.[114]

The Centre's status by the start of the 1980s was, therefore, in keeping with the liminal position between marginality and respectability that had characterized the CCCS from the very beginning. In the late-1960s the Centre endured hostility from scholars of the traditional canon and it suffered from a lack of financial assistance, yet it also received favourable coverage in the media and could draw on an international network of supporters. A decade later many of these supporters had become enemies of the Centre over the issue of theory, yet the transformation of cultural studies from something that was 'made up' on a weekly basis in Birmingham to a subject that was studied nationally by thousands of students was remarkable. The very approach that the CCCS deliberately embarked upon over the 1970s, while serving as an inspiration to a whole new generation of scholarship, also distanced itself from some of its early supporters and subsequent developments in other institutions. The embrace of political theory and a radical pedagogy ensured the Centre's ongoing marginality at Birmingham while the subject as a whole thrived – if student recruitment figures are anything to go by – elsewhere.

CONCLUSION

It is relatively easy to make a case for the marginality of not only the CCCS but also of cultural studies as a whole. The closure of the Centre in 2002 has become emblematic of the ongoing hostility of the detractors of cultural studies who choose to stand on the outside and refuse to engage with its intellectual project. Niall Ferguson trotted out the tired trope of 'Mickey Mouse degrees' at 'Disneyland' institutions in 1996, an intervention all the more depressing because of the fuel it provides for politicians with even less informed opinions.[115] Margaret Hodge lazily repeated the slur when she was the Labour minister for children in 2003, though this was nothing compared to Michael Gove's more recent raising of the relativist bogeyman: 'Carol Ann Duffy and drum 'n' bass are OK, but Austen and Eliot, Cicero and Wagner are out'.[116]

The CCCS, and what it came to stand for, was indeed under siege for large periods of its history. This has arguably been used by many of its advocates to mythologize its radical, outsider status. The American critic Thomas Frank has even gone so far as to suggest that many of the stars of the cultural studies academy have deliberately peddled a radical aura to mask their own limited theoretical alternatives to market capitalism.[117] Being on the outside provides a set of credentials easily obtained. Certainly, this constitutes part of the appeal of the CCCS mythology and explains why some even self-appoint themselves as the successors to Hoggart and Hall.[118] But arguably it also misrepresents the history of the Centre and of cultural studies more generally and does a disservice to many of those who played an active role in the various projects of cultural studies.

These mythologies ought not to obscure the productive collaborations and dialogues highlighted in this chapter that the CCCS had with the world beyond its institutional confines, with figures and organizations that have not enjoyed the same degree of attention. And they should not obscure the way in which variations of cultural studies have become ever-more mainstream since the 1980s. In the run-up to the 50th anniversary of the Centre, the sociologist Laurie Taylor devoted two episodes of his Radio 4 programme to reflecting on 'Bingo, Barbie and Barthes'. Some of his guests provided alternative readings of cultural studies that attested less to its marginality and more to its successful penetration into so many areas of academic and popular discourse. Joe Moran commented that 'there are people who write in newspapers who are doing what I would think of as cultural studies . . . that kind of attempt to merge the popular culture with the political, to try and understand the contemporary moment and to critique its assumptions . . . [it is] not that dissimilar to what the Birmingham group were doing in the 1970s'.[119] Likewise, Sir Christopher Frayling remarked of the Sunday newspaper supplements,

'9/10 of it is design, pop music, film or books about those subjects . . . take those out and it's about three pages on classical music and theatre, which used to be the sole definition of culture. With that has come a redefinition of the language with which the arts are described . . . the arts turned into culture, a much less hierarchical, elitist word'.[120] Taylor himself concluded: 'in the 50 years since Hoggart's time, cultural studies has become . . . a taken-for-granted practice. You've only got to look through a listings mag and you'll find programme after programme which seeks to interpret . . . one or another part of popular culture. . . . We're now all students, as well as consumers of popular culture'.[121]

These are all far more optimistic readings of the history of cultural studies. They point more firmly towards the mainstream than the margins. Of course, in any proper consideration of the history of the CCCS there is scope for both. It was simultaneously incredibly successful and, in certain quarters, never taken seriously. Both, however, have to be acknowledged and written into a less mythologized appreciation of the contribution of the CCCS. Moreover, to do so is to better understand what those at the Centre were trying to achieve. Cultural studies has become part of the core curricula of many institutions and its leading lights have found both fame and privileged academic positions. And the University of Birmingham arguably should have been the one institution that facilitated such an outcome. But for many within the Centre, embracing innovative approaches to politics, theory, method and pedagogy, this was never the intention. The view from the margins could be a particularly insightful one. Why risk losing this particular angle of vision?

NOTES AND REFERENCES

1. We would like to thank Roger Dickinson for his valuable comments on this article and for the access he facilitated to the archives of the Leicester Centre for Mass Communications Research. For our earlier investigation into the workings of the CCCS see Kieran Connell & Matthew Hilton, 'The Working Practices of Birmingham's Centre for Contemporary Cultural Studies', *Social History* 40: 3 (August 2015), pp. 287–311.

2. For more on cultural studies' 'myth of origin', see Graeme Turner, 'Moving the Margins: theory, practice, and Australian cultural studies', in Graeme Turner (ed.), *Nation, Culture, Text: Australian cultural and media studies* (London: Routledge, 1993), p. 4.

3. Stuart Hall, 'Cultural Studies and the Centre: some problematics and problems' in Stuart Hall, Dorothy Hobson, Andy Lowe and Paul Willis (eds.), *Culture, Media, Language: working papers in cultural studies 1972–79* (London: Routledge, 1980), p. 21.

4. A. D. Chambers, C. R. Hinings & J. M. Innes, letter to the editor, *Redbrick*, 21 October 1964. In Ann Gray Papers, US120/1, Cadbury Research Library, Special Collections, University of Birmingham [hereafter CRL].

5. Stuart Hall, 'The Emergence of Cultural Studies and the Crisis of the Humanities', *October*, 53, 1990, p. 12.

6. Stuart Hall, 'Cultural Studies and the Centre', p. 21.

7. Hall, 'Crisis of the Humanities', p. 16.

8. Stuart Hall, 'Think Small – But Hard', March 1971, p. 1. Richard Hoggart papers, University of Sheffield, MS 247/4/6/15.

9. I. Jackson, letter to *Redbrick*, 21 October 1964, Ann Gray Papers, US120/1, CRL.

10. John Rex, 'Errol Lawrence and the Sociology of Race Relations: An Open Letter', in *Multi-Racial Education*, 10: 1, 1981, p. 49.

11. For an insight into these tensions with regard the discipline of history, see Geoff Eley, *The Crooked Line: from cultural history to the history of society* (Michigan: University of Michigan Press, 2005).

12. Tony Bennett, 'In the Open: reflections on the history and practice of cultural studies', *Cultural Studies* 10: 1, 1996, p. 136.

13. See Stuart Hall, 'Cultural Studies and its Theoretical Legacies', in Larry Grossberg, Cary Nelson and Paula Treichler (eds.), *Cultural Studies*, (New York: Routledge, 1992), pp. 277–286.

14. Richard Hoggart, *An Imagined Life: Life and Times 1959–1991* (Oxford: Oxford University Press, 1993), pp. 77 & 90.

15. Ibid., p. 91.

16. Ibid., p. 82.

17. David Lodge, *Quite a Good Time to Be Born: a memoir, 1935–1975* (London: Harvill Secker, 2015), pp. 340–341.

18. T. J. B. Spencer, cited in anonymous reporter, 'University Exploration of Popular Culture', *The Times*, 6 June 1963, p. 7.

19. David Lodge, 'Richard Hoggart: a personal appreciation', *International Journal of Cultural Studies*, 10: 1 2007, p. 33; Fred Inglis, *Richard Hoggart: Virtue and Reward* (Cambridge: Polity, 2014); Michael Bailey, Ben Clarke & John K. Walton, *Understanding Richard Hoggart: A Pedagogy of Hope* (Oxford: Wiley-Blackwell, 2012).

20. Anonymous reporter, 'No beginning and no end to his story', *Birmingham Post and Mail*, c. 1964, in Ann Gray Papers, US120/1, CRL.

21. Anonymous reporter, 'A Study of "Pop" Culture', in the *Guardian*, 7 June 1963, p. 3. Hoggart's 1963 inaugural lecture, 'Schools of English and Contemporary Society', is reprinted in Ann Gray et al. (eds.), *CCCS Selected Working Papers* vol. 1 (London: Routledge, 2007), p. 17.

22. Richard Hoggart, 'Schools of English and Contemporary Society', 1963, in Ann Gray et al. (eds.), *CCCS Selected Working Papers* vol. 1, pp. 17–24.

23. D. Kemp, 'Prof. Hoggart Polishes up his Scalpel', in the *Scotsman* (undated, c. 1966), in Ann Gray Papers, US120/1, CRL.

24. Cited in Kenneth Roberts, *Leisure in Contemporary Society* (Walingford: CABI, 1999), p. 5. See also Angela McRobbie, *In the Culture Society: art, fashion and popular music* (London: Routledge, 1999), p. 94.

25. Robert Putnam, 'In my Opinion', *Daily Express*, 3 August 1966, in Ann Gray Papers, US120/1, CRL.

26. In the *Daily Herald*, 8 May 1964, in Ann Gray Papers, US120/1, CRL.

27. CCCS, *First Report*, September 1964, pp. 6–7: http://www.birmingham. ac.uk/Documents/college-artslaw/history/cccs/annual-reports/1964.pdf (accessed 8 February 2016).

28. Ibid., p. 8.

29. See CCCS, *Annual Report 1986–88*, April 1988, p. 5: http://www. birmingham.ac.uk/schools/historycultures/departments/history/research/projects/ cccs/publications/annual-reports.aspx (accessed 8 February 2016). External speakers became increasingly sporadic in later years and by 1980–81 the Tuesday seminars were opened up to include 'work-in-progress' presentations, 'investigation of topical issues' and thesis writing skills, as well as 'lectures by visiting speakers'. See CCCS *Annual Report 1980–81*, January 1981, p. 17.

30. For an overview of the work of Parker and his 'radio ballads', see Alan Filewood and David Watt, *Workers' Playtime: theatre and the labour movement since 1970* (Strawberry Hills: Currency Press, 2001).

31. Stuart Hall, 'Cultural Studies and the Centre', p. 16.

32. CCCS, *Annual Report 1964–5*, October 1965, p. 9; CCCS, *Annual Report 1966–67*, January 1968, p. 22; CCCS, *Annual Report 1968–69*, October 1969, p. 15; CCCS, *Annual Report 1975–76*, January 1976, p. 26.

33. John Rex and Robert Moore, *Race, Community and Conflict: a study of Sparkbrook* (Oxford: Oxford University Press, 1971).

34. See CCCS, *Annual Report 1964–65*, pp. 9–10; CCCS, *Annual Report 1965–66*, p. 24.

35. Hall, 'Think Small – But Hard', p. 1.

36. Richard E. Lee, *Life and Times of Cultural Studies*, p. 144; Valda Blundell, John Shepherd & Ian Taylor (eds.), *Relocating Cultural Studies: Developments in Theory and Research* (London: Routledge, 1993).

37. CCCS, *Annual Report 1964–65*, p. 22.

38. Ibid., p. 10.

39. Douglas Johnson, 'Robert Escarpit', in *the Guardian*, 8 December 2000. Available online: http://www.theguardian.com/news/2000/dec/08/guardianobituaries3 (accessed 10 February 2016).

40. James Halloran, in John A. Lent (ed.), *A Different Road Taken: profiles in critical communication* (Colorado: Westview Press, 1995), p. 188. See James Halloran, *Control or Consent? A Study in the Challenge of Mass Communication* (London: Sheed and Ward, 1963).

41. James Curran, 'The New Revisionism in Mass Communication Research: a reappraisal', *European Journal of Communication* 5: 135, 1990, p. 139.

42. CMCR, *First Annual Report, 1966–67*, p. 8; CMCR, *Second Annual Report, 1967–68*, pp.11–12. This material is housed at the Department of Media and Communication at the University of Leicester.

43. Stuart Hall and Richard Hoggart, 'Local Radio: why it must not be commercial', in *Peace News*, 14 August 1964; CMCR, *Fourth Annual Report, 1969–70*, p. 7. See also Rachel Powell, 'Possibilities for Local Radio', *Occasional Papers in Cultural Studies,* 1965.

44. See James D. Halloran, Phillip Elliot & Graham Murdock, *Demonstrations and Communication: a case study* (Harmondsworth: Penguin, 1970); Paul Willis, 'What is News – a case study', *Working Papers in Cultural Studies* 1, 1971, pp. 9–36.

45. For more on the campaigns undertaken by Whitehouse, see Lawrence Black, 'There Was Something About Mary: The National Viewers' and Listeners' Association and Social Movement History', in Nick Crowson, Matthew Hilton & James McKay (eds.), *NGOs in Contemporary Britain: non-state actors in society and politics since 1945* (Basingstoke: Palgrave, 2009), pp. 182–200.

46. CCCS, *Annual Report 1966–67*, p. 16.

47. CMCR, *Fourth Annual Report, 1969–70*, p. 5; CMCR, *Second Annual Report*, 1967–68, p. 7.

48. James Halloran, 'Violence and Mass Media', *The Guardian*, 18 November 1967, p. 5

49. Rachel Powell, in anonymous author, 'Television and People Inquiry, *Birmingham Post*, 23 June 1966

50. Richard Hoggart to Mrs M Whitehouse, Wolverhampton, 7 February 1996, Richard Hoggart papers, MS 247/4/6/19, University of Sheffield.

51. James D. Halloran, 'Mass Media and Society: the challenge of research', inaugural lecture, University of Leicester, 25 October 1973, p. 4.

52. See Richard Hoggart, *A Local Habitation, 1918–40* (London: Chatto & Windus, 1988); J. A. Lent (ed.), 'An Interview with James D. Halloran', *A Different Road Taken*, pp. 185–187.

53. Richard Hoggart, 'Schools of English and Contemporary Society', p. 20.

54. James D. Halloran, 'Mass Media and Society: the challenge of research', p. 7

55. CMCR, *First Annual Report, 1966–67*, p. 3.

56. James Halloran, in John A. Lent (ed.), *A Different Road Taken: profiles in critical communication*, p. 194.

57. Richard Hoggart, *An Imagined Life: Life and Times 1959–1991* (Oxford: Oxford University Press, 1993), p. 95; Richard Hoggart, *The Way We Live Now* (London: Pimlico, 1996); Richard Hoggart, *Desert Island Discs* (BBC, first broadcast 15 Oct 1995).

58. CMCR, *First Annual Report, 1966–1967*, p. 3.

59. CCCS, *Annual Report 1964–65*, p. 22.

60. Roger Bromley, interviewed by Kieran Connell [hereafter KC], 2 July 2013.

61. Other figures involved in the course included Ken Thompson and Janet Woollacott. See Tony Bennett, 'In the Open: reflections on the history and practice of cultural studies', p. 138.

62. Issues of *Working Papers in Cultural Studies* were sold for £1 while specific Stencilled Occasional Papers were sold for 25p. See CCCS, *Annual Report 1975–76*, pp. 35–35.

63. See Ted Striphas and Mark Hayward, 'Working papers in Cultural Studies, Or the Virtues of Grey Literature', *New Formations*, 78, 2013, pp. 102–116.

64. Christine Hardy, interviewed by KC, 19 July 2013.

65. David Batchelor, interviewed by KC, 27 January 2014. Following his time at CCCS Batchelor embarked on a highly successful career as an artist.

66. CCCS, *Annual Report 1978–79*, December 1978, pp. 1–2.

67. Charlotte Brunsdon, 'On Being Made History', *Cultural Studies* 28, 1 (2014), p. 91.

68. The pamphlet was produced by the authors of *Policing the Crisis* and corresponded with a number of Stencilled Occasional Papers on the same subject. See Stuart Hall et al. 'Twenty Years' pamphlet, c. 1973, Chas Critcher papers, CCCS Archive, Cadbury Research Library. See also Tony Jefferson & John Clarke, 'Down These Mean Streets...the Meaning of Mugging', CCCS Stencilled Occasional Paper (1973) & Tony Jefferson & John Clarke, 'Mugging and Law "n" Order', CCCS Stencilled Occasional Paper (1975).

69. See Chas Critcher, Margaret Parker & Ranjit Sondhi, *Race in the Provincial Press: a case study of five West Midlands newspapers* (Birmingham: UNESCO/CCCS, 1975).

70. Chas Critcher, paper given at the CCCS50 conference, University of Birmingham, 25 June 2014.

71. The Asian Resource Centre was established in 1976 and remains in operation in 2015. For more on its work and practices, see Gargi Bhattacharyya, *Across All Boundaries: 25 years of the Asian Resource Centre in Birmingham* (Birmingham: Asian Resource Centre, 2003).

72. Ranjit Sondhi, paper given at the CCCS50 conference, University of Birmingham, 25 June 2014.

73. Hall, 'Think Small – But Hard', p. 2.

74. M. Skully, interviewed by KC, 10 June 2014.

75. Memo on *Birmingham Free Press* by Judith Scott and Michael Green, c. 1969. CCCS papers, misc. local publications, UB/CCCS/B/15, CRL.

76. See Christoph Grunenberg & Jonathan Harris (eds.), *Summer of Love: psychedelic art, social crisis and counterculture in the 1960s* (Liverpool: Liverpool University Press & Tate Liverpool, 2005).

77. Trevor Fisher, interviewed with Brian Homer by KC, 17 June 2013.

78. The fund was set up to support *Grapevine*'s successor title *Broadside*, also run by Trevor Fisher. See CCCS agenda, 6 March 1975, Tony Jefferson papers, USS79/3, CRL.

79. Brian Homer, interviewed with Trevor Fisher by KC, 17 June 2013. *Ten.8* was established in 1979 by Homer, Derek Bishton and John Reardon.

80. 'Out of the Pumpkin Shell: Running a Women's Liberation Playgroup', 1975. Michael Green papers,

81 US129, CRL. Rebecca O'Rourke, interviewed by KC, 24 July 2013.

82. For a detailed account of the Birmingham Film and Television Workshop, see Paul Long, Yasmeen Baig-Clifford & Roger Shannon, 'What We're Trying to Do is Make a Popular Politics: The Birmingham Film and Video Workshop', *Historical Journal of Film, Radio and Television* 33: 3, 2013, pp. 377–395. For an account of the birth of Channel 4 and its connections with the CCCS see Dorothy Hobson's contribution to this volume.

83. R. Shannon, interviewed by KC, 10 June 2013.

84. See Tom Steele, *The Emergence of Cultural Studies, 1945–1965: cultural politics, adult education and the english question* (London: Lawrence and Wishart, 1997).

85. Dick Hebdige, interviewed by KC, 10 April 2014.

86. Paul Willis, teaching notes, 17 September 1975, Paul Willis papers, USS91/3, CRL.

87. See Tony Bennett, Colin Mercer & Janet Woollacott (eds.), *Popular Culture and Social Relations* (Milton Keynes: Open University Press, 1986), p. vii; Richard E. Lee, *Life and Times of Cultural Studies*, p. 142.

88. Richard E. Lee, *Life and Times of Cultural Studies:* p. 142; Sean Cubitt, 'Cancelling Popular Culture', *Screen* 27: 6, 1986, p. 90.

89. Anonymous author, 'All Bingo, Barbie and Barthes?', *Times Higher Education*, 13 March 1995. For an overview of the take-up of cultural studies in Australia see Graeme Turner (ed.), *Nation, Culture, Text: Australian cultural and media studies* (London; New York: Routledge, 1993).

90. Hall famously coined this term before the election of Margaret Thatcher in May 1979. See Stuart Hall, 'The Great Moving Right Show', *Marxism Today*, January 1979, pp. 14–20.

91. Julius Gould, *The Attack on Higher Education: Marxist and radical penetration* (London: Institute for the Study of Conflict, 1977), p. 4.

92. Ibid., pp. 5–6.

93. Ibid., pp. 7–8.

94. Editorial collective, *History Workshop* 4 1977, pp. 1–2.

95. See Leslie Sklair, 'Sociologies and Marxisms: the Odd Couple', in Phillip Abrams et al. (eds.), *Practice and Progress; British Sociology 1950–1980* (London: Allen & Unwin, 1981), p. 166.

96. Hazel Chowcott (née Downing), interviewed by KC, 20 May 2013.

97. For a recent analysis into the legacies of this agenda, see Stuart Hall & Alan O'Shea, 'Common-sense Neoliberalism' in Stuart Hall, Doreen Massey & Michael Rustin, *After Neoliberalism? The Kilburn Manifesto* (London: Soundings, 2013).

98. Editorial collective, *History Workshop* 4, 1977, p. 3.

99. Frank Webster, 'Cultural Studies and Sociology at, and after, the Closure of the Birmingham School', *Cultural Studies* 18, 6 2004, p. 855.

100. See A. H. Halsey, *A History of Sociology in Britain: science, literature and society* (Oxford: Oxford University Press, 2004), p. 123.

101. Julius Gould, *The Attack on Higher Education*, p. 52.

102. Ibid., pp. 7, 9.

103. Ibid., pp. 39–40.

104. See, for example, W. Stephen Gilbert, 'Open Season at the Ally Pally', in the *Observer*, 27 February 1977, p. 28.

105. Leslie Sklair, 'Sociologies and Marxisms', p. 165.

106. See Richard Johnson papers, USS119/6/1, CRL.

107. Martin Kettle, *New Society*, December 1979, p. 543.

108. Martin Kettle, interviewed by KC, 28 August 2013.

109. D. L. Barker, 'A Gathering of Women's Studies', the *Tribune*, 22 September 1978. Ann Gray Papers, US120/1, CRL.

110. Anonymous author, *Revolutionary Socialism*, 2, c. 1978. Ann Gray Papers, US120/1, CRL.

111. F. Rickford, 'The Making of a Rumpus', *Morning Star*, 3 December 1979. Ann Gray Papers, US120/1, CRL.

112. See Simon Frith, interviewed by M. Cloonan, cited from internet source: http://livemusicexchange.org/blog/simon-frith-and-politics-an-interview/ (accessed 17 March 2015).

113. Simon Frith, 'Theoretical Terms', in *New Society*, 27 November 1980. Ann Gray Papers, US120/1, CRL.

114. Stuart Hall, letter to the editor, *New Society*, 18/25 December 1980. Ann Gray Papers, US120/1, CRL.

115. Cited in A. Anthony, 'School for Soaps', the *Observer*, 21 January 1996, p. 56

116. Michael Gove, 'What is Education For?', speech given to the RSA, 30 June 2009. See https://www.thersa.org/globalassets/pdfs/blogs/gove-speech-to-rsa.pdf (accessed 5 June 2015).

117. See Thomas Frank, *New Consensus for Old: cultural studies from left to right* (Chicago: University of Chicago Press, 2002).

118. In 2014 a 'New Centre for Contemporary Cultural Studies' was established at an arts centre in Birmingham. Although a number of local academics were involved, its use of the cultural studies label was largely symbolic. It was less a serious intellectual endeavour than an attempt at stimulating discussion among the local community. See https://ncccs.wordpress.com/ (accessed 5 June 2015).

119. Joe Moran, in 'Bingo, Barbie and Barthes: 50 years of cultural studies', part one, BBC Radio 4 documentary, first broadcast 3 January 2014. See http://www.bbc.co.uk/programmes/b03c2zw4 (accessed 8 February 2016).

120. Christopher Frayling, in 'Bingo, Barbie and Barthes'.

121. Laurie Taylor, in 'Bingo, Barbie and Barthes'.

Part II

PEDAGOGY AND PRACTICES

Chapter 5

'Reading for Tone'

Searching for Method and Meaning

Rosalind Brunt

In his 1986 lecture, 'The Future of Cultural Studies', Raymond Williams argues that before we can engage with where we might be going, we should first study how cultural studies has emerged and developed.[1] Williams proceeds to do this by considering both the 'project' and its 'formation'. Indeed, as he views the distinctive method of cultural studies being the very way it analyses the relationship between 'project' and 'formation', he proposes, in effect, to offer a cultural study of cultural studies.

Williams's presentation of the formation of cultural studies in Britain relates primarily to developments in adult education, liberal studies for technical colleges and extramural university courses – sites whose very marginal or 'outsider' status, he argues, enabled an independent and experimental style of analysis which encouraged a project that could grow beyond the constraints of discipline boundaries. Although there is no mention of the Centre for Contemporary Cultural Studies (CCCS) in Williams's account, I think his *project/formation* approach may provide a useful means by which to develop what I was asked to speak about at the CCCS 50 conference.

The topic chosen was the transition from the period of the Birmingham Centre's founder and first director Richard Hoggart (1964–69) to that of his successor, Stuart Hall (1970–1979). As one of the few graduates to experience the CCCS under both directors, I chose to give two, mainly descriptive, brief snapshots from October 1969 and January 1972. These aimed to highlight how rapidly both the style and nature of the Centre project changed between the two periods. For this more extended piece, I'll consider some of the continuities that this transitional time represents in the work of the Centre. In particular, I will highlight the emphasis CCCS placed on notions of 'reading' culture, discuss some of the issues around method and approaches

to 'meaning' raised during the transition, and, finally, the possible continued relevance of this debate for future cultural studies.

Several of the contributions at the conference rather gave the impression that, from its inception, the CCCS was some kind of vanguardist New Left project. Far from it. Although Stuart Hall, a key mover in the post-war New Left had been Richard Hoggart's deputy from the beginning, I would characterize the Centre's first phase under Hoggart's directorship as cast very much in his own mould of social-democratic engagement within the public sphere and an intellectual formation infused with the more progressive aspects of F. R. Leavis's and Q. D. Leavis's work. When he set out aims for the Centre in his 1963 inaugural lecture, 'Schools of English and Contemporary Society', Richard Hoggart described 'the field for possible work in contemporary cultural studies' as divided into three parts, one broadly historical; a second, broadly sociological; 'while the third – which will be the most important, is the literary critical'.[2] The inaugural lecture's emphasis on the new interdisciplinarity had been received as controversially 'modern' within the still mainly traditionally Oxbridge-type English Department. The following year the CCCS joined the department. But apropos Williams's theme of marginality, it was actually and symbolically housed in temporary Portakabins, right on the periphery of the campus.

When I arrived at what were called 'the huts', it was in the autumn of 1968, after a heady year doing a Sociology of Literature MA at Essex, which had included one of the first UK university sit-ins, the CCCS had then seemed, *pace* the English Department's concerns, rather behind the curve both politically and theoretically. Other parts of Birmingham, such as the sociology and German departments and the centres for Russian and West African studies seemed more avant-garde, already engaging with new intellectual currents from both the United States and continental Europe – and their researchers came to the regular Tuesday external speakers' seminars to tell us so. Meanwhile, the Monday morning internal Centre seminars that studied key texts were concentrating mainly on an eclectic mix of the English culture-and-society tradition, American mass communication research and humanist social theorists like David Riesman or C. Wright Mills.

The idea of discussing these texts was that they would contribute a broad interdisciplinary context, a sort of home base, for Hoggart's aim that 'the most important' element of the Centre's work would remain the insights to be gained from literary studies. Indeed, what I remember most clearly from Richard Hoggart's last year and a term at the CCCS is the third type of general seminar, the Monday afternoon practical criticism session, led by him but always first introduced by students. My notes from those seminars give some idea of the range of texts we studied: 'Among School Children', W. B. Yeats, 'Tyger, Tyger', William Blake, the opening pages/first paragraphs of modern

classics like *Sons and Lovers* and *A Passage to India* (Hoggart's choices); Leonard Cohen lyrics and Adam Diment's 1967 paperback, *The Dolly Dolly Spy* (our choices).

My lasting memory of these sessions is how soon after students' tentative introductory efforts it occurred that Richard Hoggart seized the seminar with gripping virtuoso performances of what he called 'reading for tone'. This involved seeking out the nuanced complexities of each text as he repeatedly exhorted us to 'see it, taste it, smell it' and 'feel it on the pulses'. A stencilled paper he wrote for the seminar, dated 9 May 1969, is titled, with a nod to Conrad's *Lord Jim*, 'Should We in the Destructive Element Immerse?' It is about how participant observation could develop as a form of literary critical 'reading', and has the subtitle: 'Rough Notes on the Pros and Cons of Going to the Bull Ring' – the market area in Birmingham city centre.

In the paper, Hoggart takes up a number of arguments that could be made against 'reading for tone'. For instance, 'It's messy, woolly, "merely impressionistic". Resolves itself into "feeling it down there."' He then responds to those criticisms thus:

> To get the 'felt sense' of phenomena is not at all vague or woolly; it's one of the hardest of all disciplines. It requires the best attention we can give it intellectually and imaginatively. To misquote Hopkins: 'Hold it cheap may who ne'er hung there. . .' To do an expressive reading of a sort which is at all useable on even what looks like simple phenomena is very hard . . . teasing out and at the same time holding in balance all the while the public and the private, the overt and the implicit, the known and the unconscious, the directly reflecting and the contradictory or quarrelling, and so on and so forth.

Undoubtedly, the lifelong lesson for me of 'reading for tone' is Richard Hoggart's insistence, as shown here, on specificity, the close attention to exactly how the cultural artefact is working, and a recognition that an interpretative approach takes hard practice. Those seminars were clearly aimed at attuning us students to the 'thisness' of a text. But I also felt at the time, especially having been so recently a 'class of 68' Essex student, that there was a problem with the seminars. We were supposed to be a 'centre' – yet how could the rest of us, even the senior researchers, participate in an exercise that seemed to be based on a level of lived experience that we could hardly begin to attain and where there was no explicit method or shareable criteria? Richard Hoggart's readings were enthralling but other Centre members could never be more than his practical criticism apprentices, learning literary technique and attentiveness to detail. While the organicist and sensory metaphors he used to describe 'reading for tone' took for granted a shared universe of understanding, it was one that remained implicit, relying ultimately on little

more than the assumptions of Leavis's famous non-question: 'This is so, is it not?'

Richard Hoggart left the CCCS in December 1969 and was seconded to UNESCO. Just two months later, reviewing a collection of his essays and lectures, Raymond Williams described Hoggart as 'the man who analyses tone . . . an incomparable observer of the very substance of our language and feelings'. But this 'indispensable' strength combines with what Williams sees as a political weakness: a social-democratic reasonableness, 'a kind of patient speaking to and past the established structures . . . which goes along with a willingness to serve on public committees and inquiries'. Williams then makes a more direct, but I believe just, criticism of Hoggart's political choices while affirming his own allegiance to an alternative view of emerging 1970s politics. For Williams the new decade requires the 'inevitable' choice of 'a radical break, moving into open opposition . . . a longer, harder and rougher perspective . . . [which] leads on to questions – of open politics, for example, which Richard Hoggart still avoids'.[3]

Fast forward a couple of years into the 1970s and it is undoubtedly Williams's perspective and choice of questions that is engaging the CCCS. Student numbers have expanded and the Centre has left the peripheral huts for a whole corridor in the central arts building of the university. But its continuing marginality is underlined by the English Department's unwilling-ness to replace Hoggart's post to full-time and by Stuart Hall remaining only as 'acting' director until 1973. So it is for highly practical reasons as well as because of a developing collectivist spirit, that postgraduate students are becoming closely involved in the administrative and publishing tasks of the Centre. There are also subgroups, such as those for the media and subcultures covering individual thesis topics. These are self-organizing and serve as both reading groups and work-in-progress sessions.

The established pattern of the three general seminars remains, though Hoggart's practical Monday afternoon sessions become single-themed work-shops: detailed studies of the Western in film comics and popular fiction first, and a year later, a single women's magazine story, comprehensively analysed from its visual impact on the page to its structural contradictions. Meanwhile, Richard Hoggart's absence, the intellectual temper of the times and the decision to start a journal has opened up a prolonged debate in the Monday morning seminar around the basic question: So what *is* cultural studies?

How we set about answering that question was not, in the first instance, with explicit reference to Marx or a deliberate engagement with the new varieties of continental structuralism – despite some of the myth-making that might suggest this is immediately where the Centre moved as soon as Hoggart left. The emphasis, rather, was primarily on seminar texts that stressed the distinctive nature of the human sciences and offered qualitatively nuanced

readings of how culture(s) worked; a concern with phenomenology, ethno-methodology, symbolic interactionism and social constructivism; and a return to 'the founding fathers' of sociology. In this endeavour the CCCS was now joining an ongoing debate emanating particularly from the new universities and the Open University that had been set up in the mid-1960s to cater to a significant expansion in higher education.

What was already happening in these places was the emergence of types of 'critical' sociology, 'radical' philosophy and 'alternative' psychology that were challenging established academic disciplines for being too close to 'the interests of the State' on both policy and ideological grounds. Of particular interest to the CCCS, for instance, was the way the new sociology of devi-ance with its models of labelling theory and moral panic was taking on the orthodoxies of criminology.

Thus the Centre became part of a wide intellectual project that was rethinking the disciplines, their boundaries, interconnections and, indeed, their nineteenth-and early-twentieth-century origins and its Tuesday external seminars provided a forum for researchers working in the new university sec-tor, or writers for radical journals like *New Left Review* or History Workshop publications. It is this period in the years immediately after Richard Hoggart's departure when I think the CCCS actually transitioned from its social-demo-cratic foundations to become a project more radically infused with New Left and post-1968 thinking.

In terms of the Centre project's relation to a political 'formation', it would be hard to overstate the intensity of political engagement in the early 1970s: the level of opposition to the local and national UK state, particularly in terms of class and race, and solidarity around conflicts in Ireland, the United States and Vietnam. The day after Northern Ireland's Bloody Sunday in January 1972 everyone in the CCCS immediately agreed to cancel the Monday semi-nars and join the local demonstration against the British government and its paratroops. The new Centre seminar room itself contained one huge poster of Angela Davis referring to the worldwide appeal against her possible execu-tion in the United States. Most CCCS students had some kind of involvement with campus or 'outside' political movements like Women's Liberation, varieties of Trotskyism or community activism.[4] So it was predictable that the attraction of on-the-ground activism should raise the issue of political prioritization.

These concerns were behind a paper produced by Chas Critcher for an internal seminar at the start of the summer term 1970: 'Cultural Studies – A Critique'. It initiated a year-long debate about the role of the Centre and how it might respond to the challenges of post-1968. Every member of the CCCS contributed at least one 'position paper' to the debate, which was con-cluded by Stuart Hall's own devastating critique in July 1971 declaring that

we had all 'missed the moment' of developing some kind of 'utopian enclave' or even a 'red base' within the Centre.[5]

The debate was often acrimonious and guilt-tripping. At its crudest it produced a seminar refrain on the lines of 'what are we all doing sitting up here, when down there/over there . . .' In his position papers Stuart Hall rightly named this response as one of the many instances of 'bad faith' he had observed in Centre practice. After all, CCCS members did stay in the room to continue the debate on the nature of cultural studies. And the in-joke of the time, the Yeats-derived line, 'the Centre cannot hold', was, paradoxically, an indication of just how 'in' the Centre we could be and just how much the *What Is Cultural Studies?* project actually mattered.

Stuart Hall's unwavering response to the insistent demands of activism and the prioritization of 'practice before theory' was in terms of what he called, 'the politics of intellectual work'. Choosing to work within the Centre, he stressed, meant never being able to vanish behind a cloud of academic disinterest. Our choice was about assuming, with all seriousness and responsibility, a commitment to knowledge and analysis that was very much politically interested in understanding the precise workings of culture – especially if we were at all concerned with changing them.

At the same time, who were *we* to presume we had answers to *What Is Cultural Studies?* anyway? Although the Centre was expanding its postgraduate numbers, the majority of staff and students still came from a background in English literature or an 'arts' type subject. So any stab at what Stuart Hall called 'mapping the field' was new territory for all of us. As Tony Jefferson stressed at the CCCS 50 conference, 'We were all learning together – Stuart Hall along with us. No one was already an expert.'[6] Therefore in attempting to address *What Is Cultural Studies?* nothing was sacred: there were no individual specialisms and you couldn't get away with the familiar academic defence, 'Sorry, but I'm afraid this isn't my area'. However, where, according to another of Stuart Hall's maxims, 'there are no guarantees', the intellectual enterprise becomes risky and prone to tensions and crises.

Hence, besides the overtly political challenge of investigating the nature of the cultural studies project, the risky question of *What Is Cultural Studies?* also posed an intellectual challenge which could result in a failure of analytical nerve. After a seminar spent working through a new and difficult text, a similar impatience and urgency could be expressed as that felt around political activism. It derived from a wish to get away from what appeared all too nebulous, speculative and un-provable. It came across as a plea to retreat to the safety of the orthodoxies and the types of social science methodology that most closely approximated that of the natural and applied sciences and would provide a reassuring sense that we were actually 'getting somewhere'. It was a frustration combined with an urge for approaches that showed 'results';

an appeal to what was both more obviously demonstrable and also met the apparently more useful and urgent imperatives of, say, positivist sociology.

As with the call to political activism, the appeal to return to the sociological orthodoxies was also both persuasive and persistent. It was dramatically halted one day when Stuart Hall quietly intervened to pose the question, 'But aren't we in danger of forgetting something here?' When no one could think of a ready reply he coolly reminded the seminar of the whole point of all our recent readings around the distinctiveness of the human sciences, our introductory forays into Barthes, Saussure, Schutz *et al.* Surely these had underscored for us the centrality of *meanings* and their interpretation for the whole cultural studies project.

The approach he went on to outline over the ensuing months would involve a critical re-engagement with Richard Hoggart's aims for the CCCS as well as a reappraisal of his approach to understanding culture. But it would also require an emphasis on developing particular methods for analysing meaning well beyond the 'tonal' practical criticism that Hoggart had developed. This approach established an important pattern for the Centre's future practice. For the transitional period encompassed both Williams's notion of 'radical break' *and* a sense of continuity. Despite some narrow squeaks, I think the CCCS always managed to avoid academic sectarianism. Instead of abandoning texts in favour of fashionable new ones, the preferred practice became to rework and reread them. Just as the Centre never became 'Althusserian' at the height of Althusserianism, so Hoggart's pioneering work remained recognized as such, but reread in the light of, say, Gramsci or Berger or Luckmann.[7] Thus when Stuart Hall recalled us to the centrality of studying meaning, what for me proved the most productive response to *What Is Cultural Studies?* was how he guided us through a collective exploration and rereading of Max Weber and the practices of *Verstehen*, the interpretative analysis and exploration of cultural activity.

I stayed at the Centre until mid-1973 so I was also in at the beginning of an engagement with linguistics, (post-)structuralism, Marx and Engels, Gramsci and Althusser when the most intriguing research term became *ideology* rather than *culture*. But looking back, our introduction to Weber and his interest in how apparently abstract ideas may suddenly grip people and how meanings become routinized and grounded in the everyday could be seen as contributing to that change in emphasis.

Taking Weber's *The Protestant Ethic and the Spirit of Capitalism* as emblematic of the Centre's transitional phase is also to offer an exemplar of what a cultural study looks like in Williams's terms of analysing both project and formation.[8] Moreover, it adopts research methods that confront that continuing fear of evaluative risk-taking that makes researchers jump right back under the apparent security blanket of positivism. It thus addresses Hoggart's

concerns about the easy dismissal of 'reading for tone' as speculative and impressionistic.

Weber takes the charge of 'mere speculation' head on when he notes several times in *The Protestant Ethic*, that researchers are very likely to start with 'hints', 'vague impressions' and 'intuitions' – and these are as good as anywhere to begin searching for connections and causal relations. However, precisely because cultural researchers are dealing with the non-quantifiable, unrepeatable realm of culture, there is then that much more responsibility laid on us than on natural scientists to aim for rigour and precision in evidence and 'validity' and 'adequacy' in explanation. So invoking the Centre practice of rereading and re-evaluating, I'd also want to commend *The Protestant Ethic* and Weber's accompanying methodology essays as still-relevant 'inheritance tracks' for the future of cultural studies and to conclude with a few of the reasons why.

According to Weber, the purpose of cultural research is to understand 'the characteristic uniqueness of the reality in which we move'. The apparent oxymoron here points to the need both to respond to the concrete particularity of cultural objects and events and also to recognize how they form 'a finite segment of the meaningless infinity of the world process on which human beings confer meaning and significance'.[9] We therefore need to explain their origins and interconnections – how they are configured, and to render these configurations intelligible to others.

Weber was himself by all accounts a 'difficult', sometimes authoritarian figure and certainly no collectivist or much of a collegial collaborator. Nevertheless, he insists on studies of culture being clearly accessible and their methods and working definitions readily on show to all. For the very reasons that cultural significance involves concreteness and specificity and can't be rendered intelligible only by procedures based on general laws or observable regularities in the same way as the natural sciences, so cultural researchers have to be constantly explicit about their procedures. There can be no recourse to 'this is only my personal opinion': others need to know our criteria for the selection of particular features. Where does your evidence come from? Why is this cultural element highlighted, rather than that? Presenting cultural research as a constantly problematic and questioning process of refining and reformulating the original hypothesis, Weber repeatedly invokes his readers and fellow researchers in a continuous dialogic dance that is always aware of other positions and perspectives that could be adopted to investigate 'The Problem'.

However, although Weber emphasizes the 'provisional' and open-ended nature of his findings, he is nevertheless insistent on the *scientific* nature of his method. Even though 'culture itself is a value-concept' and requires qualitative criteria for its evaluation, this does not absolve researchers from

attaining 'knowledge which is not only subjective'. Albeit this may remain 'one-sided' knowledge from a particular point of view, it is still required to be scientifically valid. In common with all science, it is still 'entirely *causal* knowledge', concerned with seeking out and making explanatory connections.[10] For Weber, the explanatory dimension of a cultural study is pre-eminently an historical one. But because the very specificity of the historical development of cultural phenomena can never be rendered with the exactitude of the physical sciences, it is even more important that researchers spell out their criteria for the selection of evidence and that the interpretative constructs they make conform to logical consistency and objective possibility.

With this brief summary of Weber's methodology, I've wanted to highlight how the interpretative explanation of the *Verstehen* approach with its open appeals to a collaborative research effort provides some of what I'd felt was missing from Richard Hoggart's approach to cultural studies. Thus, when Weber offers a close textual reading, he's explicit about its investigative purpose. It's a unique document, yes, but also contains generalizable features that researchers must find causal, 'genetic' explanations for. Their main heuristic aim: how beliefs, values or ideologies might actually work in practical life.[11]

Weber's approach to cultural reading undoubtedly points up the limitations of Hoggart's implicit assumptions and over-reliance on individual experience. At the same time, the sheer brio, audacity and scholarly breadth of Weber's investigative grasp speaks to some of Hoggart's own reflections about what a good cultural study should entail. In his 1967 essay, 'The Literary Imagination and the Sociological Imagination', Hoggart suggests how the two 'imaginations' could complement each other. The literary, he suggests, offers 'a sense of pattern-and-lack-of pattern', while the best social theory demands a critical stance and 'intellectual discipline' based on constantly questioning research.[12] As I've suggested, I don't think Hoggart's own approach to cultural reading fully 'delivered'. But surely there is still plenty of potential for brave interdisciplinary work in the promise he holds out here – of the sort of reading that might combine an imaginative dynamic with interpretative rigour?

NOTES AND REFERENCES

1. This was first delivered as a keynote speech to the Association of Cultural Studies annual conference at North East London Polytechnic. It is reprinted in Tony Pinkney (ed.), *The Politics of Modernism* (London: Verso, 1989).

2. Richard Hoggart, *Speaking to Each Other, Vol 2: About Literature* (London: Chatto and Windus, 1970).

3. Raymond Williams, 'Practical Critic', *The Guardian*, 26 February 1970.

4. See Christopher Pawling, *Critical Theory and Political Engagement* (Basingstoke: Palgrave Macmillan, 2013), particularly pp. 1–11 for a useful overview of CCCS members' involvement in early 1970s political movements. See also Chas Critcher's contribution to this volume: 'Action not words: neighbourhood activism and cultural studies'.

5. Stuart Hall, 'The Missed Moment', CCCS position paper, 1971 (Richard Hoggart papers, University of Sheffield, MS 247/4/6/15). See also the discussion of 1970–1971 CCCS position papers in Kieran Connell and Matthew Hilton, 'The Working Practices of Birmingham's Centre for Contemporary Cultural Studies (CCCS)', *Social History*, 40, 3 (2015), pp. 287–311; Dennis Dworkin's contribution to this volume: 'The Lost World of Cultural Studies, 1956–1971: An Intellectual History'.

6. Tony Jefferson, paper given at the CCCS 50 conference, University of Birmingham, 25 June 2014.

7. This point is developed in my article, 'Considering Richard Hoggart's Relevance for Teaching contemporary Media Studies' in Michael Bailey, Mary Eagleton (eds.), *Richard Hoggart: Culture and Critique* (Nottingham: CCC Press, 2011).

8. Max Weber, *The Protestant Ethic and The Spirit of Capitalism* (London: Unwin University Books, 1970).

9. Max Weber, *The Methodology of the Social Sciences* (New York: Free Press, 1949), p. 81.

10. Ibid., pp 81–84.

11. Weber, *Protestant Ethic*, pp. 47–57.

12. Hoggart, *Speaking to Each Other*, p. 236.

Chapter 6

Hierarchies and Beyond? Staff, Students and the Making of Cultural Studies in Birmingham

John Clarke

Cultural studies at Birmingham developed a significant reputation for collaborative working as a form of intellectual practice. This orientation was visible in the work of the thematic subgroups that were the central point of attachment for students at the Centre for Contemporary Cultural Studies (CCCS), in the publications that emerged from such groups (stencilled papers, issues of *Working Papers in Cultural Studies* and the later series of edited volumes, and one-off research and publishing activities such as *Policing the Crisis*). Here I will link this collaborative orientation in the intellectual work of the Centre to the rather less visible, but no less important, organizational work of the Centre in which students were encouraged to take an active role. Finally, I will take up some of the implications for how 'staff-student relations' were imagined and practised within the Centre. Such innovations were not without their costs and contradictions. Nonetheless, there is something strange about adding to the growing array of cultural studies histories, reflections and archives.[1] The celebration of the Birmingham Centre induces a certain uneasiness and ambivalence, as Charlotte Brunsdon has eloquently recounted in the context of the Birmingham University conference of 2014.[2] So what follows is one attempt to think about the strange and experimental dynamics of collective working and staff-student relations in Birmingham – without any expectation that this is anywhere near a definitive account.

Let me begin from the view that, even now, it is hard to appreciate the significance of this orientation to collaborative and collective working. The interruption of the taken-for-granted hierarchical and individualized norms of the university was a remarkable undertaking and remains a deviant practice, despite the spread of rhetorics and practices of collaboration in recent decades. Indeed, I will argue later that these developments remain unembedded in the norms, habits and expectations of the academic work.

But in the 1960s and 1970s, the commitment to making work collective and collaborative was radical and was, of course, consciously articulated with a wider social and political radicalism locally, nationally and internationally. As other contributions to this volume suggest, cultural studies is nothing if not conjunctural – in practice as well as theory.[3] This commitment linked the practice of collaborative work to an anti-hierarchical view of how relations between staff and students could, and should, be conducted. Of course, as with so much else about cultural studies in this period, the process was one of 'making things up', given the absence of existing models within the academy. Instead, the possibilities of collective working borrowed from repertoires of models, images and practices from wider social, political and cultural movements: a process that Alistair Pennycook describes as 'borrowing, bending and blending'.[4]

The thematic subgroups were one key place for this process of collective innovation: a process of collaborative direction and discovery in which the possibilities of cultural studies were worked though in specific fields (media, literature, education, subcultures, etc.). Although members of academic staff took part in the subgroups, they were not the 'leaders', nor were they necessarily a regular or permanent presence: bear in mind that when I arrived in 1972, these were Stuart Hall and Michael Green, a complement of one and a half posts, which meant they were, at best, spread thinly. My own first experience of collective working came with the Subcultures group in which we tried to work out a programme of reading, discussion and research/writing from a strangely mixed set of resources: existing cultural studies texts[5]; bits of sociology (especially the 'new' sociology of deviance); scholarly and other writings about the counterculture; sociologies of youth, adolescence, generation and education, occasionally interrupted by anthropology (Levi-Strauss's work on *bricolage*, for example). This assemblage drew on Centre history, things that individuals brought with them, and an exploration of parallel or adjacent fields of work – while trying to reframe the central approaches to the study of youth into a more 'cultural studies' direction. Stuart Hall took part in the group, made suggestions (especially about possible readings) and engaged in the collective deliberations and discussions, but the dynamic of the group was shaped by a collaborative attempt to find a common thread that linked possible lines of inquiry with our individual trajectories. In the process we both made, and were remade by, the practice of collaborative working and produced an array of stencilled papers and a special issue of *Working Papers in Cultural Studies*.[6] Both these enacted a collectively articulated injunction to 'write things down' as a way of starting and shaping debates.[7] The working practices were certainly collaborative but also conflictual as positions, possibilities and practices became the focus of argument. Changing memberships from one academic year to another were part of this dynamic as new arrivals

struggled (in every sense) to come to terms with existing work, practices and relationships – and tried to remake them in new directions. Arguments about the relationships between subcultures, gender and masculinity were a critical example of these dynamics.[8]

These forms of intellectual production remain the most visible practices of collaborative working at the CCCS; however, the everyday business of Centre life was also marked by the commitment to collective practices. As with the intellectual work, the collectivist commitment was shaped by a dynamic of political or ethical principles and the demands of running a dynamic, innovative postgraduate centre on a staffing shoestring. As a result, organizational responsibilities were shared – important functions like maintaining the Centre library, managing newspaper and journal subscriptions (and the resulting piles of paper), organizing the seminar programme, and producing the Centre's journal were delegated to subgroups who were accountable to the Centre's (collective) weekly business meeting. The business of the business meeting was wide ranging: from how to respond to invitations from elsewhere, through the latest crisis in the Centre's relationships with the university, down to planning the cleaning of the Gestetner machine (on which papers and pamphlets were produced). Such involvement of postgraduate students in domains of institutional responsibility was rare in the academy (and different in critical ways from the tendency to treat students as skivvies or gofers, doing the dull labour for their academic superiors). Perhaps most striking was the work of the Admissions group, in which one member of staff and several students were responsible for recruiting next year's intake of new students.

The 'politics of intellectual work' in this moment thus involved more than the thrills and spills of intellectual innovation: the material infrastructure, the organization of the 'democratic-bureaucratic complex' and the management of the social relations of production were all at stake in the commitment to collective working. These were duller, but no less necessary, sites of collective labour. They implicated us – as students – in the survival, reproduction and development of the Centre, but this was not simply a process of delegation or even responsibilization. On the contrary, much of this work was saturated with politics – which did not just include the academic arguments, nor the collective work of research and writing, nor the recurrent and troubling questions about the relationship between the politics of cultural studies and actually existing organizations and movements (from International Socialism to the Women's Movement). But it is important to capture the sense that the politics of intellectual work also extended to the politics of organization. Whether arguing over how to manage the Centre's often fraught relationship with the university or how to manage the stencil machine (and its heady – or perhaps noxious – fumes), collective deliberations ranged widely, and invoked principles and standpoints, often in a contentious or even bad-tempered form.

For many of us, it is this sense of the contentious character of doing cultural studies in the Centre that undercuts the somewhat grandiose or epochal conceptions of something called the 'Birmingham School'. The implied coherence and unity of such ideas feel far from the everyday practices and relationships of the Centre that I experienced. As Stuart Hall once expressed it in an interview: 'people talk about the "Birmingham School" . . . and all I can hear are the arguments that we used to have in Birmingham'.[9] This is not meant to deny that there was a collective sensibility, a set of more or less shared commitments, and even a celebration of 'doing cultural studies' together, but such shared orientations were always emergent, conditional and being remade in practice – what we might call a very cultural studies experience of doing cultural studies.

The collectivization of cultural studies in the 1960s and 1970s was also necessarily uneven and contested. Drawing on an ethos of '1968', it was certainly attractive, enabling and liberatory for students emerging from much more conventional settings elsewhere. I had spent four years being taught how to be a social, scientifically informed personnel manager, and – like many of my cohorts – was ready for the possibilities of doing things otherwise. Yet the negotiation of such social and organizational relationships – and their political articulations – dragged us into uncomfortable places, demanding skills and capacities that were, at best, patchily available. In the same period, lots of groups and movements were struggling with such issues as how to organize the 'conduct of conduct' in collective relationships that preoccupied people involved in cooperative initiatives, collective living experiments, the Women's Movement and many others. Sometimes, lessons were learnt and shared from the successes and failures in these diverse settings – but not always.

In the histories of cultural studies, there are well-known and highly dramatic instances of such struggles over how to live and work together. Stuart Hall's description of the strained relationship between feminism and the Centre has come to be one of the iconic expressions of the contested character of cultural studies:

> We know it was, but it's not known generally how and where feminism first broke in. I use the metaphor deliberately: As a thief in the night, it broke in; interrupted, made an unseemly noise, seized the time and crapped on the table of cultural studies. The title of the volume in which this dawn-raid was first accomplished – *Women Take Issue* – is instructive: for they "took issue" in both senses – they took over that year's book and initiated a quarrel. But I want to tell you something else about it. Because of the growing importance of feminist work and the early beginnings of the feminist movement outside in the very early 1970s, many of us in the Centre – mainly, of course, men – thought

it was time there was good feminist work in cultural studies. And we indeed tried to buy it in, to import it, to attract good feminist scholars. As you might expect, many of the women in cultural studies weren't terribly interested in this benign project. We were opening the door to feminist studies, being good, transformed men. And yet, when it broke in through the window, every single unsuspected resistance brought to the surface fully installed patriarchal power, which believed it had disavowed itself. There are no leaders here, we used to say; we are all graduate students and members of staff together, learning how to practice cultural studies. You can decide whatever you want to decide, etc. And yet, when it came to the question of the reading list . . . now that's where I really discovered about the gendered nature of power. Long, long after I was able to pronounce the words, I encountered the reality of Foucault's profound insight into the individual reciprocity of knowledge and power. Talking about giving up power is a radically different experience from being silenced. That is another way of thinking, and another metaphor for theory: the way feminism broke, and broke into, cultural studies.

Then there is the question of race in cultural studies. I've talked about the important "extrinsic" sources of the formation of cultural studies – for example, in what I called the moment of the New Left, and its original quarrel with Marxism – out of which cultural studies grew. And yet, of course, that was a profoundly English or British moment. Actually getting cultural studies to put on its own agenda the critical questions of race, the politics of race, the resistance to racism and the critical questions of cultural politics was itself a profound theoretical struggle, a struggle of which *Policing the Crisis* (1978), was, curiously, the first and very late example. It represented a decisive turn in my own theoretical and intellectual work, as well as in that of the Centre. Again, it was only accomplished as the result of a long, and sometimes certainly bitterly contested internal struggle against a resounding but unconscious silence. A struggle which continued in what has since come to be known, but only in the rewritten history, as one of the great seminal books of the CCCS, *The Empire Strikes Back*. In actuality, Paul Gilroy and the group of people who produced the book found it extremely difficult to create the necessary theoretical and political space in the Centre in which to work on the project.[10]

I have quoted Hall's argument at some length for several reasons. First, it indicates the complex view of feminism that he sought to articulate. Second, it offers a sense of that argument as rather different from those much quoted – and usually decontextualized – first two sentences. Third, it locates the struggle around feminism within a wider discussion of 'movements' and 'moments' that also features the struggle for, and around, 'race'. Through this framing it is possible to see the Birmingham Centre as an intensely contested space, in which the smooth progress of cultural studies was never settled, not least because of the (always problematic) articulations of contemporary culture, and contemporary politics with the project of doing cultural studies.

However, my account so far treats the social relations of intellectual and organizational work at the Centre as though they are simply horizontal formations, characterized by a spirit of egalitarianism. No doubt this was the political ethos of the moment, and it was certainly the political ethos espoused and pursued within the Centre. As Larry Grossberg has recently indicated in his survey of the Centre's internal reports, the *Sixth Report* (1969–1971) identified the experimental quality of what was being attempted:

> There is a simple but radical recognition that traditional styles of intellectual work (for example, the model of the 'lonely' scholar) were simply inappropriate to the project. But then, how should the sort of collective intellectual work they were imagining be organized? The Report hints at 'experiments' 'with forms of collective organization and self-management . . . more appropriate to the project we have undertaken.[11]

Not surprisingly, the practice necessarily proved more complex. The will to make power disappear is not the same as its disappearance, and the experience of staff-student relationships in the Centre was inevitably charged with difficult dynamics. In what follows, I try to distinguish three different aspects of the tensions in play in these relationships, but I would stress that they were always entangled in the everyday. The first might be called issues of functional power. The staff of the Centre were necessarily the 'responsible adults' in terms of managing the relationships between the Centre and the forms of institutional authority, most obviously the University of Birmingham, but also outside agencies (such as research-funding bodies and publishers). In these relationships, postgraduate students were, at best, junior partners, if not invisible. During my time there, Stuart Hall, Michael Green and Richard Johnson also occupied the front line of the tense institutional relationships with the university, even if it was sometimes the activist students who created other front lines. So while the Centre's business meeting might discuss relationships with the university, or while students could serve on the Admissions group, the actual conduct of those institutional relationships rested in the hands of the staff. Nonetheless, we as students recognized the necessary, if difficult, labour of negotiation required to maintain the Centre as an enclave within 'the belly of the beast' that was the University of Birmingham. The contradictions of being 'within and against' was recurrently discussed (as it was within the larger world of Left politics).[12] So, while there may be been tensions between the practice of negotiation and the rhetorical positions adopted in Centre meetings about the university, the distinction between staff and students in this aspect was accepted as a necessary fiction. I doubt, though, that we as students paid much attention to the strains of mediating the Centre and the university experienced by Stuart, Michael and Richard – and which no doubt

intensified for their successors as universities came to imagine themselves as enterprises needing to be managed.[13]

Second, there were issues of power articulated as a nexus of age/experience/authority – the problem of how to not occupy the formal position of teacher in an academic world conventionally structured by the teacher-student binary. To some extent, this was mitigated by the 'emergent' quality of cultural studies at Birmingham – the sense that we were collectively 'making it up as we went along'. In the absence of a canon or a tradition (in disciplinary terms), the possibility of reducing, if not abolishing, the teacher-student distinction was enhanced, subsequently becoming more problematic as cultural studies became more codified (in Birmingham, this was associated with the arrival of the taught MA). But hierarchical distinctions there certainly were, even if they were often interpreted as matters of experience, rather than status. In the ebb and flow of collective work (organizational and intellectual), the staff brought a range of resources to bear. Even if the deployment of these resources was often reticent, even if they were often offered, and received, as a 'gift' intended to enable us to think, the differential capacities created sites of ambiguity: Is the offer of knowledge an exercise of authority, a seduction by the powerful, an enabling device, a collaborative contribution? Such questions shadowed the collective commitment to collaborative and egalitarian modes of working, usually overcome by the assumption of goodwill, but intermittently erupting into contestations of power and authority.

The third dynamic of tension concerns what might best be described as the problem of leadership. Here, too, personal and political dynamics were entangled – institutional roles (Centre director, academic staff, etc.) were bundled with intellectual and experiential authority (whose readings carried most weight?) and embodied in aspects of personal and charismatic authority (most evidently personified in Stuart). These entanglements produced complicated psychodramas to go alongside their productive effects, interrupting the commitments to collectivity and collaboration as ethical practices. Such eruptions and disruptions centred on the problems of how to lead without leading, how to organize collectively in spaces and settings that remained resolutely hierarchical, and how to cope with the complex psychologies of power in practice. Despite his best efforts to combine roles, our collective fixation on, and fascination with, Stuart produced some intense conflicts of intellectual, political and personal attachment and separation.

It is tempting to read these problems of power and politics as the 'realist' corrective to the various romances of cultural studies at Birmingham. They might reveal the 'dark truth' of the project – the discovery of invidious distinctions of power and authority that counteract all that '1968' mythology of collective work. But I think that would be an unfortunate reading. Such tense dynamics were certainly present within staff-student relationships at

the Centre. They erupted around various issues, often in distressing and
alienating ways for those involved. At times, they were acrimonious and pain-
ful. But, for me, they look like an integral part of being 'within and against'
the complex institutional architecture of doing intellectual work. In a recent
article Charlotte Brunsdon has addressed what she calls a 'prurient' interest
in the Centre's internal dynamics:

> My feelings here were informed by responses, and previous requests for inter-
> views, that had been prompted by an account I had written about conducting
> intellectual work at the Centre in the 1970s in which I had explored the visceral
> quality of political and intellectual argument (Brunsdon 1996). This piece,
> which I had shown to Stuart Hall before it was published, as it responded very
> directly to a comment he had made at a conference in 1990 about feminism at
> CCCS, has attracted a certain type of query. I have found that interviewers, and
> complete strangers who send emails, seem to want to probe at what they seem
> to hope will be the soft vulnerable underparts of the politics at CCCS. In a type
> of prurient, politically correct celebrity gossip, I have been pressed to spill the
> beans about what things were really like in Birmingham – by implication to
> expose 'secret sexist Stuart Hall'. So let me be quite clear: in the article 'A Thief
> in the Night', what you see is what you get – and Stuart was nothing but support-
> ive of his unruly, stroppy and opinionated students. The question so often was
> exactly how to put that support into practice, particularly as we had a number of
> contradictory views ourselves. What was so exceptional about CCCS was how
> very seriously the views of the 'students' – and we were students, although we
> did not feel like students (because we were not treated like them) – were taken.[14]

This view captures my own experience. Indeed, I am tempted to argue that
the 'romance' of cultural studies has attracted that counter-impulse to reveal
the 'seamy side' of Centre life. But if it is a romantic illusion to think that col-
lective and egalitarian approaches to doing intellectual work can simply hold
at bay the established arrangements and practices (from hierarchical authority
to hyper-individualized academicism), then it is the inverse – an exercise in
cynical debunking – to point to the limitations and failures of that project.

At various points in my later working life, I have tried to claim an inheri-
tance from cultural studies that centres on contexts, conjunctures and contra-
dictions. I think these keywords (thank you, Raymond Williams) apply to the
practices of staff-student relationships at the Centre. The ambition and desire
to create collective ways of working certainly needs to be understood con-
juncturally (not just the emergence of cultural studies as a site of intellectual
work). So, too, do the entanglements of the personal and the political within
the social relations of doing intellectual work in that form. Both the desire
and the sites of antagonism emerge from the break-up of established forms
of power, knowledge and authority in that period that *Policing the Crisis*
describes – for Britain, at least – as the 'decline of consent'.[15] The university

emerged as one of the sites in which the established order of things could be contested – and the Birmingham Centre's pursuit of an alternative collective practice both arose from that context and contributed to the project of transformation. But it is important to understand the commitment to the collectivization of intellectual work as itself conjunctural, not least in the sense that there were both forces and contextual conditions that enabled it as well as made it seem politically necessary. While it remains (for me, at least) a continuing commitment, the present conjuncture has reduced or restricted some of the contextual conditions that made it possible. The hyper-individualization and commodification of intellectual work, especially when combined with the rise of objectifying practices of performance management within universities, have produced powerful countervailing pressures. For me, this is a warning against reifying the commitment to collective work as a universal moral gesture. Instead, it is a possibility that needs to be struggled for with attention to the contextual conditions and possibilities. Above all, it needs to be pursued with an understanding of its contradictory implications. Collective working – with its anti-hierarchical or egalitarian ethos – is not a simple panacea that transcends the institutional conditions or the structures and practices of the academy. Rather, it needs to be understood as one particular site of struggle in which a variety of contradictions are condensed. Nevertheless, I believe that it remains powerfully productive, both as a practice and as an ideal.

NOTES AND REFERENCES

1. Including this volume and Kieran Connell and Matthew Hilton 'The Working Practices of Birmingham's Centre for Contemporary Cultural Studies', *Social History* 40, 3 (2015), pp. 287–311.

2. Charlotte Brunsdon, 'On Being Made History', *Cultural Studies*, 29, 1 (2015), pp. 88–99.

3. See the chapter by Mikko Lehtonen, and the introduction by Kieran Connell and Matthew Hilton in this volume. On the centrality of conjuncture to Stuart Hall's work, see my 'Conjunctures, crises and cultures: valuing Stuart Hall', *Focaal— Journal of Global and Historical Anthropology*, 70 (2014), pp. 113–122.

4. Alistair Pennycook, *Global Englishes and Transcultural Flows* (London: Routledge, 2007), p. 47.

5. In particular, Phil Cohen, 'Sub-cultural Conflict and Working Class Community'. Working *Papers in Cultural Studies. No.2.* (Birmingham: Centre for Contemporary Cultural Studies,1972), pp. 5–51; Paul Willis, 'The Motorbike Within a Subcultural Group', *Working Papers in Cultural Studies No. 2.* (Birmingham: Centre for Contemporary Cultural Studies, 1972).

6. Issue 7/8, subsequently republished as Stuart Hall, and Tony Jefferson (eds.), *Resistance through Rituals* (London: Hutchinson, 1976).

7. See Ted Striphas and Mark Hayward, 'Working Papers in Cultural Studies, Or the Virtues of Grey Literature.' *New Formations*, 78 (2013), pp. 102–116.

8. See, for example, Angela McRobbie, and Jenny Garber 'Girls and Subcultures' in Stuart Hall and Tony Jefferson (eds.), *Resistance Through Rituals* (London: Hutchinson, 1976), pp. 209–222; Angela McRobbie, 'Angela McRobbie Interviews Herself: How Did It Happen? How Did I Get There?', *Cultural Studies,* 27, 5 (2013), pp. 828–832.

9. Lawrence Grossberg, 'On postmodernism and education: an interview with Stuart Hall', *Journal of Communication Inquiry*, 10 (1986), p. 59.

10. Stuart Hall, 'Cultural Studies and Its Theoretical Legacies' in Lawrence Grossberg, Cary Nelson and Paula Treichler (eds.), *Cultural Studies* (New York: Routledge, 1992), pp. 283–284.

11. Lawrence Grossberg, 'Searching for a Centre: reading the emergence of Cultural Studies through CCCS's annual reports.' *Cultural Studies*, 27, 5 (2013), p. 853.

12. See, for example, The London-Edinburgh Weekend Return Group, *In and Against the State* (London: Pluto Press, 1979).

13. John Clarke, 'So many strategies, so little time: Making Universities Modern', *Learning and Teaching: The International Journal of Higher Education in the Social Sciences*, 3, 3 (2010), pp. 91–116.

14. Charlotte Brunsdon, 'On Being Made History'; Charlotte Brunsdon, 'A thief in the night', in Dave Morley and Kuan-Hsing Chen (eds.), *Stuart Hall: Critical Dialogues in Cultural Studies* (London: Routledge, 1996), pp. 276–286.

15. Stuart Hall, Chas Critcher, Tony Jefferson, John Clarke and Brian Roberts *Policing the Crisis: Mugging, The State and Law'n'Order* (Houndmills: Palgrave Macmillan, 1978).

Chapter 7

Theory, Politics and Practice

Then and Now

Tony Jefferson

What follows is a reflection on cultural studies as a field of inquiry. I will adopt a 'then' and 'now' approach, and offer a broad sketch of some key theoretical and political developments that have precipitated the shift between the two moments. However, it will remain based on my own personal, hence inevitably idiosyncratic, journey, not least because opening up to the personal constitutes a key theme in my narrative.

THEN: THE SEVENTIES

I arrived at the Centre in September 1972, a schoolteacher relieved to be escaping the taxing rigours of classroom and playing field, influenced by the counterculture of the 1960s and aiming to make this my object of study. My preparatory reading (burning the midnight oil after prepping the following day's lessons) included Herbert Marcuse, Norman O. Brown, Timothy Leary and R. D. Laing among others. I expected to find the Centre's director to be the author of the *Uses of Literacy*, Richard Hoggart; instead, I encountered a student-led meeting with a denim-clad black man hovering at the back of the room. I later discovered that this was the new acting director, Stuart Hall. I had never heard of him.

Outside the academy, conflict raged: the cultural critique and practices of the counterculture had unleashed a repressive ideological and legislative backlash (against drugs, 'obscenity', squatting, etc.); political internment and Bloody Sunday had escalated the war between the British army and the IRA; and the government's attempt to control union activity and pay demands through legislation and the courts led to the most days lost to strikes for over 50 years. Internationally, terrorist violence escalated (24 gunned down

at Israel's Lydda airport, for example), Uganda's Idi Amin expelled 40,000 British Asians (many of whom came to Britain, which exacerbated already difficult race relations) and the United States was attempting, with unprecedented ferocity, to bomb Vietnam into submission.

The extent and level of conflict made politics an inescapable reality. Moreover, the general post-1968 ambience, the conservative backlash, and the fact that the Left chalked up victories during the 1970s, at home (e.g. the miners' two victories over the Heath Government) and abroad (e.g. the defeat of the United States in Vietnam), served to promote the proliferation of Marxist-inspired political groups (Socialist Workers Party, International Marxist Group, Big Flame, etc., all of whom were represented in the student body at the Centre), as well as the leftward shift inside the Labour Party. But, whatever the sectarian political differences outside the academy, inside it the common intellectual project – thinking the role of culture within a social formation – generally overrode such differences (which is not to say that there were not theoretical differences swirling around the place).

Under Stuart's leadership, the Centre moved away from its literary origins to embrace new disciplines, especially sociology and history, and from Hoggart's social-democratic labourist politics to engage New Left politics and the many varieties of post-1968 Marxism competing under its umbrella. Intellectually we operated at two levels: the weekly General Theory seminar where we studied the writings of Marx and the neo-Marxists, cultural theorists (like Raymond Williams), historians (like E. P. Thompson), and key works from the sociological canon (like Durkheim, Weber and the phenomenologists); and smaller subgroup seminars, where individuals with a similar focus to their intended dissertations – in my case, youth subcultures – met to attempt to help each other progress, through discussing particular texts and critiquing each other's fledgling efforts. Here, more focused reading was undertaken: the Chicago school, 'labelling' theorists and the 'new criminology', for example.

Of all the theorists studied, the neo-Marxists Althusser, Gramsci and Poulantzas were probably the most influential, at least for many of us. For the purposes of this chapter, I can think of two reasons for this: they stressed the political and practical importance of theoretical work; and they were attempting to produce a re-invigorated Marxism subtle enough for the complexity of the times. Let me take each of these points in turn.

THE POLITICS OF INTELLECTUAL WORK

Althusser was a practising Communist who consistently extolled the practice of philosophy (indeed his political work tended to be that of philosophical

'corrections' to the party's theoretical positions). His earliest definition of philosophy – 'a theory of theoretical practice' – he later admitted to be idealist.[1] His rectified definition – 'philosophy "represents" the class struggle in the realm of *theory*, hence philosophy is neither a science, nor a pure theory (Theory), but a *political practice of intervention in the realm of theory*' – renders all three terms, theory, politics and practice inseparable as well as indissolubly linked to the class struggle.[2] Further, theory was placed alongside the other practices of the social formation, economic, political and ideological: 'theory constitutes a fourth practice, theoretical practice, that transforms ideology into knowledge with theory'.[3] Within this intellectual universe, there was no escape from the politics of intellectual work; to deny this reality, to suggest that this was not the case, was itself a political position. Given the parlous state of the actually existing communist world, the renovation of Marxist theory also seemed to be necessary work.

Gramsci had a similar take on the inseparability of politics and intellectual work, and the link to class. Talking of intellectuals, he distinguished between the 'traditional' and the 'organic'. The position of the former, although apparently independent of class 'derives ultimately from past and present class relations and conceals an attachment to various historical class formations'; the latter are 'the thinking and organising element of a particular fundamental social class'[4]. The role of the political party 'is that of channelling the activity of these [working-class] organic intellectuals and providing a link between class and certain sections of the traditional intelligentsia'[5]. Within this scenario, all intellectuals, consciously or otherwise, were part of the class struggle; and doing theoretical work was as much a part of the struggle as doing politics. In an increasingly complex world with its specializations and divisions of labour, I saw this as our allotted role in the struggle.

COMPLEXITY AND COMMITMENT

Attempting to be an organic, working-class intellectual did not mean one simply sided with working-class views of the world, whatever they happened to be; rather, the struggle (using Gramsci's terminology) was to transform working-class 'common sense' ideas into 'good sense'. Specifically, the struggle was as much against Left reductionism as the everyday common sense that informed the dominant ideology. The task was to persuade the Left of the need to rethink intellectually exhausted ideas, with their catastrophic political outcomes, just as Althusser was doing inside the French Communist Party and Gramsci had been doing for the Italian Party from inside his prison cell. A small anecdote may illustrate this. I never saw Stuart get angry in public, except once. Someone had said something denunciatory,

I don't remember what, in relation to intellectual work, as opposed to taking more direct political action. Stuart banged the table and said, in defence of the necessity of intellectual labour, 'if we discover one more mediation . . . ' In some ways this summarized our entire project: to uncover the complex mediations between some element of contemporary culture and 'the class struggle'; to show how the vicissitudes of the class struggle worked through the various levels – economic, political, ideological – of the social formation to manifest culturally in the way that they did in particular places at particular times (or 'conjunctures').

This project also required commitment. To the extent that the dominant ideology had become thoroughly entrenched as the common sense of the age, that is, hegemonic, this necessitated not only attention to complexity, but also to the need to render accessible whatever new insights we thought we had achieved (if it was to stand any chance of becoming part of a new common sense). Thus, to quote Stuart again, we had 'to work twice as hard' as traditional intellectuals. In this he offered, as in so much else, an inspirational example.

If 'mediation' was a core concept in the pursuit of anti-reductionist complexity, Althusser's 'relative autonomy' and Gramsci's 'hegemony' stand out as the other two. The former provided the lodestar for trying to rethink Marx's 'base-superstructure' metaphor in a way that did not reduce all the elements of the superstructure to simple manifestations of the (economic) base (thus obviating any need to take them seriously in their own terms). Of course Marx had never been this reductive. What Althusser did was rescue Marx (and Engels) from simplistic readings – *'the Capital-Labour contradiction is never simple, but always specified by historically concrete forms and circumstances in which it is exercised'* – and converted this into the rule and not an exception – 'the apparently simple contradiction [between capital and labour] is *always overdetermined'*. [6] He also challenged us to think *'the relative autonomy of the superstructures and their specific effectivity'* without abandoning *'determination in the last instance by the (economic) mode of production'*.[7] Some found this contradictory (either something was autonomous or it wasn't); perhaps especially Althusser's gnomic addition: '(f)rom the first moment to the last, the lonely hour of the "last instance" never comes'.[8] However, we were inspired by this idea, grappled with and criticized it, yet also attempted to use it in concrete case studies.[9]

Gramsci's concept of 'hegemony' stemmed from his attempt to explain class domination in the industrial Capitalist democracies of Western Europe and the United States in the aftermath of the Russian Revolution: how such societies had not produced a similar uprising. As I expressed it later for a criminology dictionary, his 'key insight was that successful class rule entails

the creation – through alliances, concessions, compromises and new ethico-political ideas and projects – of a collective will which was not narrowly class-based but had popular, national appeal': class domination that had been 'achieved through the production of consent rather than through the use of coercion or force'.[10] It was this notion that was to prove central in our project that produced the book *Policing the Crisis*.[11]

A CONJUNCTURAL ANALYSIS: THE EXAMPLE OF *POLICING THE CRISIS*

Policing the Crisis had its origins in the sense of outrage occasioned in our youth subcultures group with the sentencing (in March 1973) of three local teenagers to extremely long sentences (20 years in one case) for the violent robbery (labelled a 'mugging') of a man in Handsworth in Birmingham. As the youth subcultures group was becoming 'expert' on the youth question, we felt a need to make sense of this and a political responsibility to do something about it. From this, a support committee for the boys (who were all juveniles) was formed, which produced a pamphlet, *20 Years*, a polemical response to an uncomprehending and largely hostile tabloid press. This early intervention paved the way for the project that produced the much lengthier book *Policing the Crisis*, first published in 1978. The length of the book and the time taken from conception to publication had something to do with our attempt to take seriously the complexity of the issues involved: to produce an account rigorous and persuasive enough to mount a serious challenge to the dominant common-sense understandings of 'mugging' and the excessively punitive response it had evoked, both of the Left and of the Right. Its lengthy gestation was also a product of the Centre's commitment to genuinely collective authorship, where different perspectives and concerns were subjected to intensive and prolonged discussion and debate, before, during and after the production of written drafts. Whether we succeeded is for others to judge, of course. But, we did demonstrate, contra the dominant common sense on punitive sentencing of the Right, that the severe reaction to mugging was incoherent in its own terms, and that the idea of 'moral panic', the Left's explanation of overreactions of this sort, needed to be rethought as symptomatic of a crisis of hegemony. As we put it in the original Introduction, our 'practice' involved 'taking sides – struggling with the contradictions', hoping it might 'help to inform, deepen and strengthen' the practical struggles of a variety of practitioners dealing with penal reform and race relations: '(W)e hope they will read it as we have tried to write it: as an *intervention* – albeit an intervention in the battleground of ideas'.[12]

THE TRANSITION: THATCHERISM AND THE EIGHTIES

In 1977 I took up a full-time Home Office–funded Police Research Fellowship at Sheffield University although I still attended the 'State subgroup' seminars until 1979 (which was also the moment Stuart left for the Open University). My (unfinished) PhD and the fellowship (and a subsequent Cobden Trust-funded project on police accountability) were attempts to explore the 'specific effectivity' of one element of the superstructures, namely, the police, a crucial component of Althusser's 'repressive state apparatus'. The overarching theoretical question continued to be Marxist – how is class reproduction secured through the relative autonomy of the state? – while the empirical work ranged widely over the gamut of politically contentious policing issues that dominated the conflict-ridden, riotous 1980s.[13] This work was also linked to ongoing political campaigns and activities: against the new police bill and monitoring the policing of the miners' strike, for example. But the world was changing as Thatcherism's neo-liberal policies progressively transformed the social landscape and feminists, post-structuralists, postmodernists, postcolonialists and many Marxists variously contested the old theoretical order. 1989, when the Berlin Wall came down and communism effectively collapsed as a meaningful force in the world, cemented this subordination of Marxist theorizing; but there were two tragic earlier signs that presaged this collapse: in 1979 Poulantzas committed suicide and the following year Althusser strangled his wife, Hélène, and was committed to a mental hospital. The significance of these two events, how they might have recast the rationalistic tendencies in their respective writings, was completely missed at the time.

Although the latter event will always have an 'unfathomable' dimension ('three expert doctors' concluded that Althusser had been 'in a "state of dementia" and therefore not accountable' for his actions), one hypothesis, provided by a long-time doctor friend of Althusser, suggested that he was unconsciously seeking to destroy himself, which he achieved by killing the person who believed in him most; which would make this a form of 'suicide' by proxy.[14] Both men had histories of depression that, in Althusser's case, led to crippling self-doubts and terrorizing anxieties. Both men's work was characterized by the rational formalism of their structuralist tendency (albeit in an unresolved tension with 'practice' and the class struggle) as they variously sought to render Marx consistent, coherent and 'scientific'. Had we been as aware of their private, tormented inner lives as we were of their public writings, we would have been better placed to see how their 'search for correctness'[15] was driven as much by internal desires as events in the world, as Althusser was eventually able to acknowledge. Of the period when his theoretical anti-humanism was under attack from all sides, he says: 'It was a marvellous period! I had at last achieved what I wanted: to be right, alone

and against the world!'[16] When Stuart Hall said of Poulantzas's last book, published the year before his suicide, that it is a book 'clearly coming apart at the seams; where no single consistent theoretical framework is wide enough to embrace its internal diversity', he could have been referring to Poulantzas the man, 'coming apart at the seams', struggling to hold on to old certainties in the new intellectual climate.[17] 'It is strikingly *unfinished*', Hall continued. Poulantzas may well have seen it as unfinishable, a difficult, perhaps unbearable, truth for a man for whom certainty and truth meant so much.

If reading their public works through their private anxieties would have enabled us to re-evaluate the significance of their intellectual and political interventions – a task that might seem redundant in today's very different intellectual climate – the broader significance of taking the psychic dimension as seriously as the social one is this: it would enable us to make a different sense of the massive changes under way in our post-Thatcher, neo-liberal world; to see neo-liberalism as not just a political and economic project but also one with psychic ramifications. To 'think' both social and psychic aspects together seems to me to be what is now needed. This forms a crucial part of the subject matter of the following section.

NOW: A POST-COMMUNIST, NEO-LIBERAL WORLD

Even as I was continuing to write about policing within the old, Marxist-dominated framework, I started to write about men and masculinity, influenced by feminism and a psychoanalytically informed post-structuralism[18]. This was triggered partly by taking seriously the feminist mantra, 'the personal is political', as difficulties in my own personal life emerged. If Marx had alerted us to the (class) history that goes on behind all our backs, it was Freud who had initiated a similar revolution at the level of subjectivity in revealing the unconscious at work behind the conscious, intentional self. Thinking subjectivity without losing a grip on the socio-historical, that is, thinking psychosocially, became for me the new, grand theoretical project. And, just as our approach to Marxism was influenced by neo-Marxists, so my approach to Freud was 'under the influence' of neo-Freudians, especially those within the object-relations tradition, like Melanie Klein and, in the somewhat different US relational tradition, like Nancy Chodorow and Jessica Benjamin.

This 'turn to subjectivity' has, of course, had many manifestations – the linguistic subject, the discursive subject, the reflexive subject, and now the affective, embodied subject – each with a different theoretical provenance.[19] Interestingly, Althusser's influential essay on 'Ideology and the Ideological State Apparatuses' is often seen as the starting point of this interest with its claim that '*ideology hails or interpellates concrete individuals as concrete*

subjects'.[20] However, in 1985, when he came to write his account of killing his wife, Althusser had become much more aware of the role of his troubled inner world in forming him as a 'concrete subject'. Then he spoke as a psychoanalytic subject aware that his perceptions were 'always-already . . . invested with meaning in the phantasy projections which were the product of my anxieties'.[21] It is this notion of the subject, which can begin to explain why particular individuals 'invest with meaning' (and thus take up) particular discursive positions (rather than others). This not only moves the debate beyond all these variations of the social subject (interpellated, linguistic, discursive, etc.), but it also moves it beyond a version of the psychoanalytic subject inspired by Lacan.

It is revealing that Althusser, in his essay on 'Freud and Lacan'[22], saw Lacan doing for Freud what he, Althusser, had been doing for Marx, namely, attempting to render it a science; in the case of Freud, a science of the unconscious. This desire for 'scientific' closure that was to prove Althusser's undoing also mars the Lacanian subject. It has the same structuralist predilections. It is this that produces, not actual, embodied, historical subjects with their particular anxieties and related discursive investments, but universal, abstract subjects: products of the 'Symbolic order' that is always already structured by language, desiring to return to the illusory sense of wholeness inaugurated by the 'Imaginary order' ('the mirror phase').[23]

Politically, the turn to subjectivity is connected to the rise of identity politics. This has made the concept of identity a key area of debate. Here too, Stuart Hall makes the essential point about the importance of investment. Arguing that 'Identities are . . . points of temporary attachment to the subject positions which discursive practices construct for us',[24] he insists on the need to understand a subject's *investment* in taking up particular positions in discourse, a move that takes him beyond Althusser's ['one-sided'] interpellated subject, via Stephen Heath's notion of 'suture',[25] to embrace a psychoanalytic dimension:

> The notion that an effective suturing of the subject to a subject-position requires, not only that the subject is 'hailed', but that the subject invests in the position, means that suturing has to be thought of as an *articulation*, rather than a one-sided process, and that in turn places *identification* . . . firmly on the theoretical agenda.[26]

Thinking this articulation, between the psychic and the social, 'mutually constitutive but not identical fields', is where 'the real conceptual problems lie'.[27] This remains the case today, nearly 20 years on from Stuart's celebrated essay. This is also where methodological problems lie since the presumed psychoanalytic subject is a defended subject: one that is committed to

unconsciously defending itself, in a variety of ways, from the anxiety that all of us experience. In the case of cultural studies, with its methodological predilection for qualitative rather than quantitative research, which essentially means hermeneutic work of various kinds – analysing texts, ethnographical and interview-based work – the issue of producing data from defended subjects becomes problematic. This has not been seriously addressed, partly because the psychoanalytic subject dominating the field is Lacanian. Given the abstract, universal subject at the core of Lacanian work, it is unsurprising that research within this tradition is theoretical rather than empirical and, where empirical, text-based rather than based on actual subjects being observed, interviewed, etc.[28]

One reason for this theoretical bias of Lacanian research is that methodological developments involving a defended subject have taken place elsewhere, in what is now the developing field of psychosocial studies, much of which is based in the object-relations tradition of Klein, Winnicott and Bion.[29] The origins of this new field of psychosocial studies within the United Kingdom include a number of university departments (usually sociology or social work) starting in the mid-1980s with what is now the University of East London (which does have a long-standing cultural studies tradition). Now, there is a Psychosocial Studies Association (replacing the Psychosocial Studies Network), a 'sociology, psychoanalysis and the psychosocial' study group within the British Sociological Association (BSA), an online *Journal of Psycho-social Studies* and a Palgrave Macmillan Book Series, Studies in the Psychosocial, which has already published 14 titles. As far as I can tell, there is little crossover with cultural studies.

CONCLUSION

I started with the conflictual politics of the 1970s and the Centre's related project of attempting to understand the cultural dimensions of given social formations in all their theoretical complexity: intellectual work which necessarily entailed both a politics and a practice. *Policing the Crisis* was the example chosen to demonstrate the nature of a specific conjuncture through a particular, cultural activity, 'mugging'. Thatcherism and the neo-liberal upheaval it inaugurated, along with demise of communism, ushered in a slew of theoretical developments variously responding to a new conjuncture. Of these, the new concern with subjectivity, which involved an engagement with Freud and psychoanalysis, was the issue of most resonance to me, both personally and politically (which are always mutually implicated, as Althusser found out, albeit too late to prevent his tragic undoing). Although cultural studies have been concerned with the issue of subjectivity, the turn to

Lacan has left the field poorly equipped to undertake needed empirical work with actual subjects rather than texts. In this regard, the new psychosocial studies where the object-relations tradition is more in evidence (albeit alongside much Lacanian-inspired work) would seem to be better placed to address the complexity of the cultural realm that is always already mediated through the inner world phantasies of particular subjectivities.

However, if the turn to subjectivity introduces a new level of indeterminacy to the social process, this does not mean throwing out the baby, 'determinacy'. Far from it. If the 'real conceptual problems' lie in understanding the relationship between the psychic and the social realms, the better we understand each realm the more likely we are to understand this relation. Here, I suggest, we could do worse than return to Stuart's 'Marxism without Guarantees' essay for a way of thinking about doing theoretical work. In a magisterial response to the idealism of postmodernism and other 'post-Marxist' critics, Stuart argued for (and demonstrated using concrete examples from the field of ideology) a Marxism that is 'open' but also 'scientific', demonstrating both the subtlety of mind and connectedness to the concrete that, to my mind, made him Gramsci's natural heir. By 'open' he means giving up on the idea that 'particular outcomes' can be predicted (or guaranteed); by 'scientific' he means, with reference to a 'marxist theory of politics', the attempt to understand 'the limits to political action given by the terrain on which it operates . . . [a] terrain . . . defined . . . by the existing balance of social forces, the specific nature of the concrete conjuncture'. This entails '[U]nderstanding "determinacy" in terms of setting limits, the establishment of parameters, the defining of the space of operations, the concrete conditions of existence, the "givenness" of social practices'.[30] In a nice final twist, he suggests:

> It would be preferable, from this perspective, to think of the 'materialism' of marxist theory in terms of 'determination by the economic in the *first* instance,' since marxism is surely correct, against all idealisms, to insist that no social practice or set of relations floats free of the determinate effects of the concrete relations in which they are located. However, 'determination in the last instance' has long been the repository of the lost dream or illusion of theoretical *certainty.*[31]

The difficulty of giving up this certainty may well have had a part to play in the personal tragedies of Poulantzas and Althusser. However, 'the determinate effects' of located 'concrete relations' still need to be addressed. The Greek finance minister Yanis Varoufakis, a self-confessed 'erratic Marxist', seems to be using Marxism in a similar way: grappling with it to understand as best he can 'the specific nature' of the present 'conjuncture'.[32] The stakes could not be higher.

NOTES AND REFERENCES

1. Louis Althusser, *The Future Lasts Forever: A Memoir* (New York: The New Press, 1993), p. 184.

2. Louis Althusser, *For Marx* (Harmondsworth: Penguin, 1969), p. 255; emphases in original.

3. Ben Brewster in Althusser, *For Marx*, p. 252.

4. Geoffrey Nowell-Smith in Antonio Gramsci, *Selections from the Prison Notebooks* (London: Lawrence & Wishart, 1971), p. 3.

5. Ibid., p. 4.

6. Althusser, *For Marx*, p. 106, emphases in original.

7. Ibid., p. 111, emphases in original.

8. Ibid., p. 113.

9. See for its application to policing, Roger Grimshaw and Tony Jefferson, *Interpreting Policework* (London: Allen & Unwin, 1987).

10. Tony Jefferson, 'Hegemony', in Eugene McLaughlin and John Muncie (eds.), *The Sage Dictionary of Criminology* (3rd edn, London: Sage, 2013), p. 218.

11. Stuart Hall, Chas Critcher, Tony Jefferson, John Clarke and Brian Roberts, *Policing the Crisis* (2nd edn, Houndmills: Palgrave Macmillan, 2013).

12. Ibid., p. 4; emphasis in original.

13. Tony Jefferson and Roger Grimshaw, *Controlling the Constable* (London: Frederick Muller, 1984); Tony Jefferson, *The Case Against Paramilitary Policing* (Buckingham: Open University Press, 1990).

14. Althusser, *The Future Lasts Forever*, p. 280.

15. Stuart Hall, 'Nicos Poulantzas: State, Power, Socialism', *New Left Review* 119, 1980, p. 69.

16. Althusser, *The Future Lasts Forever*, p. 186.

17. Hall, 'Nicos Poulantzas: State, Power, Socialism', p. 68.

18. Tony Jefferson, 'On Men and Masculinity', *Changes* 7, 4 (1989), pp. 124–28.

19. Paul du Gay, Jessica Evans and Peter Redman (eds.), *Identity: A Reader* (London: Sage, 2000).

20. Louis Althusser, *Lenin and Philosophy and Other Essays* (2nd edn, London: New Left Books, 1977), p. 162, emphases in original.

21. Althusser, *The Future Lasts Forever*, p. 7.

22. Althusser, *Lenin and Philosophy*, pp. 181–202.

23. 'In Lacan's theory we speak our selves into existence through the narratives we create, driven by the movement of our repressed desire for the mother . . . All experience outside the realm of language and representation is considered delusory', Rosalind Minsky, *Psychoanalysis and Culture* (Cambridge: Polity, 1998), p. 213.

24. Stuart Hall, 'Introduction: Who Needs "Identity"', in Stuart Hall and Paul du Gay (eds.), *Questions of Cultural Identity* (London: Sage, 1996), p. 6.

25. Stephen Heath, *Questions of Cinema* (Basingstoke: Macmillan, 1981), p. 106.

26. Stuart Hall, 'Who Needs "Identity"', p. 6, emphases in original.

27. Ibid., p. 7.

28. 'The subject, no more Freud's ego built out of identifications, is always inhabited by what Lacan calls the Other, those others who lie outside the self within the inter-subjectivity of language. The subject, always imbued with the Other, has no substance of its own in the form of personal traits, aptitudes or dispositions nor a distinctive personality', Rosalind Minsky, *Psychoanalysis and Culture*, p. 62.

29. For example, Wendy Hollway and Tony Jefferson, *Doing Qualitative Research Differently: A Psychosocial Approach* (2nd edn, London: Sage, 2013).

30. Stuart Hall, 'The Problem of Ideology—Marxism without Guarantees', *Journal of Communication Inquiry*, 10, 2 (1986), p. 43.

31. Ibid.

32. Yanis Varoufakis, 'How I became an erratic Marxist', *The Guardian*, 18 February, 2015, pp. 29–31.

Chapter 8

Seeking Interdisciplinarity

The Promise and Premise of Cultural Studies

Lawrence Grossberg

Over the past decades, interdisciplinarity has become a common desiderata or at least a buzzword of the academic world. Many universities have made some sort of public commitment to it. It has been increasingly recognized, sometimes with alarming rhetorics of urgency, as necessary for the sorts of knowledge that societies need (and will need) to address the problems they face, and necessary for the sorts of education that people will need if they are to become intelligent citizens of the world. For example, in *Facilitating Interdisciplinary Research*, a 2005 report commissioned by the National Academies of Sciences and Engineering, and the Institute of Medicine, the authors assert that

> much depends on the nation's response to the challenges described in this report. Strengthening IDR [interdisciplinary research] is not merely a concept that is philosophically attractive or that serves the special interests of a few neglected fields. It has been vital since the creation of our great research universities – and critical during times of national emergency.[1]

There have been numerous university task forces and foundation reports calling for real changes in the organization, value and reward systems, and the communication networks of universities.[2] It has been frequently pointed out that there already exists, in many institutions, a 'hidden university' of interdisciplinary work, and many studies have noted that the intellectual and research communities of faculties are rarely bound to the disciplines any more. And yet, according to the Social Sciences Research Council,

> The fact is, universities have tended to approach interdisciplinarity as a trend rather than a real transition and to thus undertake their interdisciplinary efforts

in piecemeal, incoherent, catch-as-catch-can fashion rather than approaching them as comprehensive, root-and-branch reforms . . . Instead of implementing [interdisciplinary – ID] approaches from the perspective of a thorough-going reform, many universities are simply adopting the ID labels without adapting their disciplinary artifacts . . . The lack of systemic implementation taken in order to re-design and not just rename these structures and thus actively support ID research has actually created initiatives that are inherently incapable of achieving the very goals they seek to accomplish and unfortunately unable to serve the very constituents they hope to support.[3]

There are no doubt good reasons for this failure. The first is that interdisciplinarity requires collaborative work; it cannot be done by an isolated, individual scholar. Insofar as it actually requires non-normative forms of collaboration, the barriers have always been obvious: academic institutions are organized to judge and reward individual's scholarly (and teaching) careers. Hiring, promotion, tenure and merit raises are all tied to measurements of individual accomplishments. Interestingly, the bench sciences have successfully challenged such calculi for some time, and are pushing even further against them in recent years. But in the human – qualitative, critical – sciences, the logics of commensuration and value remain rigidly formalized in bureaucratic practices and structures. Universities are also buffeted by the winds of external forces, including professional organizations, state apparatuses and the commercial academic publishing industry. For the most part, contemporary universities have not exhibited a great deal of moral or intellectual courage in responding to such internal and external forces. That has meant, for example, that in recent decades, what real advances have been made in moving towards and supporting interdisciplinary research have largely been clawed back into disciplines operating under conditions of financial retrenchment and increasing fragmentation, which has resulted in a kind of affective investment in disciplinarily defined territories. This is often represented as being interdisciplinary *within* one's own discipline.

The second reason for the sizeable gap between commitment and realization is that, apparently, no one is quite sure of what it is that is being proposed, what is it that constitutes interdisciplinarity. It is often used so ambiguously that some academics simply throw up their hands and suggest that interdisciplinarity refers to 'scholarship that would otherwise not occur within the existing departments'.[4] The following are only some of its current referents:

1. Multi-disciplinarity involves bringing disciplines together in an additive way that does not challenge or transform the disciplines. It simply involves limited and transitory communication, for the purpose of sharing information or knowledge or insights.

2. Cross-disciplinarity involves a discipline borrowing from one or more disciplines. In this way, the first discipline is transformed in a limited way and only as a result of its own actions.
3. Specializing interdisciplinarity involves the creation of overlapping sub-specialties across disciplines with increasing consistency of subjects and perhaps methods.
4. Transdisciplinarity involves the creation of a body of knowledge (usu-ally theory or methodology) that moves across and shapes multiple disciplines. In such cases, a vocabulary that originates in one or more dis-ciplines comes to define and transform work in a wide range of disciplines.
5. Interdisciplines involve the creation of new hybrid 'disciplines' as the real convergence, appropriation, or translation of the organizing concepts and methods of multiple disciplines, creating a new hybrid object of study that cannot simply be claimed by any of the original, single disciplines.

But some intellectual projects have a unique claim to interdisciplinarity, and cultural studies is certainly at the top of any such list. Part of the mythos of the Centre for Contemporary Cultural Studies (CCCS) is that it inaugurated a significant effort to change the practice of intellectual work in the academy, by emphasizing both interdisciplinarity and collaboration, by creating a space of experimentation and convivial dissensus. In fact, one might say that inter-disciplinarity is constitutive of the practice of cultural studies. The reasons are rather straightforward: insofar as it asserts that everything exists only in relations, insofar as it defines its research problematic in terms of contexts as problem spaces, and insofar as it emphasizes the necessity of grappling with complexity rather than following the easier paths of various reductionisms, cultural studies will always find itself having to escape the limits of any and every discipline. The question is how far does it have to go? Does it have to do more than simply carry out some raids across or even transgress disciplinary borders? Will it have to reconfigure the discursive fields of knowledge? While cultural studies has often led the charge and flown the banner of interdisci-plinarity, the results have been, I fear, rather disappointing to say the least. This may be, in part, on account of the fact that we have too often succumbed to institutional framings of the question: Where does cultural studies (or interdisciplinarity) belong? Does it belong inside disciplines? Or in the space between some disciplines? Or as a discipline (programme or field) in its own right? Or does it have some strange metaphysical existence as a supplement to any and all disciplines?

I want to recall here something that happened at the CCCS early in its brief history; the chair of the sociology department at the university, having heard some rumours that the people 'over there', in the Quonset hut at the edge of the campus, were reading and talking and even teaching about sociology, wrote a

letter to the student newspaper. He stated, for the public record as it were, that what the Centre was doing had nothing whatsoever to do with sociology, and that those people involved with the Centre had no legitimate claim to speak, use or teach sociology.[5] I am not sure that anyone at the Centre understood the challenge well enough to respond. They were certainly reading widely in sociology and social theory, and debating the strengths and weaknesses of such work. They were trying to use it, they knew they needed it, or something like it, but perhaps they did not know how.

There have been three major versions of interdisciplinarity in cultural studies. The first, like the multi-disciplinarity referred to above, was Hoggart's vision of bringing together people representing different disciplines to research and talk about a single object or event. And if you could not find academic disciplinarians willing to be involved, the members of the Centre could take on the responsibility of speaking for the disciplines. This was, for example, how the first effort at collaborative, interdisciplinary research ('Cure for Marriage') at the Centre worked. It imagined or perhaps fantasized that the result of such a conversation would be greater than the sum of its parts. At its best, such a model is an object-based form of interdisciplinarity; and if and when it gives up its sense of experimentation, it risks simply becoming another discipline, defined by its own objects (often mistakenly assumed to be popular culture or media culture).

This practice of interdisciplinarity is generally doomed to fail because each of the disciplines speaks a different language (and each language embeds different assumptions), so in the end, individual disciplinary representatives can only talk past each other. Let me explain from the perspective of cultural studies, or any critical practice built upon a relational theory. If any phenomenon only exists in and is constituted as what it is only in relations (so that as the relations change, the phenomenon changes and vice versa), then one might understand the disciplines as practices that cut off, erase or subtract relations from the complex totality of whatever contextual field one is working in, be it a particular situation, conjuncture, social formation or even epoch. Each discipline constructs an abstract object, not because it is not real, but because it has been extracted from the complexity of relations that define its capacities, effects and fragilities. In that sense we can describe disciplinary objects as 'artificial' and general, as the result of pushing the relative autonomy of each instance into the illusion of absolute autonomy. Consequently, even when various disciplinary scholars act as if they understand each other, even when they think they are talking about the same 'thing', they may not be. Each has constructed an object within his or her own disciplinary universe of possibilities; each has made only certain relations visible, while rendering others invisible and unspeakable.

We have probably all found ourselves called into such impossible tasks. I remember when I first arrived at my current university, the Provost asked

me to get involved in a group writing a research proposal for a grant on the globalization of democracy. The initial problems were defined by linguistic, theoretical and methodological differences, but it did not take me long to realize that we were not operating in the same metaphysical universe, that the object that supposedly provided the common reference point of our conversation was so radically differentiated among us as to render cooperative labour and communication impossible. The problem is, no doubt, exacerbated in the US academy by the size of the academy itself, and both the rigidity and the power of the disciplinary formations and organizations themselves. But this assessment is probably too quick, for time and resources can mitigate the difficulties. For one thing, the languages of various disciplines may not always be as far apart as we might assume, and for another, assumptions can be laid bare and discussed. Even more, given time, languages can be learnt and conversations enabled. This is, after all, what often happens in the bench sciences; this is possible, one must add, because the system of grants and significant financial support often gives scientists the luxury of taking the time necessary to arrive at some common understanding of the object, built upon a necessary predefinition of a common research question, which has already been formulated in the grant application itself and subject to significant peer evaluation at all stages of the research. The human sciences rarely have the luxury of time and money, but more importantly, the fact that languages can be learnt does not guarantee that common objects can be seen or are being constructed.

In the human sciences, unfortunately, interdisciplinarity is more commonly embodied in practices that I earlier referred to as transdisciplinarity, which was for a while called travelling theory. It describes the appropriation of theoretical or methodological discourses, which are called upon to transcend or at least escape the particularity of any discipline. Yet the fact that both the common languages and marks of differentiation with the human sciences are often displayed in terms of transdisciplinary theoretical positions, concepts and premises means that it is easier to assert one's conclusions with statements of certainty that seem not to allow for real conversation or advance. The result is a proliferation of descriptions and explanations with no criteria for compromise, adjudication or even evaluation. To put it simply, how does one recognize or 'measure' whether the conversation has been advanced or not? Such theoretically defined conversations are also increasingly marked by political inflections that can make deliberate cooperation even more difficult. In my own efforts to establish a series of interdisciplinary research communities at my university, I found that the various groups often implicitly but visibly defined themselves as much by political commitments as by the theories that were assumed to ground them, in ways that further closed off the possibilities of productive and convivial disagreements.

Too often, such transdisciplinary practices generally fail to self-reflectively question whether moving concepts between contexts – cultural studies is less concerned with the disciplinary contexts than with historical contexts – is possible. They too often fail to acknowledge that such efforts require real work. And they fail to reflect on what kind of work it might require. Such practices are consequently particularly problematic in cultural studies, given its pragmatic and radically contextual approach to theory, although such transciplinary work is too often mistaken for cultural studies in the United States. Cultural studies assumes, in Stuart Hall's words, 'the mutual articulation of historical movement and theoretical reflection'.[6] This doesn't mean that concepts are entirely bound to their origins, but that to make use of concepts in other contexts, 'they have to be delicately dis-interred from their concrete and specific historical embeddedness and transplanted to new soil with considerable care and patience'.[7]

A third version of interdisciplinarity has become even more common than either of the first two; it involves what one might call guerrilla raids on other disciplines. It is also, in my opinion, the most problematic, for it ignores the questions of authority, competence and rigour (not in the sense of exactitude that operates in the bench sciences but in some other as yet unspecified sense, which has to be constructed differently inside and outside the disciplines). Often such raids involve highly selective extractions without knowing what the choice means or involves, because what one is choosing depends entirely on what one is not choosing. One does not necessarily know how whatever one is extracting is interpreted, judged or valued, because one does not know the arguments in which it is located, the alternatives that are present, or the complexities that surround and penetrate it. Too often, we do not treat other disciplines as potential critical interlocutors – asking what they know (even if, given the limits of disciplinarity, they do not know that they know it) and what tools they offer (even if they subordinate those tools to very specific ends). We treat them as a mere collection of statements from which we are free to rescue whatever may suit our purposes; they become resources for a project defined elsewhere, within our own discipline; these appropriations are made on the basis that they already agree with our positions, or they can be read into our own theoretical and/or political arguments. Or even worse, they are the result of fashion, as we turn to concepts, vocabularies and practices that are *au courant, a la mode* as it were. Unfortunately, for example, much of what passes for discussions of contemporary capitalism are based not on a serious engagement with the fields of economics and political economics, nor on a sustained empirical engagement with economic analyses, but on a habit of citing left-wing economists (with little regard to whether they agree or whether their own theoretical edifice is compatible with one's own) or 'postmodern' theorists on the economy. In 1990, Stuart Hall wrote what could have been

the response to the chair of sociology's attack from years earlier. Against this raider's view, he argues: 'We had to respect and engage with the paradigms and traditions of knowledge and of empirical and concrete work in each of these disciplinary areas in order to construct what we called cultural studies'.[8]

Cultural studies offers two other possible versions of interdisciplinarity, which I might call anti-disciplinary and alter-disciplinary. The former represents disciplines as vertical silos surrounded by impenetrable walls; interdisciplinarity refuses the vertical division of space in order to operate in the horizontal space between and through the silos, in the process deconstructing the very possibility of the disciplines. I am sympathetic with such arguments, especially when they reconstitute research and pedagogy as problem-centred rather than object-centred. But all too often, such approaches fail, like the earlier versions, to address the problematics of expertise and rigour. They fail to ask the epistemological question – how do you know and more importantly, how do you know what you know – because they have satisfied themselves with a kind of metaphysics of the horizontality of discursive fields. (Ironically, university administrators often buy into this image when they talk about teaching students to think 'outside' the box, but what they actually have in mind is teaching students to think inside two or three boxes.) But cultural studies is – and I believe, must be – problem-centred, always investigating the conjuncture as a problem space.

Alter-disciplinarity, or transformative interdisciplinarity is, I propose, the form of interdisciplinarity that cultural studies offers as its own practice or at least, its imagination of interdisciplinarity as a project and possibility. As Hall put it, again in what I think of as his answer to the chair of sociology: 'Serious interdisciplinary work involves the intellectual risk of saying to professional sociologists that what they say sociology is, is not what it is. We had to teach what we thought a kind of sociology that would be of service to people studying culture would be, something we could not get from self-designated sociologists. It was never a question of which disciplines would contribute to the development of this field, but of how one could decentre or destabilize a series of interdisciplinary fields'.[9]

This involves not merely recruiting the disciplines into the service of an interdisciplinary project but rather, the construction of that project as a conversation among interdisciplinary formations. If the disciplines as they are currently formed construct 'autonomous objects' disembedded from the complex structures of relationships that comprise the social totality, then one has to begin by 'fixing' or re-articulating the disciplines. That is, rather than simply taking up what the discipline 'knows', one has to push that knowledge back into the social formation, a formation that is always partly discursive, thus making explicit what it is that the discipline actually knows. In other words, this transforms the knowledge the disciplines thought they knew by

realizing that they did not and could not know what it was they had, what it was that they knew, without the larger context. In this sense, one might say, paradoxically, that cultural studies does not start by knowing anything, nor is it simply a thief stealing what it can from others. Rather, it is a generous thief, for it attempts to help those it steals from realize the value of what they have, and then steals it so that it can insert it into an even larger set of relations. As a result, each discipline becomes an interdisciplinary formation in its own right, re-inserting its object back into the complexity of relations in which it is embedded, in order for there to be a common reality as the basis of an interdisciplinary conversation. If each dimension has its own practices, logics and temporality, it is also the case that in being articulated together, each provides conditions of and resistances to the others, each partly constructs and deconstructs the others. Hard work indeed!

Cultural studies tries to understand the disciplines themselves within a logic of articulation and disarticulation, as forms of embeded disembeddedness. They think they are free of any entanglements with the rest of the disciplines but they are always deeply embedded with that totality; the question is what sorts of techniques do disciplines use to disembedded themselves or at least to construct the appearance of their own disembeddedness, which in turn has empowered at least some of the disciplines in powerful ways? In other words, we have to realize that the construction of autonomy, the fetishism of disciplinary objects, is an articulation of a real historical fragmentation that has to be struggled against. This does not make the disciplines into a single assemblage because each still has its specificity, defined now not by a singular object per se but by its unique way, its own forms of crystallization, into the complexity of the conjuncture. By emphasizing the complexity of the relations that constitute any object or event, every such object or event becomes a multiplicity or, in cultural studies terms, an articulated unity. It is not that the disciplines provide multiple perspectives on the same object, but that each constructs the context in terms of the relations afforded by the construction of its own entrance point.

Cultural studies becomes an interdisciplinary conversation among inter-disciplinized disciplines. It requires us to re-imagine the possibilities of such conversations, and the infrastructure necessary to move them forward. This is the continuing task of cultural studies, a risky task no doubt, but one that reaches into the imagination of the future possibilities of knowledge and education. But perhaps there is another way of thinking about cultural studies as interdisciplinary experimentation, another way of staging the conversation, not by starting with the re-articulation of what it means to be a discipline, but by constructing every site of investigation in a conjuncture as the intersection of multiple maps. It is to think of the interdisciplinarity of cultural studies as a cartographic practice.

Cultural studies reconstructs the conjuncture by mapping a multiplicity of planes or dimensions. I think of the work of assembling each map as comparable to that of putting together one of those mega jigsaw puzzles, only without the benefit of the picture that guarantees the outcome. Each piece you add is likely to change your sense of what is going on, and can modify the significance of other pieces. So the puzzle is constantly changing, constantly remaking itself. Now imagine a multi-dimensional jigsaw puzzle (start by thinking about Spock's three-dimensional chess), and you have some sense of the task cultural studies poses. I can identify three maps that are, I believe, integral to the imagination of the sorts of conjunctural analysis that defines cultural studies. First, one can construct what might be called a structural-materialist map of the complex relations, structures and contradictions within and among the political, economic, cultural and social levels or instances of the social formation. Each level is defined, we might say, by its own specificity (of practices) and by a certain relative autonomy. This is perhaps what most of us in cultural studies have been trying to accomplish; in Deleuzean terms, it is a map of the milieu – but we are too often pulled back into our own disciplinary comfort zones.

But another map might be constructed on the basis of something other than an articulated unity (structure of dominance) of levels. Such a map would diagram, across a number of dimensions, the multiplicities and articulations of the logics, formations and technologies of power, including the forms of resistance to which they respond and to which they give rise. Thus, instead of starting with economics as a predefined arena of markets or exchange or exploitation, we might begin to see it as a complex set of apparatuses of value production and capture, which cannot be separated from organizations of affective obligations and social relations, or from logics of commensuration. Similarly, instead of thinking of politics in terms of a preconstituted difference between ruling blocs, bureaucracies and 'the people', or between the state and the popular, we might think of it as a range of apparatuses of governance, including administrative, biopolitical (discipline, normalization, securitization), cultural (ideological, common sense), that are subjectivizing, differentiating and violent, as well as a range of counter-organizational apparatuses of resistance, cooperation and escape. Similarly we can reconceive the social in terms of the organization of time and space, and the distribution of populations according to logics of the same and the different, and the cultural in terms of the production of incorporeal transformations through the multiplicity of discursive formations and affective configurations. The result would be a hybrid Venn diagram-like map of the multiple logics and technologies of power and resistance, creativity and constraint.

A third map would (re)produce the conjuncture as lived or experienced, not in individualist or subjectivist terms; it would be a kind of map of the popular

or everyday life. It might be thought of as a social and material phenomenology in which 'experience' does not define the ground of truth but is rather simply one material element of the context, an empirical reality that is no more or less real, no more or less self-defined, than any other. In Deleuzean terms, this is a map of the territory as expressive; this map of the popular diagrams the ways people live with, within and against the organizations of reality described in the first map. It would describe how people actualize the logics of perception, judgement and calculation with which they confront the material realities around them, and the organizations of affective possibilities and limits that shape the vitalities, cohesions and textures of their lives. By embedding power in the lived, the conjuncture appears as a set of transversal vectors, marking the distributions of lived crisis and struggles: for example, dispersed crises of commensuration (in which one cannot calculate the comparable worth or value of commodities, financial instruments, art, knowledge, etc.); crises of temporality (making time itself into a problem in which the relation of past, present and future is indefinable); and crises of translation (in which the ability to find or articulate commonalities across differences disappears). Such a map of lived crises and struggles, of the instabilities and uncertainties that are constantly reconfiguring the conjuncture as a site of contestation, define both the limits and the possibilities of consent, adaptation and resistance; they shape the felt challenges of political change in people's lives. These vectors do not follow straight lines that neatly transect the space of the conjuncture; rather they appear as plot lines meandering all over the space-time of the conjuncture, like an ever-changing spider web.

The cross fertilization of these maps offer a rich interdisciplinary understanding of the conjuncture as a problem space, in which any event can be located as a point of crystallization (a strange attractor) constructed by the complex, contingent articulations of regimes of social practices, technologies of power, and lines of lived struggle. It suggests a different practice of interdisciplinarity, a more temporary and necessarily collaborative problem-centred approach, but one that seeks not to solve a problem but to, produce knowledge in the service of changing the world. It is a vision of the future project of cultural studies.

NOTES AND REFERENCES

1. The National Academies, *Facilitating Interdisciplinary Research* (2004).
2. When I was asked in 2005 by the dean of the College of Arts and Sciences of my university to lead a task force on Interdisciplinarity, I discovered that there had been four previous reports produced over a decade, almost of them filed away and ignored. The report we produced, 'Institutionalizing Interdisciplinarity in Academic Affairs

at UNC-CH' (April 2007) provides an overview of the various considerations that had already been offered and efforts already made by other universities including the University of California at Santa Barbara, the University of California at Los Angeles, MIT, the University of Michigan, the University of Ottawa, and Duke University. Additionally, numerous foundations have contributed to the discussion. In addition to those cited here, one might include The Boyer Commission's *Reinventing Undergraduate Education* (n.d.), and the Commission on Professionals in Science and Technology, *Mapping Academic Disciplines to a Multi-Disciplinary World* (2003). There is also a large body of more traditional scholarly literature on the subject (and even a professional academic organization devoted to it). Representative of this work is Julie Thompson Klein, *Interdisciplinarity: History, Theory and Practice* (Detroit: Wayne State, 1990) and *Crossing Boundaries: Knowledge, Disciplinarities and Interdisciplinarities* (Charlottesville: University of Virginia Press, 1996).

3. Social Science Research Council, *Interdisciplinary Research: Trend or Transition* (2004).

4. Association of American Universities, *Report of the Interdisciplinary Task Force* (October 2005).

5. This letter is available in the CCCS Archive at Birmingham University and is discussed in Connell and Hilton's contribution to this volume.

6. Stuart Hall, 'Marx's notes on method: A "reading" of the "1857 Introduction to the *Grundrisse*"', *Cultural Studies,* 17, 2 (2003), p. 137.

7. Stuart Hall, 'Gramsci's relevance for the study of race and ethnicity', in David Morley & Kuan-Hsing Chen (eds.), *Stuart Hall: Critical Dialogues in Cultural Studies* (London: Routledge, 1996), p. 413.

8. Stuart Hall, 'The Emergence of Cultural Studies and the Crisis of the Humanities.' *October,* 53 (1990), p. 16.

9. Ibid.

Part III

POLITICS

Chapter 9

The Centre's Marxism(s)

'A Little Modest Work of Reconstruction'?

Gregor McLennan

E PLURIBUS UNUM?

It seems to be widely agreed that for much of the 1970s, the Centre for Con-
temporary Cultural Studies (CCCS) was notably Marxist in some significant
sense, and that this phase was probably the Centre's most distinctive and coher-
ent. However, this generalization is no sooner stated than contested – or at least
problematized. The questions immediately multiply and compound. Is it valid or
even useful, for example, to even talk about the identity of 'The Centre' as such,
whether across its different phases or within each (supposed) phase? There were
plenty of people, after all, who were not (exactly) Marxists, and there were dif-
ferent sorts of Marxists. Even if we are referring to the Marxism, or otherwise,
of CCCS leaders, that still doesn't equate to the Centre's Marxism. Or does it?

Was it the Marxism that defined the cultural studies project in that period,
or was Marxism the discursive vehicle for more generic cultural stud-
ies concerns (and the residual tensions in all social investigation between
the theoretical, the empirical and the political)? After all, the injection of
Marxism into British academia from the mid-1960s, carried by large new
cohorts of young lecturers and postgrads, was very widespread, re-moulding
many existing disciplinary and interdisciplinary spaces.

Then, how much of the 1970s are we talking about, and to what degree?
It's not as though the part-decades either side of the seventies were *non-* or
*anti-*Marxist in cultural studies – or were they? And the now-legendary ten-
sions and unsettlings around race and gender, though kept under wraps to
an extent, were still right there working both *within and against* the central
Marxist concerns, were they not?

Next: was the Marxism *authentic* in the period when the CCCS was appar-
ently 'structured in dominance'? The very terminology triggers a controlling

response from straight Left perspectives, in the form of a syllogism: the dominant theoretical mode in the relatively coherent Centre period was Althusserian; but Althusserianism was both politically conservative and philosophically idealist (i.e. not Marxist); therefore, the Centre was not actually Marxist at the very moment it may have thought it was. Against this: even though the *terminology* of Althusser was taken up by many, his scientism, theoreticism, and anti-humanism were all strenuously qualified or actively opposed – partly through the counter-balance of Gramsci, but in other orthodox-, heterodox-, and non-Marxist ways too. In a candid retrospective, Colin Sparks suggests that *Working Papers in Cultural Studies* (WPCS) 6 on 'cultural studies and theory' marks the decisive break into Althusserianism (= not Marxism), conveniently failing to mention that Colin's own self-styled 'low-flying materialism' finger-waggingly occupies its first chapter, followed in short order by a crunching correction of Barthes by Iain Chambers and a frontal assault on Althusser by Robin Rusher, both of whom were way to the Left of simpering Gramscian Eurocommunism. Moreover, Stuart Hall's canonical reading of Marx's 1857 Introduction to the *Grundrisse* occupied a significant chunk of the latter part of the issue, the main aim of which was – surely? – to transcend rather than reinforce the polarizations of theory and history, structuralism and culturalism. Revisiting some of the same themes further down the line, WPCS 10 *On Ideology* carried the same mix and balance of old, new, hard and soft Left inclinations.

So: the questions 'What is cultural studies anyway?' and 'What is Marxism anyway?' are continually re-posed, sometimes symbiotically, sometimes not, and they don't stay stable enough to yield any satisfactory summation of the overlaps, interweaves and directions of dependency. At one point, we might have wanted to say that to be Marxist 'in the strict sense' requires embracing at least five dimensions, and in the right manner: a philosophical anthropology, a theory and methodology of history, a structural logic of capitalism, a socio-economic sociology, and a revolutionary class politics (from which the core prompts for cultural analysis would follow). But is that to say that we cannot be 'seriously' Marxist or seriously *engaged* with Marxism if we stick to just one or two dimensions, or dispute the going orthodoxy in any of them?

Economizing on the number of angles, Eric Olin Wright and associates in the 1990s stated the three constituents of Marxism as: the critical analysis of capitalism (powered by the labour theory of value); historical materialism as a stadial theory of social emergence and development; and diagnoses of the political present in terms of class and class struggle. Goran Therborn's more recent triangular schema features historical social science, dialectical philosophy and revolutionary politics. Along with many others, Wright and Therborn feel that these structures are now irremediably 'broken'. Each side of the triangles can be treated separately from the others, and each side requires much

pluralistic qualification if it is to hold up in any shape or form. In particular, revolutionary class politics, which in traditionalist mode formed the motivational apex that held the whole thing together, is unsustainable today, they say. Yet they see themselves as continuing the tradition of a Marxist sociology.

Those continuing to occupy the 'resilient Marxist' slot in what Therborn calls 'the repertoire of positions' will loudly protest, holding that these are excessive and pessimistic revisions, conducted by people who have, frankly, ceased to be Marxists. With considerable force, resilients nowadays point to the naked state of the world in support – the 2008 crash at the hands of finance capital, the accelerating centralization of productive resources, and the obscene, spiralling discrepancies of sheer wealth, noting also the corresponding revival of esteem for Marx's basic analyses and vision. Within cultural studies networks too, the increasing embarrassment around Marxism in the 1980s and 1990s has itself come to feel slightly embarrassing, such that discussions today around the event of Stuart Hall's death strain to insist upon his consistent allegiance to at least a broad Marxism, and of course to a raging anti-neo-liberalism, in spite of some obvious post-Birmingham, post-Marxist proclivities.

NOT A MARXIST CENTRE . . . AT LEAST IN ANY SIMPLE SENSE . . .

Given the difficulty of resolving these questions, the Marxism of the Centre in the 1970s can perhaps best be couched in 'Sartrean' terms. Famously, in *Search for a Method*, Sartre took Marxism to be the 'unsurpassable' philosophy of our time, especially with regard to the 'regressive/analytical' stage of a two-step 'regressive-progressive' procedure. That's to say, only Marxism, with its unrivalled comprehensiveness and 'totalizing' sequence of investigation (cf. my five dimensions), can enable us properly to 'situate' all manner of cultural phenomena and human aspirations, and in unapologetically historical-materialist terms. But 'lazy' Marxism is a constant danger, pre-emptively treating as 'concrete truths' what are in effect 'regulative ideas' and 'problems' to explore; failing to see that totalization is never complete, but 'perpetually in process'. This requires many more 'mediations' than comfortably entertained among the faithful – mediations that, for Sartre, included existentialism, psychoanalysis, sexuality and micro-sociology – which perforce operate within the orbit of Marxism like 'enclaves', but simultaneously both 'engender' and 'reject' it. Having established some indispensable hierarchies of determination, 'simple' Marxists then fail to embrace/perceive the richness and singularity of cultural 'projects', which, being possibility-oriented, constantly push to breach current identities and transcend given situations.

The 'progressive' step in the method of socio-cultural comprehension there-
fore involves a further stretch, towards a keen descriptive grasp of the 'the
profundity of the lived' and a theoretical commitment to history on the move.

So that was my quick way with Sartre, playing up his resonance today given
the current vogue in cultural theory of a certain sort of vitalism or affirmative
witnessing. The take-away point for our purposes is that the Sartrean two-
step formulation is in some ways better than talk of structuralism-culturalism
as a way of acknowledging the considerable variety of people, stances and
projects in the Centre without losing the sense that a tangible commonality
of discourse *was* also being worked through, with Marxism somewhere near
the hub of it all.

The opening contributions to the Routledge *CCCS Selected Working
Papers* are indicative in that regard, especially if they now possess premier
documentary status. Stuart's overarching Preface, for example, doesn't seem
quite right to me, either in itself or in relation to his own 1970s productions.
(I'll return to this in a moment.) He says that the CCCS was not 'in any simple
sense, a Marxist centre', and emphasizes its long-standing 'quarrel' with
orthodox Marxism. Nothing whatever to dispute there, but he then phrases
the notion of an 'all-encompassing framework in which culture could be ade-
quately thought' that some at Birmingham were aspiring to as though it nec-
essarily leads beyond *all* forms of Marxism. To me, this too swiftly conflates
directions sought at the time with directions taken since. Similarly, Stuart
talks about the constitutive importance of theorizing the 'relative autonomy of
cultural forms and the relationship between "the cultural" and other practices
in a social formation'. I hesitate over this too, because it's not as though any
set of 'other practices' you might like to flag up would fit the bill. It was the
relative autonomy of the cultural from *socio-economic practices*, the mode of
production, the 'economic base', that was primarily at issue. The very words
used to define the theoretical predicament here (relative autonomy, social
practices, social formation) are directly taken over from a wider Marxist
discourse that pre-existed and shaped these Centre moves.

A related toggling goes on in Larry Grossberg's (new) essay that fronts
the 'theory' part of Volume 1 of the *Selected Working Papers*. Somewhat
undermining his declared radical historicism, Larry reconstructs the debates
around what were chiefly Marxist conceptual problems as though they were
eternal features of cultural studies scholarship, in which the 'substantive'
impulse continually rubs up against the 'methodological or meta-theoretical'
impulse. And he repeats a couple of frequently heard but surely deficient
designations of what the business of conceptual construction involves at any
time, and certainly not at *that* time, namely 'making it up as we go along',
and using theory like a 'tool box' that we can dip into in order to prise open
all manner of immensely complex issues. Such pragmatist sentiments would

find ready endorsement (at any time) from the sorts of pluralistic (but not indiscriminate) sociologists that cultural studies people customarily enjoy denigrating. Fortunately, that was only part of Larry's reconstruction, because there are other contrary emphases in play, and the texts that he singles out as greatest hits – *Policing the Crisis, Resistance through Rituals* – are accepted as addressing 'central Marxist concerns' though, it goes without saying, not in a 'reductive' way.

The introductions to the 'big blue books' are a little more straightforward in describing the necessary double emphasis. Thus, in the first volume, Ann Gray states that the struggles over the cultural studies project in the 1970s took place specifically in relation to whatever grounding a 'Marxist framework' offered, while the editors of Volume 2 effectively note that 'the Marxist conception of consciousness, whilst contested, served as a framework within which different forms of cultural expression could be subsumed'. These are 'Sartrean' markers of a basic kind – Marxism not so much as established 'content', more as problem-formation and an overarching horizon (though Althusser's notion of a dominant 'problematic' still looks useful too).

But something a little more detailed could be suggested in terms of the logic of Sartre's progressive-regressive method. As a first-phase matter of explanation and 'situating', *some* kind of Marxist analysis was generally accepted as the starting point in most Centre contexts. At the Centre general meetings, especially when discussing whether our notion of organic intellectuals was going to reach as far as covering action in support of this or that workers' dispute or community project, it seemed that quite a spread of (perfectly genuine) Marxist/socialist allegiances were brought to bear, including Marxist/socialist-feminist allegiances. Was this just a case of the loud Marxists out-talking the non-Marxists, in the same way that the men talked over the women? I don't think so. And I don't recall any obvious 'hegemony' being exercised by *Marxism Today*-style comrades over the doctrinally tougher, who certainly made their presence felt.

On the more ostensibly academic side, but still partly in the hazy realm of personal memory, most of the subgroups I attended featured key Marxist texts and authors as the obvious pivots around which debate needed to flourish. The British Marxist historians in the history group; Poulantzas in the 'state' group; Voloshinov and Brecht in the 'language and ideology' group; Macherey in the 'literature' group; Braverman in the 'labour process' group . . . and so on, quite apart from Marx and Engels in person. Of course, I only went to some of the large (and shifting) array of groups, and quite possibly the ones I chose were bound to be more Marxisant than others, given that that's what I was looking for (in a suitably complex way, I trust). But my sense is that other than 'heavy' economic theory around the details and sustainability of the labour theory of value, which was not conspicuous in the CCCS, large tracts

of the five Marxist dimensions mentioned earlier were indeed being explored and developed across the board, as well as being critically probed. And even in the eddies of the stream where a certain heterodox swirling ruffled the flow, with associated discomfort on all sides, the *engagement* with Marxist texts and concepts remained deep and genuine. Ros Coward's *Screen* stand-off with a group closely aligned with Stuart Hall, and John Ellis's scything of Charles Woolfson's attempt to take Voloshinov up to Glasgow (a 'debate' reprinted in *Selected Papers* Volume 1, chapters 16 and 22) are obvious cases in point. Steering clear of the details or merits of those heated exchanges, it's apparent that the polemics revolved around who could legitimately take the neo-Marxist high ground: What was the best way with a properly materialist analysis of signification and subjectivity, and at what point does being residu-ally non-reductionist leave you with nothing much to say?

The subgroups provided the material and coherence of most of the annual issues of WPCS, and in those texts it's again evident – always only up to a point, I grant – that when it comes to the analytical/'regressive' axis of prob-lem-formation, there was a definite commonality in Marxism. For example – to develop an earlier hint – in several journal issues the figure of sociology was constructed as decidedly 'not us', meaning, to a considerable extent, not Marxist. A (negative) chain of association was presumed and illustrated in each case: Sociology = positivist, superficial, concerned exclusively with values in others, spuriously value-neutral itself, apolitical or merely reform-ist, and therefore obscurantist, distorting, dangerous (= *ideological*). Thus, even in *Resistance*, which clearly takes much from sociology and features sociologists among its authors, a veritable 'sociological trinity' of substan-tive ideas about post-war social change – affluence, consensus and *embour-geoisement* – was targeted for demolition. Methodologically, participant observation research was deemed to be indelibly tarnished by 'naturalistic' methods that actively supressed the commitments and subjectivities of the researchers; it had a 'mystified consciousness of its own practice'; and even Howard Becker was held to plunge us into a 'depoliticised and de-moralised phenomenological never-never land'.

In similar vein, cases were built against other sociological distinctions and approaches: Parkin's division of working-class value systems into dominant, subordinate, and radical types (in *On Ideology*); the *Affluent Worker* scheme of solidaristic versus instrumental mindsets (in *Working Class Culture*); educational sociology's categorizations of 'disadvantaged' and non-disadvan-taged children (in *Unpopular Education*); and the race relations sociologists' default contrast between 'weak' and 'strong' family groups in the process of ethnic 'acculturation' (in *The Empire Strikes Back*). The problem with all these schemas was that they remained on the surface, 'hyper-typifying' real experience, reifying empirical groups, concentrating on evidence from

attitudes not underlying material realities, remaining merely descriptive when they should be fully *explanatory*. And being fully explanatory meant grasping the fundamental material logic of capitalist society, especially its *class* nature. Sociology's inability to reach that level of depth derived from sociologists' own petit bourgeois class location and the nature of the discipline itself as, at best, a social-democratic project (said Eve Brook and Dan Finn). No doubt some decent critical sociologists could *entertain* Marxism, but they could not rigorously embrace it, said Chas Critcher, because even though studies like the *Affluent Worker* were 'meticulous, sophisticated, substantial', to the point of approximating a 'skeletal' Marxism . . . this was ultimately only of a 'confused' sort. The Education Group noticed a significant attempt at structural analysis in the 'old' sociology of education, but this 'was not related to the class organization of the society as a whole'. Errol Lawrence saw that the race sociologists could recognize 'class differences', but they just didn't get 'class determinations'. In Paul Gilroy's terms, the most they could achieve was a 'sociologistic pseudoMarxism'.

The authors of *Women Take Issue (WTI)* felt no need to dwell by proxy on the flaws of sociology in relation to what was better in Marxism, because the Women's Studies Group was fully and directly engaged in the interrogation of the adequacy of the core Marxist concepts themselves. Complex arguments, acute cultural observations embodying the theorization of lived difference, and tough political questions for and from feminism were spread throughout WPCS 11 in relation to the patriarchal character of both doctrinal Marxism and the political Left. As often noted, this intervention – not just the publication of the journal, of course – profoundly disrupted habitual Centre tenets, norms and practices. And in a sense there was no going back: the steady displacement of Marxism out of the central organizing position in radical thought through the 1980s was well under way here. Yet the 40-page chapter 3 of *WTI* (together with its sequel in chapter 8) by Lucy Bland, Charlotte Brunsdon, Rae Harrison, Dorothy Hobson, Frank Mort, Chris Weedon, and Janice Winship represents perhaps the single most sustained, collectivized analysis of the 'structured relations of production and reproduction' to have taken place at the Centre, and as such should be acknowledged, whatever its other goals, as a highly original contribution to neo-Marxist understanding.

STUART HALL – INTELLECTUAL MEDIATOR IN AND THROUGH MARXISM

I don't think I've said anything terribly controversial so far; I've only been trying to supply a few specifics – mildly interesting I hope – to fill out the general statement I opened with, freely culling reminiscences and texts to

that end. But now I want to say something that might be more provocative, to do with how we are to look back on Stuart Hall's own Marxism, and to that extent, on a significant aspect of cultural studies at Birmingham. Again, it goes without saying that in his essays and teaching Stuart continually sought out – as Richard Johnson constantly did – 'the best Marx'; avoided at all costs any crass recycling of '*Manifesto* Marxism'; developed projects and ideas in a number of areas in a novel and admirably 'conjunctural' way; simultaneously added to and breached the genre instructions of traditional historical materialism and routine class analysis. Cultural studies, in Stuart's hands, was emphatically more than 'applied Marxism', under any brand label (possibly even 'Gramscian'). Luckily, however, this is allowed for in my 'Sartrean' gloss on what it means still to be Marxist, because the main divergencies, as I see it, pertain to the 'progressive' leg of the regressive-progressive two-step, namely, the characterization and appreciation of movements and moments once the provisional analytical 'situating' has been worked through in something like standard Marxist terms. Plus, there's an opposite misconception that needs adjustment: the idea that cultural studies, principally in the person of Stuart, developed a set of distinctive problems and concepts all of its/his own. (*Nota Bene:* I am aware that a longer paper is needed to substantiate the following assertions.)

Steering back to Stuart's reading of the '1857 Introduction', for instance, there's no doubt that this was an early, fertile, *quality*, commentary and problem-raiser on a difficult and puzzling text. But some readers of the reading find more in it than is actually there, and more than Stuart claimed for the piece (he was seldom wrong about people, including himself). It has been said, for example, that in the parts illuminating Marx's handling of the production-consumption nexus, Stuart develops a distinctive repertoire of the three forms of intermediation between these two signifying poles – but actually, it's all rather squarely there in Marx's own words, as an even longer, meticulous exegesis like Terrell Carver's makes clear. And it's sometimes suggested that Stuart plies the sections on the relationship of the sequence of analytical categories to the real (and imagined) historical order so as to come up with a precise historicized epistemology, or perhaps something stronger, a historicist critique of epistemology – but if you want that full and feisty case, it is Derek Sayer (in *Marx's Method*) that makes it, not Stuart. Finally, it's sometimes said that in the 1857 reading Hall intimated the basis of his own developed 'method of articulation' (supposedly coming to maturity after his entanglement with Ernesto Laclau) – but his articulation of the movement from the context-less abstract to the concrete as the result of multiple determinations, though thoroughly well rounded, was along the lines of what others were digging out of Marx too, such as David Hillel-Ruben, Galvano Della Volpe, Althusser, of course, but also his nemesis Sartre in a short-hand

summary in *Search*. What Stuart was certainly doing, and inimitably, was synthesizing, at one remove, the structuralist and culturalist tendencies on the broader Marxist and radical scene that many others could not bring themselves to inter-relate.

Now leap ahead to possibly the most cited of all Hall essays on our topic, 'The Problem of Ideology: Marxism without Guarantees'. This 1983 publication came after the Birmingham years, and it provided the title of a later collection in Stuart's honour, with the reference to Marxism rather stunningly omitted (from the book as well as from the title). This may in turn have been responsible for the curious emerging tendency to suggest that being 'without guarantees' – of anything! – was Stuart's signal contribution to critical thinking in general (though a better bet, if you wanted overarching guarantee-less-ness, would have been Isaiah Berlin). As to the paper itself, for once – in my view – the rhetoric was a touch out of kilter. It certainly had the *form* of Stuart's typically inspiring interventions – the gifted re-posing of a major issue, inclusivist insight into the different available interpretative takes, imaginative sideways borrowings and an authoritative, though always generous and provisional, resolution. Yet, implausibly excessive caricatures of standard Marxism were quickly set up, against which the 'immense force' of post-structuralist criticisms had to be readily conceded. A due balance was not looking promising, despite the stated intention of rehabilitating important Marxist ideas by way of 'a little modest work of reconstruction'. As a consequence, hard work had to be made of a series of mightily qualified, negatively charged formulations, along the lines of not being *fully* convinced that the critiques 'wholly and entirely abolish every useful insight, every essential starting point' in a materialist theory of ideology.

My own rhetorical purpose in 'bending the stick' a little around these two celebrated expositions can now be directly revealed. To me, the quality, scholarship and force of several essays of Stuart's, written when he was less loosely bound to the organizing terms of a Marxist theory of culture and ideology – in its analytical or 'regressive' dimension at least – and when he cannot easily be depicted as theorizing for the sake of cultural studies per se, are in danger of being overlooked or undervalued.

I'm thinking of the essay on Marx in *Class & Class Structure* (1977), being the written version of the meticulous preparation Stuart did for his hugely impressive slot in a high-powered conference involving Nicos Poulantzas, Paul Hirst and Jean Gardiner among others. I'm thinking of the chapter reworking 'base and superstructure' in *Class, Hegemony and Party* (also 1977), marking Stuart's scintillating entry on to the stage of the 'Communist University of London' a year or so before. And I'm thinking of 'The Hinterland of Science' paper, hurried out of him late in the day by the editorial team of *On Ideology* (yet again, 1977), but brimming with

strenuous connectivity across a staggering range of reference. And the common themes were as already mentioned: the best Marx, relative autonomy, grasping – fully – 'both ends of the chain', signification and determination, the first and the last instance, understanding the idea of society as a 'complex unity' without that turning into an endless series of plural cultural identities. He had, of course, a naturally open and hybrid sensibility, and perhaps he also just needed, over time, to move on somewhat. I am *not* saying that this Hall was the best or the only Hall, all things considered. But there's no reason to question the author's statement that in these pieces he was working – somewhere, but firmly – 'within the framework of Marx's problematic', within the 'analytical matrix' set by the concept of 'mode of production', and there's no doubt that this delimited commitment enabled Stuart to exhibit to the full the style of theorizing – that of grand, but political, intellectual mediator – in which he truly excelled.

NOTES AND REFERENCES

The text of this contribution, I hope, makes clear which authors and points can be found in which volumes of CCCS papers. I therefore only list the latter here, followed by details of publications mentioned that are not collected under the Centre's auspices as such.

Cultural Studies 6: Cultural Studies and Theory (Birmingham: CCCS/Russell Press, 1974).

Resistance Through Rituals: Youth Subcultures in Post-War Britain (London: CCCS/ Hutchinson, 1976).

On Ideology (London: CCCS/Hutchinson, 1978).

Women Take Issue: Aspects of Women's Subordination (London: CCCS/Hutchinson, 1978).

Working Class Culture: Studies in History and Theory (London: CCCS/Hutchinson, 1979).

Unpopular Education: Schooling and Social Democracy in England Since 1944 (London: CCCS/Hutchinson, 1981).

The Empire Strikes Back: Race and Racism in 70s Britain (London: CCCS/ Hutchinson, 1982)

CCCS Selected Working Papers, Volumes 1 & 2, (eds.) Ann Gray, Jan Campbell, Mark Erickson, Stuart Hanson, and Helen Wood (London: Routledge, 2007).

Other references:

Colin Sparks, 'Stuart Hall, cultural studies and marxism', in David Morley and Kuan-Hsing Chen (eds.), *Stuart Hall: Critical Dialogues in Cultural Studies* (London: Routledge, 1996).

David Hillel-Ruben, *Marxism and Materialism: A Study in Marxist Theory of Knowledge* (Hassocks: Harvester, 1977).

Derek Sayer, *Marx's Method: Ideology, Science and Critique in 'Capital'* (Hassocks: Harvester, 1979).

Erik Olin Wright, Andrew Levine, and Elliott Sober, *Reconstructing Marxism: Essays on Explanation and the Theory of History* (London: Verso, 1992).

Galvano Della Volpe, *Logic as a Positive Science* (London: Verso, 1980).

Goran Therborn, *From Marxism to Post-Marxism?* (London: Verso, 2010).

Jean-Paul Sartre, *Search for a Method* (New York: Vintage/Random House, 1968).

Stuart Hall, 'The "Political" and the "Economic" in Marx's Theory of Classes, in Alan Hunt (ed.), *Class & Class Structure* (London: Lawrence and Wishart, 1977).

Stuart Hall, 'Rethinking the "Base and Superstructure" Metaphor', in Jon Bloomfield, et al. (eds.), *Class, Hegemony and Party* (London: Lawrence and Wishart, 1977).

Stuart Hall (with Iain Chambers, John Clarke, Ian Connell, Lidia Curti, and Tony Jefferson), 'Marxism and Culture: Reply to Rosalind Coward', *Screen*, 18, 4 (1977), pp. 109–19.

Stuart Hall, Chas Critcher, John Clarke, Tony Jefferson, and Brian Roberts, *Policing the Crisis: Mugging, the State and Law and Order* (London: Macmillan, 1978).

Stuart Hall, 'The Problem of Ideology – Marxism Without Guarantees', in Betty Matthews (ed.), *Marx: 100 Years On* (London: Lawrence and Wishart, 1983).

Rosalind Coward, 'Class, "Culture" and the Social Formation', *Screen*, 18, 1 (1977), pp. 75–105.

Terrell Carver, *Karl Marx: Texts on Method* (Oxford: Basil Blackwell, 1975).

Chapter 10

Early Feminism in the CCCS

Stories and Reflections

Maureen McNeil

The crest of the second wave of feminism delivered me into the Centre for Contemporary Cultural Studies (CCCS). In 1980 I was appointed as lecturer in women's studies in the CCCS at the University of Birmingham. The specification for this post came directly from the eruption of feminism within the CCCS. So I owe much to the encounter between the CCCS and feminism. However, I was rather surprised when I was asked to make a contribution on 'early feminism' for one of the round table discussions that structured the CCCS 50th Anniversary Conference since I wasn't around the Centre during the 'early feminist' period (c.1974–80).[1] Indeed, as noted above, I came to the CCCS precisely *because of* this eruption of feminism. I thought the organizers were either confused or perverse in not asking one of the 'early' CCCS feminists to step into this breach. I'm not sure quite why I decided just to get on and do it, but there is no doubt that the following commentary comes from a very specific vantage point. My musings about feminism and the CCCS primarily up to circa 1980 are reflective and speculative, filtered through my distinctive personal lens. Others will have their own accounts (some more directly experiential) of the entry of feminism into the CCCS and perhaps about the background to the decision to create a lectureship in women's studies within the Centre. For these reasons, this piece is a very particular take on 'early feminism' in the CCCS. I begin by examining some of the stories which have already circulated about the emergence of feminism within the CCCS and then I return to its traces, particularly in *Women Take Issue* (*WTI*), to draw out other features of 'early feminism' at the CCCS.

FEMINISM AND THE CCCS: UNEASE AND INTERRUPTION

Reviews and appraisals of the early encounter between feminism/feminists and the CCCS have tended to register difficulties, unease, interruption and disturbance in the wake of this meeting. The first public stock-taking was offered in 1978 by the *WTI* Editorial Group who cited the impetus for their project as coming from their unease generated by 'the continual absence from CCCS of visible concern with feminist issues' and their finding it 'extremely difficult to participate in CCCS groups'.[2] This unease was echoed by the editors of the later CCCS feminist volume, *Off Centre: Feminism and Cultural Studies* (1991),[3] who looked back on the history of feminism within the CCCS, surmising that: 'the relationship between feminism and cultural studies is not always an easy one'[4] and, indeed, the very title of this volume signals this.

Twelve years after the publication of *WTI* and more than ten years after his departure from CCCS, Stuart Hall reflected on the first stirrings of feminism in that Centre. In an international cultural studies conference at Champaign-Urbana, Illinois, he offered what is by now the most graphic and possibly most infamous commentary on the emergence of feminism at the CCCS: 'As the thief in the night, [feminism] broke in; interrupted, made an unseemly noise, seized the time, crapped on the table of cultural studies.'[5]

It is striking that feminist cultural studies scholars have not noticeably recoiled from this 'profoundly shocking description'.[6] Charlotte Brunsdon, who was herself a member of the *WTI* Editorial Group, and Sue Thornham, a UK cultural studies researcher without direct affiliation to the CCCS, while both clearly troubled by Hall's intervention, have thoughtfully, it could even be said, productively, responded to it.[7] Reflecting on Hall's take on the 'interruption' of cultural studies by feminism and on his jarring formulation, with its scatological imagery, launched these two researchers on their own distinctive explorations of cultural studies' politics and theory. Brunsdon interpreted Hall's comments as a reminder of the 'materiality of political and theoretical disagreements', in a set of reflections about the emotional landscape of the political/intellectual life of 1970s CCCS.[8] Her response takes on a reflexive, personal tone as she acknowledges and even documents her own implication in the 'rows', 'betrayals', 'rejections' and 'trauma' entailed in the 'challenges' fuelled and informed by the Women's Movement which resonated in the CCCS during the late 1970s (Brunsdon's own terms). Nevertheless, this personal tone becomes political as she ponders the costs, as well as the benefits, of identity politics, particularly as they were manifested in the CCCS in the 1970s. This informs her insistence on the need for historicization and specification in invoking the categories of 'woman' and 'feminist'. It also leads to

her suggestion that, by the late 1990s, feminism had increasingly come to be regarded as a matter of positioning, rather than identity.

Thornham is more detached in her approach to Hall's commentary, although like Brunsdon, she neither dismisses his remarks nor condemns him for making them. She draws attention to the registers of voice, language and narrative in comparing Hall's appraisal with the accounts provided by the *WTI* editors. While clearly perturbed by Hall's construction of feminism as effectively outside of cultural studies, as 'a hostile, potentially invasive force', she is also disturbed by the uncertainty and lack of confidence she finds in the editorial voice of *WTI*.[9] She does not hesitate to state that she detects the 'marginalization of women and feminist theory' in her reading of these markedly different accounts of feminism's entry into the CCCS. In response she sets out to bolster feminist cultural studies by extending its theoretical resources and by demonstrating its intellectual achievements. One crucial strand of Thornham's project entails the invention or unearthing of a theoretical canon for feminist cultural studies as she nominates intellectual/political 'mothers' whose work might be placed alongside that of the established 'fathers' of cultural studies.

Writing later in an introduction to a collection of early feminist CCCS stencilled papers and with direct reference to Brunsdon's and Thornham's responses, Janice Winship, another member of the *WTI* Editorial Group, downplayed Hall's scatological framing with an amusing reference to pigeons' deposits in rooms on the 8th floor of the Muirhead Tower (the location of the CCCS at the University of Birmingham from 1977). She gives Hall's comments a further positive spin, suggesting that his intervention may have enabled a 'long overdue public discussion' about feminism in the CCCS.[10] Nevertheless, Winship's commentary does provide some graphic detail about the difficulties women experienced within the CCCS from 1972 to 1980, as she recalls the obviously too rare moments when she was '[personally] emboldened enough to contribute' to CCCS discussions, the 'dislocation for women' there, and the sense that feminism was regarded by other members as 'a threat to defend against'.[11]

Some more distanced commentators have also picked up on the reports from the front line of the encounter between feminism and cultural studies in the CCCS alluded to above, pondering and sometimes amplifying the registration of difficulties. For example, the Australian cultural studies chronicler Graeme Turner observed: 'One might have imagined that cultural studies provided a theoretical and political environment within which feminist work could prosper *but* . . .' It is worth noting that Turner rounds off his account with the following appraisal: 'The feminist contribution to cultural studies has been immensely productive and profoundly discomforting.'[12]

The intensity of the appraisals and re-appraisals of the impact and significance of early feminism for the CCCS and cultural studies more generally threatened to render me speechless or at least with nothing to write about in this piece. But I couldn't let myself off the hook that easily, not least because there is no doubt more to be said about early feminism in the CCCS and also because the pattern of evaluations, responses and consequences are themselves so fascinating. I will now briefly add my own gloss on these commentaries and exchanges.

I begin by the somewhat straightforward observation that there is a shifting reference point as the perusal is, in some instances, focused on feminism and the CCCS and sometimes on feminism and cultural studies (the field more generally). For very good reasons, *WTI* contributors often fused the two: their unease is about their positioning within the CCCS and about their uncertain relationship to the emerging field of cultural studies. Quite simply: the CCCS *was* cultural studies and cultural studies *was* the CCCS for them. They were all postgraduate students, undertaking their first publications, finding their feet on a tricky terrain – cultural studies – that was then itself in formation. There was, at that point, and particularly from their vantage point, no certainty that a field that might be called 'feminist cultural studies' should, could or would be forged.[13] Their uncertainty and insecurity about this was palpable and this is what Thornham picks up on.

The pattern in later reviews has been generally one of extracting the positive contributions and achievements of feminist cultural studies from those experiential difficulties within the CCCS in the 1970s. In this regard I think it is worth paying close attention to the commentaries and to the positioning of their articulators. From rather different perspectives, Stuart Hall and Charlotte Brunsdon can both recall the visceral pain and messiness associated with the birth of feminist cultural studies, while knowing that, as they were speaking or writing, it was alive and developing. By the 1990s there was a strong cluster of work, a record of intellectual achievement associated with feminist cultural studies that had earned the respect of Hall and his international audience at the large cultural studies conference he addressed in Illinois in 1990. Brunsdon draws attention to this in contextualizing Hall's otherwise alarming picture of feminism as an invasive, messing interruption. Although not complacent about the banishing of sexism from the field, she is sufficiently confident about the status of feminist perspectives within it that she declares that 'the gender agenda' has become part of cultural studies' 'common sense', making at least 'token attention to gender' a feature of the field.[14] Moreover, commenting in the 1990s, both Hall and Brunsdon insist that cultural studies cannot and should not be associated exclusively with the CCCS.

The various evaluations, reviews and revisitings indicate the importance of noting from whose vantage point, when, and on what terms appraisals of early

CCCS feminism have been made. The *WTI* authors were explicitly register-
ing that neither they as women and/or as feminists, nor feminist insights were
being accommodated within the CCCS and within cultural studies as it was
being constituted in that institutional location in the late 1970s. Much later
Hall frames the attempts to make space for feminism in terms of illegitimacy
(illegality), interruption of and messing with a seemingly pre-existing CCCS
project and order. As Thornham detects, these accounts of feminism and
feminists in the CCCS expose not merely matters of difference, they bespeak
differentials of authority and power. I might add in this regard, that there are
also significant differences between dealing with disenfranchisement and
dealing with interruption.

In addition, in considering later commentaries, it is striking that Turner's
review contrasts markedly with that offered by the editors of *Off Centre*,
the *WTI* successor project. Franklin, Lury and Stacey present the problems
between feminism and cultural studies as *relational*, as they seek to scope the
terrain for their generation of feminist CCCS members. Turner, despite the
benefit of hindsight and his summative assessment that the feminist contribu-
tion to cultural studies has been 'immensely productive', characterizes that
input as 'profoundly discomforting'. In this summation the experiential angst
of Hall coming out of a specific time and setting – a conjunctural moment (in
cultural studies terminology) – is recast as a fixed characterization of feminist
cultural studies. In effect, a rather problematic, patriarchal and retrospective
evaluation deriving from immersion in a very intense set of confrontations is
rendered as a more sweeping assessment of feminist cultural studies.

As it happened I was a feminist who was catapulted in 1980 into the so-
called mess which had been precipitated by feminism's appearance in the
CCCS. As I recall I was mostly excited, if somewhat nervous, about my
appointment as a lecturer in women's studies there. Bright-eyed and rather
naïve, I had no real sense of what this placement would mean then. However,
I now see some of the unease, the clashes, and the challenges that preceded
and possibly precipitated (and which certainly did not end with) my appoint-
ment as rather inevitable.

This returns us to the historical conjuncture and the positioning of the
CCCS and feminism in the 1970s. The CCCS and the Women's Movement
were contemporaneous, co-terminus social and political emergences. The
CCCS was founded in 1964 and second-wave feminism was surfacing in
Britain and elsewhere by the late 1960s. As this dating indicates – feminism
wasn't there at the outset of the CCCS, but by the mid-1970s it had seeped
or 'broke[n]' in. This was partly as a result of the expansion of access to
higher education in Britain which entailed not just the entry of scholarship
boys (among whom were Richard Hoggart and Raymond Williams) into the
academy in the 1950s, but which, from the 1960s, also included more women

(mainly middle-class at first but, increasingly, some from working-class families as well). As the Editorial Group of *WTI* noted, up until 1974, there had been only two or three women, while there were twenty men working in the CCCS and then in 1974 there was something of an influx of women.[15]

But it was not merely the physical presence of female postgraduates (and eventually female staff members) that brought feminism to the CCCS, it was the engagement (unevenly, variously manifested, and with diverse consequences) of increasing numbers of CCCS members with the activism and ideas of the wider Women's Movement that brought feminism into the corridors of the CCCS. Given that the CCCS and this movement were both stirrers and shakers of the social and political world of 1970s Britain, clashes were rather inevitable.

The 'early feminist' CCCS members were trying simultaneously to come to grips with cultural studies and to bring it into dialogue with the activities and perspectives of the Women's Movement. There were many complications and challenges to this work of translation, transformation and perhaps even transubstantiation. Elsewhere in the academy women's studies was emerging as the most obvious vehicle for such work. Not surprisingly, feminists in the CCCS invoked this emerging alternative inter-discipline both to orientate and to bolster their own investigations. Unsure of their standing within cultural studies, it sometimes seemed that they quite simply *were doing* women's studies.[16] However, that was not straightforward either, not least because of tensions that animated the contemporary British Women's Movement, including between activism and academia, with there being considerable scepticism about academic institutions, intellectuals and theory afloat at that time. This aside, awareness of and commitment to the accumulating traditions, practices, priorities and even theoretical debates of cultural studies predominated and distinguished CCCS work from other strands of women's studies.

My characterization of CCCS feminist stirrers and shakers is also a reminder that there was no way feminism's manifestation within the CCCS could have been anything other than disturbing. Analysing women's 'subordination' (the term used in the *WTI* subtitle) required considerable 'unsettling' of established relations (to borrow from Thornham's subtitle). Here we might also remember the diverse forms of militancy at key moments in the history of feminism. (Not that there was, to the best of my knowledge, any burning, looting or sacrificial heroism in the CCCS!) From a rather different perspective, projecting anachronistically and deploying the broadest connotations of the term, perhaps early feminists could be said to have been *queering* the terrain of cultural studies in terms of its orientations, priorities, questions, approaches and methodologies. However, if we look at it genealogically, early feminist disturbance in and of the CCCS fits with longer patterns in gender and sexual politics. In the CCCS this disturbance enabled the filtering

in of new priorities and concerns as cultural studies was recast not only to interrogate class oppression, but also to address gender, sexual and other forms of oppression; as women's lives (as well as men's) were brought into focus; and as, for example, soap operas as well as current affairs programmes became topics for cultural studies investigations. This upheaval also entailed fresh scrutiny of the political/intellectual tools available to analyse contemporary power relations (especially, but not only gender relations) – particularly of the repertoire provided by even an enriched (particularly by the theories of Althusser and Gramsci) Marxist tradition.

Last but not least, in revisiting the exchanges about early feminism causing a mess within the CCCS, I think there should be some acknowledgement that it was the capacity to disturb, to challenge conventions and assumptions, to refuse containment which characterized the CCCS itself and the forms of cultural studies it fostered. CCCS protocols and practices were about transdisciplinarity, breaking down barriers between teachers and students, experimentation in modes and forms of publications, reaching out to local communities and bringing their members into the CCCS, revising and questioning Marxism, etc. In short, these were precisely about disturbing the status quo, messing things up. Indeed, in his Illinois address Stuart Hall was himself pushing against the containment and packaging of cultural studies as it was coming out in the United States and elsewhere: challenging its reduction to cultural theory, calling for continuous and dispersed reinventions of its traditions in site-specific variations. In effect, he was telling his audience: if you want to do cultural studies, be prepared for interruptions, disturbance and mess.

REVISITING *WOMEN TAKE ISSUE*

In this section I step back from the trouble and the troubling, from the fray of appraisals of early feminism at the CCCS, to look more closely at some of its traces myself. As the preceding discussion suggests, early feminism at the CCCS was forged with reference to both the Women's Movement and to the political concerns (primarily pertaining to class issues, informed by Marxism) being generated within the Centre more generally. In the following discussion, mainly through my own rereading of *WTI,* I explore some further features of early feminism at the CCCS.

Women Take Issue was a brave, Janus-faced experiment in forging feminist cultural studies: it spoke to Marxists in the language and with the insights of feminism and it deployed Marxism to unpack the structures of male power. Much of the analysis shows the authors wielding the tools of Marxist theory, demonstrating that these feminist CCCS analysts were mistresses/masters of

its nuances, pulling it in new directions to accommodate the study of gender relations.[17] The article 'Women "Inside and Outside" the Relations of Production'[18] exemplified this. It is an admirable, if somewhat contorted, exploration of how far Marxist analysis could, at that time at least, be stretched in an attempt to understand women's position in contemporary capitalism. As Brunsdon has quipped, it was a product of: 'A time when we thought . . . that we could make Marxist and feminist categories fit together.'[19] It is not smooth or conclusive, but it clearly did demonstrate that CCCS women were serious Marxist theorists, while highlighting the limitations of that theoretical framework for addressing women's oppression.

Their perceptions of the limitations of Marxism launched some early CCCS feminists on a search for better resources for investigating the personal dimensions of the political, mindful as they were that much female oppression was not restricted to the realm of production. In this regard they adopted what has subsequently come to be regarded as a characteristically cultural studies strategy (at least in its CCCS incarnation) of 'mapping the field'. This took a disciplinary form. In this sense, the pursuit of the 'personal as political' was disciplined in a quite literal way. They made forays into disciplines and traditions that might provide fresh resources that would help them address the parts that Marxism couldn't reach in the study of gender relations. The two prime disciplinary encounters rehearsed in CCCS stencilled papers and *WTI* were with psychoanalysis and anthropology. In both these forays the authors took their cues from intellectual currents of the contemporary Women's Movement. Juliette Mitchell's *Psychoanalysis and Feminism* had garnered considerable attention when it appeared in 1974 and Brunsdon recalled the CCCS Women's Study Group undertaking 'a long collective reading' of it.[20] Mitchell's text figures prominently in the article by Steve Burniston, Frank Mort and Christine Weedon (1978) which ranged beyond that text, offering a distinctive synthesis of feminist explorations of psychoanalysis and of potential feminist borrowings from this tradition.[21] Burniston et al. review and appraise Mitchell's and other feminist psychoanalytic thinking from a staunchly feminist Marxist perspective. While they do not flinch in their critical evaluations, they leave their readers with a lingering sense that psychoanalysis does have something to offer feminism and that Marxism itself will never prove adequate or sufficient in tackling the personal/political dimensions of gender oppression.

The second major disciplinary encounter rehearsed in *WTI* was with anthropology. Some CCCS researchers turned in this direction as they sought to undermine assumptions about the naturalness of gender oppression and to highlight the insights that discipline might offer in showing diversity in social arrangements – particularly with regard to the power dynamics within family and kinship.[22] The authors of that *WTI* article demonstrated that even the most promising Marxist text (Engels's *Origins of the Family, Private Property and*

the State [1884] was the prime focus in this regard) was inadequate in its the-orization of gender relations and of their relationship to capitalism. Moving beyond Engels, they mapped the burgeoning field of feminist anthropology to assess how it might be mined to enrich the study of gender relations. This article was an early exploration of historical and cross-cultural perspectives on the family and kinship and of how this research might be used to move beyond the restricted insights of Marxist theory. While its authors recognized the need to venture outside of Marxism, they did stick with the notion of 'reproduction' – a decidedly Marxist concept – using it as their segue into anthropological research and theory.

One thread used to weave the complex fabric of CCCS feminism was the Women's Liberation Movement slogan 'the personal is political'. It is important to note that, while from a contemporary twenty-first-century per-spective, this declaration may seem something of a cliché, in the 1970s (and indeed, into the 1980s) it constituted a profound, if sometimes troubling, political pillar. Many feminists, including some working within the CCCS, were exploring its meaning and significance in diverse political contexts and struggles. Within the CCCS it seems to have been a crucial, but by no means unproblematic, orientating reference point. Accordingly, it is interesting to explore how it was deployed and to speculate on its implications for those who were engaging (in many different ways) with second-wave feminism while working at the CCCS.

From one perspective, 'the personal is political' was something of an explanatory mechanism which may have helped some feminists to understand certain inconsistencies (inequalities) and patterns in the power dynamics per-vading the internal life of the CCCS which was, as noted previously, in many ways a masculinist and, in some respects, even patriarchal institution at that point. It gave them a handle on what they identified as the 'masculine domina-tion of both intellectual work and the environment in which it was being car-ried out'.[23] The very title of the volume – *Women Take Issue* – indicates this. The introductory editorial article explained the marginalization of women and women's concerns within the CCCS and identified the difficulties female members of Centre subgroups had experienced. This piece represented some of the characteristic problems within the CCCS with which female members wished to 'take issue' as matters of intense personal *and* political concern. These included: under-representation of women within the student commu-nity (although there are hints that this situation was improving), problematic gendered dynamics within subgroups, lack of attention to women's issues, the failure to respond to the Women's Movement and 'difficulties in gaining recognition for feminist academic work'.[24]

It was only in retrospect, in the reflections of Brunsdon and Thornham that other gendered patterns were explicitly highlighted. Brunsdon (1996) drew

attention to the gendering evident in the completion of PhD dissertations at the CCCS. While noting that for many reasons the awarding of PhDs was by no means regarded as the most crucial goal for the CCCS at that time and thus that completion rates were generally not high, she tracks women's relative lack of achievement in this regard and recalls the anxiety about this among women students.[25] Thornham (2000) provided a more extensive review of the patriarchal features of the political/intellectual CCCS project into the 1980s. This included the reverential designation of 'the founding fathers' of cultural studies (Hoggart, Williams, Thompson) and the masculinist orientation of the theoretical canon which guided it. Indeed, as noted above, Thornham proposes an alternative feminist cultural studies canon and theoretical repertoire. Additionally, she assessed that the language and presentational mode of *WTI* registered the authors' uneasy positioning and their lack of a sense of entitlement as authors/ shapers of both cultural studies and the CCCS.[26] This was perhaps another sense in which the personal registered the internal politics of the CCCS.

In considering the organizational/institutional playing out of feminism it is important to return again to the intensity of political life within the CCCS mentioned previously and vividly evoked by Hall, Brunsdon, Winship and many others. Indeed, given the commitments to collective, alternative, politically oriented education and research, the CCCS environment was one in which the political could very easily and very often did become *intensely* personal. (And I can confirm that this continued to be the case well into the 1980s and 1990s.) The precept that 'the personal is political' could hence be mobilized both to justify and to intensify this pattern. From what I have gauged both directly and indirectly, it was used extensively in both these ways. In this regard, organizationally, the decision in 1976–77 to create a general women's forum within the CCCS which was distinct from the Women's Studies Group,[27] was a striking and somewhat ambivalent move. It could be interpreted as an attempt simultaneously to both tackle and contain the internal gender/political struggles within the CCCS. It effectively created a distinct institutional site where 'the personal as political' could be explored and its consequences dealt with. But this reorganization also ensured that members could get on with feminist research elsewhere – specifically (but not only) in the Women's Studies Group.

As indicated above, 'the personal is political' could have been in some crucial ways a spectrum through which to gauge and situate the problems of gender relations within the CCCS from a feminist perspective. However, the precept's effectivity was not realized exclusively negatively as, on some occasions, it seemed to have registered more positively and more directly. For example, there is an allusion in *WTI* to a moment in Centre activities which came to be regarded as a turning point in the decision to dedicate a specific issue of the *CCCS Working Papers* (eventually appearing as *WTI*) to feminist

issues. This was Dorothy Hobson's playing at a Centre meeting of taped interviews with housewives discussing their isolation and other problems.[28] I remember Michael Green recounting this incident to me shortly after my appointment to the CCCS. As I recall, he regarded this occasion as crucial in re-orientating CCCS priorities. At the time I also felt that in telling me about this episode in CCCS history he was also declaring the impact of this presentation as pivotal in the creation of a lectureship in women's studies in the CCCS and providing me with background to my appointment. In effect, this moment and the telling and retelling of it played out the personal as political in a number of ways: not least as my own employment/career opportunity was rendered as due to a political awakening triggered by local housewives 'voicing [their] oppression'.

The accounts of the foregoing episode can be regarded as apocryphal, indicating a rather literal feminist rendering of the 'personal' with a direct, substantial impact on the politics and institutional structure of the CCCS. Nevertheless, there is considerable evidence of the uncertainty about the implications of the slogan 'the personal is political' and about its potential ramifications within the CCCS and for cultural studies more generally. In this sense Charlotte Brunsdon's piece, 'It Is Well Known that by Nature Women Are Inclined to be Rather Personal', was a pivotal contribution to the *WTI* collection.[29] This article problematized the relegation of women to the realm of 'the personal' and worried the naturalization of this. Nevertheless, Brunsdon foregrounded the tensions around the slogan: 'The discovery of the politics of the personal is central in understanding women's subordination, but that remaining within the politics of personal experience will not fundamentally transform this subordination.'[30] She seemed to be signalling both the strengths and limitations of this Women's Movement injunction as a guideline in tackling women's oppression.

As Brunsdon's reflections indicate, there were ways in which early CCCS feminists echoed and endorsed the slogan 'the personal is political'. Nevertheless, as I see it, it was their critical and somewhat wary relationship to this slogan (which Brunsdon's article does rehearse) that was most generative in the forging of feminist cultural studies and reforming (if I may use that term!) the CCCS. There was what might be described as a tempered or tailored deployment of the slogan which was not only expressed organizationally/ institutionally as noted above, but also through disciplinarily forays and, perhaps with most lasting consequence, through the research strategies that evolved with reference to it. Indeed, there is a sense in which feminists in the CCCS in the late 1970s seemed to be trying both to run with, yet contain and channel, the injunction that 'the personal *is* political'.

Possibly most significantly, a number of researchers found ways of turning personal dimensions of their own entanglements with femininity into highly

politicized research investigations. Here we might mention Dorothy Hobson's interviews with housewives (which led to her later work on women's leisure, media and particularly soap operas), Janice Winship's research on women's magazines, Rachel Harrison's investigation of the ideology of romance, and Angela McRobbie's pursuit of working-class girls' culture. Each of these projects involved researchers delving into contexts and/or cultural forms which were crucial to their own personal formations in femininity and as women. There were often, but not always, openly acknowledged high levels of identification with the subjects addressed or assumed and considerable investments in the cultural forms.

The following commentary by Brunsdon could be taken as a collective reflection on what was at stake in these individual research trajectories: 'We have somehow to hold the necessary articulation of female experience (our oppression lies partly in the invisibility of this experience) with the struggle to understand the determinants on this experience to allow us to change it at a more individual level.'[31] It may be worth pausing on this formulation and the linguistic moves it incorporates – from 'we' and 'our oppression' to the more generalized 'female experience' and the shift in reference from collective 'oppression' back to 'change . . . at a more individual level'. This appraisal signals the entanglement of the personal and the political that was at the heart of much early feminist research at the CCCS, but it also conveys the jostling to find some route out of it – or at least, some way of working through it.

There was a lot going on in the initiation of research trajectories documented within *WTI*. The danger in looking back on this early CCCS feminist research is precisely that we can naturalize it (as, indeed, I have done to some extent) as the initiation of research trajectories. Yet, who was to know that so much of this research would not only continue, but come to constitute the field of cultural studies? We can now see this work as launching research careers/identities, knowing that a number (but crucially, not *all*) of these students would go on to become internationally esteemed researchers and cultural studies academics. But this is possible only with hindsight.

These researchers were pursuing their own personal political entanglements, while investigating more generalized patterns, trying to find appropriate ways of analysing the gendered phenomena they were studying. Collectively, they were mapping what Charlotte Brunsdon subsequently identified as 'the discursive field of the feminine'. She articulates what was at stake in these moves: 'Traditional first-world femininity is made strange by feminism – it is denaturalized, and therefore the multiplicity of textual sites on which it is elaborated become areas for possible investigation.'[32] This was a crucial step in the identification of a new range of 'women's genres',

opening feminine popular culture and mass cultural feminine forms to serious academic/political analysis.

It is difficult to register the significance of these research trajectories from an early twenty-first-century vantage point since the key features of their moves have subsequently become a kind of second nature within feminist cultural studies practice. Their strategy constituted a version of what Donna Haraway, in another context calls, 'going with the trouble'.[33] For early CCCS feminists, the trouble was specific nubs of their personal entanglements with femininity. They quite literally 'troubled' femininity in manifestations which were close to them as individuals: housewives' 'leisure', women's magazines, romance fiction, etc. This brought them to the subsequently labelled terrain of 'women's genres' and fuelled their interrogation of popular culture. In 'going with the trouble' of femininity they were challenging the disavowals of many feminists who were, at that point, distancing themselves from femininity and from cultural critics who quite simply did not consider popular culture to be culture at all.

While pondering the precept of the 'personal is political' and explorations of the convolutions of specific forms of femininity absorbed early feminist CCCS researchers, their gaze was fixed on 'women'. This was not a totally undifferentiated category for most of them, not least because of lingering attachments to Marxism. Awareness of class was reinforced by the left-leaning socialist tendencies which held sway in much of the British Women's Movement in the 1970s.[34] Although I have joined with others in picking out Hobson's playing of tapes of interviews with working-class Brummie housewives as something of a turning point in the gaining of credibility for feminism within the CCCS, it is also not irrelevant that it was the voices of *working-class* women that effected this. Interestingly, class was almost always invoked through references to the figure of the working-class woman, who almost came to embody class in many CCCS feminist publications of the 1970s. Beyond this, there were occasional acknowledgements of the need to 'recognize the *different* oppression' of women who were not white, straight, middle class, young, etc.[35] However, it would take concerted challenges from the CCCS Race and Politics subgroup, through investigations of the situation of black girls in early 1980s Britain, the clarion call 'White women listen' issued by Hazel Carby and other women in that subgroup, and later direct explorations of lesbianism (by Chris Griffin and others) to shake the some-what monolithic castings of femininity and the category of women.[36] Within *WTI* itself there are also some surprising moments when developments within the British state (equal rights legislation, etc.) are discussed in rather decon-textualized ways, without introduction or acknowledgement of the national specificity or global diversity of women's struggles.[37]

POSTSCRIPT

It is beyond my remit to consider later phases of feminism within the CCCS –
including ones in which I was directly involved. Elsewhere in this volume Jackie
Stacey tells a different story, about a different phase of feminism in the CCCS.
What I can say is there could be no happily-ever-after endings to any tales about
feminism within the CCCS. Subsequent generations of feminists in the CCCS
still grappled with sexism which certainly wasn't completely dispelled by its
early feminist interventions. Nevertheless, as *Off Centre* demonstrated and as
my allusions in this chapter indicate, feminism did live on in the CCCS after
the early 1980s. Indeed, as the collections edited by Terry Lovell and others
demonstrate, feminist cultural studies emerged as an identifiable strand within
the field as a whole. In fact, in the conference which precipitated this volume
and in her contribution to this collection, Jo Littler contends that it is still alive
and kicking – dispersed into many settings in the twenty-first century.

I have learnt from both feminism and cultural studies, that there are no
neutral stories. Returning to my initial invitation to contribute to the CCCS
50th Anniversary Conference (and to write this piece), I was aware that ven-
turing accounts of a phase of either feminism or the CCCS were particularly
tricky ventures. In this regard I was mindful of Clare Hemmings's tracking
of related pitfalls in the storytelling about Western feminist theory: the recur-
rence of the tropes of progress, loss or return.[38] It is very difficult to provide
any account of the CCCS, without registering loss – given the subsequent
institutional struggles, enforced transformations and ultimately the closure of
the cultural studies unit at the University of Birmingham (see especially Ann
Gray's account in this volume). Likewise, it is almost impossible to avoid
casting any manifestations of feminism without reference either to progress
(in the form of theoretical sophistication, political inclusiveness and/or range)
or to loss (of activism, excitement, authenticity, insight, etc.). I may not have
avoided these perils in positing the stories embedded in this chapter. More-
over, I have no doubt stepped on toes, unearthed unhappy memories, triggered
sensitivities (choose the image or analogy you find most appropriate). There
is not much I can do about that now . . . but at least I do not regret taking up
a unique invitation to revisit and ponder the early stirrings of feminism within
the CCCS – the rich and complex world into which I was catapulted person-
ally and politically in 1980. And, of course, in writing this . . . I've extended
the invitation for you to do this as well.

NOTES AND REFERENCES

1. Charlotte Brunsdon delineates different phases in CCCS feminism. This article
focuses primarily on 'early feminism', a phase which she contends ends with the

publication of Angela McRobbie and Trisha McCabe (eds.), *Feminism for Girls*: *An Adventure Story* (London: Routledge & Kegan Paul, 1981). See: Charlotte Brunsdon, 'A thief in the night: stories of feminism in the 1970s at CCCS' in Dave Morley and Kuan-Hsing Chen (eds.) *Stuart Hall: Critical Dialogues in Cultural Studies* (London: Routledge, 1996), p. 279. There is no precise chronology here, but other markers of a new phase which might be cited include the appointment of Chris Griffin as a full-time researcher on the Social Science Council Research Project—Women and Work with Special Reference to Gender and the Family in 1979 or the creation of the lectureship in women's studies in CCCS in 1980.

2. Editorial Group, 'Women's Studies Group: trying to do feminist intellectual work' in Women's Studies Group, Centre for Contemporary Cultural Studies (eds.), *Women Take Issue: Aspects of Women's Subordination* (London: Hutchinson, 1978), p. 7.

3. See Stacey in this volume.

4. Celia Lury, Sarah Franklin & Jackie Stacey, 'Preface', *Off Centre: Feminism and Cultural Studies* (London: Harper Collins Academic, 2001), p. ix.

5. Stuart Hall, 'Cultural studies and its theoretical legacies', in Larry Grossberg, Cary Nelson, and Paula Treichler (eds.), *Cultural Studies* (London: Routledge, 1992), p. 28.

6. Charlotte Brunsdon, 'A Thief in the Night', pp. 278–279.

7. Sue Thornham, *Feminist Theory and Cultural Studies: Stories of Unsettled Relations* (London: Arnold, 2000).

8. Charlotte Brunsdon, 'A Thief in the Night', p. 278.

9. Sue Thornham, *Feminist Theory and Cultural Studies*, p. 3.

10. Janice Winship, 'Introduction', Section 4: Women's studies and feminism, in Ann Gray, Jan Campbell, Mark Erickson, Stuart Hall & Helen Wood (eds.), *CCCS Selected Working Papers*, vol. 2 (London: Routledge, 2007), p. 428.

11. *Ibid.*, p. 419.

12. Graeme Turner, *British Cultural Studies: An Introduction* (London: Routledge, 1996), pp. 203, 206, my emphasis.

13. See, for example, the subsequent collections: Terry Lovell (ed.) *Feminist Cultural Studies*, Vols.1 and 2 (both Aldershot: Edward Elgar, 1995).

14. Charlotte Brunsdon, 'A Thief in the Night', pp. 279–280.

15. Editorial Group, 'Women's Studies Group: trying to do feminist intellectual work', p. 11.

16. Thus it was not surprising that the lectureship created in 1980 was designated as an appointment in women's studies, within CCCS.

17. Janice Winship recalls ambivalence among CCCS feminists during this period as they both sought and disavowed patriarchal approval (Janice Winship, 'Introduction', p. 419).

18. Lucy Bland, Charlotte Brunsdon, Dorothy Hobson, Janice Winship, 'Women "inside and outside" the relations of production', in Women's Studies Group, Centre for Contemporary Cultural Studies (eds.) *Women Take Issue: Aspects of Women's Subordination* (London: Hutchinson, 1978), pp. 35–78.

19. Charlotte Brunsdon, *The Feminist, the Housewife, and the Soap Opera* (Oxford: Clarendon Press, 2000), p. 88.

20. *Ibid.*, p. 8.

21. Steve Burniston, Frank Mort, Christine Weedon, 'Psychoanalysis and the cultural acquisition of sexuality and subjectivity' in *Women Take Issue*, pp. 79–95.

Charlotte Brunsdon, 'It is well known that by nature women are inclined to be rather personal', in *Women Take Issue*, p. 31.

22. See especially: Lucy Bland, Rachel Harrison, Frank Mort, Christine Weedon, 'Relations of reproduction: approaches through anthropology', in *Women Take Issue*, pp. 155–175.

23. Editorial Group, 'Women's Studies Group: trying to do feminist intellectual work', p. 11.

24. *Ibid.*, p. 16.

25. Charlotte Brunsdon, 'A Thief in the Night', p. 276.

26. Sue Thornham, *Feminist Theory and Cultural Studies*, p. 3.

27. See discussion of this in Editorial Group, *Ibid*, p. 14.

28. Editorial Group, 'Women's Studies Group: trying to do feminist intellectual work', pp. 14–15. This material derived from interviews Dorothy Hobson had conducted with local working-class housewives with children, reported in: 'Housewives: isolation as oppression' in *Women Take Issue*, pp. 79–95.

29. Charlotte Brunsdon, 'It is well known that by nature women are inclined to be rather personal', pp. 18–34.

30. *Ibid.*, p. 23.

31. *Ibid.*, p. 31.

32. Charlotte Brunsdon, *The Feminist, the Housewife, and the Soap Opera*, p. 14, 25.

33. Haraway uses this term in a variety of analyses, generally as a way of encouraging researchers and commentators not to simply critically condemn or dismiss various forms of technoscience, but rather urging them to 'go with' these in order to comprehend more fully how technoscience works in contemporary capitalist cultures. See, for example: Donna Haraway 'Staying with the trouble: xenoecologies of home for companions in the contested zones', Fieldsights: from the Editorial Office, *Cultural Anthropology Online*, 27 July, 2010, http://www.culanth.org/fieldsights/289-staying-with-the-trouble-xenoecologies-of-home-for-companions-in-the-contested-zones, accessed 19 December 2015.

34. Rowbotham was a key figure, frequently cited by CCCS feminist but there were many others who could also be cited. See especially her: *Woman's Consciousness, Man's World* (Harmondsworth: Penguin, 1973).

35. Charlotte Brunsdon, 'It is well known that by nature women are inclined to be rather personal', p. 30. See, for example, Charlotte Brunsdon, 'It is well known that by nature women are inclined to be rather personal', p. 30.

36. Valerie Amos and Pratibha Parmar, 'Resistances and responses: the experiences of black girls in Britain', in Angela McRobbie and Trisha McCabe (eds.), *Feminism for Girls*, pp.129–48; Hazel Carby, 'White women listen: black feminism and the boundaries of sisterhood'; Pratibha Parmar, 'Gender, race and class: Asian women in resistance' in Centre for Contemporary Cultural Studies, *The Empire Strikes Back* (London: Hutchinson, 1982), pp. 212–275; Chris Griffin, 'The good, the bad, and the ugly' (CCCS stenciled paper, 1982), republished in Ann Gray, Jan Campbell, Mark

Erickson, Stuart Hall & Helen Wood (eds.), *CCCS Selected Working Papers*, vol. 2, pp. 549–560.

37. Lucy Bland, Rachel Harrison, Frank Mort, Christine Weedon, 'Relations of reproduction: approaches through anthropology', pp. 155–175.

38. Clare Hemmings, *Why Stories Matter: The Political Grammar of Feminist Theory* (Durham: Duke University Press, 2011), p. 3.

Chapter 11

Idealizations and Their Discontents

Feminism and the Field Imaginary of Cultural Studies

Jackie Stacey

When I was invited to be part of an event, and then to contribute to this edited collection, on the 'influence and legacy of the Birmingham Centre for Contemporary Cultural Studies (CCCS) 50 Years On', I felt a familiar mix of anxiety and excitement, a combination I remembered well from my experiences of being a PhD student at 'the Centre' between 1985 and 1992.[1] On the whole, when I was studying there, the strength of the excitement was sufficient to make the anxiety tolerable, and sometimes to transform it or drown it out altogether. A conference on this subject at the University of Birmingham – an institution that had finally managed to close down cultural studies there in 2002, after a long history of battles over its working practices and politics – this prospect could hardly fail to generate ambivalence. The timing also meant that the depth and mix of feelings could not have been more charged, taking place as it did in the year that both Richard Hoggart and Stuart Hall had died. Preparing to return to Birmingham for the conference, I kept searching for the right phrase to describe my heightened sense of anticipation. More than overinvested or overdetermined, *hypercathected* described the ways that the charged layers of this occasion were bound to draw upon and repeat the depth of attachments, projections, idealizations and repudiations which had always characterized participation in the Centre's activities.[2] It was this blend of psychic intensity, political commitment and intellectual experimentation that made the prospect of retrospective evaluation especially daunting.

Reflecting upon this combination of anxiety and excitement now, the two seem more obviously on a continuum than they appeared to me at the time. It's clear in retrospect that the thrill of being part of the Centre rested upon an unpredictability that came with improvisation and rule breaking; and therein too, of course, lay the anxiety. In the exhilaration prompted by the abandonment of conventional academic protocols (which had led many of us

to want to study at the Centre in the first place), there always lurked the possibility not only of failure and exposure but also of very powerful feelings of disappointment, reproach, anger and blame. A politicized alternative to the academic establishment in the 1970s, the Centre tended to attract those drawn to dismantling conventions and challenging authority. Not surprisingly, then, the group dynamics were of a particularly intense character.

Having spent several years now engaging with psychoanalytic approaches to how groups and institutions work – and how and why they so often do not – my own reflections on the history of the Centre have become increasingly influenced by such frameworks.[3] At the conference, I was asked to speak about the place of feminism in the history of politics at the Centre/department. Approaching this history now from a perspective influenced by group analytic thinking and writing involves a commitment to an often-uncomfortable acknowledgement of my own place in some pretty difficult and unpleasant group dynamics: these are histories of exclusions and divisions, as well as of productive connections and alliances. Group analytic approaches also afford a particular kind of reflection upon the place of the Centre's own institutional practices in the type of cultural studies it produced and published (and sometimes did not publish).[4]

One of the striking things I found in trying to prepare my talk for the conference was how hard it was to find a language for some of these affective group dynamics that structured everyday life at the Centre, and which seemed so vital to this history. There is something ephemeral and ungraspable about such dynamics, and yet they were just as determining of Centre practices as the more concrete changing social, political and economic contexts that shaped its work. These shifting undercurrents influenced the textures and rhythms of the Centre's day-to-day activities.

Whatever the downsides and costs, the Centre was the focus for intense attachments for many different generations of postgraduates. Even for those who, like me, did not arrive until the mid-1980s and had the sense we had already missed the 'heyday' years of the Centre's earlier radical and experimental practices, there was a continuing investment in the sense of being part of an academic project that was also fully engaged with the world beyond it – whether it was the feminist analysis of Thatcherism which took place alongside campaigns against the Alton Bill (restricting women's access to abortion) or against Clause/Section 28 (prohibiting the use of local government funding for any activities which were deemed to promote the normality of homosexuality and of 'pretended family relationships'); whether it was challenging racism in Birmingham and being in dialogue with Black Audio Film Collective or Sankofa about films such as *Handsworth Songs* or *Passion of Remembrance*; or whether it was continuing to challenge the norms of the academic curriculum by taking the

study of popular culture into English literature, sociology and anthropology departments.[5]

Because of the contested histories and conflicting accounts of the Centre, I anticipated that *whatever* was going to be said at the roundtables at the conference, the genres organizing our interactions with each other would all be subject to a number of what Eve Kosofsky Sedgwick famously called 'paranoid readings'.[6] Put another way, borrowing from Mary Cappello, I anticipated 'my readerly apparatus . . . [going] a little crazy' as I tried to take in the potential overload of undercurrents that might inform such a reading: who would be in the room; who would have decided to stay away; what would be 'speakable' subjects and what would need to remain unspoken?[7] I kept getting distracted by the idea of how the conference itself would inevitably provide the perfect material for a cultural studies analysis, precisely because the Centre had produced so many people who were skilled at 'reading culture' simultaneously as textual, psychic, empirical, historical and, of course, political.

The problem for anyone from Birmingham Cultural Studies who decided to accept the invitation to join this project of reflecting upon its history '50 years on' would inevitably be an awareness of all the dangers of so doing: the narrative conventionalities; the temptations (and exclusions) of nostalgia; the narcissistic gestures; the inevitable repressions; the transparent overinvestments; the naming and claiming; the envy and resentments; the idealizations and disappointments; the pessimism about politicized intellectual futures. The danger was that only a kind of 'meta-commentary' could avoid these glaring pitfalls; but then such a talk might reproduce a cliché of another kind: that of mastery and detachment.

This invitation to 'look back and assess' thus promised to generate one of the most intense academic occasions I had attended. Most people I spoke to at the conference felt something of this charged anticipation. The very different constituencies present at the event added to this heightened charge: people whose lives had continued to be intertwined (intellectually, domestically, sexually, politically) for nearly five decades; others who had fallen out with each other bitterly and not seen each other for as long; some people who had never met and would only be known to each other through their publications; others who had lost their jobs when the department was dismantled by the same university now hosting this event; then there would be those who'd gone in another direction entirely, and not kept in touch with anyone; and, of course, there would be the many people who would not be there, either because they couldn't or because they did not want to be, or because the Centre's history was simply irrelevant to their lives now.

In her nuanced and compelling account of 'being made history' at the conference, and by the whole research project behind its organization, Charlotte

Brunsdon enacts something of what Dick Hebdige (following Stuart Hall) calls the 'worldliness of Cultural Studies'. Brunsdon sums this up as referring to 'its messiness, its engagement with the outside world in which it is being thought, its involvement in what is outside the academy, its lack of theoretical or disciplinary purity'.[8] Unlike other notions of worldliness that might suggest a sophisticated knowingness, this use of the term gestures towards cultural studies as an unfinished process of knowledge formation, something open to revision and contestation. As Brunsdon puts it: 'If abstraction is necessary in order to think beyond the particular, the drive at CCCS was always to return to the particular – the worldly – to see if the thinking achieved was adequate to it.'[9] This worldliness requires a methodological practice anchored in – but never reducible to – multiple contextualizations; and, in this article, Brunsdon demonstrates how a written account of an event might proceed from such a commitment. The subtle textures of her prose, as it moves between accounts of the conference to the particular contexts of the late 1960s when the Centre was established and back again, are striking not least because of the elegance with which she shifts scale in her writing.

Scaling up and down in this way is something for which the CCCS became famous. These moves in scale can be traced throughout Brunsdon's account, as she shifts time frames and geopolitical contexts with great compositional elegance. This is no easy feat, as it takes time (and often many rewrites) to produce the detail of these very different contexts and to achieve a fluency that can move across these scales: from international economic crises to a reading of a moment of verbal exchange which had perhaps been misunderstood by the audience at the conference; from undercutting stories of mythical conflict in the Centre's history to challenging the readings of the limited political optimism attributed to the early 1970s. The apparent ease with which Brunsdon shifts across contextual details of such different scales is matched by her refusal to smooth over the surfaces of their lack of proportionality. These moves enact the expansive and yet meticulous methods of Birmingham Cultural Studies at its best and evoke a sense of its worldliness through the quality of the writing itself. That both the method and the prose achieve this – by refusing more conventional proportions – speaks to the ambition of CCCS work in the 1970s to invite dialogue and engagement rather than to deliver a seamless and tidy intervention.

One dimension of this worldliness of cultural studies that has continued to be hard to include in writing about its history has been its psychic dynamics. If this worldliness rests partly on a certain sense of affective 'messiness', then we might argue that unconscious processes are almost bound to be part of this mess – or, indeed, that they may be held partly responsible for its inevitability. For psychoanalysts would no doubt argue that what cultural studies has identified as the necessarily incomplete picture of a particular historical

conjuncture has something to do with an ever-present, affective undertow that disturbs closure and always pushes tidy narratives beyond our grasp.

The history of this dimension of the Centre's worldliness involves quite a different set of scales and another vocabulary: the intra-psychic patterns of the subject's history; the inter-psychic exchanges with others; the 'poly-psychic' atmospheres of the multiple groups that comprised the Centre. Given how central the 'subgroups' were to the identifications and practices of Birmingham Cultural Studies, it is interesting that there remains so little attention to theories of how groups work. A group analytic approach would share with cultural studies a belief in the untidy and contested process of history making. Taking a social definition of the psyche as its starting point for thinking about how groups produce an idea of themselves by generating their own histories, this approach would see collective processes as involving the constant negotiation of mutual projections and fantasies in the stories that circulate. In so doing, it would argue, all groups necessarily bring longer histories and wider geographies into their analysis of particular local interactions. It is the messy worldliness of these affective dimensions that combine personal with social and political formations that might be considered as another vital, if slippery, cultural context for understanding the Centre's history. In the competing accounts of this history, little attention has been paid to such dynamics, although they inevitably shaped the intellectual and political life at the Centre.

Throughout this history, the Centre's many projects were deeply invested in identifying the conditions of possibility for social transformation through cultural analysis and activism. In the 1980s, this promise drew many feminist postgraduates of my generation to Birmingham. The political purpose of these activities was assumed to go with the territory, even as the exact terms of what was political were constantly contested. This produced a kind of aura around the Centre, which circulated internationally through its reputation and its publications. Studying at the CCCS seemed to promise to combine expansive intellectual scope with the ambition of political activism: a place where academic activities might be connected to something of social value, even if what that was exactly was always endlessly contested.

In the process of negotiating one's place within this terrain, people sometimes felt like insiders and at others like outsiders, as they navigated the multiple forms of belonging and exclusion that structured those shifting boundaries: some would find themselves defined as the problem rather than the new solution; some would be part of the radical transformation of the Centre's protocols and practices; others would end up defending what were deemed to be in need of revision and transformation; some subgroups completed work that resulted in the Centre's publications; others generated considerable amounts of writing that never got published. And some people

never really settled into any subgroups at all, and remained on the outside, willingly or not.

As the Centre developed a reputation for radical publications and unconventional academic protocols (such as collectively authored books and postgraduate involvement in the admissions process), so its image began to shape the expectations of each new group of postgraduates who arrived. In turn, the confirmation or (more usually) mismatch between these expectations and what people found to be realizable at the Centre then shaped the affective exchanges governing everyday life there. The pre-arrival fantasies about becoming part of 'the Centre' were often so intensely invested that they were bound to lead to disappointment and frustration. The Centre was not the only academic space with an established reputation for radical work in the 1970s and 1980s: the history of consciousness programme at Santa Cruz was often compared with the Centre; and many women's studies programmes emerging at this time were also characterized by attachments to this particular mix of political and intellectual investment. But these spaces were few and far between, and there was not another academic space in the United Kingdom that had developed a reputation for public interventions in quite the same way.

When I arrived at the Centre in October 1985, Thatcher – then into her second term of office – had just viciously defeated the miners, privatized a number of nationalized industries and utilities, and was successfully scapegoating single mothers, immigrants and lesbians and gays. Her success in transforming British domestic and international affairs drove the urgency of political analysis produced by academics at the Centre. For the many postgraduates involved in various forms of anti-Thatcherite politics at the time, the Centre spoke to what Lauren Berlant, in a different context, has called the 'desire for the political'.[10] There was a very tangible, visceral pull towards inhabiting the spaces within the Centre that connected to the political dynamics beyond it. It was sometimes as if we had arrived expecting to live that connection simply by being there. Each new cohort of postgraduates that arrived at the Centre in the mid-1980s seemed motivated by their own mix of this desire for the political, bringing a range of incompatible expectations about what exactly that might mean. And often, because of the Centre's reputation by that time, these expectations had been projected on to this unusually politicized intellectual space even before people had stepped into the quirky paternoster that transported them up to the eight floor of the Muirhead Tower.

As with all forms of idealization, the only certainty was that the Centre could never meet these expectations. Each new generation joining the Centre engaged in its practices partly based on the tensions between their expectations of an institution with a formidable international reputation and their experiences of actually working there. By the mid-1980s, stories had circulated widely about how feminism had successfully installed itself at

the Centre in ways that had transformed many of its previous Marxist and post-Marxist suppositions. These narratives sat alongside and intermingled with others about how the work on black identity and racism had emerged in ways that had exposed the whiteness of both cultural studies and feminism. These stories of conflict and transformation promised a politicized space where knowledge production would necessarily be conflicted. Everyone expected this and maybe even sought this out by deciding to study there. But the critical language that seemed to be missing at the time, and perhaps continues to be, was any kind of framework for understanding the inevitable painful frustrations and unsatisfactory messiness of the group processes that characterized life at the Centre.

By the time I arrived there, in 1985, the Centre had developed an international reputation for both dismantling conventional academic authority and for having established itself successfully through alternative values and practices. The fantasies projected onto the Centre as an imaginary space, which could meet the desire for the political had a history that promised more than it could possibly deliver. This success conferred its own normative forms of authority, of course, even as it sought to dismantle others and remain open to critique and invite future challenges. Groups generally function by generating accounts of their own histories and by establishing their own boundaries in ways that both include and exclude. The invisibility and unpredictability of these inclusionary and exclusionary processes constituted that continuum of anxiety and excitement that came to define the Centre's affective atmosphere.

Feminism had a famously complex place in the Centre's history. Defining feminism, mobilizing it and revising it became sites of conflict and resentment, as well as of hard-won successes that transformed the syllabus and related agendas. During the 1970s, feminist challenges to the core intellectual frameworks of the Centre had already shaken up many theoretical and political assumptions and had opened up the space for new debates about reproduction, divisions of labour, sexuality and domesticity to be taken seriously. I arrived at the Centre aware of the painful and costly battles that had already been fought there in the previous decade, and for which it had partly become known. Many feminists of my generation were drawn to study at the Centre by reading *Women Take Issue*.[11] When we began the project that resulted in the eventual publication of the co-edited *Off-Centre: Feminism and Cultural Studies* in 1990, we imagined it as a sequel to the 1978 volume.[12] Like *Women Take Issue*, it combined empirical social issues with close readings of cultural texts.

Influenced by the emergent interdisciplinary field of women's studies in universities in the 1980s but sometimes frustrated by aspects of its unquestioning social-scientific leanings, feminists at the Centre continued to bring

under the critical lens of cultural studies an analysis of the category 'woman', without losing sight of the material and historical character of inequalities. Blending elements of the incompatible epistemologies so evident in the *Off-Centre* collection, our project was one that refused (or just failed to achieve) any kind of satisfactory resolution of these competing frameworks. Our aim was not just to make the category of 'woman' textually nuanced, nor simply to subject it to post-structuralist and psychoanalytic readings (that was already being accomplished by feminists in literary and film studies); instead, the challenge was to cross these conventional epistemological boundaries, and experiment with new conceptualizations of the dynamics between social, economic, political and cultural formations. We sought to produce a feminist cultural studies that addressed the domestic and reproductive spheres, as well as the productive ones, and that extended structural and institutional analyses into an understanding of the power relations of desire, embodiment and emotional investment. Returning to *Off-Centre* in preparation for the conference, I was really struck by the untidy combination of theoretical frameworks and methodologies it deployed. Looking at the chapters again for my conference paper, this mix seemed rather cavalier and more than a little naïve in places. A more generous reading might find a certain cultural studies worldliness in its messy combination of methods.

Part of the research that was eventually published in *Off-Centre* came from subgroup work. MA and PhD students worked alongside their supervisor (Maureen McNeil), who had to endure/tolerate having her own work edited by postgraduates whose own writing had yet to mature fully, to put it mildly. What defined the chapters that were eventually included in the final publication was as much a result of complex group processes as of following any kind of plan. Collaborative writing always meant inclusions and exclusions; and it also meant a lot of invisible work behind the scenes. Ambitions, no doubt individual as well as collective, were fuelled by a combination of urgent political outrage and by a permissive atmosphere at the Centre that encouraged methodological experimentation and incongruous combinations of conceptual frameworks. Emerging directly from the energy of various group dynamics at the Centre, the confidence to risk publishing this unconventional collection was generated by the heightened energy that came from the desire to be part of the continuing history that cultural studies at Birmingham had come to represent.

Another way to put this would be to say that this feminist collaborative collection was motivated by an identification with, and a desire to transform, the 'field imaginary' of cultural studies and its place in the political and intellectual landscapes of the time.[13] Elsewhere I have gestured briefly towards why it might be generative to think about the history of cultural studies through the concept of a *field imaginary*: 'the affective force that constitutes the psychic

life of the field'.[14] Here, I draw on Robyn Wiegman's work to argue that this field imaginary was inseparable not only from the multiple worldly contexts that formed its history but also from the psychic dynamics that organized its everyday protocols. These might also be described as the affective forces that produced another, often neglected, dimension of the worldly contexts constituting the field of cultural studies. By their very nature, these forces appear elusive and remain hard to delineate.

In *Object Lessons*, Wiegman tracks what she calls the field imaginaries of subjects motivated by the political desire for social justice, such as women's studies, queer studies and studies of intersectionality, anatomizing the specific academic protocols and wider transformative ambitions of intellectual projects founded on what she calls identity knowledges. For Wiegman, identitarian investments in such fields intensify the affective attachments in them to such an extent that disappointment and failure are built into their founding gestures. Detailing the ways in which these desires *necessarily* mean that the knowledge produced will fail to deliver what they were required to promise, Wiegman shows how such academic fields sometimes even produce the exact opposite of their good intentions. According to Wiegman, the knowledge we produce in these politicized projects is inextricable from our own desires and anxieties, in ways to which we may remain oblivious and over which we may have much less control than we wish. Whether conscious or not, there is an inevitability to the in-built dynamics of such projects within the academy. These are not obstacles to be overcome nor are they barriers to better knowledge; rather, the frustrations, discontents and disappointments in the histories of these subjects are a consequence of the constitutive promises that drove their founding. Once produced within the landscapes of these field imaginaries, these affective knowledges have taken on lives of their own, following unpredictable routes and becoming agents of their own consequences and futures. Put simply, if these fields had psyches, this is what they might look like.

In many ways, Birmingham Cultural Studies is an interesting counterexample to Wiegman's argument: it was not founded upon an identity category, nor even upon the intersection of several. But, from its inception, it *was* importantly grounded in arguments about class cultures. And it became an increasingly highly politicized project whose field imaginary was arguably charged with the overinvestments and inevitable disappointments of many of the academic 'social justice' projects mentioned by Wiegman above. By the 1980s, identity categories named a number of subgroups, such as the Women's Studies Group and the Race and Politics Subgroup, around which some of its key publications were organized. The study of contemporary culture at Birmingham thus included class, 'race', ethnicity and gender, but it was never simply founded upon them, or even a combination of them.

To illustrate this, I offer a short anecdote. I remember a moment shortly after I arrived there when I was part of the new postgraduate cohort invited by the staff to design the MA core course. This initiative came in response to criticisms from the previous year's postgraduates who had challenged the top-down academic decision-making and had suggested the core course be more democratically devised in the future. My cohort was rather thrown by this responsibility but a small group of us came up with the idea of devising the first term's syllabus around the categories of critical thought relating to race, class and gender. The response from the three academic staff to what we had produced was 'It's fine and we can do this if you want to; but it is not Cultural Studies.' There was a strong sense in the room that our proposed course outline had lost the specificity of a cultural dimension that really mattered beyond those more sociological categories of inequality – even if they were woven into its textures and contours, the cultural was never reducible to them.

Despite the ways in which identity categories increasingly came to shape the directions of particular cultural studies debates in the 1980s, they also provided the tools to dismantle them, and the field imaginary of Birmingham Cultural Studies was never primarily organized around them. My first introduction to Centre research activities illustrates this tension. I was invited to the end-of-year presentations by subgroups the summer before registering as a new PhD student there. The stand-out event of the day, filled with more tension and charge than I knew how to assimilate, was a panel provocatively titled: 'As an arsehole, I . . .' The three speakers on the panel, dressed in black and sipping chilled white wine at 11 a.m. as they presented their papers, used this formulation to speak back to the assumptions behind the identity claims informing it. The panel was clearly targeted at subgroups and other postgraduates whose statements about identity, especially those beginning with such a formulation ('As a woman, I . . . ,' 'As a lesbian, I . . . '), had by this time become familiar. Mobilizing Lacanian feminist arguments about the split subject that seeks to secure itself and others through the illusory coherence of an enunciated 'I' in language, this panel delighted in the rage they managed to generate and seemed triumphant when members of the Socialist Workers' Party in the room left in disgust. The panel performed an intimidating display of contempt for identity politics and for its by now familiar genres of authorizing experience. For the newcomers to the CCCS, like myself, this was unlike anything I had witnessed previously. I felt for those positioned as the objects of this critique; but, fresh out of a women's studies MA, I also recognized something in the panel's frustration with the logic that flowed from political statements beginning with claims to the authenticity of experience. The event dramatized and synthesized the more general tensions around identity politics in Birmingham Cultural Studies. If identity claims at the Centre were never easily endorsed as an uncontested route to knowledge

production, the politics of identity nevertheless remained a central focus for debate and, sometimes antagonisms, throughout the 1980s and into the 1990s.

The intense affects described here – the investments and attachments, the frustrations and resentments – circulated around feminist cultural studies at this time. For Wiegman, there is an inevitability to the ways in which politicized academic fields fail to deliver the impossible promises we have invested in them. Many of the affective processes Wiegman identifies chime with the complex psychic dynamics of Centre practices, and her analysis provides one of the few routes into the terrain I have been struggling to describe in this chapter. Through an implicit psychoanalytic lens, she assumes that the reasons behind such shortfalls are largely beyond our control and are built into the overinvested field imaginaries structuring the programmes we hope to develop and deliver.

The appeal of Birmingham Cultural Studies was its ambition to try and hold these two incommensurate and yet equally necessary models of culture in the frame simultaneously: culture as located in the deeply rooted and structured power relations of specific histories and geographies; and culture as always escaping our finished analytic descriptions because of its dynamic and constitutive psychic, as well as social, formations.[15] This might be referred to as the messy worldliness of cultural studies that drew many of us to the Centre at this time.

One stunning artistic materialization of this vision of culture can be found in John Akomfrah's three-screen installation on the life and work of Stuart Hall: *The Unfinished Conversation*.[16] As I have argued elsewhere, the spectator's attention moves between and across the three screens, as extracts from Hall's television appearances and from his own home movies and family album are interspersed with news footage, music, poetry and clips from popular films. The simultaneous display of these very different scales of historical and geopolitical representational genres make it impossible to settle on a single story or to isolate a location. Instead, the fleeting associations of this poetic mix leave us with a sensual overload – our bodies seem to hold a sense of what must remain in excess of a tidy biographical or historical portrait. Like the worldliness of Birmingham Cultural Studies, this mix of aesthetic scales performs connections between located times and spaces and the ever-widening concentric circles of influence that shape their cultural imaginaries. Shifting across these global and local scales through multiple framings, this work simultaneously traces the poetics of fragmented yet deeply imbricated cultural limitations and possibilities. For me, this work gives the field imaginary of cultural studies an aesthetic form.[17]

One way to reflect upon the history of feminism at the Centre would be to see it as an integral part of the affective forces that *reconstituted* the psychic life of cultural studies. This is precisely the tension between the institutionally

grounded and the more ephemeral – but no less determining – imaginary formations that Wiegman seeks to elaborate in the US academic context. Although a very different project, Birmingham Cultural Studies produced a field imaginary shot through with many of the unrealizable expectations and desires detailed in *Object Lessons*. To borrow Wiegman's vocabulary, we might argue that the psychic life of the Centre emerged out of a combination of its particular alternative academic protocols and the intense investments in a number of different, and sometimes conflicting, political projects, closely aligned, but never fully defined by, identity knowledges. In addition to these dynamics, the ongoing everyday institutional struggles to sustain the Centre's independence and to maintain its attempts at more democratic and inclusive group decision-making added to the ways in which it had become the site of idealizing attachments and repudiating denunciations.

From a group analytic perspective, idealization inevitably ends in disappointment and frustration since it is motivated by a desire to rid ourselves of any uncomfortable or intolerable ambivalence. Idealization is the fantasy of being free of ambivalence. The combinations and scales of intellectual and political ambition at the Centre invested its institutional spaces and practices with a set of psychic expectations it was required to promise, but could never meet. As a result, the continuum between excitement and anxiety provided one of many affective axes that organized the charged relations of everyday life there.

Looking back at feminist politics at the Centre in second half of the 1980s, when *Off Centre* was written, it seems to me now to have been shaped by a very particular dimension of the field imaginary of cultural studies. This has something to do with the quality of our desire for the political at that time. If the psychic life of a field draws upon structures of feeling embedded in its foundational gestures and the expectations they generate, then these structures of feeling continue to evolve through the specific pressures and limits afforded by different historical conjunctures. In the mid-to-late-1980s, there was something specific about the forms of idealization and frustration that shaped feminist experiences of the Centre. At the risk of producing an overly schematic account of an uneven and messy set of dynamics, this chapter ends by briefly mapping how the psychic life of cultural studies at the Centre was shaped by the particular combination of the political battles against Thatcherite policies and a parallel set of institutional struggles at the University of Birmingham, affecting the higher education sector more generally.

Over the previous two decades, the Centre had become a beacon of radical promise to those outside it. Even the physical space of the Centre itself, with its famous large circular table for democratic debate, and its location on the eight floor of the Muirhead Tower, looking out over the city of Birmingham,

had become part of its mythology. Somehow, the space itself seemed to have secured the Centre's status as a successful radical outpost. Never popular with the university that housed it, the Centre had survived a number of challenges at various moments in its history. But during 1986, it entered into a very serious dialogue with the university management about its future. At odds with the increasingly market-driven neo-liberal University of Birmingham, the Centre battled (unsuccessfully) against the management's demand that it consider becoming a regular department (merging with part of sociology), and dropping its collective practices. The introduction of large-scale undergraduate degrees in media and cultural studies was now required if cultural studies at Birmingham was to survive. To many postgraduates of that time, this change signalled a threat to collaborative research and writing and to collective decision-making at the Centre – the reasons many of us had been drawn to study there. These losses looked like an inevitable outcome since the staff would simply no longer have the time to devote to these alternative ways of doing academic work. As the postgraduates, like myself, protested forcefully against the loss of these protocols, the academic staff whose livelihoods and futures were at stake (unlike those of us who were, after all, only passing through) found a more positive narrative in these new possibilities for Birmingham Cultural Studies. Under intense duress (no doubt made worse by the postgraduate protests), the staff accepted the terms of the university's offer of a future.

Alongside these changes, the Thatcherite project had succeeded in undermining feminist and Left agendas, producing a popular contempt towards various figures and groups who were constructed as the 'enemy within': including black people, single mothers, gays, feminists, welfare 'scroungers', immigrants and trade unions, especially the National Union of Mineworkers. The vilification of these targets was accompanied by Thatcherite discourses shifting assumptions about oppression and exploitation, legitimizing the entitlement claims of what McNeil has named 'the new oppressed': fathers, tax payers and foetuses.[18] Feminists at the Centre were involved in fighting the Alton Bill and Clause/Section 28, integrating these political campaigns into their research activities and writing (even if their PhD topics took them in quite different directions). The urgent and focused political engagement came from a deepening outrage at New Right attacks on the very foundations of post-war social democracy that had been assumed to be sacrosanct: the welfare state, the right to strike and shared social responsibility for others. Socialism and feminism had lost ground as visions of alternative values, and were rejected and discredited by a new popular political tide that seemed to be running in the opposite direction. As individuals, markets and nations increasingly became the political currency of the day, replacing even the idea of society itself, any kind of social justice project became an easy target for ridicule and accusations of political correctness.

In this beleaguered context, there was little doubt that the values of every-one at the Centre, however fragmented it may have felt internally, were under attack. The new managerial discourses underpinning the marketization of universities in the United Kingdom and elsewhere matched the flow of the political tide in the country more generally. It seemed difficult if not impos-sible to slow this rising tide down at all, never mind halt or reverse its direc-tion. Instead of sustaining its place as the beacon of radical promise it had appeared to be from the outside in the early 1980s, the Centre had become a site of struggle with a Thatcherite university management. What had been assumed to be external to the Centre threatened to move into the heart of its everyday practices and undermine its ambition to provide an alternative political vision. For those who had been there for many years, the protests and reactions of the postgraduates no doubt appeared naïve – for how could we have imagined Thatcherism as a force that might be kept outside a public-sector institution – the very site of her most forceful attacks.

The clarity of our opposition to Thatcherite policies gave reassuring focus and no doubt an easy self-righteousness to our sense of the political task. There was no doubt who the 'enemy' was at that time, as Thatcher became one of the most hated politicians in history – hated, as Jacqueline Rose and others have argued, with a misogynistic intensity fuelled by cultural fantasies about powerful and punishing femininity.[19] This doubly beleaguered position (seeking refuge from external political attacks only to find them extended into the site of refuge itself) afforded a galvanizing sense of purpose, on the one hand, and, on the other, a fury generated by feelings of impotence and marginality.

The Centre's promise had invited a structural identification for new post-graduates not only with the content of a political programme but also with the fantasy of belonging to, and being grounded in, an oppositional space within the academy. When the autonomy of this space came under attack by those whose values echoed aspects of the Thatcherite project, and the Centre itself threatened to be eroded by what we had hoped to be escaping, many of the postgraduates were thrown back on our own overinvestments and forced to face the inevitable results of our idealizations. We had projected onto the Centre an impossible set of fantasy expectations. If we imagined, before we arrived there, that the Centre would be a bastion from which we might seek succour in the midst of the devastating shifts in political discourse achieved by the Right, then soon afterwards the psychic life of the field exceeded our grasp, as we felt the Centre go under siege. In this context, this newly launched challenge to the Centre's practices by the university gave everyday life there a particular affective charge.

This is only one brief narration of a complex series of changes and con-flicts. Like all stories, it is of course an invested one. Others would no doubt

tell it very differently or inflect it with other emphases. Reflecting on this account of the place of feminism in the politics of Birmingham Cultural Studies in the mid-to-late-1980s, when the Centre was the focus for so many (maybe too many) aspects of my life in my late twenties, it looks to me too much like a predictable story of loss. This story of loss seems all the more inevitable with the hindsight provided by the department's abolition by the university in 2002. The losses are multiple: the loss of a clear political focus – Thatcherism (now neo-liberalism seem ubiquitous and more dispersed); the loss of the combination of the cultural and the political, which we thought made the feminist study of popular culture a political activity in and of itself (I am not sure if anyone really would really claim that today); and the loss of a wish that bringing the popular into the academy would continue to be a transformative political act (maybe even one with an enduring legacy).

But, as Clare Hemmings has pointed out, accounts of the history of feminism too often rely on conventional 'stories of progress, loss and return'.[20] The stories we tell, she argues, are always invested ones whose structural inclusions and exclusions mobilize power in their bid for narrational (and historical) authority. To produce such a narrative (solely of loss) would go against the grain of the models of culture that people at Birmingham worked so hard to produce: the messy, uneven, unfinished and worldly versions of culture that defy the disciplines and refuse to be contained by linear narratives and stories of success or failure.[21]

In resisting this story of loss in thinking about the '50 years on' part of the brief here, I have been drawn to what queer theorist Elizabeth Freeman calls 'temporal drag', the visceral pull of past temporalities that defy the linear teleologies of the 'then' and the 'now' narrations. Instead, Freeman offers readings of 'imaginative works that embrace the afterlife of [a series of failed] revolutions as part of the political present tense'. We might think about, as Freeman puts it: how to 'consider the temporality of a present marked, even over-determined, by a sense of "historical post-ness"'.[22] Reflecting on her intellectual and political history, Freeman explains: 'at one point in my life as a scholar, I thought the point of queer was to be always ahead of actually existing social possibilities'; but instead, she argues, she now finds herself 'interested in the tail end of things . . . whatever has been declared useless'.[23] Freeman reminds us of the importance of locating our relationship to the history of a particular field within a model of temporality that complicates conventional chronologies and teleologies.

Just as Hemmings offers us other ways of imagining the stories that we tell about our place in the history of feminism, so Freeman opens up a language of queer temporality that might enable us to envisage the affective dynamics of the afterlife of Birmingham Cultural Studies. The past can no more be treated as finished time than the vision of culture can be positioned

as an object to be held still and examined. The invitation to reflect upon this history has to be met by a version of the past that grapples with accounts of the messy and contested cultural dynamics of Birmingham Cultural Studies and its contexts. If the changing group dynamics that formed the psychic life of the space, as well as of the field, are to be included in this account, then the fantasies projected onto and circulating around the Centre also need to be articulated. Pushing against conventional narratives and constructions of past-present relations that would give this history a graspable and easily legible form, we might look instead to how forms of temporal drag continue to constitute the lingering and unpredictable afterlife of cultural studies (including this archiving project).

In response to this invitation to reflect upon the feminist politics of the late 1980s and early 1990s in the history of Birmingham Cultural Studies, we might think with Freeman about its temporality without simply reinscribing ourselves in teleological narratives of loss and argue that there is a temporal drag at work here that might articulate its atmospheres, affects and moods, as well as its structures, institutions and events. If for Freeman the concept of temporal drag in queer studies is the 'visceral pull of the past on the supposedly revolutionary present', then we might reverse this formulation and use temporal drag to think about the afterlife of feminism at the Centre and its continuing, if dispersed, pull on the politics of the present.

NOTES AND REFERENCES

1. For brevity's sake, I shall use 'the Centre' throughout the chapter to refer to the Centre for Contemporary Cultural Studies (CCCS) during the time I was a postgraduate there. During this period, however, academic staff at the Centre joined with colleagues from Sociology to form the Department of Cultural Studies (DCS).

2. *Cathected:* to invest with emotional energy, or, for Freud, libidinal energy. Freud used the term *hypercathexis* to refer to an additional energy being added to any already cathected psychical element. http://nosubject.com/index.php?title=Hypercathexis, accessed 8 December 2015.

3. There is a vast literature in this field, but common starting points include: S.H. Foulkes, *Therapeutic Group Analysis* (London: Karnac Books, 1964); and Bill Barnes, Sheila Ernst and Keith Hyde, *An Introduction to Groupwork: A Psychoanalytic Perspective* (London: Palgrave Macmillan, 1999).

4. As I shall mention later in the chapter, there was also a considerable amount of writing that was never actually published.

5. *Handsworth Songs* is a 1986 film, directed by John Akomfrah and produced by Lina Gopaul; *Passion of Remembrance* is a 1986 film directed by Maureen Blackwood and produced by Sankofa.

6. Eve Kosofsky Sedgwick, 'Paranoid Reading and Reparative Reading, or, You're So Paranoid, You Probably Think this Essay is about You', *Touching Feeling: Affect, Pedagogy, Performativity* (Durham, NC: Duke University Press, 2003), pp. 123–152.

7. Mary Capello, *Called Back: My Reply to Cancer, My Return to Life* (New York, NY: Alyson Books, 2009), p.16.

8. Dick Hebdige 'The Worldliness of Cultural Studies' *Cultural Studies*, 29, 1 (2015), pp. 22–32.

9. Charlotte Brunsdon, 'On Being Made History', *Cultural Studies*, 29, 1 (2015), pp. 88–99.

10. Lauren Berlant, Cruel Optimism (Durham, NC: Duke University Press, 2011).

11. CCCS Women's Studies Group, *Women Take Issue: Aspects of Women's Subordination*, (London: Hutchinson, 1978).

12. Sarah Franklin, Celia Lury and Jackie Stacey (eds.), *Off Centre: Feminism and Cultural Studies* (London: Harper Collins/Routledge, 1991).

13. The term 'field-Imaginary' was by Donald E. Pease to designates a disciplinary unconscious in his article 'New Americanists: Revisionist Interventions into the Canon' in *Boundary 2*, 17, 1 (1990), pp. 1–37. Robyn Wiegman's reworking of this concept is especially interesting for the history of cultural studies; see footnote 14 below.

14. Robyn Wiegman, *Object Lessons* (Durham, NC: Duke University Press, 2012), p. 14.

15. For a fuller account of this argument, see Jackie Stacey, 'The Unfinished Conversations of Cultural Studies', *Cultural Studies*, 29, 1 (2015), pp. 43–50.

16. *The Unfinished Conversation* was commissioned by Autograph ABP and directed by John Akomfrah, produced by Lina Gopaul and David Lawson (all of Smoking Dogs Films, and previously of Black Audio Film Collective, 1982–1998).

17. This argument is outlined in Stacey, 'The Unfinished Conversations'.

18. Maureen McNeil, 'Making and Not Making the Difference: the Gender Politics of Thatcherism' in S. Franklin, C. Lury and J. Stacey (eds.), *Off-Centre: Feminism and Cultural Studies*, (London, Harper Collins Academic, 1991).

19. Jacqueline Rose, 'Margaret Thatcher and Ruth Ellis', *New Formations*, 6, (1988); Heather Nunn, *Thatcher, Politics and Fantasy: The Political Culture of Gender and Nation* (London: Lawrence and Wishart, 2002); Jackie Stacey 'Ravishing Maggie: Thatcher Thirty Years On' in New Formations 70 (2011), pp. 132–151.

20. Clare Hemmings, *Why Stories Matter: The Political Grammar of Feminist Theory* (Durham, NC: Duke University Press, 2011), p. 3.

21. For a discussion of the diverse forms of politically-engaged work present today, both inside and outside the academy, see Jo Littler's chapter in this volume.

22. Elizabeth Freeman, *Time Binds: Queer Temporalities, Queer Histories* (Durham, NC: Duke University Press, 2010), p. xiv.

23. *Ibid.*, p. xiii.

Chapter 12

The Centre for Contemporary Cultural Studies – A Political Legacy?

Richard Johnson

As a willing, though often-sorrowful participant in the commemorations around the Centre for Contemporary Cultural Studies(CCCS), I nonetheless feel rebellious. The contradictions and coincidences confuse: we grieve for lost founders, teachers and activists and are challenged to remember the past, while the academic corporations, led by the volte-face of the University of Birmingham, make capital from their work. I find this difficult because my uppermost feeling about the CCCS is that it is an *uncompleted story*, even a story *cut short*. Because it feels unfinished, I hesitate to consign it to the past, though I understand the need for a history. It is a past, however, which still carries a hope, a charge. I keep on thinking what about the future then? What about the politics? Can't we complete the story? Isn't that making history too?

In many ways, the story does continue, in academic life, in the many international versions of cultural studies, in its palpable influence on other disciplines, and in the fine intellectual work, with a clear political pertinence, which so many scholars connected to the CCCS have produced. There are also many professional practitioners, from artists to teachers and social workers, who acknowledge a similar debt. The CCCS, however, was meant to be a broader political project though confined by the academic setting. So I come to the question at last. Can we learn something from the CCCS for current political practice?

WHAT WAS THE PROJECT ANYWAY?

There are many versions, many projects perhaps. The CCCS had its own political struggles and balances: different causes lost and won. My own selective remembering of involvement (1974–1993) picks on two aspects.

The first, exemplified in Stuart Hall's life and work, is the project of rethinking Left political practice through understanding cultural processes, a recasting as complex, and as evasive, as the definitions of culture themselves. Of course to study culture critically, especially revaluing its popular forms, was already a political act, but something more was always at stake.

The second aspect concerns ways of working together, the daily practice. The CCCS attempted a way of working that was genuinely collective, a form of participatory democracy. Associating with 'collective work' was a commitment to explicitly anti-dogmatic thinking, in a style modelled by Stuart himself and extended by successive challenges. Intellectual openness, the practices of collective work and perhaps the commitment to the 'contemporary' invited wider social movements to impact on agenda and methods of study. I want to recover these two features as political legacies for today.

THE CULTURE DIFFICULTY

There are some difficulties to work through first. It is not a question of teaching cultural studies to politics – of 'applications' or 'impacts'. Political tasks 'outside' also set agenda and prioritize ways of knowing. 'Really useful knowledge' has a different register from academic kinds. Whether based in PhD theses or activist experiences, it will always require translation to get a cutting edge and a relevance to the lives of millions. Humanities scholarship, where cultural study often lives, tolerates indecision, revels in complexity and likes deconstruction more than creation. Political practice on the other hand requires us to decide in order to act, decide which differences to ignore, for instance, which to compromise over and which to insist on. The difficulty of *this* practice is how to stay open and to learn, yet be effective. I have not found it easy to use my academic self in my political practice in making this crucial transition.

So the relation between political practice and theory and research in cultural studies is two-way and complex. One great virtue of the theory work instituted by Stuart, was putting the different versions of culture alongside each other – 'mapping' them – but also showing their differences and implications by analysing – 'unpacking' – specific cultural objects, practices or conjunctures. No doubt we took different things from this and identified different omissions at different times – feminist theory, psychoanalysis, later post-structuralisms, etc. The main lesson, however, is that there are always political issues at stake in the paradigms explored and all have flaws or limits, so that a synthesizing, willing-to-learn attitude is important for politics too.

Connections with political practice were there from 'the beginning'. In Britain cultural studies came out of the need to correct 'applications' of

Marxism which were disastrous. The study of culture, consciousness and ethics was a political cure. The early classics of cultural studies in Britain – Richard Hoggart's *The Uses of Literacy* and the early work of Raymond Williams and Edward Thompson – held consciousness or culture in a close embrace with the conditions of life of working-class people, in present, past or, in Williams's case, by constant *implication*.[1] This had powerful resonances for artists and activists, many from working-class childhoods, and for questing conscience-laden middle-class individuals. Early cultural studies contributed to a new political tendency, a New Left. Because no new party emerged, we overlook the longevity of the struggle to refound the Left, coeval with, if less potent than, the neo-conservative and neo-liberal projects.

There was a difficulty, however, even in these first exemplary texts, a difficulty often greater in the 'cultural turn' that followed. The crudest version of this difficulty is the failure to deal adequately with economic social relations and the slide towards making culture (or consciousness, discourse or identity) the determining moment in social formations and political practice. 'Culturalism' was the rather clumsy critical category used to raise this issue in the later 1970s.[2] Was this also an attempt to exorcise our own fear that the CCCS' mission threatened to reduce everything to culture?

RETHINKING 'STRUCTURE' IN POLITICS

A better version of the 'culture difficulty' is the need to distinguish different forms of power without reductions or simple determinisms. This requires a form of abstraction (of making real distinctions) within a social whole, which Williams saw as 'indissoluble' and Thompson called 'experience'.[3] The constitutive power of language and other forms of signification for identity and behaviour is real, and far from always conscious. Its power is different, however, from physical coercion, law, political representation, or the power of capital to exploit labour, manipulate markets and heap up wealth unequally. In hegemonic projects, these means are always employed in combination, but to analyse outcomes and seek alternatives we need to see the differences between them. Neo-liberal governments since the 1970s have combined state power and public discourse to empower employers, weaken workers, create new markets and punish worklessness. To have the ghost of a chance of electoral success, alternative parties need a believable vision of a sustainable material future. The hope of millions cannot rest on a new discursive articulation alone. Alternative forces must chart a future that is in Ernst Bloch's words 'objectively Possible', that is economically sustainable and perhaps already emergent.[4] The May 2015 election showed the difficulty, in England though not in Scotland, of putting an alternative vision in place. Anti-austerity

plus anti-Trident was not enough despite the rightness and symbolic reso-
nance of both causes. They met much realist popular doubting (and still do).
Will a different path of development secure me a living? Will I be safe in a
dangerous world?

Culture is everywhere but it is not everything, nor is it separate from the
structures that undergird everyday living and its practical exigencies. Our
understanding of these must include more than those aspects of production
and labour that preoccupied the old Marxists. Feminist criticism and research
highlights the importance of the reproductive, nurturing, consuming and
caring routines of life and the gendered divisions of labour and power that
currently sustain them. These rough, changing textures of living have their
own possibilities and traps to be grasped politically: class antagonisms and
cross-class relations, new assemblages of the feminine and the masculine, the
ferment around sexuality and the global clashing, communing and mixing of
religions and ways of life. As the planet becomes more obviously one social
world, political thinking has also to be global. This means deconstructing the
Eurocentrism and imperial traces of inherited frameworks, but also listening
to 'Southern Theory'.[5]

So what kinds of cultural study, according to this view, should attract our
attention as scholars? Analysing political or other discourses at their most
amplified or public moments gives us limited purchase. We need to know how
political projects and media forms act on ordinary lives, not only their rela-
tive popularity, but crucially how far they serve ameliorative transformations
that can be sustained. To lack this realist element is to stay uncritically with
mere 'popularity', rather in the way that mainstream politics so often stops at
short-term electability. Neither does much to halt the deepening injustice and
accelerating threats to life on the planet.

A LEGACY LOST OR DEFERRED?

In the dispersed global development of cultural studies productive aspects
have been passed over or unduly subordinated.[6] The attempt to identify the
specificity of the cultural, while holding fast to other different forms of power,
was overtaken and sometimes lost. I do not think this was only an effect of
academic success and a resulting political containment. Certainly, for a while,
cultural studies became a high-value global 'brand' but this is not the whole
story. Theoretical development, even the stress on theory, was also a wrestling
with political conundrums.

When I joined the CCCS in 1974, Marx, Gramsci and Althusser were being
read as well as theorists of culture. We debated theories of culture and power
of course, but there were many other interests. Less often remembered was an

interest in 'organic' transitions, revolutions if you will. This was pursued in theory (Marx, Maurice Dobb, Althusser, Gramsci), in historiography (Marxist history in France and Britain, the Annales School, Labour, social and later, oral history) and in our own concrete studies. We were fascinated by 1945 and 1880–1920 and wrote on the 1940s and 1950s as moments of accelerated change. A History Group strand was separate (too separate) from parallel feminist work on rethinking 'structure' and mode of production in terms of gender and on the changing position of women (often through women's genre) from the 1950s onwards.[7]

Policing the Crisis (1978) is the best-known example of this kind of conjunctural or transitional history, though there was similar work on state schooling.[8] It is obvious now that the topic of transitions fascinated us because we were living through one – the 'regressive modernisation' that was later dubbed Thatcherism. But what is also interesting today about the 1970s and early 1980s is the holding on to several different things at once: some conception of structure (and transitions there), engagement with everyday patterns of life and meaning (especially in subcultures, school and work cultures, in women's lives and black experiences) and also a strong critical focus on public discourses (including media, arts and politics) and their 'popularity'. There were limits of course. It was hard to integrate the different projects, and the (often-uncomfortable) academic location prescribed work that was descriptive and critical rather than more directly developmental of a new politics of the Left.

From the later 1970s theories of discourse overtook the inherited agenda of 'cultural materialism' just as it grappled with greater political complexity. It was, however, an advance to recognize how different political causes could be forwarded and linked, 'articulated' through the associative character of language.[9] Attention was directed away, however, from everyday life and the common sense generated there. The typical objects of discourse analysis were formal politics, media, literature or art, but particularly literature. 'Text based analysis' in this particular sense became the dominant form of research. By the early 1980s, I was arguing that we ought rather to attend to the whole 'circuit' of culture, which rested on more embedded and shared everyday meanings and practices.[10] Some discourse approaches repeated the culturalist difficulty. Discourse was the only social and 'material' level, with power, knowledge, the social and subjectivity all constructed at one go.[11]

Yet the take-up of post-structural and postmodern theory, modelled on linguistic understandings, made a lot of *political* sense. The binaryism of Marxist theory (class vs. class), often adopted by the social movements of the 1960s and 1970s, became a liability as political subjects, all with progressive possibilities, multiplied and clashed. Teaching cultural theory with political intent in the 1980s could be a nightmare, trying to reconcile the claims of

socialist, feminist, anti-racist, black, gay and queer politics, each with their own literatures, internal debates and criticisms of each other. So there were good political reasons to be interested in theories that specifically addressed social complexity and multiplicity, the shifting nature of antagonisms and alliances and a certain indeterminacy of the political field. There was also the revived interest in psychoanalysis, especially in forms that could deepen our understanding of relations of power, including the political shifts to the Right.[12]

Today, despite the difficulty of doing any critical work in the universities, the key issues are being addressed once more and often very creatively. Scholars now combine social understandings with complex cultural analysis including an increasing interest in memory and past-present relations. Psychosocial research enriches our knowledge of power relations, including class, and gives a more dialogic, inter-subjective view of identities. Some of the most interesting work has come from scholars – often socialist-feminist historians, sociologists or psychologists – who seek concrete connections between class, gender, race and sexuality in nations, empires and colonies.[13] With capitalist dynamics and class formations back in the picture, we can start to understand the interlockings, contradictions and displacements within the whole ensemble of social relations, sometimes through labour and its divisions, sometimes through the associative or defensive deployments of discourse, metaphor, image and narrative. Evidently this is not a simple 'return to Marx', to 'Freud' or anything else but a repositioning and reworking of a rich legacy of political-cultural ideas according to the tasks of the times.

THE HARD ROAD TO RENEWAL

Stuart Hall's work on the depth and reach of the cross-party neo-liberal project is another starting point for recovering the political legacy of the CCCS, especially via the 1980s essays associated with *Marxism Today* and *New Times*.[14] These essays were critiques of Thatcherism and its successors certainly, and had a strongly discursive inflection, but they were more than this. His Gramscianism ensured that the *making of the popular* informed his analysis of political discourse. Nor was discourse theory or the fascination with ideology taken on as an exclusive theoretical frame.[15.] He persisted, rather, with a theory of *representation in discourse* where what is represented also retains its own complex being - 'a discourse is a way of talking *about or representing something* . . . It is *part* of the way in which power operates'.[16]

There were limitations however. The rich ethnographical and autobiographical strands in cultural studies were in the frame only implicitly.[17] Similarly,

when the authors of *New Times*, with whom he cooperated, sought to supply an economic dimension in the shape of neo-Fordism, the relation with more critical work was very ambiguous. The authors seemed to *accept* this neo-Fordist world, a sea change in capital accumulation, as a relatively neutral process. So the task must be to 'modernise'. So what happened to the neo-liberal critique?[18] Was this disconnection the reason why some *New Times* writers came to support New Labour? I greatly prefer the single-authored essays in *The Hard Road to Renewal (HRR)*, partly because it is here that the other agendum of the essays, always present but sometimes overlooked, becomes more explicit – the cultural critique of Labour and the Left.[19]

CULTURE AND WORKING-CLASS AGENCY

Even today much of the Left shares the belief that, as *HRR* puts it, socialism is 'the natural centre of gravity of working-class ideas'.[20] Though there are many pressures in working-class life pointing to solidarity and collectivity, there is no automatic relay between social standpoint and political outlook, so that Marxist political economy, even with Lenin's political insights, remains insufficient as political knowledge. Cultural study and thoughtful political practice show us, rather, *different* forms of class consciousness, a diverse working-class world without clear boundaries, 'much more than class going on' and class relations always complicated by gender, racial ascriptions and ethnicity, sexual difference, working and non-working status, including the central issues around 'disability', dependence, generation and ageing. Actually all this difference co-exists with a deepening *structural* class polarization on a global scale, a simplification of quite a 'classic' *Communist Manifesto* kind. The differences and commonalities are lived with, tolerated, celebrated or fought over depending on how they are defined. A consciousness of class takes different forms: pro-UK Independence Party working-class opinion, for example, is anti-establishment, anti-austerity and alive to the squeeze on public services, but ascribes the problems of daily life to immigration and the European Union forces, 'external' to nation and people.

This is why political agencies are needed that deploy a concrete understanding of all this difference and of ways to represent them as negotiable, common interests. More is needed here than the militant's evocation of working-class unity and determined and active campaigning. *Politics involves a rooted and representational cultural authorship.* This is why cultural research is so important and should be done in a political context. It is crucial to tap into what Gramsci called 'the good sense' of 'common sense', which is the starting point for a new hegemony.[21]

THE BATTLE FOR 'ROOT IDEAS'

The popular radicals of the 1830s called their own enlightenment 'really useful' to distinguish it from knowledge useful for labour under capital and the 'moral and religious education' of the schools. The people must know the causes of their distress and hear of solutions, whether the Charter and manhood (only usually) suffrage, Owenite communities or all-inclusive trade unions.[22] Hall calls such spearhead knowledge 'root ideas'.[23]

Until the rise of the Corbynite movement, most Labour politics stayed within the terms and language of the dominant neo-liberal framework while giving some weight to working-class needs, where they did not threaten capital. Ed Miliband's bitty electioneering looked courageous against all this conformity. All the best advice on building an alternative hegemony – from Gramsci, Hall and the linguist Lakoff for instance – stress that borrowing from the dominant frameworks defeats the most modest of attempted gains, even electorally.[24] Root knowledge is not a matter of programmes or policies or sound bites, but of fundamental commitments that need intellectual and cultural work to define, disseminate and enliven. It is not enough to announce them or carve them in stone. This is because language is already 'overpopulated', filled with others' meanings or already articulated, connected, to others' political visions.[25] There is therefore a real hard cultural labour to heave terms like freedom and choice from their neo-liberal anchorages and give them meanings consistent with greater equality. What would it mean, Stuart Hall asked, for *everyone* to have significant choices? Today, the politically invested term 'aspiration' does not have to evoke individuals or 'hard-working families' struggling up a greasy ladder of pay and status (with inevitable 'losers'). People can aspire instead to social connections and solidarity, enjoy a less work-dominated life and seek ultimate improvement for all.

Struggles over ideas may be conducted philosophically or drawn out from activist causes. The National Health Service (NHS), for instance, already a favourite example in *HRR*, is not only a uniquely economical way of caring for health, but it also exemplifies social solidarity, equality of treatment and an ethos of public service. Similarly, getting rid of nuclear weapons not only allows more resources for social needs, but also implies a different, more independent international role, no longer dominated by NATO's wars nor serving US global dominance.

VENTURING BEYOND IN THE ACADEMY

In his major work *The Principle of Hope* Ernst Bloch (1885–1977), developed a number of ideas necessary for a political practice of transition.[26] These

included, in a Marxist re-evaluation of utopianism, concepts like 'forward dreaming', 'concrete utopia', 'the objectively Possible' and 'thinking' as 'venturing beyond'. Bloch understood the past in future-oriented ways – as 'undischarged possibilities'. His three volumes are a veritable encyclopaedia of future-oriented human practices and representations – the 'open dimension' in daydreams, customs, plans, art, objects and literature. Utopian wishing is an ordinary human practice corresponding to real tendencies in the present. Its truth is tested, not merely affirmed, in political practice. As he put it: 'There is an open dimension in people, and dreams, plans live within it. The open dimension is also in things, in their leading edge, where becoming is still possible'.[27]

The CCCS had a utopian, hopeful side, but a testing, anxious side as well. Hopes were nourished of new ways of learning, of opening up a whole new continent of knowledge (no less), knowledge that could change the world (no less). With ambitions pitched so high, everyday practices were demanding and often personally costly.

'Staff and students together!' was a slogan of the 1968 student occupation at the University of Birmingham. It signalled a project of 'university reform', challenging the academic powers of the time (as today it would challenge modern line management). In the wake of 1968, the CCCS was an attempt to realize such a vision on a small scale and at a favourable time.

More sharply, in this experiment, pedagogic authority and even charismatic performance was challenged. Formally democratic internal governance, collective policymaking and small group projects meant that postgraduate students could lead as authors, researchers, introducers of texts and theories, etc. These novel internal relations, to which students admitted other students, opened academic doors to new social movements, younger generations, excluded social subjects, marginalized cultural currents and silenced voices and crazy projects. Intellectual openness (with exclusions) and democratic participation (with contradictions) enabled the feminist insurgency, the profound questioning of 'race', nation and empire and, later, the complexities of sexual difference and the challenge to whiteness.

There were many difficulties in these practices. They depended on a greater commitment from both staff and students than is usually required of even conscientious teachers and learners. Risky collective books rather than single-authored monographs or completed PhD theses could threaten or defer conventional careers. Single-discipline criteria and academic power could still bite back in assessment and examination. The responsibilities of 'director' could be partially transformed internally but were absolutely required in relations with university management. The search for appropriate pedagogies in a more egalitarian context was a process of trial and error, with inputs as much from 'rebellious' students as from staff. Success in attracting students

and many international visitors was not matched by an expansion in resources until the later 1980s. Compromises had to be made to prevent closure, full-scale entry into first-degree teaching, an increasingly regulated domain, for instance. The whole experiment depended on autonomies (within and outside the university) that were lost as management and market criteria tightened.

WIDER RELEVANCE TODAY?

I have written elsewhere about how collective work can be a strategy for the times within a beleaguered academy.[28] Power accrues to participants – students and teachers – whenever they work *together* in relations of *relative equality* on an intellectual-political project. As campus activism revives, there is promise of larger political gains from staff-student alliances.

I end here, however, on the potential of collective group work in specifically political contexts. Working together in these ways should be an aspect of party branch life for instance, or of educational, artistic and research collectives linked to branches. These can include teachers and students, of course. Indeed, as these practices spread, from many different roots, more and more people have learnt how much more productive and satisfying egalitarian group work can be than the exclusionary, deadening routines of hierarchical and machine politics.

The potential and need for cultural work of this kind increases as alternatives to neo-liberal dominance across the Western democracies develop. Open thinking about the future is at a premium.[29] The key political issues are not so different from those raised by New Left intellectuals in the 1980s or indeed the 1950s: to unite and renew a broad and open Left politics, to hear and talk back to all those *differentiated* popular preoccupations, seeking also the commonalities, and to use expertise and creativity in art, new media and culture to disrupt and supplant the dominant public discourses. And it is still true, I think, that those of us who pursue particular causes underestimate the need to progress the larger, longer, cultural revolution.

NOTES AND REFERENCES

1. Richard Hoggart, *The Uses of Literacy* (London: Chatto and Windus, 1957); E.P. Thompson, *The Making of the English Working Class* (London: Gollanz, 1963); Raymond Williams, *Culture and Society 1780–1950* (London: Chatto and Windus, 1958) and *The Long Revolution* (London: Chatto and Windus, 1961). Thanks to participants in the *CCCS-50 Years On* Conference and in the preceding *Academic Activist Workshop* for discussions on politics and intellectual work. Thanks to Barbara Henkes for wise comments on a first draft and to the editors for their advice.

2. For one starting point – 'neither culturalism nor structuralism will do' – see Richard Johnson in 'Histories of Culture/Theories of Ideology: Notes on an Impasse' in Michelle Barrett *et al.* (eds.), *Ideology and Cultural Production* (London: BSA and Croom Helm, 1979) pp. 49–77.

3. See, for example, Raymond Williams, *Marxism and Literature* (Oxford: Oxford University Press, 1977), especially pp. 80–82; Thompson, *Making of the English Working Class*, especially the Preface.

4. See the reference to Bloch in Note 26 below. For a rereading of Gramsci for hope see Richard Johnson, 'Optimism of the Intellect? Hegemony and Hope', *Soundings*, 54, (2013), pp. 51–65.

5. Raewyn Connell, *Southern Theory: The Global Dynamics of Knowledge in Social Science* (Cambridge: Polity, 2007).

6. When I visited Taiwan, a key node of global transmission and mixing, in 2009 I found that cultural studies was often identified with postmodern theory tout court. See Richard Johnson, 'North and South: Reflections on a Spring Migration to Taiwan' *Monumenta Taiwanica*, 2 (2010), pp. 1–26.

7. For (some of) the History Group work see Richard Johnson, Gregor McLennan, Bill Schwarz and Dave Sutton (eds.), *Making Histories: Studies in History-Writing and Politics* (London: Hutchinson, 1982); on the feminist theory and research see CCCS Women's Studies Group, *Women Take Issue: Aspects of Women's Subordination* (London: Hutchinson, 1978).

8. Stuart Hall, Chas Critcher, Tony Jefferson, John Clarke & Brian Roberts, *Policing the Crisis: Mugging, the State and Law and Order* (London: MacMillan, 1978); CCCS Education Group, *Unpopular Education: Schooling and Social Democracy since 1944* (London: Hutchinson, 1980).

9. See, especially, Ernesto Laclau and Chantal Mouffe, *Hegemony and Socialist Strategy: Towards a Radical Democratic Politics* (London: Verso, 1985).

10. Richard Johnson, 'What is Cultural Studies Anyway?', *Annali Anglistica,* XXVI, 1–2 (Napoli: Instituto Universitario Orientale, 1983). Republished in several collections.

11. Michel Foucault's influential version of discourse is susceptible to this criticism, for example *Discipline and Punish: The Birth of the Prison* (London: Allen Lane, 1977).

12. An important (admittedly late) route into psychoanalysis in the CCCS MA programme was Julian Henriques, Wendy Hollway, Cathy Urwin and Valerie Walkerdine, *Changing the Subject: Psychology, Social Regulation and Subjectivity* (London: Methuen, 1984).

13. See, for example, Catherine Hall, *Civilising Subjects: Metropole and Colony in the English Imagination 1830–1867* (Cambridge: Polity, 2002); Clare Midgley (ed.), *Gender and Imperialism* (Manchester: Manchester University Press, 1998); Anne McClintock, *Imperial Leather: Race, Gender and Sexuality in the Colonial Contest* (London: Routledge, 1995).

14. Stuart Hall, *The Hard Road to Renewal: Thatcherism and the Crisis of the Left* (London: Verso, 1988); Stuart Hall and Martin Jacques (eds.), *New Times: The Changing Face of Politics in the 1990s* (London: Lawrence and Wishart and Marxism Today, 1989).

15. For this critique see Bob Jessop, Kevin Bonnett, Simon Bromley and Tom Ling (eds.), *Thatcherism: A Tale of Two Nations* (Cambridge: Polity, 1989) and the reply in *Hard Road to Renewal*.

16. Stuart Hall and Bram Geiben, *Formations of Modernity* (Cambridge: Polity and Open University, 1992), p. 318. emphasis supplied.

17. But see his return to Caribbean routes and his important work with black and ethnic minority artists.

18. For similar views of *New Times* see Michael Rustin in the book itself: 'The Trouble with New Times', pp. 303–20 and John Clarke, *New Times and Old Enemies: Essays on Cultural Studies and America* (London: Harper Collins, 1991), pp. 153–79.

19. *Hard Road to Renewal*. The last part entitled 'Crisis and Renewal on the Left' is full of relevance for today.

20. *Hard Road to Renewal*, p. 177.

21. Stuart Hall and Alan O'Shea, 'Common-sense Neoliberalism', *Soundings*, 55 (2013), pp. 8–24.

22. Richard Johnson, '"Really Useful Knowledge": Radical Education and Working-class Culture 1790–1848', in John Clarke, Chas Critcher and Richard Johnson (eds.), *Working Class Culture: Studies in History and Theory* (London: Hutchinson, 1979), pp. 75–102.

23. *Hard Road to Renewal*, especially 'The Battle for Socialist Ideas in the 1980s', pp. 177–95.

24. *Hard Road to Renewal*, especially the critique of Labour, for example p. 209; George Lakoff, *The All New Don't Think of an Elephant* (Vermont: Chelsea Green Publishing, 2014).

25. Mikhail Bakhtin, *The Dialogic Imagination* (Austin: University of Texas Press, 1981), pp. 293–94.

26. Eenesto Bloch, *The Principle of Hope,* 3 Vols. (Cambridge MA: MIT Press, 1986).

27. Bloch, *Principle,* I, p. 288.

28. Richard Johnson, 'Complex Authorships: Intellectual Coproduction as a Strategy for the Times' *Angelaki,* 3, 3 (1998), pp. 189–204.

29. My own experience of this has been in Left Unity and in CND, locally and nationally. My city's branch of Left Unity founded a People's Art Collective to link its politics with local artists, musicians and poets.

Part IV

TRAJECTORIES AND BOUNDARIES

Chapter 13

Disciplinary Crimes under the Volcano

Iain Chambers and Lidia Curti

This is a rather disturbing return to the scene of the crime, further deepened by the recent deaths of Richard Hoggart and Stuart Hall. Cultural studies was founded in Birmingham and then the very same university closed it down. Perhaps this is the parabola of the intellectual shutdown presently underway in Western academia, where knowledge is increasingly packaged as information to be rendered transparent to the metaphysics of the market. In an epoch characterized by the ethical bankruptcy of neo-liberalism sustained in a political positivism that denies the idea of justice and implicitly refuses to cultivate a critical citizenship – what John Berger not so long ago called 'economic fascism' – the freedoms that once permitted critical thought and led to cultural studies are today clearly on very difficult ground.[1] At this stage, cultural studies represents not simply a crime against the previous disciplinary boundaries and protocols of the European humanist model of higher education, but is also quite simply off-world as far as present-day audit culture, busily rendering the planet transparent to the unilateral will of Tina (There Is No Alternative) is concerned. Here, of course, capital and culture simply become one.

The fundamental premise that we have personally inherited from cultural studies and the heady days at Birmingham in the 1970s is that of operating with the idea of critical work sustaining a cut or wound in the received canon and disciplinary consensus that cannot be healed. This would subsequently resonate in encounters with Foucault and Fanon, together with feminism and Italian critical thought. It is to suggest, against the grain of the present-day neo-liberal organization of higher education and its managerial and market-oriented protocols, the necessity of radically transforming inherited intellectual fields and disciplines into explicit ruins through exposure to other formations of knowledge. Rather than simply fine-tune, renovate and reduce an inheritance to meet market imperatives, the critical cut here constantly

seeks to disturb the grounds of authority, exposing them to unauthorized questions and unsuspected histories. This means that doing anthropology, fieldwork, sociology or historical research – crossing and contesting their languages and premises – can never be the same again. If neo-liberalism is also brutally transforming higher education into a ruined landscape, then the critical lesson of cultural studies perhaps helps us to seize out of the teeth of that disaster another set of critical tools, languages and maps with which to navigate the increasingly restricted premises of the present and avoid the seemingly inevitable colonization of our future.[2]

So, in our particular case, and referring to the locations of analysis, this is to consider the transit, transformation and translation of cultural studies in a non-anglophone space and series of practices. This is to suggest connections leading to both a resonance and dissonance seeded outside the North Atlantic axis. Cultural studies was initially brought to Naples by Lidia after a period of study at the Centre in Birmingham in 1964. It was subsequently sustained in the lessons, talks and visits of Richard Hoggart, Stuart Hall and Raymond Williams by the English Department at the 'Orientale' in Naples. All of this was accompanied by the diffusion of their writings in Italian: *The Uses of Literacy, The Popular Arts, The Long Revolution*.[3] In the following years there were other translations, among which the much-quoted essay by Stuart, 'When Was the Postcolonial. Thinking at the Limit', published in English in 1996 but first delivered at the conference 'The Postcolonial Question' organized at the Orientale in 1993.[4] Meanwhile the journal *Anglistica*, published at the Orientale, transmuted from a strictly literary enterprise into becoming a journal of English and cultural studies. Today, it is a free international and interdisciplinary online publication.[5] It was also during this period in the early 1980s that the national association of university English studies (Associazione Italiana di Anglistica – AIA) created a third stream of cultural studies alongside the established literary and linguistic components of the association. This dimension, despite misunderstandings, diffidence, and an often entrenched opposition that saw in cultural studies merely a sub-branch of the sociology of literature, continues down to the present.

At the same time, the growth of Italian cultural studies was never merely a mirror of its British counterpart. It was crossed by local critical work and traditions so that the necessity of confronting one's historical formation and unpacking its cultural baggage took place on different grounds. It sought to establish itself in very a different historical and political configuration, one characterized by a hegemonic left-wing culture under the aegis of the Italian Communist Party. Here, despite its political genealogy and radical credentials, institutional left-wing culture tended to endorse conservative definitions of culture. It produced an intellectual and academic status quo where the work of Antonio Gramsci was largely transformed into the endorsement of

orthodoxy.[6] In this climate, cultural studies in Italy had necessarily to work against the grain and transform the very concepts of culture, the political and the popular, into a series of unsuspected critical problematics. This meant wrenching attention away from critical orthodoxy and seeding an established left-wing, but profoundly aristocratic, cultural formation with questions and perspectives imported from elsewhere. In particular, the insistence on a political reformulation of the very concept of culture that emerged from below in the popular practices of everyday life and consumer habits ensured much antagonism and the guarantee of not being taken too seriously.

The temptation was simply to reduce the challenge of cultural studies to an Anglo-Saxon variant of the sociology of culture, or simply to consider it a passing fad imported from other shores. Such holding operations worked for a while. Still seeds were cast and destined to take root, and not only in the field of anglophone studies. And then there was the troublesome centrality of the return of an unorthodox Gramsci via cultural studies. This was not the Gramsci who had been mummified in the disciplined political philology of the Italian Communist Party, but an altogether more flexible figure activated as a thinker of praxis who insisted on the centrality of cultural power for understanding political processes and their formation in precise historical moments and conjunctures. The question of culture – and this, after all, was the central theme of cultural studies as it developed under the grey skies of Birmingham in the 1960s and 1970s – was not to be considered simply as a superstructural effect or consequential expression of an infrastructure that was being prioritized elsewhere in political analysis. The heart of the political question, that is the configuration and direction of historical processes brought together in a ruptural unity or new historical bloc, was intimately tied and ultimately decided in the power of culture to propose and promote a new culture of power. Kids on the streets, with strange hair styles, dressed in funny clothes and listening to the sounds of the descendants of former black slaves, were not simply the symptom of the 'Americanization' of European city life. They were also the articulation of another cultural register that certainly escaped the chauvinism of cultural definitions by local intellectual élites, both in Britain and Italy. This suggested an autonomy of initiatives that were to bring a series of repressed, subaltern pasts back into the present and mess up the existing understanding and organization of cultural power. That capitalism, as the Frankfurt School in its assured handling of the historical dialect of reification had constantly argued, was always ready to ride this new configuration and turn punk into product and profit was undeniable. At the same time, however, the very mechanisms of defining, defending and disseminating 'culture' suddenly acquired far more extensive horizons and tapped into altogether deeper histories. If Italian intellectuals and academics were slow to register this important shift, musical groups such as the Neapolitan

band Almamegretta were busily stretching and bending the confines of local musical and cultural traditions. Caribbean dub and the bass histories of the Black Atlantic were crossed with Mediterranean musicalities and narratives to sound out counter-narratives of capitalist modernity under Vesuvius.[7] Here the languages of locality and wider historical processes were musically mixed down into an emergent political order of meaning and a renegotiation of 'home' and belonging.

In this manner, cultural studies in Italy has gradually come to create a series of critical rents in both the institutional and intellectual fabric. This shift has certainly been less marked than in Britain or the United States. There are no university chairs or disciplines called cultural studies. This is in part due to the national centralization of university teaching programmes and recruitment, leading to the perpetual creation of a conservative consensus and the establishment of powerful academic lobbies punishing innovation and critical transgressions.

Still, the cat is out of the bag. Gramsci on the move comes home from his travels, both from London and New Delhi, frequently unrecognized or else sullenly cast in a suspicious light after his handling by foreigners. All of this has occurred in the context of the dispersal of the post-1945 settlement, which was not simply about the coming down of the Berlin Wall, the socialist bloc and European communist parties. There was also the deeper ground swell of decolonization, the expansion of the struggle for civil rights that went through and beyond racial and ethnic discrimination to invest questions of sexuality, gender and ecological choice. Such prospects have more recently been dramatically deepened and de-provincialized with the increasingly direct ingression of an altogether more complex, transnational world of asymmetrical powers announced by the modern-day migrant and what Fanon announced over fifty years ago was destined to block the horizon: the planetary redistribution of wealth.[8] This has led to the explicit withdrawal and suspension of social and political justice and the militarization of borders in Western Europe (and elsewhere) from the English Channel to the Mediterranean by an increasingly xenophobic Europe in which the strands of race, capitalism and modernity are drawn ever tighter through the geography of power into a single web.

Confronting these issues – and recalling that the initial source and understanding of cultural studies was sought in the instance of the contemporary (it was the Centre for *Contemporary* Cultural Studies) – we are faced with the inheritance of a transdisciplinary approach that smuggled Antonio Gramsci away from orthodoxies into becoming central to both British and Italian analyses of the present. Such unequivocal developments as the centrality and extension of mass media to the social significance of the Internet in the cultivation and extension of the modern political landscape, have only

deepened the initial understanding of political power inherited from Gramsci. The nexus of cultural formations in brokering the languages of politics through individual and collective interpellation remains central to change and challenging the existing order of power. The extensions, reconsiderations and new lexicons that have come from Foucauldian understandings of biopolitics and from feminism, or from Fanon and the registered centrality of the racialized hierarchies of colonialism to the making of the postcolonial present, have only deepened this inheritance.

Here, in passing from the 'internal colonisation' examined by Gramsci in 'The Southern Question' (1926) to present-day subaltern studies in India and Latin America, we are forced to confront altogether more piecemeal logics.[9] These were violently assembled out of the repressed histories of national unity in establishing the narrative coherence of hegemony. To be unified or colonized was never a request, always an order that came out of the barrel of a gun, exercised in the name of a law written elsewhere. The violence of state formations, mirrored and reaffirmed overseas in colonial practices and spaces, consistently troubles the modern national narrative and its historiography, and that includes Italy and its particular colonial unconscious. Even the massive emigration of Italians overseas to the Americas, Australia and the rest of Europe – around 30 million since 1860 – fails to provoke the connection to the present migration from the south of the world: history is tied down into epochal compartments, cut off from each other, and not permitted to flow into an interrogative constellation that would query the premises of the present. So present-day migration encounters largely negative attitudes and xenophobic measures without any reference to the nation's own colonial past and an inheritance connected to racist subjugation and the 'colour line' so central in Anglo-Saxon postcolonial studies. This repressed past is destined to become increasingly troublesome in a country that considers itself to be uniformly white. It has been the linear historicism of the progressive movement of a 'passive revolution', and not the interruptive logic of a Gramscian understanding of conjunctures, discontinuities, historical blocs and cultural formations, that commands institutional authority. In this situation cultural and postcolonial studies continue to sustain other, more open horizons. These are traced in the reconfiguration of a national and European past responding to the migration not only of bodies and histories from elsewhere but also to the movement across the linguistic, literary and cultural spaces of national identity. These propose a postcolonial poetics and politics that exposes 'Italianess' to non-authorized questions and unsuspected futures. This is above all illustrated in the important presence of a literature of migration in Italian, up until now considered a minor colonial language; a literature that reminds us of a forgotten past and at the same time becomes the voice of a culture of resistance and reconfiguration.[10]

Of course such critical and cultural perspectives were not absent from the post-war Italian scene. In their different ways Ernesto De Martino, Franco Fortini, Raniero Panzieri, Mario Tronti and Pier Paolo Pasolini contributed to a humus in which cultural studies could flourish. The difference, which also reveals the cultural configuration of a political conjunction, is that these voices remained largely isolated in their pronouncements, restricted to categories and disciplines that reduced the wider impact of their work and practices, often held hostage in the stasis of institutionalized Marxism and an aristocratic configuration of cultural debate wedded to ideas of 'scientificity' and objective truth. In particular, Pasolini's razor-sharp criticisms of Italian culture – both its comfortable hegemonic accommodations and the anthropological mutation of its popular forms – insured his isolation and marginalization in subsequent cultural considerations. The struggle against this particular economy of knowledge, unilateral in its intellectual pretensions and often profoundly undemocratic in its exercise, is still underway.

Against this background, littered with its own particular problems and interests, what appeals to us is the rerouting of cultural studies in a southern European and Mediterranean context. This inevitably leads to asking often recognizable questions while simultaneously drawing upon diverse cultural, conjunctural and critical lexicons. This particular exit from an Anglo-American world historically dominated by empiricism has not occurred so much through the fetishization of theory (another Anglo-American phenomenon), as by cutting into the sedimented inheritance of European humanism and the inevitable undoing (after Nietzsche, after Freud) of the abstract Kantian categories and Hegelian dialectic that presumes reason is truth and truth is reason. As James Baldwin would have put it, or Frantz Fanon or Assia Djebar for that matter, critical possibility is not produced by deliberate rationality, rather we feel that it is fundamentally dependent on coming to terms with the past that cruelly configures our present. Here, all of the critical potency that emerges from challenging a local historicism and its patrolling of the present comes to the fore.

It is in this situation, often characterized by institutional and intellectual stasis, that a marked interest in cultural and postcolonial studies has increasingly developed over the last twenty years. In the context of an increasingly planetary debate – from Indian subaltern studies, Latin American theories of decolonization and critical debate in sub-Saharan Africa – there have emerged significant local contributions from Sandro Mezzadra, Miguel Mellino, Cristina Lombardi Diop, and the research grouping around Annalisa Oboe at the University of Padova.[11] Here the Roman publishing house of Meltemi was a crucial agent of diffusion, publishing key works by Appadurai, Bhabha, Butler, Gilroy, Glissant, Spivak, Mbembe and others. These were also accompanied by two significant translations of essays by Stuart Hall carried out

by Giuseppe Leghissa and Miguel Mellino in 2006. Both curators, in their respective introductions, dealt with the question of the translatability of Hall's writings in the Italian context, again opening up windows and perspectives for crossing and evaluating the local terrain.[12] In the very same year a small collection of papers on Gramsci, Said and postcoloniality, the fruit of a conference at the Italian Institute of Philosophical Studies in Naples was also published.[13] Sandro Mezzadra's important *La condizione postcoloniale* was published in 2008. It elaborated an important interaction between the Italian workerist tradition (Panzieri, Tronti, Negri) and postcolonial studies. Today, at least among a generation of scholars and intellectuals that includes the already mentioned Sandro Mezzadra, Annalisa Oboe, Miguel Mellino and Cristina Lombardi Diop, not to speak of a host of younger scholars in the fields of Italian sociology, anthropology and historical studies, the terms of cultural and postcolonial studies circulate widely. These are distilled into sociological, political, literary and historical studies of migration, colonialism, racism, citizenship, political economy and border theory, both in courses in the social and human sciences and in specific PhD programmes in Naples, Palermo, Venice, Calabria, Bologna and elsewhere.

In the present moment, where in Naples we tend to run the inheritance of cultural and postcolonial studies into what we practice as Mediterranean studies, let us rapidly indicate two instructive perspectives.

One almost inevitably commences from Antonio Gramsci's analysis of the 'southern question' and its transference from the Italian Mezzogiorno to an altogether wider set of maps that stretch to include other souths of the world in their subordination and resistance to imposed cultural, political and critical templates. Here there is the well-known example of the passage between Italy and India and the question of subaltern studies. As always the translation encounters transformation. Gramsci's subordination of the peasants in an alliance with an eventual working-class leadership goes astray in India (or in Fanon's Algeria and much of sub-Saharan Africa) when the peasants themselves become the principal force of revolutionary change. Of course, the conjunctural manner of Gramscian thought never excludes such possibilities. It was never a template, always, as Edward Said would have put it, a travelling theory.

It is also at this point, considering such cultural and intellectual traffic, that we could respond to the gaps that open up between the formal democracy we are accustomed to and the informal demands and desires for social freedom and historical justice as expressed in the recent revolutions in north Africa, particularly in Tunisia and Egypt since 2011. These were very much revolts against neo-liberal governments, those that had been aided and abetted by the West. There, the appeal to ideas of 'democracy' clearly exceeded its increasingly limited exercise in occidental society and threatened to go

off the map. Once again, templates break down in translation and transfor-mation. Jurgen Habermas's understanding of the public sphere gets roughly reworked, even lost, in Tahrir Square. One passes from the concept of citizenship, or the public sphere, as an abstract category and the product of European rationalism and nationalism, to the practices and processes of a citizenship – that also appeals to transnational belongings as contemporary migration reminds us – interrogating and interrupting the category, and hence the West itself.[14]

In a similar breakdown of the occidental imperative, the Western obsession with the religion of others (and, in particular, Islam) becomes a critical boo-merang that ultimately reveals the centrality of religion, that is Christianity, to the making and reproduction of modern, secular life in the West. Here we are brought to acknowledge the role of Christianity in the European appropriation of the rest of the planet, where the concept of a unique evangelical truth sus-tained ideas of cultural and racial superiority and the ensuing epistemological violence rendered modernity a profoundly colonial and imperial exercise.[15]

This idea of listening and responding to *non-authorized modernities* also allows us to refer to recent work on a transdisciplinary mapping of the Medi-terranean through sound. Mapping the Mediterranean through music and sounds has involved less an exercise in the history or sociology of music, and rather more of thinking with music as history, as sociology.[16] Rather than an object that illustrates processes seemingly occurring elsewhere, music becomes the instance, practice, process and performance of histories, cultures and archives that are suspended and sustained in sound. This suggests how the poetical in becoming a critical *dispositif* or apparatus in its own right proposes a historical extension and cultural revaluation of what we consider to be the political. It is a form of learning from the subaltern and the south of the world, a south that in its violent colonial construction, appropriation and rule has always been a laboratory of modernity. Clearly this south and accompanying border zone is a shifting signifier, a mobile category. It runs not only along the shores of Europe and the Mediterranean sea, but also inter-leaves with other souths whose accumulative pressure increasingly propose a dramatically diverse critical compass with which to navigate a pluriversal planetary modernity.

Finally, by way of a conclusion that might better indicate the detours and difficulties of pursuing cultural studies in contemporary Italy, we would like to propose four intersecting dimensions that we consider sustain the operabil-ity of cultural studies in our present political and pedagogical context.

First, we are always speaking in terms of the crossing, not the cancellation, of the disciplines that apparently authorize knowledge in order to propose points of departure rather than conclusive arrivals. This implies, and this is our second point, that whatever 'method' cultural studies is supposed to evoke

does not emerge from the protocols of the disciplines that are interpellated, but rather lies in their critical appropriation in the light of a conjunctural configuration that always requires an inter-and transdisciplinary understanding. Third, we are clearly operating with a lacerated epistemology. Here a Kantian critical distance that ensures that the object of analysis is constructed according to the rationality of the sovereign subject is replaced by the analysis and the analyst being configured and constructed within the problematic that he or she is seeking to understand. Finally, such a critical passage and perspective confronts us with the dismantling of European humanism, with its particular historicism and universal premises (those 'white mythologies' that have been distilled into the occidental historical formation of the social and human sciences). Under the critical impact of the universality of the planetary relationships of asymmetrical powers we are forced to abandon the European imperative and follow Fanon in the promotion of a humanism measured not against Europe, but against the world and still to come.

NOTES AND REFERENCES

1. John Berger and Jean Mohr, *A Seventh Man* (London: Verso, 2010), p. 7. An earlier and shorter version of the article here was published in *Critical Arts*, 28, 4 (2014), pp. 871–874.

2. Domenico Losurdo, *Liberalism: A Counter-History* (London: Verso, 2014); Pierre Dardot and Christian Laval, *La nouvelle raison du monde: Essai sur la société néolibérale* (Paris: Editions La Découverte, 2009); Michel Foucault, *Society Must Be Defended, Lectures at the Collège de France, 1975–76* (London, Penguin, 2004); Seyla Benhabib, *The Claims of Culture: Equality and Diversity in the Global Era* (Princeton: Princeton University Press, 2002).

3. Richard Hoggart, *Proletariato e industria culturale* (trans. by Lidia Curti, 1970); Stuart Hall e Paddy Whannel, *Arti per il popolo* (trans. by M. Concolato Palermo, 1970); Raymond Williams, *La lunga rivoluzione* (trans. by P. Splendore, 1979). They were all published by Officina, Rome, in a series directed by Ferdinando Ferrara and Richard Hoggart.

4. See Iain Chambers and Lidia Curti (eds.), *The Postcolonial Question. Common Skies, Divided Horizons* (London: Routledge, 1996); Italian trans. *La questione postcoloniale. Cieli comuni, orizzonti divisi*, a cura di Iain Chambers e Lidia Curti, (Naples: Liguori, Napoli 1996). Among the invited speakers on that occasion were Stuart and Catherine Hall, Paul Gilroy, Vron Ware, Trinh T. Minh-ha, Larry Grossberg and Angela McRobbie. Homi Bhabha and Hanif Kureishi had visited the Orientale a few months earlier to give talks that were included in the volume.

5. *Anglistica*: http://www.anglistica-aion-unior.org

6. Paolo Capuzzo and Sandro Mezzadra, 'Provincializing the Italian Reading of Gramsci' in Neelam Srivastava and Baidik Bhattacharya (eds.), *The Postcolonial Gramsci* (Abingdon: Routledge, 2011).

7. The idea of cultural creolization, already at work in the ancient Mediterranean world, is announced in the song 'Hannibal's Children', reinforced and relayed over dub 'riddims' in Almamegretta, 'Figli di Annibale': https://www.youtube.com/watch?v=10bu1qNe19o, as well as in 'Black Athena': https://www.youtube.com/watch?v=PMXVp2b2jqk.

8. Frantz Fanon, *The Wretched of the Earth* (Harmondsworth: Penguin, 2001), p. 55.

9. Iain Chambers, 'The "Southern Question"… again', in Andrea Mammone, Ercole Giap Parini and Giuseppe A. Veltri (eds.), *The Routledge Handbook of Contemporary Italy* (Abingdon: Routledge, 2015).

10. See Lidia Curti, *La voce dell'altra, Scritture ibride tra femminismo e postcoloniale* (Rome: Meltemi, 2006) and Iain Chambers and Lidia Curti, 'Migrating Modernities in the Mediterranean', *Postcolonial Studies*, 11, 4. Among Curti's essays on women's literature of migration in Italy, see, 'Female literature of migration in Italy' in *Feminist Review* 87 (2007), and 'transcultural itineraries in women's literature of migration in Italy' in *Feminist Review Special issue* (2011).

11. Sandro Mezzadra, *La condizione postcoloniale* (Verona: Ombre Corte, 2008); Miguel Mellino, *La critica postcoloniale* (Rome: Meltemi, 2001); Cristina Lombardi Diop and Caterina Romeo, *Postcolonial Italy. Challenging National Homogeneity* (London: Palgrave, 2013); the Padova research network Postcolonialitalia can be consulted at: http://www.postcolonialitalia.it/index.php?lang=en&Itemid=143.

12. See Stuart Hall, *Pratiche del quotidiano. Culture, identità e senso comune* (Milan: Il Saggiatore, 2006); Stuart Hall, *Il soggetto e la differenza. Per un'archeologia degli studi culturali e postcoloniali* (Rome: Meltemi, 2006).

13. Iain Chambers (ed.), *Esercizi di Potere. Gramsci, Said e il postcoloniale* (Rome: Meltemi, 2006).

14. For a further discussion on this point, see the Review Forum on sociology and empire in *Postcolonial Studies*, 17, 4 (2014), with contributions from Emma Kowal, Gurminder K. Bhambra, Herbert S. Lewis, George Steinmetz and Gregor McLennan.

15. Iain Chambers, 'The unseen order: Religion, Secularism and Hegemony' in Neelam Srivastava and Baidik Bhattacharya (eds.), *The Postcolonial Gramsci* (Abingdon: Routledge, 2011).

16. See Iain Chambers, *Mediterraneo blues. Musiche, malinconia postcoloniale, pensieri marittimi* (Turin: Bollati Boringhieri, 2012). This volume explores further through cartographies of sound some of the themes already elaborated in Iain Chambers, *Mediterranean Crossings. The Politics of an Interrupted Modernity* (Durham: Duke University Press, 2008).

Chapter 14

'To tell a better story'

The Curious Incidence of Conjunctural Analysis

Mikko Lehtonen

The 'long project of cultural studies', as Stuart Hall called it, is not first and foremost about culture but about understanding contemporary conjunctures *with* culture.[1] The project was born in Britain in the 1950s in order to understand what was going on in the post-war 'now'.[2] For Hall, 'cultural studies really begins with the debate about the nature of social and cultural change in postwar Britain'.[3] The main object of the project has from the outset been to 'identify and articulate the relations between culture and society'.[4] Hence one could expect that conjunctural analysis, where the cultural dimensions of human practices are studied in their worldly setting, would be at the heart of cultural studies projects.

The political dimension of cultural studies has been palpable ever since, in various ways. Practitioners of cultural studies have been interested in the relations of culture and power. This has produced fruitful analyses on, for example, the politics of popular culture, gender and multiculturalism. Often such analyses have outlined important contours of local, national and transnational social contexts. They have deepened our understanding of the mutual relations and determinations between economic, political and cultural phenomena. Yet such analyses have but seldom met the challenge of understanding contemporary *conjunctures* stressed by Hall.

In this text, I try to sketch why the proliferation of cultural studies has not meant the spread of conjunctural modes of study to the same degree. Why is it so, as Hall wrote, that 'it has always been impossible in the theoretical field of cultural studies . . . to get anything like an adequate theoretical account of culture's relations and its effects'?[5] Cultural studies is, of course, famously not one formation but many things. All cultural studies must not and cannot be made in the mode of thorough conjunctural analysis. All conjunctural cultural studies projects do not follow the same models. There are different

ways of being a conjuncturalist. The hybrid formation of cultural studies
contains among other things, nevertheless, a number of conjunctural cultural
diagnoses.[6] Such diagnoses seem, however, to be more an exception than a
rule in the overall corpus of the internationalized cultural studies of the last 50
years.[7] The project of conjunctural analysis may be, and indeed is, long, but
at the same time it is quite thin. At the end of the text I will discuss in detail
why it has been so also in the Nordic countries, especially Finland.

WHAT IS THIS THING CALLED CONJUNCTURAL ANALYSIS?

Conjunctural analysis is a mode to address the 'worldliness' and 'dirtiness'
of culture, as Hall put it.[8] This entails that the conjunctural approach does
not take for granted the prevailing modern notions of economy, politics and
culture as separate spheres.[9] As a part of denaturalizing the present, the con-
junctural approach sees the notion of distinct spheres as a historical construc-
tion that, nevertheless, has real effects. The approach questions such modern
notions that see various aspects of the overall social reproduction forming
autonomous spheres (seeing producing human lives as 'economy', mutual
cooperation and power relations entailed in it as 'politics' and symbolic
action as 'culture'). Instead, conjunctural analysis underlines that 'economic',
'political' and 'cultural' aspects have to be examined as dimensions of the
complex wholes of overall social reproduction, embedded in complex social
formations and determining each other in contextually specific ways.

The conjunctural approach is a mode of contextual analysis, examining
the ways in which culture as a realized signifying system is embedded in
a whole range of activities, relations and institutions, of which only some
are manifestly 'cultural'. Such an approach could be exceptionally useful in
analysing such contemporary societies where the domain constituted by the
activities, institutions and practices that are called 'cultural' has expanded to
an extent unseen before.[10] Conjunctural analysis makes it possible to study
the relations of culture with all that is customary in modern notions thought
not to be culture. It is a way to analyse what role cultural dimensions have in
economic and political practices – and vice versa.[11]

The conjunctural approach does not entail merging the economic, the
political and the cultural into one. Stuart Hall wrote of the need to see the
relations between the different processes of material production as 'members
of a totality, distinctions within a unity'.[12] For him the totality was complexly
structured and differentiated. It did not obliterate but preserve distinctions – the
unity of its 'necessary complexity' 'precisely *requiring* this differentiation'.[13]

The conjunctural approach does not argue that everything is culture.
Instead, it underlines that all social practices depend on and relate to meaning

and sees cultural dimension as one of the constitutive elements of any practice.[14] Hall's example of the discursive character of all social practices is economy:

> The discursive or meaning-dimension is one of the constitutive conditions for the operation of economy. The 'economic', so to speak, could not operate or have real effects without 'culture' or outside of meaning and discourse. Culture is therefore . . . constitutive of 'the political' and 'the economic', just as 'the political' and 'the economic' are, in turn, constitutive of, and set limits for, culture. They are mutually constitutive of one another – which is another way of saying that they *articulated* with each other.[15]

Articulation is, indeed, a vital concept in piecing together conjunctures. Etymologically, the meaning of 'articulation' as joining together is quite close to the meaning of 'conjuncture' as something that has been bound together.[16] The concepts of articulation and conjuncture open up the specificities of each 'now' by referring to how various components or factors are bound to each other. The conjunctural approach, then, highlights that 'specific historical moments are the site of entanglements between multiple formations and tendencies'.[17] As Lawrence Grossberg remarks: 'Our job is to listen to the whole thing, take it apart, put it together, see its relations and articulations between the political, the cultural, the economic, the social, in all of its complexity, and then to try to describe it to . . . tell a better story'.[18]

As the vital concepts of the long project of cultural studies, articulation and conjuncture highlight the connections of studied phenomena ('cultural' and other) with other phenomena. For Hall, articulation refers to forms of the relationship through which two distinct processes are drawn together to form a 'complex unity'. Such unities are therefore results of many determinations, where the conditions of existence of the one do not coincide exactly with that of the other.[19] The concept of articulation hence provides tools 'to think of how specific practices (articulated around contradictions which do not all arise in the same way, at the same point, in the same moment), can be nevertheless thought *together*'.[20]

CONJUNCTURAL ANALYSIS AND NEO-LIBERALISM

Lately conjunctural analysis has been used by cultural studies practitioners especially to understand the effects of 'neoliberalism'. One of the most visible cultural analysts of neo-liberalism John Clarke, has separated two kinds of analysis, epochal and conjunctural.[21] Epochal analysis is a term Clarke adopts from Raymond Williams for whom in such analysis 'a cultural process is seized as a cultural system, with determinate dominant features: feudal

culture or bourgeois culture or a transition from one to the other'.[22] Williams contrasted this with 'authentic historical analysis' where it 'is necessary at every point to recognize the complex interrelationships between movements and tendencies both within and beyond a specific effective dominance. It is necessary to examine how these relate to the whole cultural process rather than only to the selected and abstracted dominant system'.

For Clarke, a conjuncture is a site where multiple temporalities become condensed, entangled and co-constitutive of crisis.[23] According to him, the idea of conjuncture marks a 'moment of condensation: an accumulation of tendencies, forces, antagonisms and contradictions' that 'produces a point of uncertainty and possibility'. Clarke suggests thinking of the conjuncture as a point where different temporalities – and more specifically, *the tensions, antagonisms and contradictions which they carry* – begin to come together.[24]

Clarke assumes from Williams the insistence that specific historical moments are the site of entanglements between multiple formations and tendencies. For Clarke, much of the critical work on neo-liberalism has largely avoided these requirements for analytical work, having been 'overly fascinated by tracing the dominant' and as a result confirming its dominance.[25] For him, it seems, neo-liberalism should not be used as an all-inclusive explanatory stamp. One should, instead, analyse concrete conjunctures in order to find out how neo-liberal aims are in each case fulfilled – or not fulfilled.[26]

The analytic force of a conjunctural analysis of neo-liberalism is because it does not take for granted the hegemonic position of neo-liberal projects. Instead, it asks how the possible hegemonic positions of such projects are or are not fulfilled. Such an approach opens up the conflicting arenas where neo-liberal projects are put forward, opposed and modified. This, in turn, offers possibilities to analytically discern the potential points and forces of resistance to such programmes.

THE CURIOUS INCIDENCE OF NON-PROLIFERATION OF CONJUNCTURAL ANALYSIS

On the basis of this short round-up of conjunctural analysis it might be clear that if conjunctural analysis is anything, it is hard. Conjunctural diagnosis requires a lot of intellectual effort. How to piece together the complex formations where economic, political and cultural dimensions or factors determine and are joined to each other in specific ways? How to overcome the received categories (even spheres) of economy, politics and culture, in figuring and formulating the research questions, identifying and assembling the data needed in answering the questions and in doing the tough work of concrete analysis – and still see the economic, the political and the cultural

as 'members of a totality, distinctions within a unity'? If anything, conjunctural analysis is time-consuming and requires serious transdisciplinary work. It cannot be easily made by separate individuals and certainly not inside customary disciplinary boundaries. Further, it cannot be easily (if at all) boiled down into handy 'how to' manuals.

All this goes against the grain of current crypto-positivist models of knowledge production.[27] Conjunctural analysis involves such long-term basic research that tends to be marginalized in the current academic capitalism that favours competing for external funding, producing clearly defined articles with given theoretical frameworks and limited research data as well as seeking such results that could be swiftly turned into economic profit.[28]

Contrary to such positivist ideas that see the researcher as a neutral observer, conjunctural analysis supposes such researchers are politically motivated. Intellectual and political works are, of course, not one and the same thing. Intellectual work has its own agendas and temporal terms that do not necessarily coincide with political agendas and deadlines. Intellectual work simply cannot be substituted for politics – or vice versa. Yet, as Stuart Hall underlined time and again, there is a 'politics of theory', meaning that intellectual work is 'a practice which always thinks about its intervention in a world in which it would make some difference'.[29]

The 'politics of theory' entails the social contexts of the knowledge produced. If cultural studies wants to intervene and make a difference by producing 'the best knowledge possible in the service of making the better world', whom should it aim the knowledge produced at?[30] How to overcome what Stuart Hall, speaking of the Centre for Contemporary Cultural Studies (CCCS) of the 1970s, illustrated in the following way:

> We were trying to find an institutional practice in cultural studies that might produce an organic intellectual. . . . The problem about the concept of an organic intellectual is that it appears to align intellectuals with an emerging historical movement and we couldn't tell then, and hardly can tell now, where that emerging historical movement was to be found. We were organic intellectuals without any organic point of reference.[31]

Most of the conjuncturalist analyses have come from the anglophone world (e.g. Hall, Clarke, Grossberg). On top of that, there is such work in Latin America (e.g. Barbero and Canclini)[32] and South-East Asia (e.g. Chen)[33] that one could characterize as conjuncturalist. In the Nordic countries, the context I know best, the prevalent model of cultural studies has been that of contextualizing (and not conjunctural) analysis. Cultural studies has found a foothold in Nordic countries in established disciplines (communication and media studies, sociology, literary studies, musicology etc.), where it has been acquired as a way of addressing the everyday, contextualizing cultural texts

and hence asking new questions concerning the role of symbolic action in production and reproduction of power structures.

The spread of cultural studies in the Nordic countries was related to their relatively marginal position in Europe. To speak specifically of Finland, both the humanities and the social sciences had until the 1970s quite a strong national and even nationalistic imprint. When cultural studies entered the intellectual fields of the country in the 1980s, mostly via youth and media studies, they represented a distinctively non-national and non-nationalistic field of research. It was no coincidence that cultural studies was first adapted in these countries in youth studies that were interested in new urban and cosmopolitan experiences as well as with the Anglo-Americanization of youth cultures, and highly influenced by the studies of subcultures carried out in Birmingham. Even in Finland, media studies were in a central position in absorbing influences from the work carried out in the CCCS.[34]

The translation and adaptation of cultural studies were also linked to changes in the intellectual centres upon which the Finnish researchers focused their attention. Until the 1980s, the main international intellectual influences in Finland (and the Nordic countries in general) came from Germany. In the 1970s, the Marxist influences continued that tendency since they, too, were largely German. The coming ashore of cultural studies coincided with the Anglo-Americanization of research that increasingly took place in the 1980s and was linked with the change of direction of cultural flows as a whole.

These changes coincided in the 1980s with drastic changes in Finnish culture. Whereas the culture had until the 1970s been characterized by a 'two cultures' model (that of the official or bourgeoisie and that of the workers and small farmers) with very strong tones of popular enlightenment on both sides, now the cultural publicity was rapidly commercialized, epitomized by the break-up of the monopoly of the state-owned broadcasting company YLE in the 1980s.

At least in Finland this was also a period when the intellectuals loosened their connections to the Left. The baby-boomers were politically very active in the 1970s with strong Marxist research programmes. In the 1980s, baby-boomers as well as later generations of intellectuals turned into more disciplinary work without such overall perspectives of the social formation as a whole than in the preceding decade. Culture was taken more seriously than before in the social sciences and in the humanities. This did not, however, entail as much looking at culture as a dimension of overall social reproduction but meant mainly looking at the textual aspects of social phenomena.

The Finnish community of cultural studies gained a foothold relatively quickly in the academia. The first centre for contemporary cultural studies was established in 1984 at the University of Jyväskylä. Its journal *Kulttuurintutkimus* (Cultural Studies) soon became influential. The network

of cultural studies, later developed into a society, has long been organizing successful biannual conferences with hundreds of attendants. At the same time, however, cultural studies has been predominantly an academic project and its political potential has been underused.

The Nordic countries, politically a periphery of the (European) centre, are nevertheless not that marginal in the field of global cultural studies. The International Association for Cultural Studies, growing out of the Crossroads in Cultural Studies conferences, first organized in Finland in 1996, is registered in Finland. Some international cultural studies journals, such as the *European Journal of Cultural Studies* and *Culture Unbound*, are edited in the Nordic countries. Such initiatives would have not been possible, let alone successful, without a relatively strong status of cultural studies in the social sciences and humanities.

On top of spatial specificities there are also important temporal or conjunctural specificities. The post-war conjuncture, where the cultural studies first developed in the United Kingdom, lasted longer in the Nordic countries. Talking about Finland, the neo-liberal ideas have been, since the 1990s, increasingly applied, but they have met such policies that aim at levelling the regional differences in the country and at income transfers so that the state prevents too much economic inequality. Hence the neo-liberal project has not necessarily been as successful in Finland as in some other countries, even though it has slowly but surely gained increasing foothold as the political field has during the past twenty or so years generally moved to the Right.[35]

WHAT HAS TO BE DONE?

How can we produce research in Finnish cultural studies that would help to picture the conjuncture at hand and sketch alternative futures? Research has its own agenda and timetables. Yet there are some burning social and cultural problems Nordic cultural studies practitioners should address.

First, the question of neo-liberal hegemony and its opposing forces. Why do the defenders of the welfare state seem to be on the defensive when it is well known that the people largely support welfare state ideals? Why, on the other hand, do people in favour of the traditional Nordic welfare model not, contrary to their deepest convictions, support such political forces that built the model in the first place?

Second, how to fight populist xenophobia, a regrettably widespread phenomenon in Nordic countries today? How to dismantle the following problematic configuration: on the one hand, the state is unable to solve the riddle of people being treated at the same time as different and equal; on the other

hand, the official quarters preach the liberal understanding about differences and wish that the actual conflicts would just fade out, hence creating room for xenophobic populism.

Cultural studies is in a special position to address these problems with its stress on the importance of the symbolic dimensions in producing current power structures and identifications. As the Left, at least in Finland, is in the deepest crisis it has experienced in almost a hundred years, the re-politicized cultural studies might with conjunctural approaches help them realize that it is not just about the economy or about politics, but, first and foremost, about culture.

NOTES AND REFERENCES

1. Stuart Hall on the reprinting of *Policing the Crisis*, http://vimeo.com/56838357, accessed 5 Jan 2016.

2. Lin Chun, *The British New Left* (Edinburgh: Edinburgh University Press, 1993); Dennis Dworkin, *Cultural Marxism in Postwar Britain* (Durham: Duke University Press, 1997).

3. Stuart Hall, 'The Emergence of Cultural Studies and the Crisis of the Humanities', *October* 53, 3 (1990), pp. 11–23. See also, for example, Stuart Hall, 'A Sense of Classlessness', *Universities & Left* Review, 4 (1958), pp. 26–32.

4. Cary Nelson, Paula. A. Treichler & Lawrence. Grossberg, 'Cultural Studies: An Introduction', in Lawrence Grossberg, Cary Nelson & Paula A. Treichler (eds.), *Cultural Studies* (New York: Routledge, 1992). As Lin Chun puts it in *The British New Left*, pp. 26–27:

> The novelty of the New Left thinking can be seen in its 'culturalist totality' which framed new political perspectives. In what was later on known as cultural studies, for the first time a discourse of culture became central in political discussions, and culture was used to 'designate a central process and area of social and political struggle' – .This militant, interventionist cultural engagement was where the New Left contribution to socialist theory and practice can be first identified.

5. Stuart Hall, 'Cultural Studies and its Theoretical Legacies', in Lawrence Grossberg, Cary Nelson and Paula A. Treichler (eds.), *Cultural Studies* (New York: Routledge, 1992), p. 284.

6. The most famous of these is Stuart Hall, Chas Critcher, Tony Jefferson, John Clarke & Brian Roberts, *Policing the Crisis: Mugging, the State and Law and Order* (London: Macmillan, 1978).

7. 'Conjuncture' does not appear as a reference in Tony Bennett, Lawrence Grossberg & Meaghan Morris (eds.), *New Keywords: Revised Vocabulary of Culture and Society* (Oxford: Blackwell, 2005). Neither is it discussed in Graeme Turner, *What's Become of Cultural Studies?* (London: Sage, 2012), to give just a few examples. The concept seems to be largely absent also from the work conducted in the CCCS itself. In the indexes of the two volumes of CCCS Selected Working Papers,

'conjuncturalism' has only eight references, four of which are to an introductory essay by Lawrence Grossberg, written especially for the collection. See Ann Gray, Jan Campbell, Mark Erickson, Stuart Hanson & Helen Wood (eds.), *CCCS Selected Working Papers, Vols. 1 and 2* (London: Routledge, 2007).

8. Stuart Hall, 'Cultural Studies and its Theoretical Legacies', p. 278.

9. The idea of economy as a distinct sphere became possible along the development of so-called self-regulating markets. Such development made it necessary to dissociate economy from other social reproduction and treat it as a separate sphere. See Arturo Escobar, 'Economics and the Space of Modernity', *Cultural Studies*, 19, 2 (2005), p. 143. Modern politics as a sphere was subsequently based on the separation between the social and the economic and defining the political rights as formal and not extended to economic questions. Around the same time, culture became understood as a spiritual realm, detached from the worldly spheres of economy and politics.

10. Stuart Hall, 'The Centrality of Culture: Notes on the Cultural Revolutions of Our Time', in Kenneth Thompson (ed.), *Media and Cultural Regulation* (London: Sage, 1997), p. 209.

11. As such, conjunctural analysis is a way to implement the programme of cultural studies formulated by Lawrence Grossberg in the following way:

> Cultural studies is built on the desire to find a way to hold onto the complexity of human reality, to refuse to reduce human life or power to one dimension, one axis, one explanatory framework. It refuses to reduce the complexity of reality to any single plane or domain of existence – whether biology, economics, state politics, social and sexual relations, or even culture.

See Lawrence Grossberg, *Cultural Studies in the Future Tense* (Durham: Duke University Press, 2010), p. 16.

12. Hall refers here to Marx's *Grundrisse*. See Karl Marx, Grundrisse: Foundations of the Critique of Political Economy (Harmondsworth: Penguin, 1973), p. 99.

13. Hall went on to stress that any phenomenon and relation must be comprehended both by its internal structure and by those structures with which it forms some more inclusive totality:

> Both the specificities and the connections – the complex unities of structures – have to be demonstrated by the concrete analysis of concrete relations and conjunctions. If relations are mutually articulated, but remain specified by their difference, this articulation, and the determinate conditions on which it rests, has to be demonstrated. It cannot be conjured out of thin air according to some essentialist dialectical law.

See Stuart Hall, 'Marx's Notes On Method: A "Reading' of the '1857 Introduction"', *Cultural Studies,* 17, 2 (2003), p. 127.

14. Stuart Hall, 'The Centrality of Culture: Notes on the Cultural Revolutions of Our Time', pp. 225–226.

15. Ibid., p. 226.

16. As Juha Koivisto and Mikko Lahtinen remark: 'The Latin coniungere – to bind, to join – continues to mark the modern meaning of conjuncture as a 'combination of many circumstances or causes' (Samuel Johnson, Dictionary of the English Language, 1755). In Diderot's and d'Alembert's Encyclopædia (1751–65), conjuncture is

defined as 'the "coexistence in time of many related facts, which change the one to the other . . . the conjunctures would be, if it were permitted to say so, the circumstances of the times, and the circumstances would be the conjunctures of the thing'''. Juha Koivisto & Mikko Lahtinen, 'Conjuncture, politico-historical', *Historical Materialism*, 20,1 (2012), p. 267.

17. John Clarke, 'Of Crises and Conjunctures: The Problem of the Present', *Journal of Communication Inquiry*, 34, 4 (2010), p. 340.

18. Lawrence Grossberg, 'Interview with Lawrence Grossberg', *Communication and Critical/Cultural Studies*, 10, 1 (2013), p. 83.

19. Stuart Hall, 'The "Political" and the "Economic" in Marx's Theory of Classes', in Alan Hunt (ed.), *Class and Class Structure* (London: Lawrence and Wishart, 1977), p. 48.

20. Stuart Hall, 'Cultural studies: Two Paradigms', in Richard Collins & al. (eds.) *Media, Culture and Society: A Critical Reader* (London: Sage, 1986), p. 45.

21. John Clarke, 'Of Crises and Conjunctures', pp. 339–340.

22. Raymond Williams, *Marxism and Literature*, (Oxford: Oxford University Press, 1977), p. 121.

23. John Clarke, 'Of Crises and Conjunctures', p. 341.

24. Ibid., p. 342.

25. Ibid., p. 340. For Lawrence Grossberg, in a similar vein,

'the discourses of neoliberalism seem to make the work of conjunctural diagnosis even more difficult, because neoliberalism has become an adjective that can be placed in front of almost anything. It is a term – certainly not a concept – that 'lets us off the hook' – and we would be better off without it unless its meaning is always specified and contextualized.'

See Grossberg, *Cultural Studies in the Future Tense*, p. 141.

26. See also Janet Newman & John Clarke, *Publics, Politics and Power* (London: Sage, 2010).

27. For Joe L. Kincheloe and Kenneth Tobin positivism equals such knowledge that is formal, intractable (founded on an assumption that the world is basically an inert, static entity), decontextualized, universalistic, reductionistic and one-dimensional. The twosome write: 'This "undead" positivism never operates in the name of positivism, and like a zombie walks the socio-political and educational landscape shaping the way we think, what we see in the world, and, of course, how we produce knowledge.' See Joe L. Kincheloe and Kenneth Tobin, 'The Much Exaggerated Death of Positivism', *Cultural Studies of Science Education*, 4, (2009), p. 513–528.

28. For example, Sheila Slaughter & Larry L. Leslie, *Academic Capitalism* (Baltimore: Johns Hopkins University Press, 1997).

29. Stuart Hall, 'Cultural Studies and its Theoretical Legacies', p. 286.

30. Lawrence Grossberg, *Cultural Studies in the Future Tense*, p. 55.

31. Stuart Hall, 'Cultural Studies and its Theoretical Legacies', p. 281. Hall refers here to the distinction made by Gramsci into 'traditional' intellectuals, a class apart from the society, and such thinking groups each class produces 'organically' from its own ranks who articulate the feelings and experiences which the masses could not

express for themselves. See Antonio Gramsci, *Selections from the Prison Notebooks* (London: Lawrence & Wishart, 1971), p. 9.

32. Jesus Martin Barbero, *Communication, Culture and Hegemony: from the Media to Mediations* (London: Sage, 1993); Nestor Garcia Canclini, *Hybrid Cultures: Strategies for Entering and Leaving Modernity* (Minneapolis: University of Minnesota Press, 1995).

33. Kuan-Hsing Chen, *Asia as Method: Toward Deimperialization* (Durham: Duke University Press, 2010).

34. Unfortunately there are no comprehensive histories of these developments either in English or Finnish, nor such examples (in English) of this early work that could be mentioned here.

35. See Mikko Lehtonen, '"What's Going On" in Finland? Employing Stuart Hall for Conjunctural Analysis', *International Journal of Cultural Studies*, 19, (2016), pp. 29–41.

Chapter 15

Cultural Studies Untamed and Re-imagined

Keyan Tomaselli

Humanities scholars often create strange spellings from well-known words, 'imagine' (a verb), for example, becomes 'imaginary' (an adjective). Imaginary is derived from C. Wright Mills who in 1959 wrote about the *sociological imagination.*[1] He identified sociology in relation to other disciplines like psychology or anthropology. Sociology imagines its object of study as structures of society. The *geographical imagination* thinks of society and the environment which it shapes as sets of interacting spatial relations. The '*literary imagination*' deals with the written storytelling. The *historical imagination* imagines the past based on received documents, stories and archaeologies, while *futurism* and *science fiction* imagine the future. For me, cultural studies (CS) examines the *relationship* between texts (the imagined) and contexts (political economy, institutions, policy and regulation, markets, etc.) in the imaginary of never-ending struggle. Media studies examines media-society relations vis-a-vis regulation, institutions and the circuit of culture.[2]

This chapter examines the ways in which CS was continuously re-imagined in Africa through different phases of struggle and liberation. These were similar to, and also different from, the work of the Centre for Contemporary Cultural Studies (CCCS) at the University of Birmingham. The CCCS had developed a rigorous philosophical interrogation of a variety of disciplines and concepts in establishing its transdisciplinary body of knowledge. Three themes emerged from the CCCS 50 Conference as historically constituting the project: (a) how academics could work as organic intellectuals in exposing anti-democratic tendencies; (b) how to create the New Left (opposing anti-humanist Stalinism on the one hand and critically interrogating capitalism on the other); and (c) CS offered the 'critical cut that cannot be healed, creating a critical ruin that cannot be reassembled', as Iain Chambers observed.[3] Pervasive and repressive hegemonies – within and without the academy – would

be contested, fractured and exposed, and then replaced with democratic bodies of practice.

Once a globally collaborative and uniquely energetic space, CS is now largely an undergraduate teaching programme sometimes celebrating, but more usually studying, consumptive aspects of neo-liberalism. To some extent, CS has been re-imagined and tamed by the neo-liberal enemy it sought to expose. For example, *Porn Studies, Celebrity Studies, Consumer Culture,* and a whole slew of titles on fashion studies, are just some of the new journals that feed the field's frenzy, if critically. As a US respondent comments of his experience of the taming effect of CS in his own institution:

> Several of us . . . tried to make the new major praxis-based (I hate to say 'activist-oriented' because that is too limiting), but the CS-theory hegemonic gained control and most of the students ended up researching topics that tried to discover 'hidden' agendas in such things as women's fashion magazines, or investigating inherent ageism in the consumer society, as represented by the greeting card industry. Such kinds of tired and 'tamed' old topics ('conveyer belt research' usually wrapped in layers of woolly 'positionings' and 'interrogations') have completely lost their edge to effect any change whatsoever. What I noticed is that students gained a kind of aggressive certainty that they had been taught how to see society's secret underwear, lacy and red! And this has indeed emboldened them to be more proactive. But from what I can ascertain, that jaunty sense of having the inside view has just allowed them to find a more secure place (yes, wearing the red lacy panties) in the very system they were once critiquing.[4]

Some students and their lecturers, ironically, interpret these critiques as technical manuals enabling their successful entry into neo-liberal enterprise. If this is what some strands of CS have become, how, then, did we in South Africa imagine CS from the late 1970s when engaged in the cauldron of anti-apartheid struggle?

SOUTH AFRICAN CULTURAL STUDIES DURING APARTHEID

Our own story started in the 1970s, a time of high economic growth and growing repression. Apartheid-supporting universities took a scientistic view of the world, doing administrative research, while the mainly English-language anti-apartheid institutions were conduits for successive Western-derived scientific revolutions: structural-functionalism, then quantitative, then Marxist and later, CS and post-structuralism.[5] Frictions of geography and cost, and the cultural and academic boycotts impeded flows of theory, largely encapsulating us within hermetic conceptual bubbles at the bottom

end of Africa. Pro-apartheid universities emphasized method, conducted administrative research and advised the state; the liberals studied theory and protected civilization; while the Left geared their intellectual work towards class resistance. Different processes were operative in Kenya and Zimbabwe, dealing with the contradictions of post-liberation issues, dealt with below.

The key interruption to apartheid had been the 1976 Soweto uprising, followed by the untamed aftershocks that coursed through the country resulting in the unbanning of the liberation movements in February 1990. For the conservatives, the objective was how to reform apartheid as its structural contradictions exposed increasing fissures. For liberals and the Left that analysed apartheid as a kind of racial capitalism, the objective was how to contest and then replace it with democracy, social justice and human rights. Thousands of community-based anti-apartheid projects arose from the early 1980s as street protests were organized into civic structures with clear programmes of action. Many hundreds of such organizations were embedded within the four liberal universities now engaged in action research.[6]

One such project was the Contemporary Cultural Studies Unit established at the University of Natal (now, KwaZulu-Natal (UKZN)), Durban, in 1985. The project, later named The Centre for Communication, Media and Society (CCMS), had arisen from the smoke of the 1976 Soweto children's uprising when a group of lecturers and students investigated why resistance had failed for so long. Starting with the Frankfurt School, they examined collectivized academic responses to the study of hegemony in South Africa and in other societies. The CCCS was among those they found whose model was recommended by them as the basis of the UKZN intervention, though it took another 9 years for the university community to accept and implement the proposal.

The Unit replicated the CCCS model. This was done first, by establishing its own working papers series, 12,000 of which circulated within the United Democratic Front[7] (UDF) and black union structures between 1985 and 1988.[8] Second, a book series: *Addressing the Nation*, was established in conjunction with South African, UK and US publishers, replicating the CCCS publishing relationship with Hutchinson. A third initiative involved importation of left-wing books from International General, many hundreds of which were sold to the same constituencies.[9]

Fourth, the relocation of the intellectually activist *Critical Arts* (established at Wits in 1980) from Rhodes University where I had been lecturing between 1981 and 1984, to UKZN, provided a key rallying point. Fifth, the Unit's first graduate intake in 1986 included community-based activists, and it hosted two community-based media groups within its offices. Sixth, campus location afforded institutional protection from the Security Police, as by 1984 UKZN had unambiguously declared its anti-apartheid stance.

In a seventh simultaneous process, the Unit attracted MA and PhD students whose later policy work was influential in shaping (or engaging) post-apartheid media, cultural, heritage and health policy.[10] Finally, a key mandate was to facilitate transdisciplinarity within the institution itself, one that was very parochial, disciplinarily conservative, and still wedded to the Eurocentric notion of 'high culture'. Ironically, among the most tactically conservative was the Left that had enabled the establishment of the Unit in the first place but who then questioned its action research orientation that had linked the Unit and community organizations in struggle. The issue was less the nature of this relationship than with the problematization via Peirceian semiotics of two sites of analysis: 'culture' and 'media'.

Herein lay the contradiction. The Left had largely abandoned 'culture' and 'media' to the state, so total was its assumed discursive hegemony. Anyone dabbling in these sites outside the increasingly powerful black union movement was accused of collaborating with apartheid or imposing an alienating structuralism. 'Culture' (or ethnos) was the philosophical basis for apartheid, and 'media' was the consent-inducing means, while the repressive state apparatuses enforced compliance. This reductionism was fractured by CS but not easily accepted by those Marxist theorists and Thompsonites[11] who studied reality as material, concrete and always referable. The result was that some campus-bound historical materialists and Althusserians were teaching about the ineffectiveness of struggle even while black schoolchildren and the thousands of organizations and unions that constituted the UDF, formed in 1983, were making history in the streets, liberating whole areas in their dormitory towns, and taking the struggle directly to the apartheid state. Theory in both liberal and some Marxist frameworks could not imagine resistance while in others they were at the forefront of mass mobilization.

The critical cut, then, was already the prerogative of the growing internal resistance which had developed its own cultural and media initiatives while many Left academics were arguing the finer points of reified theory or whether or not an E. P. Thompson approach was more class-sensitive than was CS' navigation between culturalism on the one hand and structuralism on the other. The culturalists were suspicious of semiology, with its alienating structuralism that objectified individuals via 'imported thought-shops' and the analysis of representation trapped within dyadic textual relations.

Critical Arts was the initial vehicle which took on cultural and epistemological hegemonies by examining text-context relations via analysis of representation. We were developing our own cultural and media studies (CMS) in the late 1970s before knowing about Birmingham. However, our sources were the same, linked to the Marxist interruption of disciplinary orthodoxies, as it swept through English-speaking universities after the mid-1970s. Theorists whose publications had travelled to South Africa included Marx (Lenin was banned),

Nicos Poulantzas,[12] Louis Althusser,[13] and Antonio Gramsci[14] who entered via sociology, development studies, politics and history. The deterministic analyses of imperialism by media political economists like Armand Mattelart, Hans Enzensberger[15] and Herb Schiller[16] struck analytical chords within left-wing communication scholars who were grappling with how media were functioning within an apartheid state. Raymond Williams's more thoughtful examination of the Marxist base-superstructure couplet assisted in better problematizing culture and economy,[17] while Vincent Mosco's book[18] offered a critique of that tamed genre of American CS that lacks groundedness in political economy. Peirceian triadic pragmatist, semiotics and dramaturgy filtered in via performance studies.[19] CCMS intersected these theoretical trajectories with action research, participatory methods and Freirean critical pedagogies.

Backgrounding this ferment were attempts to recontextualize the above theories and theorists that now included the study of representation and counter-ideology into a unique class structure, scrambled historical periodizations and an idiosyncratic experience of postcoloniality. Our belated introduction to the CCCS corpus in the early 1980s enabled us to draw on and apply a much more systematic body of work that examined the relationship of texts to contexts. These studies, as was the encoding/decoding model, were very useful in actual resistance practice, notwithstanding debates about whether or not Birmingham needed to be decentred.[20]

Simultaneously, we were trying to indigenize these imported theories in terms of African philosophies and non-Cartesian (i.e. African) ways of making sense. After 1990 our student body was increasingly comprised of Africans from all over the continent, and a highly diverse South African registration. Our alliance with black, white and Indian communities of struggle in Durban had brought activists onto campus and into our activities. Simultaneously, some of our anthropological field experiences took us into unknowable realms that tested the limits of Cartesian rationality.[21]

While, like at the CCCS, we debated terms, concepts and methods, we did not however think of ourselves as being organic or technical intellectuals. Rather, we worked with the grassroots UDF organic intellectuals and civic structures as facilitators enabling theory in practice via resistance (during the 1980s). Our sites of struggle included broadcasting, media and cultural policy research (1990s), development and public health communication responding to AIDS denialism and the resulting genocide (2000s), the latter moment being coterminous with the new struggle as our hard-won democracy, alarmingly, began to recede in the mid-2000s.[22] The Unit was located in a province that had been a veritable killing field that dominated our daily lives preceding the peaceful transition in April 1994. These intellectual moments were not planned but thrust upon us by breaking circumstances that required urgent responses, pulling us simultaneously into a variety of different directions.[23]

The CCMS had incorporated a social justice approach, working with both internal and external anti-apartheid organizations. Action research changes outcomes on the go, offering practical solutions for pressing problems within local frames of reference. The Zulu weekly *umAfrika*, for example, survived after 1994, as our students helped it to recurringly re-imagine its design, storytelling, news sources, readership and distribution over a 30-year period.

Ruth Teer-Tomaselli worked on the South African Broadcasting Corporation Board, bringing public service broadcasting theory back into its mission.[24] Eric Louw established the Durban Media Trainer's Group and worked with local cadres, among other projects while AIDS denialism and the resulting state-directed passive genocide required its own urgency.[25]

While CS has now largely mainstreamed into South African undergraduate curricula, often as jargon to be learnt by rote, as a handbook for business students or as a literary text-bound activity, it has largely lost its critical activist anchor that interrupts orthodoxy.[26] The above-mentioned red lacy panties is one example; others include simply cutting and pasting all manner of examples into CS jargon. The best analogy I and my colleague Marc Caldwell could think of is this: 'There's a bat, there's a ball, a pitch and scoreboard, but it's just not cricket.'

The mainstreaming effect occurred for three reasons: (a) post-apartheid students going into an uncertain employment future were alarmed when teaching as a profession had been (ironically) denigrated by the first minister of education. They thus shifted their sights with regard to employment certainty towards commercial sectors, in a new society that was emerging from analogue cobwebs into the Information Age; (b) the previously conservative universities' teaching administrative research embraced British media studies because of the global successes of CMS in recruiting undergraduate students; while (c) the internal liberation movement that had been informed by critical theory and media studies had conferred political legitimacy on this approach.

Media studies no longer automatically assumes the study of media-society relations, but is increasingly being taught by literary scholars as texts (e.g. red panties), but not as 'kinds of texts' (e.g. as part of a constantly hybridizing political economic value chain or circuit of culture as the CCCS expresses it), in the absence of activist organic intellectual practices (to question rather than celebrate commodity fetishism).[27] Red panty CS has been tamed, it has lost its critical dialectical cut, and the 'ruin' has been reassembled into a re-imagined grand narrative often linked to the study of corporate communication, celebrity lust and consumer culture as celebration of neo-liberalism (a term or process that itself may not be critically examined in the classroom). CS, as it was later applied in South Africa in communication departments, was not itself reconstituted and indigenized to take account of the very different but

sometimes familiar class, race, ethnic and gender structures and relations that characterize South Africa.

THE NEW IMAGINARY

Responding to these and other broader issues of context, indigenization and social reconstruction, the humanities became the focus of dual projects simultaneously emanating from two different ministries at the end of the 2010s: the Academy of Science for South Africa (ASSAf[28]), located in the Department of Science and Technology, and also the Department of Higher Education and Training (DoHET[29]). The ASSAf report that called for more state support for the humanities was framed within the needs of the knowledge economy, global competitiveness, and the employability of humanities graduates. The DoHET charter offered mechanisms for implementation.

While the thorny and often essentialistic issue of indigenous knowledge systems was hotly debated within the ASSAf, but not within the more rigorous postulates of decolonizing theory, my own tentative proposal was that an all-inclusive new imaginary was needed.[30] This would: (i) generate employable (critical) graduates; (ii) vest authority in the thinking citizenry rather than solely in reactive state authority; (iii) invest analysis with new, diverse, ways (methods) of making sense, reflective of our multicultural, multiethnic, society; (iv) examine the nature of power relations, and equip graduates with expertise to successfully manoeuvre within institutions for career purposes, while also ensuring institutional social responsibility; and (v) take into account the plurality of ontologies, cosmologies, identities and imaginaries that now jostle for legitimation in a postmodern media-driven world, of which South Africa has become something of a continental hub.

What is to be protected is not Eurocentric or Afrocentric cultures, theory or philosophy, nor imagined notions of civilization, nation or economy. Rather, the new imaginary requires that instead of defending these paradigm fundamentalisms that we rather critically engage this post-European Renaissance culture and build a more inclusive and dynamic humanities and social science that responds to the many contexts in which the diversity of multicultural, multilingual, multireligious generations of South Africans now find themselves.

In short, a new imaginary offers interventionist mechanisms via action research that can shape humanistic outcomes within the divisive conditions imposed by history. Application, community engagement and social intervention open up a disciplinary polygamy that will ensure continued academic relevance in a world in which higher education is often dismissed as 'imaginary', that is, ivory towerish and lacking concrete relevance. The critical cut

here occurs in contesting the textualization of research that lacks grounded real-world community-based work, a factor in the closure of the CCCS in 2002.

THE AFRICAN IMAGINARY

In east Africa, CS derived from popular performance and political praxis. Handel Kashope Wright[31], a Sierra Leonian now based in Canada, cites Ngugi wa Thiong'o[32] and the CCMS as among the originators of a performative, action-based, CS on the continent. The critical cut in Kenya was the Karimithu Theatre project, tamed by the authorities by causing its facilitators to go into exile, two of whom were accepted by Zimbabwe. This different trajectory was co-terminous with British CS and a response to postcolonial conditions in South Africa, Zimbabwe and Kenya respectively, all former British colonies.[33]

Research within this paradigm is performance-based, lived and self-reflexive, starting from the experience and ontologies of the researched. These are very different to the Cartesian mind and orthodox scientific methods, though they can be as essentialist; in Africa the ancestors are part of daily life and religion – that is the blind spot in most kinds of Western CS, a serious lack when it comes to the study of texts and contexts across Africa. This different – performative – trajectory has resonance with, but no connection to, Jean-Paul Saetre's non-Cartesian theory of the structure of the imagination. Presence (the material) and absence (the imagined spirit world), in Africa's case, are conjoined in mythological belief. Anglo-Saxon CS is relatively weak in its appreciation of the kinds of imaginary phenomena that are taken for granted in non-Cartesian societies.[34]

The later linking thread was indeed British CS as introduced to the University of Zimbabwe's English Department by the University of Oslo (UO). UO drew UKZN, among others, into this network, though CS found itself on the back foot in this troubled postcolonial society, resulting in the voluntary professional exile of many of the Zimbabwean UO graduates.

In short, CS is an ethically driven field that examines the relationship between domination and resistance; it also offers interventionist mechanisms via action research that can shape outcomes sought by individuals and groups even within the conditions imposed by history and which are not of their own making. This opens up to us a disciplinary inclusiveness that will ensure academic relevance in an increasingly hostile instrumentalist world.

What was exposed at the CCCS 50 Conference is the failure of CS to systematically stem the repressive tide of the kind of unfettered and unregulated neo-liberalism whose banking proxies nearly destroyed the global economy

after 2007.[35] No other field has so systematically imagined itself as a player in the winning or losing of struggles, of interrupting conceptual orthodoxies as did the Birmingham trajectory and some of its diasporic variants. Few disciplines take sides explicitly, though all do, whether admitted or not. Where some journals do retain the critical cut, the classroom has lost the sharpness of praxis, and while tertiary management tolerates abstract political economic critique, it is intolerant of questions that address the failing systems and myopic assumptions that manage the contemporary neo-liberal academy.

Where the Birmingham Centre was always an unrealized asset at its home institution, the CCMS's research directions always had the support of UKZN's top management. Where the CCCS was on the losing side, the CCMS was on the winning side of history, just until the win was lost by wilful regression into a corrupt elitist hegemony resulting, after liberation, in the highest income disparities in the world. CS was part of the South African policy moment of the 1990s: cultural, media, education and health promotion. But the Left in South Africa, once in power, lost its way, talking Left but walking Right as Patrick Bond observes.[36]

CONCLUSION

If capital can survive the banking meltdown, and with state connivance still reward the thieving perpetrators for utter failure and dishonesty, the failure itself becomes lauded as legitimate success. Processes are turned inside out, to quote Karl Marx' – all that's solid melts into air'. Capital does not need thuggish robber barons anymore – they are all wearing ties, Gucci shoes, driving high performance cars and behave politely. The impolite thugs of the early 20th century have become the legally protected polite thugs of Wall Street and High Street and of whatever streets in which they hide in South Africa.

The CCCS conference marked the closure of a heady, never-to-be-repeated era, one that began 50 years earlier. At its wake where its ageing CS apostles met, joked and commiserated with each other, the warmth and collegiality was extraordinary, borne from a common project that had started in England but which also arose out of Frankfurt School sociologies and psychologies of Nazism. Out of this perhaps last collective gasp emerged the CCCS Archive, a living index to what could have been, hosted by the same university that had thought it had laid the CCCS to rest. Yet, the cessation of the CCCS in 2002 could not impede CS's growth elsewhere or, indeed, its 'pop-up' reinsertion into its old nemesis, as Richard Johnson expressed it at the event itself.

Cutting critical thought remains the raison d'être of the academy – though it may take on new forms. In South Africa, many old organic intellectuals who once fought apartheid from the trenches are now the self-enriched

technical intellectuals of the new crony elitism, though many others are now again popping up as the new organic intellectuals forcefully interrogating the new hegemonies and reminding their constituencies that the new nationalist Africanist imaginary has eliminated history, class and critical analysis from the current debate. The generation replacing us battered old timers (the once-were-warriors) was present at the CCCS 50 but largely silent: for many of them CS is a syllabus, not a revolt, philosophy or reconstruction; for them no interruption is necessary, no new order is even imaginable under current circumstances, though two youngsters from the periphery did briefly interject at the conference with appeals about the need to decolonize theory. But the responses were largely reflective of a monocausal northern metropolitan imaginary.

All in all, here at UKZN, the CCMS and many others in many disciplines have been part of a global era and intellectual movement that may never again be repeated. This chapter is thus testimony to the vision of the staff-student committee whose ceaseless work arising out of the smoke of Soweto 1976 put in place a project that has endured 23 years into the post-apartheid era.

NOTES AND REFERENCES

1. Charles, W. Mills, *The Sociological Imagination* (Oxford: Oxford University Press, 1959).

2. Paul du Gay, *Production of Culture/culture of Production* (London: Sage, 1997).

3. Iain Chambers, 'Cultural Studies under Mediterranean Skies', *Critical Arts*, 28, 5 (2014), pp. 871–874. See also, Lidia Curti and Iain Chambers in this volume.

4. Writer requests anonymity.

5. See Keyan G Tomaselli. and P. Eric Louw. 'Shifts Within Communication Studies: From Idealism and Functionalism to Praxis—The South African Case'. In B. Dervin and U. Hariharan (eds.), *Progress in Communication Sciences 10* (Ablex: New Jersey, 1993), pp. 279–312.

6. These included the Universities of Witwatersrand (Wits), Cape Town, Natal and Rhodes, which enabled anti-apartheid activities both on and off-campus. Afrikaans-language universities tended to be aligned with the state.

7. Ineke van Kessel, *Beyond Our Wildest Dreams.* (Charlottesville and London: University Press of Virginia, 2000). For more information, see: http://overcomingapartheid.msu.edu/multimedia.php?id=65–259-15 (date accessed: 3 July 2015).

8. Keyan G. Tomaselli (ed.), *Rethinking Culture.* (Bellville: Anthropos, 1988) and Keyan G. Tomaselli, 'Alter-Egos: Cultural and Media Studies', *Critical Arts,* 26, 1 (2012), pp. 14–38.

9. For example, Armand Mattelart, and Seth Siegelaub, *Communication and Class Struggle 2: Liberation, Socialism* (New York: International General, 1983); Armand Mattelart, and Seth Siegelaub, *Communication and Class Struggle 1: Capitalism, Imperialism* (New York: International General, 1979).

10. See, for example, P. Eric Louw (ed.), *South African Media Policy. Debates of the 1990s.* (Belville: Anthropos, 1993); Keyan G. Tomaselli, and Alum Mpofu, 'The Re-articulation of Meaning in National Monuments', *Culture and Policy*, 8, 3 (1997), pp. 57–76.

11. Edward P. Thompson, *The Poverty of Theory* (London: Merlin, 1968).

12. Nicos Poulantzas, *Classes in Contemporary Capitalism* (U.S.A: Verso, 1975).

13 Louis Althusser, *Lenin and Philosophy and Other Essays* (London: New Left Books, 1971).

14. Antonio Gramsci, *Prison Notebooks* (London: Lawrence and Wishart, 1971).

15. Hans M. Enzensberger, 'Constituents of a theory of the media', *New Left Review*, 64 (1970), pp. 1–31.

16. Herbert Schiller, *Culture Inc.* (Oxford: Oxford University Press, 1989).

17. Raymond Williams, *Marxism and Literature* (Oxford: Oxford University Press, 1977).

18. Vincent Mosco, *The Political Economy of Communication* (London: Sage, 1996).

19. Keyan G. Tomaselli and Arnold Shepperson, 'Re-semiotizing the South African Democratic Project: The African Renaissance', *Social Semiotics*, 11, 1 (2001), pp. 91–106.

20. Keyan G. Tomaselli, 'Encoding/Decoding, the Transmission Model and a Court of Law', *International Journal of Cultural Studies,* 19, 1 (2015), pp. 59–70; Maureen McNeil, 'De-centring or re-focusing cultural studies. A response to Handel K. Wright', *European Journal of Cultural Studies*, 1, 1 (1998), pp. 57–64; Handel K. Wright, 'Dare we de-centre Birmingham? Troubling the "origin" and trajectories of cultural studies', *European Journal of Cultural Studies,* 1, 1 (1998), pp. 33–56.

21. Keyan G Tomaselli, 'Virtual religion, the fantastic and electronic ontology', *Visual Anthropology,* 28, 2 (2015), pp. 109–126.

22. Thabo Mbeki, Speech at the Opening Session of the 13th International Aids Conference, 9 July 2000. Available at: http://www.thepresidency.gov.za/pebble. asp?relid=2644, accessed 3 July 2015; Eileen O' Gorman, 'Magic Johnson, HIV/AIDS and No Denial'. 2012. Available at: https://blog.fh.org/2012/07/magic-johnson-hivaids-no-denial/, accessed 3 July 2015.

23. Keyan G. Tomaselli, 'Alter-Egos: cultural and media studies', *Critical Arts* 26:1 (2012), pp. 14–38.

24. Ruth Teer-Tomaselli, 'DEBI does democracy: recollecting democratic voter education in the electronic media prior to the South African elections', in George Marcus (ed.), *Connected: Engagements with Media* (Chicago: University of Chicago Press, 1996).

25. Emma Durden and Eliza Govender, *Investigating Communication, Health and Development* (Johannesburg: Jacana Media, 2012).

26. Keyan G. Tomaselli, 'Policing the text: disciplinary threats and spin doctoring', *Communicatio*, 26, 2 (2000), pp. 81–86. See response by Michael Chapman, 'Rebranding English till it hurts', *English Academy Review,* 17, 1 (2000), pp. 44–55.

27. See Daniel Miller, *Material Culture and Mass Consumption* (London: Blackwell, 1994) as an example of commoditization being studied uncritically as a 'text'.

28. ASSAf Consensus study on the future of the Humanities in South Africa: Status, prospects and strategies. (South Africa: Academy of Science of South Africa,

2011). See URL:http://www.assaf.co.za/wp-content/uploads/2011/08/25-July-Final.pdf, accessed 3 July 2015.

29. Department of Higher Education and Training, *The Future of Humanities and Social Sciences in South African Universities Conference Report* (Johannesburg: Centre for Education Policy Development, 2012).

30. Linda T. Smith, *Decolonizing Methodologies: Research and Indigenous Peoples* (London: Zed Books, 1999).

31. Handel K. Wright, *A Prescience of African Cultural Studies: The Future of Literature in Africa Is Not What It Was* (New York: Peter Lang, 2004).

32. Ngugi wa Thiong'o, *Decolonising The Mind: The Politics of Language in African Literature* (Nairobi: East African Educational Publishers, 1988).

33. Keyan G. Tomaselli, Nyasha Mboti and Helge Rønning, 'South–North perspectives: the development of cultural and media studies in Southern Africa', *Media, Culture and Society*, 35, 1 (2013), pp. 36–43.

34. I am indebted to Paul Wallace for the Saetrean insights. Wallace argues that the CCCS undervalued Saetre's approach. This lack will not be examined here, though Saetre was present in early CCCS reading lists.

35. See Chas Critcher's contribution to this volume.

36. Patrick Bond, *Talk Left, Walk Right. South Africa's Frustrated Global Reforms* (Pietermaritzburg: UKZN Press, 2006).

Chapter 16

Entering into the Expressway of Cultural Studies

Practices in China

Huang Zhuo-yue

It was a great honour to have been given the opportunity to participate in the 50th Anniversary of the Centre for Contemporary Cultural Studies (CCCS), and share the great achievements of the CCCS' prominent scholars. For years, my colleagues and I, together with my students, have read these works and attempted to trace and understand the thoughts and ideas, and also have been engaged in related studies. I was, therefore, delighted to meet with the authors of these books and papers, and other respected figures. I feel fate has brought us together. Meanwhile, as a scholar outside of the CCCS, I am eager to introduce new audiences to Chinese scholars' experiences with cultural studies, and to share with you the academic events in China and a vision of the future of cultural studies.

THE CCCS IN CHINA

It is commonly believed that cultural studies was introduced into China in the mid-1990s. Based on this time frame, it has been 20 years since this subject came to China. That is to say, Chinese scholars have had their own 'moment of cultural studies' for a not-very-short time, and had their own 'genealogy of cultural studies' for a not-very-long time. Compared to the 50 years' history of the CCCS, 20 years is short. However, much work has been done during these 20 years in China. A few young Chinese scholars have been planning to comb through the historical development of cultural studies in the country, and examine the comparatively short but very complex 'paths' of Chinese cultural studies. No doubt this project will be very challenging due to the extremely large quantity of works produced by Chinese scholars.

When cultural studies was first introduced into China, the scholars more or less worked with comparatively vague definitions of the term. With further studies after some time, the name 'Birmingham School' began to be used more often. For a time, it was even treated as the synonym of cultural studies.[1] Later on, many scholars began to use the term 'British Cultural Studies' as a more inclusive concept than the 'Birmingham School'. Still later on, with the broadening of the horizons of cultural studies, another name, 'International Cultural Studies' emerged, and a concept of 'Chinese Cultural Studies' also came up in localized academic practices.[2] However, during all these years, the CCCS has been seen as a source of inspiration and a theoretical 'centre'.

The influences of the CCCS and cultural studies on Chinese academia can be found, first of all, in the fact that the introduction and research projects of cultural studies have integrated into the important processes of knowledge production in contemporary China. A large number of original works published by the CCCS, such as the *Stencilled Occasional Papers*, *Occasional Papers*, *Working Papers in Cultural Studies*, *CCCS Annual Reports*, etc., as well as other original materials from Britain, the United States and Australia, were brought to China. Many works of distinguished scholars were translated into Chinese, such as the works of E. P. Thompson, Raymond Williams, Stuart Hall, David Morley, Paul Willis, Angela McRobbie, Dick Hebdige, Ann Gray, Lawrence Grossberg and Jorge Larrain, as well as the important works edited by Stuart Hall, including *Resistance through Rituals: Youth Subcultures in Post-war Britain, Doing Cultural Studies: The Story of Sony Walkman, Representation: Cultural Representations and Signifying Practices,* and *Questions of Cultural Identity*.[3] Williams's *Culture and Society* has two Chinese versions and at least another six works of his were translated into Chinese. Furthermore, many works of cultural studies scholars outside of the CCCS such as Terry Eagleton, Mike Featherstone, Tony Bennett and others were also translated into Chinese and raised great interest among Chinese scholars. These works can all fit into a category of 'doing cultural studies'. In addition, numerous works on the historical development of cultural studies and the CCCS were also translated, such as those by Jim McGuigan, John Storey, Dennis Dworkin, Chris Barker, John Hartley and Fred Inglis.

By 2000, only a few years after being introduced into China, cultural studies had already become a hot new field in Chinese academia. The *Cultural Studies* website established in the early period drew many scholars' attention and participation with its rapidly updated information and articles. It is in 2000 that Professor Tao Dongfeng and others started the first academic journal, also titled *Cultural Studies*, and it is in the same year that I created my course 'An Introduction to Cultural Studies' for the graduate students at Beijing Language and Culture University (BLCU), which was the first course on the subject in China. Cultural studies, thereafter, has been enlisted into

the curriculum of BLCU. Doctorate programmes with a specialization in cultural studies were also set up in such universities as Tsinghua University, BLCU, Beijing University, Nanjing University, Capital Normal University and Renmin University. With Professor Wang Xiaoming's great effort, the first department of cultural studies was established at Shanghai University in 2004, which was, to an extent, modelled on the CCCS in terms of curriculum design and instructional systems. The scholars mentioned above were all born in the 1950s and were often called the 'first-generation cultural studies scholars' in China. Under their leadership, cultural studies has grown fast, and 'second- and third-generation cultural studies scholars' also emerged. Nowadays in China, in more than 100 universities, there are teachers and scholars engaged with cultural studies, and numerous doctorate and master's candidates have chosen to deal with cultural studies-related topics in their theses or dissertations. Also, some dissertations specifically focus on the CCCS, either focusing on a certain scholar or on a particular subject matter.[4]

It is worth mentioning here that cultural studies was also brought into face-to-face communications and discussions through some forums and conferences, among both Chinese and international scholars. In 2005 I initiated the 'BLCU International Cultural Studies Forum' with the support of Stuart Hall. That year, Tony Bennett, John Storey and other international scholars participated in the first forum. The second forum was held in cooperation with the journal *Theory, Culture & Society*.[5] Mike Featherstone and Scott Lash together with nearly a hundred domestic and overseas scholars participated in the forum. Later, the Australian scholar Ien Ang and former members of the CCCS including David Morley, Charlotte Brunsdon, Ann Gray, Jackie Stacey and Erica Carter, participated in the forums and communicated with Chinese scholars.[6] The BLCU forum has created a bridge between China and Great Britain and facilitated communications between cultural studies scholars. In the past 15 years, hundreds of conferences were held among Chinese scholars on various issues concerning cultural studies.

The brief introduction above shows that cultural studies as a new approach has spread to different disciplines or fields through a series of procedures of knowledge production such as the translation of books, journal publications, curriculum design, degree granting, the building of networks, application and approval of national-level projects and various forums, lectures and conferences (because of too much related material, it is hard to list all examples. Some explanation will be added in the next section). The roles of Chinese scholars in cultural studies have transformed from the initial 'introducers' of ideas to independent producers of theories and knowledge, who created an open, bright landscape of knowledge production in the Chinese discursive contexts with their efforts dealing with global encounters and transcoding of 'meanings'. In short, it is not an overstatement to say that cultural studies

as well as the CCCS has had more influences on Chinese academia than any other contemporary Western thought over the past 15 years.

WHY IN CHINA?

Scholars outside of China may wonder why cultural studies found its soil of growth and kindled enthusiastic responses and debates in China. I think this can be understood from the following aspects.

First, in terms of academic paradigms, traditional Chinese educational systems came to an end and Western higher education systems were introduced into China from the beginning of the 20th century onwards. Between the 1950s and 1990s, the disciplinary structures in almost all Chinese universities resembled those of Western universities in terms of different disciplines being cut into blocks and disciplinary boundaries being demarcated. That is to say, the objectives and methodologies in each discipline were mandated, and cross-disciplinary transgression could not easily be achieved. While this facilitated the refinement and specialization of studies, it also had its side effects. On the one hand, there may be repeated or excessive knowledge production in one discipline, while on the other hand, many significant issues may fail to fit into and therefore be excluded from existing disciplinary territories. Therefore, this situation caused disciplinary crisis and also triggered reflections on it. However, cultural studies offered a way, not the only way but an important way, to relieve and alleviate the crisis. As we know, since the 1960s, reflections on disciplinary crisis can also be found in the United Kingdom, on which scholars of cultural studies have made a large number of comments. For example, Richard Hoggart wrote 'Schools of English and Contemporary Society' in his early years and Stuart Hall worked on a series of papers like 'The Emergence of Cultural Studies and the Crisis of the Humanities', etc.[7] These imply an awareness of reforming the old disciplinary system and extending the boundary of knowledge. In China, these kinds of interdisciplinary studies are called 'scaling up'.[8] This was first opposed by the faculty from the departments of literature and aroused heated debates, but cultural studies finally won a decisive success and has been widely accepted into various disciplines. First, all kinds of marginal culture and popular culture that were once neglected are revalued and share with classical studies the same important status in literature research. Meanwhile, the study of gender, race, ideology, etc., are introduced to traditional textual analysis, which greatly broadens academic horizons. Under the influence of cultural studies, disciplines such as history, communication, sociology, education, sinology etc. have also had a 'cultural turn' in China. The introduction of the discourse of popular politics in particular brings with these disciplines many fresh topics

to explore and much power to redefine themselves. Cultural studies bridges the communication between different disciplines, making multidisciplinary cross-references and intensive dialogues more convenient and smooth.

Besides, since the 1990s, Chinese scholars experienced a situation of 'farewell to revolutions' and return to the 'study room' from 'the square'.[9] This means that the intellectuals have begun staying away from the centre of politics, and have been marginalized by the new social reforms, with empirical and scientific studies being the only evaluating criteria for scholars' achievements. However, some scholars were reluctant to accept reality. Instead, they hoped to find a new path for intellectual criticism and cultural politics so as to combine their theories with reality, and combine their research with socio-political issues. Under such circumstances, they were naturally attracted to cultural studies which enabled them to find a connecting point to articulate their profession and the wider society, and to construct a new critical theory.

Secondly, in terms of social processes, the spreading influences of cultural studies in East Asian countries such as China, Japan, and South Korea can be explained by the fact that those countries encountered similar social-structural problems in the unfolding of modernities and postmodernities. For instance, Asian countries encountered similar situations of an industrial society, commercialism, populist movements, mass communications, class polarization, and later, global capital and wealth flows, national culture and pluralist-political conflicts, overseas immigration and identity diaspora, electronic mediascape, post-feminist waves, etc. These have already existed in Western countries, which cannot be theorized or resolved by the old knowledge systems and methodologies. Thus cultural studies was ushered in naturally.[10] Particularly in China, the Anglo-American approaches to cultural studies–inspired Chinese scholars since China had been brought under a national policy of 'developmentalism' and 'neo-liberalism' since the 1990s and became quickly integrated into the waves of globalization. Chinese scholars needed to enhance their consciousness of local problems while communicating and dialoguing with cultural studies scholars from other parts of the world, and to develop a set of new critical approaches.

The emergence of cultural studies in China is also to a certain degree related to an intellectual-political tendency of 'turning left' in China.[11] The 'first-generation' Chinese cultural studies scholars were mostly born in the 1950s and belonged to an intellectual group tagged as 'enlightenmentalists' before the 1990s. Having experienced the 'Cultural Revolution' and authoritarian regime in the 1960s and 1970s, they were engaged in the liberalization and enlightenment movements of the 1980s as liberalists. However, when market liberalism gradually gained ideological dominance and became the major power constructing the fields of social life, this intellectual group of 'enlightenmentalists' began to split from within. Some scholars attempted

deep reflections on global capitalism and communicated with others from America, Latin America, India, etc. They had profound doubts and critiques over ideas such as 'modernity', 'globalization' and 'one-way development'. Others showed more concern with Chinese social changes and problems, and investigated issues relating to capital accumulations and the exploitation of the underclass, the reconstruction of social consciousness through pop culture, consumerism and its impacts on traditional customs, the dissolution of socialist heritage by neo-liberalism and so on. From these situations emerged a tendency of 'turning left' among Chinese scholars. Many of these scholars later became engaged to different extents with cultural studies programmes, or utilized the perspectives of cultural studies in their examinations of social transformations in China. But these cultural studies scholars as a branch of the post-Mao 'enlightenmentalists' did not necessarily share the political stances of the older generations of leftists. While their reflection and critique on society were more or less based on socialist historical legacy, they by no means hoped to return to the old socialist idea and practice mode. It is hard to group them into the same category because of their complex background. Most of them nevertheless in a sense were still liberalists or 'enlightenmentalists' in nature. One of their goals is to resist and prevent the all-dominating power which manifested as authoritarianism in the past and as domination of capitals and market in contemporary times. As for this, it is not important as to how it is named or labelled, precisely as Stuart Hall said, cultural studies always attempts to mobilize and release the agency of a 'passive historical-cultural force' in the social process, this function itself is more important than any naming (such as 'leftist' vs. 'rightist' or 'socialist' vs. 'liberalist').[12]

LOCALITY AND CONTEXT

While visiting China, some cultural studies scholars from other countries expressed their hope that Chinese scholars could establish their own scholarship on cultural studies with localized features. This is a friendly reminder. But it need not be an excessive worry. There was little doubt that Chinese scholars would produce distinctive scholarship with characteristics of their own, since they would need to come to terms with the deep-level structures and issues of their own history and society. To cite a word frequently used by cultural studies scholars, what we are doing is a type of 'contextualism' after all.

Seen from the larger historical contexts, the following features can be observed in Chinese society culture and intellectual history in general. First, pre-modern China was largely a para-Confucian society, with traditions

different from Christian traditions in Western societies. Chinese people dealt with family and everyday life matters mainly according to a type of secular ethics, and based their principles of laws and principles of the mind on the worship of 'Nature'. In this way, the Chinese formed their particular behavioural patterns and cultural temperaments. Although Taoist and Buddhist discourses also had great influences on Chinese thoughts and minds, leading to diversified cultural landscapes, they never served as the mainstream dominant ideology. In the 20th century, after a brief democratic movement and a humanistic trend, China transformed into a socialist country, and even until today, the Chinese regime is still defined as a socialist regime, at least in terms of its official socialistic ideology. Hence Confucianism, socialism and humanism as the major ideological trends have had profound effects on Chinese social structure, cultural ideas and ways of life. The rise of neo-liberalism in the 1990s has tremendously changed the social structure and social consciousness in China, but not enough to eliminate the influences of its past. The result is a new social situation in which several co-existing ideological tendencies constantly conflict with, intertwine and integrate with each other, which characterizes the localized features of contemporary Chinese culture and mechanisms of power.

Secondly, the class configuration had its own peculiar characteristics in China. On the one hand, there was a distinction between the elite and the masses, and between high culture and low culture in traditional China. However, their boundaries were comparatively less clear-cut or stable than those in Britain or other European countries, because there always existed a special, non-hereditary institution of education-for-all and official selection in China,[13] which resulted in a dynamic, fluid system characterized by social-class mobility between the official and the populace and between the elite and the mass (e.g. an individual could move to an upper or lower social class, and periodic cycles of social class circulation could occur). This level of difference between China and the West can be seen as a difference between 'grade' and 'distinction'. Although different grades of social classes always existed in traditional China, there was no rigid class 'distinction'. Thus the two cultures (the elite and the popular) can often contain each other.[14]

On the other hand, since the rural areas hold a huge proportion in terms of geography, population and administrative units, they should therefore be the most important basis for our study of classes in China. Although, with the influence of Western discourses in the early modern time, a new name of 'working class' also emerged in China, the term nevertheless did not refer only to the labours in the urban factories, but also the labourers in rural areas who constituted the majority of the lower social classes. Even today, the lower classes working in the cities are mainly from the rural areas (with a population of about 300 million), and are often called 'migrant workers'

(peasant workers), 'New Workers' or 'New Working Class'.[15] Those workers are the social underdogs who are most severely exploited by the capital accumulations and market rules in China, and they are even deprived of the power to name themselves.[16] Hence, to understand the class culture of China, we must come to grips with the work, culture and lifestyle of this social group, as well as the multiform cultural clashes that ensue due to their participation in the modernization and urbanization processes, rather than just limiting our scope of investigation to the urban middle-class culture.

The third issue is the relationships between China and the West. The West played an active role in China in the context of early transnational colonization from the 16th century onwards. This led to the West and China reflecting on their own histories differently.[17] In the 16th century, missionaries from Western countries came to China with their 'universalist' and 'mono-centric' concepts, which precipitated long-term conflicts and debates with Chinese culture, philosophy and religion. In the mid-19th century, China, confronted with tremendous national social and cultural crises, had a semi-colonial experience under an overall intrusion of various Western forces and powers, which made two local voices coexist for a long time. One was to 'learn from the West' and the other was to 'resist the West'. After the 1950s, China entered into a socialist period, marked by the success of combining Chinese revolution with international communism. This was, of course, at the cost of rejecting any communications with the West, and 'westernization' was even seen as a synonym for the 'vicious capitalism', and was treated negatively in the dominant ideology in China at the time. However, in the 1980s, the relationship between China and the West was again pushed into a more complicatedly tangled maelstrom when various Western thoughts and theories were introduced into China as powerful discourses 'from the outside', while in the meantime, an ambivalent dichotomy of 'to embrace the West' versus 'to resist the West' was further organized into the multilayered discourses of progress versus nostalgia, globalization versus anti-globalization, regional versus universal and so on. It was due to such a historical experience that the contemporary Chinese society became one full of paradoxes and cultural complexities.[18]

The above brief summary does not provide a complete overview of Chinese locality or localized features, but rather outlines an important and distinctive context. That is why the applicability of foreign concepts and discourses need to be carefully considered and handled in Chinese cultural studies. I agree with the opinion that the characteristics, foci and future of Chinese cultural studies should be based on deep and thorough investigations into China's own long history and 'long revolutions', and it is from these investigations that Chinese scholars can develop their unique and powerful insights.

Of course, this does not mean that Chinese cultural studies can be separated from its international context. We still need to continue the constant communications between Chinese and international communities of cultural studies, to share new inspirations from each other, and to anticipate new prospects by continually tracing back to the origin of the CCCS. After all, it sets an important example for Chinese cultural studies. That is why I went 'back to Birmingham' after many years, so as to repack and set out on the road to the future of cultural studies.[19]

NOTES AND REFERENCES

1. In China, an early introduction to the Birmingham School was given in Luo Gang, Liu Xiang-yu (eds.), *Reader of Cultural Studies* (Beijing: China Social Sciences Press, 2000).

2. For a detailed description, see the 'Preface' Huang Zhuo-yue (ed.), *British Cultural Studies: Practice and Event* (Beijing: SDX Joint Publishing Company, 2011).

3. Stuart Hall and Tony Jefferson (eds.), *Resistance Through Rituals: Youth Subcultures in Post-war Britain* (London: Hutchinson & Co., 1976), the book is translated into Chinese by Meng Deng-ying (Beijing: China Youth Press, 2015); Paul du Gay et.al, *Doing Cultural Studies: The Story of Sony Walkman* (London: Sage Publications, 1997), the book is translated into Chinese by Huo Wei (Beijing: The Commercial Press, 2003); Stuart Hall (ed.), *Representation: Cultural Representations and Signifying Practices* (London: Sage Publications, 1997), the book is translated into Chinese by Xu Liang and Lu Xin-hua (Beijing: The Commercial Press, 2003); Stuart Hall and Paul Du Gay (eds.), *Questions of Cultural Identity* (London: Sage Publications, 1996), the book is translated into Chinese by Pang Li (Kaifeng: Henan University Press, 2010).

4. Given the incomplete statistical data in the Chinese network database, it is hard to get an overall depiction of master's theses or doctoral dissertations on scholars of the CCCS in China. According to the limited information, there are about ten doctoral dissertations and more than 20 master's theses on Raymond Williams. There are more than two doctoral dissertations and more than 10 master's theses on Stuart Hall. A master's degree is a three-year academic programme in China. Chinese doctoral dissertations or master's theses on some other scholars from the CCCS will not be listed here.

5. Mike Featherstone is the chief editor of this English journal which has published many papers on cultural studies.

6. The speeches by David Morley, Ien Ang, Jackie Stacey and Erica Carter were translated into Chinese and published in *Literature & Art Studies*, 4 (2011), 6 (2013) and *China Book Review*, 3 (2013).

7. Richard Hoggart, 'Schools of English and Contemporary Society', *Speaking to Each Other,* (London: Penguin, 1973); Stuart Hall, 'The Emergence of Cultural Studies and the Crisis of the Humanities', *October,* 53, (1990), pp. 11–24.

8. Tao Dong-feng, 'Challenges to Literary Theories from Cultural Studies', *The Frontier of Literature*, 1, (2000), pp. 193–5.

9. Chen Si-he, 'Three Value Orientations of Intellectuals in A Period of Transformation', in *A Collection of Chen Si-he's Essays* (Guilin: Guangxi Normal University Press, 1997), pp. 177–8.

10. Huang Zhuo-yue, 'Preface to The Trace of Thoughts: Interviews of Contemporary Chinese Cultural Studies' in Zou Zan (ed.), *The Trace of Thoughts: Interviews of Contemporary Chinese Cultural Studies* (Harbin: Heilongjiang Education Publishing House, 2014), p. 3.

11. 'Turning left', a special expression in Chinese academia, is associated with contemporary social context. Left ideology took the dominant position before the 1980s (Mao era). After that, however, there was a great emancipatory movement causing an extensive free-market experiment in China, which is called 'turning right'. After the mid-1990s, a lot of intellectuals tended to criticize the over-liberalism in the Chinese market and the current of thought thereby started 'turning left'. This new thought is also named as the 'new left' by some scholars, but it is not the same as the 'new left' in the Anglo-American world because of this different context. For further elaboration, see Dai Jinhua, 'The Cultural Mirror City and Invisible Writing' and Wang Hui, 'Mapping the New Prospect of Global Knowledge and Thought' both in Zou Zan (ed.), *The Trace of Thoughts: Interviews of Contemporary Chinese Cultural Studies* (Harbin: Heilongjiang Education Publishing House, 2014), pp. 23–4, 38–9.

12. Lawrence Grossberg, 'On Postmodernism and Articulation: An Interview with Stuart Hall' in David Morley and Kuan-Hsing Chen (eds.), *Stuart Hall: Critical Dialogues in Cultural Studies* (London: Routledge, 1996), p.140. For a further explanation of the issue, see Huang Zhuo-yue, 'Homage to Hall: In Honour of Stuart Hall's 80th Anniversary', *Reading*, 404, 11 (2012), p. 118.

13. The phenomena, and the social formation differences between China and the West resulting from it, have been given a lot of descriptions by the missionaries in China in the 19th century. See also Samuel Wells Williams, *The Middle Kingdom* (New York: Charles Scribner's Sons, 1883), p. 563.

14. Huang Zhuo-yue, 'Historical Bifurcation of the "Popular" Narrative: A Concept of Popular Literature in A Comparative Vision of China and the West' in *Huang Zhuo-yue's Essays on Thought History and Criticism* (Beijing: Beijing Language and Culture University Press, 2012), pp. 36–9.

15. See Lü Tu, *New Workers in China: Loss and Rise* (Beijing: Law Press China, 2003).

16. See Guo Chun-lin, 'Cultural Crisis in Our Age: A Case Study of the Naming of "New Workers"', *China Book Review*, 284,10 (2014), pp.66–9.

17. Within the American Sinology circles, this phenomenon has been seen as an 'Impact-response model'. See John K. Fairbank and Ssu-yu Teng, *China's Response to the West* (Cambridge: Harvard University Press, 1954); Joseph R. Levenson, *Confucian China and Its Modern Fate* (Berkeley: University of California Press, 1958). For opposing views, see Paul A. Cohen, *Discovering History in China: American Historical Writing on the Recent Chinese Past*, (New York: Columbia University, 1984), ch.1.

18. There have been a large number of debates over this issue since the 1990s. Even now, it is still a very important topic that covers various kinds of standpoints and ideas. It is hard to list all of them here. For early discussions, see Huang Zhuo-yue, 'Rethinking Globalization Universality and Post-Colonial Issues', *Zhejiang Social Science*, 6 (2001); Wang Ning, 'Globalization Nationalism and Surnationalism', *Journal of Southwest University for Nationalities*, 7 (2007).

19. This is also the title of a book written by a Chinese scholar, Xu De-lin, *Back to Birmingham: Exploration into Genealogy of British Cultural Studies* (Beijing: Beijing University Press, 2014). It was 8 years ago that I first visited the University of Birmingham.

Part V

DIALOGUES AND PRACTICES

Chapter 17

Action Not Words

Neighbourhood Activism and Cultural Studies

Chas Critcher

When I was younger I could remember anything, whether it had happened or not.

—Mark Twain

In the second edition of his *British Cultural Studies: An Introduction*, Graeme Turner inserted a chapter simply called 'Politics' to remedy a deficiency in the first edition which omitted the political impetus behind cultural studies. His discussion is mainly about the politics of intellectual work. But, certainly in the early days of the Centre, many of its members were politically active outside academia, in Left and, later, feminist groups. My own involvement, which would last twelve years, was in a community action project.[1] The relationship between that political activity and my intellectual work in the centre was far from straightforward. It is difficult to recall now, some forty-five years later, how those links appeared to me then. Here I want to explore how we can retrospectively make sense of the connection between cultural studies and a community action project in one of Birmingham's most deprived inner city areas.

Before we had even graduated, a group of us had decided to set up a community action project in Handsworth, a familiar location for students studying social problems or doing voluntary work. We spent the summer of 1969 setting up the project. We raised enough money to purchase a ten-year lease on a large Victorian house with the address Forty Hall Road, which became the title for the whole project. Though we had common values driving the project, we didn't have a specific plan of action. Five or six of us moved in and got to know the area so we could assess our options.

The activities of the project were largely demand-led. People asked us directly to do things or indicated indirectly what they would like to see happening. It is not hard in retrospect to appreciate how local people would react to a houseful of helpful students. Immediately they wanted to use our education: cultural capital, if you prefer. Neighbours turned up at our door with letters from authority they did not quite understand or long and complex forms which confused them. Then, later, it became the final demand for an electricity bill they couldn't afford to pay or the slowness of Social Security to respond to a request for a cot for a newborn baby. Mothers were worried what their kids would get up to after school or in the holidays with nothing useful to do. Somebody else wanted to move a three-piece suite: did we know anybody with a van?

And so the Forty Hall Road project took shape: a generalist weekday advice service augmented by a legal advice session staffed by volunteer solicitors; two weekly clubs for children, with an annual week's holiday in the Wyre Forest; a beat-up Transit van with a garage round the corner full of emergency furniture. So far, so doing good, much like other Handsworth projects. But Forty Hall Road was supposed to be different because we were practising socialists. We offered not only help but the potential to organize and have access to an understanding of how and why Handsworth was like it was. This was more easily expressed when later we rented a small shop. The large window display was used to analyse local issues: the power utilities, Social Security, housing, police brutality.[2] We also sold radical books and magazines so that the Action Centre, as it was modestly called, felt and looked different from a local Citizens' Advice Bureau. We were also committed to the principle of self-determination. So those with complex Social Security cases would be referred to the local branch of the Claimants Union based in the shop. We spent a lot of time attempting, and largely failing, to get people living in council houses to organize themselves into a tenants' association. More mundanely, we made a concerted effort to recruit and pay (cash, no questions asked) local people to staff the advice centre – of all these strategies, this was probably the most successful.

In the 1970s the project expanded, flourished and then declined. By the time I left in 1981 to take up a lecturing post at Sheffield City Polytechnic, there was little to show for our efforts. This was only one example of a series of such projects in the inner cities. So perhaps it could be located and its relationship to cultural studies better understood by looking at the history of community action in Britain in the 1960s. Unfortunately this does not appear to exist. A few fragmentary accounts of attempts to define the distinctiveness of radical community action are hard to find, published as they often were in pamphlet form.[3]

What does exist, by contrast, is a history of mainstream paid community work, with which community action had a tortuous and occasionally

antagonistic relationship.[4] Community workers were employed by councils or voluntary groups with aims which, while often vague, were rarely socialist. They did not necessarily live in the area and their careers might have taken them out of it altogether. There were such community workers in Handsworth in the early 1970s, employed by a variety of organizations, focused on specific issues like housing or with a particular slant such as faith groups advocating racial harmony. Forty Hall Road often cooperated with them over particular cases of need or campaigns over local issues. We still thought we were different because ours was a socialist practice but, and I cannot emphasize this too much, our community action project was almost entirely untheorized. We were driven less by intellectual understanding than by a burgeoning sense of injustice. The largely poor people of Handsworth were the victims of a system which denied them rights and did not even ensure that they claimed the few rights they had been granted. This seemed to us to be a disgrace in the midst of the Affluent Society. That was as much analysis as we required. We were unlikely to draw on cultural theory of any kind, especially as most of those who passed through Forty Hall Road had studied, and would often go on to pursue careers in, quite different areas such as engineering, education or social work. They might well have picked up reformist or radical ideas in the course of their education and in the student milieu of the late 1960s but these fed a sense of injustice rather than contributing to a clear-cut analysis.

Many community workers shared similar ideas. It was not an occupation to pursue if you felt that the poor were getting what they deserved. So a history of community work, in which community action was an often disruptive presence, may indicate connections with cultural studies or New Left ideas in general. The next step is to briefly review the history of mainstream community work. Then I will try to identify similarities and differences with the history of cultural studies.[5]

COMMUNITY WORK HISTORY

Community work was a child of the late 1960s. Its parents were the social-democratic state and the voluntary sector. In the early 1960s official reports on topics as diverse as planning, social work and primary education advocated community work as crucial to the process of social reform. The Gulbenkian Foundation produced two influential reports proposing a new role and career structure for community work. The Labour government elected in 1964 was aware of social problems in the British cities and anxious to avoid the racial confrontations evident in such areas in the United States. 1968 became the turning point for community work when they announced two initiatives. The Urban Programme, funded 75% by central government and

25% by local councils, would invite applications for funding from projects designed to tackle inner city problems. The directly funded Community Development Projects would be located initially in twelve deprived areas of the United Kingdom. What they did not anticipate was the radical thought and action that this would unleash. Many young social science graduates had become aware of the existence of pockets of social deprivation in the expanding economy. They had also become disillusioned with the Labour Party's feeble attempts to champion their cause, whether in government or in local councils where Labour authorities' management of such resources as housing was often indistinguishable from Conservative regimes. From this group many community workers were recruited into a workforce which would expand from one thousand to six thousand over the next decade. The Community Development Projects especially soon got out of hand, producing action research projects which revealed and condemned the inability of the state to compensate for the inequalities generated by the capitalist economy. They were consequently discontinued in 1974.

Commentators on this history identified a common agenda of combatting deprivation and extending democracy. Community workers occupied a contradictory position, working for government but with the working class. Their techniques involved giving a radical edge to traditional activities such as residents' groups; using new communication techniques such as newsletters to raise awareness; and providing children with playgrounds and play schemes. The role of the advice centre (of which Forty Hall Road/the Action Centre was typical) was not only to provide practical advice but to 'break down distinctions between advisers and advised' involving 'efforts to make such centres information resources for whole areas in collective actions' and 'with encouragement offered to people to take up their own cases and not merely to expect assistance in the form of advocacy'[6] (Baldock, 1979, p. 174).

Other analyses (Craig, 1989) argued that community work was tied up with the welfare state.[7] Rights were at the heart of community work which thus inevitably confronted the state which had sponsored it. Fiercely critical of the welfare state until the mid-1970s, community work was then forced to defend it from ideological attack and economic cutbacks. The 1980s saw pressure to incorporate community work into local projects aimed at ameliorating mass youth unemployment or defusing ethnic tensions. Cash-strapped local authorities saw community work as a luxury they could ill afford. Hopes that the new Labour government from 1997 would reverse the trend were dashed by the redefinition of community work as a means of dealing with social exclusion. 'Community' had also been reinterpreted to mean the locus for the treatment of mental illness or old age: care in the community. Over forty years, the state had reclaimed the term and the activity from its radical critics and practitioners.

COMMUNITY ACTION AND CULTURAL
STUDIES: FOUR SIMILARITIES

The direct links between community action and cultural studies, as embodied in the relationship between Forty Hall Road and the Centre for Contemporary Cultural Studies (CCCS), were mostly contingent and intermittent. I was personally the strongest link but these were largely two lives led in parallel: Forty Hall Road and the CCCS. Questions about Social Security in the morning; quandaries about structuralism in the afternoon. Only one other medium-term member of the project had anything to do with the Centre. The others knew of it but their degrees had been in other areas. There were occasional interactions. For example, a funded study called *Race in the Provincial Press* which was subcontracted to the Centre was actually conducted by members of Forty Hall Road as a fundraiser for the project. The most obvious crossover was *Policing the Crisis* with its origins in Forty Hall Road's familiarity with the mother of one of the perpetrators of a vicious attack. Forty Hall Road supported the boys' parents and campaigned against the sentence. Writing a book was a logical intellectual outcome, but it was not one anybody in Handsworth was likely to read. Indeed, I am not sure that anyone else in Forty Hall Road ever read it, at least to the end.

However, indirectly the relationship between the two was more clear-cut. Both the Centre and Forty Hall Road had in common their status as projects informed by and attempting to realize the political principles of the New Left. I have clustered these common elements into four themes.

The first thematic similarity is that these were collective and youthful enterprises. They drew and depended upon the boundless energy of youth, willing and able to work tirelessly on collectively sanctioned projects. Their originality required constant innovation since this was not how intellectual or community work was normally conducted. But with collective work comes the danger of internecine strife, in the form of interpersonal tensions and factional tendencies. Though quite different in size and structure, both groups habitually generated an emotional intensity far in excess of what the issues at stake warranted. Conflictual personalities did not help, including my own.

Collectivities proclaiming socialist or egalitarian principles will always experience dilemmas about leadership. There has to be some for the group to have any direction, achieve its goals or coordinate daily activity. But those who believe in equality resist hierarchies, especially based on status. There must surely be a better way than the traditional model of leaders and led. The CCCS, as part of a university, was required to have a formal hierarchy. To their credit the 'lecturers' did their best to break down barriers with 'the students'. They ceded powers in ways which would be unthinkable (and illegal) now. For example, applicants to the Centre were interviewed by a

panel consisting largely of postgraduates. Forty Hall Road had no require-
ment for formal hierarchies. But some members of the house developed a
longer history with, and deeper commitment to, the project than others. The
turnover among house residents in the first few years was extensive as some
recruits found that it was not for them. One reason undoubtedly was the per-
sonnel and style of leadership. I can certainly remember denying that Forty
Hall Road had any leaders while proceeding to act like one.

The second thematic cluster is that both cultural studies and community
action occupied and exploited 'spaces' in the liberal democratic state which
were subsequently closed down. Neither community action nor cultural
studies could have happened when and where they did without the massive
expansion of higher education in the 1960s following the Robbins Report of
1963. Those who benefited included lower middle-class and upper working
class young men and women whose experiences, lifestyles and aspirations
were very different from those traditionally offered higher education. Much
of this expansion also occurred in the arts, humanities and social sciences. So
analysing culture and society or poverty and inequality became commonplace
university activities.

This was the space into which the CCCS emerged. Its meagre resources were
initially secured against considerable faculty opposition. The postgraduate
student population was sustained either by government scholarships without
strings or by self-funding often through teaching 'liberal studies' to apprentices
(another challenging and occasionally hair-raising experience).[8] For the CCCS
to work, the university had to make concessions in a context where accountabil-
ity was loose, targets vague and governance devolved to faculties and depart-
ments. We now know it would not be allowed to last but this space within the
university system was the precondition for the existence of the CCCS.

Community work also occupied a space in the liberal democratic state.
As recounted earlier, this was opened out by government policy. The aims of
community work (like those of social science) were open to multiple inter-
pretations. Resources released by the central and local state could be taken
up and used by those with dissent in mind. As with cultural studies, career
paths opened up for radical practitioners. This space for community work was
closed down much faster than that for cultural studies. Community work was
incorporated into mechanisms of social control or packages of personal care.

The third common thematic cluster is that of socialist renewal. In the case
of cultural studies the renewal was theoretical: how to rethink socialism
outside of old categories and in the context of a new kind of society. In the
case of community action the renewal was practical: to reform socialism's
old organizing practices in the context of the inner city. Both reflected disil-
lusionment with the Labour Party and trades unions as failing to confront or
even ameliorate capitalist inequality. But both also distanced themselves from

other socialist organizations, whether old like the Communist Party or new like International Socialism or the International Marxist Group. For cultural studies the differences were intellectual. Constantly mobilizing the same rigid categories of class or party simply failed to explain or accommodate the changing complexities of capital. For community action the differences were strategic and tactical. The long-term aim was not to recruit members for the party or to form a revolutionary vanguard. The tactics did not involve offering leadership or revolutionary rhetoric to the dispossessed. The thoughts and actions of sectarian politics were rejected.

The fourth thematic cluster was that of 'race' as it was then still commonly called.[9] By the late 1960s immigrants from the New Commonwealth had made their way to Britain, settling mainly in larger towns and cities such as Birmingham. The housing market propelled them to areas where cheap rooms in large houses could be rented, regardless of colour. Thus people with black or brown skins took their place among the deprived. But a common material position was no guarantee of mutual understanding. On the streets and in the newspapers racial hostility was much in evidence. For the CCCS, as is well known, race had to be theorized into cultural studies as an ironic legacy of colonialism. It altered what or who needed to be understood in terms of class. Any sense of what was or might become a common culture had to accommodate peoples with their own religious heritage, family structures, food, dress and music which were quite different from those of the indigenous working class. Then from within came the critique of this developing position. Race could not be tacked on to the existing framework. It demanded a wholly new conception of the field of cultural studies in which the black experience took centre stage. Whatever the arguments, race wrenched cultural studies away from its white progenitors.

In its usual untheoretical way, community action implicitly adopted a position later called 'multiculturalism'. New migrant cultures were accepted in their own terms. Race should not affect how people claimed their rights or behaved towards each other. There were recognizable problems specific to each community but their common interests should have enabled them to work together. The initial challenge to this well-meaning liberalism came from within the black community. Some members drew from the US civil rights movement and its black intellectuals' ideas about the potential for black political consciousness and leadership. They were consequently sceptical about the role of young, white middle-class students in their community and on occasion would tell us so. Yet even that level of negotiation and interaction was derided by young African Caribbeans. Their preference in the 1970s was for the enclosed world of Rastafarianism, wilfully designed to exclude white people. We thus became more acutely conscious that to some local people (men more than women) our presence was entirely irrelevant.

Relationships with the Asian – largely Indian Punjabi – community raised a different set of problems. Some were simply linguistic, since few first-generation immigrants spoke fluent English. Others were cultural, the often complex relationships across gender and generation difficult for Forty Hall Road members to decipher. The exception was Ranjit Sondhi who eventually decided that this ethnic distinctiveness justified the development of a specialist agency, the Asian Resource Centre, which, remarkably, is still there forty years on.

These four thematic clusters represent the considerable overlaps and similarities between the projects of cultural studies and community action. An obvious omission so far is any reference to feminism or gender. But that is not a similarity between cultural studies and community action. It is one of two significant differences, the other being the relationship between theory and practice.

COMMUNITY ACTION AND CULTURAL STUDIES: TWO DIFFERENCES

The internal feminist critique of cultural studies and the subsequent controversies are well documented. Cultural studies had been constructed by men using categories appropriate for their experience. The effect had been to exclude women and the categories appropriate for their experience. It was not enough to add women on. The whole conception of culture needed to be rethought, putting gender inequality and patriarchy at its core. Questions of sexuality and subjectivity, never considered by the founding fathers, pointed to the relevance of psychoanalysis to the cultural studies project. Such a brief and bland summary cannot do justice to the sharpness of debate and conflict over the role of feminism in recasting cultural studies. It would never be the same again.

None of this is true in anything like the same ways for community action. There was belatedly a feminist critique observing that whereas community issues impinged mostly on women, most community workers were men. A feminist agenda for community action would concentrate on issues previously unrecognized such as domestic violence and sexual abuse. The women's refuges of the 1970s were an implicit rebuke to community action. Other potentially novel issues included women's physical and mental health. A feminist slant could also be given to issues community action did recognize, like the victimization of unsupported mothers by Social Security regulations.[10] But feminist politics may not have easily fitted into the community context since it had no geographical allegiance. Networks of women were bound together by similarity of experience, not proximity of residence.

Usually as many women as men were involved in Forty Hall Road. Most would have identified themselves as feminists but not in a particularly radical

way. For the project, it was not a matter for concern or comment whether advice or support was offered to or from a man or a woman. Sexual relationships inside and outside Forty Hall Road were regarded as a private matter. In practice many of the poorest members of the community were single mothers. They had often been neglected or abused by the fathers of their children but the project was not designed to acknowledge, analyse or act upon this obvious fact.

The biggest difference between cultural studies and community action has been saved until the end and serves as a conclusion. For me, political practice has to be more than intellectual work alone. On that basis we may say that cultural studies was largely theoretical with its political practice implicit; while community action was largely practical with its theoretical ideas implicit. This difference may result from a range of wider factors. Philosophical ideas are notoriously hard to convert into political practice. The story of the New Left is partly about this tension. It may also be that there are differences of temperament and personality between those more comfortable handling ideas and those more comfortable executing projects.

In the shadow of the 2015 general election in which the hegemony of neo-liberalism was all but complete, both cultural studies and community action seem to belong to a distant past when radical ideas and actions came easily, if fractiously. Now the conservatism of common sense is to the fore. National myths and burgeoning inequality are favoured over any sense of common humanity, much less endorsement of such ideals as equality, justice or welfare. So the New Left project, of which cultural studies and community action were both manifestations, came to understand the powers of its enemies but could do little to prevent their consolidation and extension. Still, we gave it a bloody good try.

NOTES AND REFERENCES

1. Community action has been defined as 'a form of community work whose main features are a support of disadvantaged groups in conflict with authority and an accompanying populist, reformist, Marxist or social anarchist perspective on society' (See Peter Baldock, 'Why Community Action? The Historical Origins of the Radical Trend in British Community Work', *Community Development Journal,* 12, 2 (1977), p. 68). This seems to get to the heart of the matter but the specifics of this position might be better served by removing the ambiguities of both 'community' and 'action'. A more precise description would be 'neighbourhood activism'. I have used that in the title but elsewhere stuck to the term in vogue at the time.

2. Examples can be found in the CCCS Archive at Birmingham University.

3. A significant exception is O'Malley's dense and detailed account of a decade of community action in Notting Hill. Reading it forty years on, I was struck by how

in London everything was much bigger: the size and complexity of neighbourhood problems, the range of activist strategies, the recalcitrance of the local council, the incursions of sectarian groups and the presence of demagogues or dubious characters. Birmingham was all much lower key. See Jan O'Malley, *The Politics of Community Action* (London: Spokesman Books, 1974).

4. Since this piece is a mixture of memoir and musing, academic referencing is deliberately sparse. My retrospective understanding of the history of community work is based upon the articles from the field's main journal and one comprehensive text-book: Peter Baldock, 'Why Community Action? The Historical Origins of the Radical Trend in British Community Work', *Community Development Journal*, 12, 2 (1977), pp. 68–74; Gary Craig, 'Community Work and the State', *Community Development Journal*, 24, 1 (1989), pp. 3–18; Chris Miller and Richard Bryant, 'Community Work in the UK: Reflections on the 1980s', *Community Development Journal*, 25, 4 (1990), pp. 316–325; Keith Popple and Mark Redmond, 'Community Development and the Voluntary Sector in the New Millennium: The Implications of the Third Way in the UK', *Community Development Journal*, 35, 4 (2000), pp. 391–394; Keith Popple, *Analysing Community Work: Its Theory and Practice* (Buckingham: Open University Press, 1995).

5. I have assumed a general knowledge of the history of cultural studies, excised of controversy. I have relied mainly on the works of Graeme Turner, notably the three editions of *British Cultural Studies* and the later *What's Become of Cultural Studies?* See Graeme Turner, *British Cultural Studies: An Introduction* (London: Routledge, 1990) and Graeme Turner, *What's Become of Cultural Studies?* (London: SAGE, 2012). The cultural studies entry in Wikipedia was also remarkably helpful.

6. Baldock, 'Why Community Action?', p. 174.

7. The best account of this experience by far is fictional: Tom Sharpe's, *Wilt* (London: Secker and Warburg, 1976).

8. Race is now a discredited term but was widely used at the time so I have adhered to the terminology of what was known as race relations.

9. Marjorie Mayo, (ed.) *Women in the Community* (London: Routledge and Kegan Paul, 1977).

Chapter 18

Cultural Studies and Channel 4 Television

A Moment of Conjuncture

Dorothy Hobson

THE CCCS, CULTURAL POLITICS AND CHANNEL 4 TELEVISION

A meeting of minds; a shared moment in history; a 'structure of feeling'; all these epithets come to mind when thinking and trying to understand the relationship between the Centre for Contemporary Cultural Studies (CCCS) and the early formation of Channel 4 Television.[1] As I researched the development of the channel between 1982 and 1987, I realized that there was a symbiosis of thought which spanned the two decades between the founding of the CCCS in 1964 and the establishment of Channel 4 Television in 1982.[2] And even more evidently there was an influence and shared adherence to the political and intellectual developments which the work of the CCCS had pioneered and which fed into the philosophical guiding of the channel in its early inception. Of course, it was not a conscious or pre-planned influence but there was definitely a shared conjuncture of mood, intention and philosophical ideas.

This chapter is a personal account of my own intellectual and practical involvement with parts of the British television industry in the late 1970s and 1980s. This was when I was at the CCCS and involved in ethnographic research with television producers and audiences. Talking to broadcasting executives and production staff immediately revealed that there was an awareness and understanding of the work of the CCCS in the broadcasting industry.

In fact, it quickly emerged that there was more understanding of the work of the CCCS among broadcasters than there was in reverse by academics. While the main focus of this chapter is about Channel 4 Television, it is also relevant to include brief references to other channels where the influence of the CCCS was making an impact. In the late 1970s I spent time researching television productions with Associated Television (ATV) (the Midlands Independent

Television [ITV] contractor), BBC Birmingham, BBC Television Centre and London Weekend Television (LWT) (the ITV London weekend contractor). At every company there were individuals – both executives and production staff – who were aware of the theories of cultural studies whether through the writings of the CCCS or the courses of the Open University. I remember discussing the latter, for example, with the head cameraman on the BBC1 situation comedy *Butterflies* during one of the breaks from filming at the BBC Television Centre.[3] Many people were aware of left-wing cultural theory, something that was part of their own cultural and intellectual education and development. It was clearly a time when the work of the Centre was having an impact, however small, on individuals in the television industry.

Another moment of coalescence of the work of the Centre in its concentration on popular culture led to a moment of shared interests with the press and broadcasting media. In July 1982 my book *Crossroads: The Drama of a Soap Opera* was published and I was asked to be a contributor to the Radio 4 programme *Start the Week*.[4] At that time the programme was the leading intellectual discussion programme on British media and to be asked to appear on it was a privilege. What was very interesting in terms of the growing importance of the work of the Centre was that the theme of the programme was Popular Culture. Another participant was Sylvester Stallone whose film *Rocky 2* had just been released.[5] Neither of us were the usual people to appear on the programme but this was one moment of popular culture breaking into the most intellectual and politically respected programme on British media. Each of us was defending popular culture; Stallone the glorification of boxing in his film and me defending the study of a soap opera by an academic and the relationship of the genre to its audience. Stuart Hall saw this as a moment of importance for advancing the work of the Centre. In fact, *Crossroads* attracted significant media attention – I was interviewed on radio and television by journalists nationally and internationally and was asked to write for newspapers as diverse as *The Times* and the *Sydney Morning Herald*. I did decline an invitation to pose outside ATV studios in academic dress for a feature in *The Sun*! Part of this was a fascination within the media that a soap opera could be taken seriously and the strength of my arguments was that this recognition of its connection with popular culture came via the interviews and the words of the women who read *Crossroads* and gave their views on its strength and connections with their everyday lives.

FROM CROSSROADS TO CHANNEL 4 TELEVISION

Shortly after the publication of *Crossroads* I was contacted by Sue Stoessl who was head of research and marketing at the new British television channel

Channel 4 which was to begin broadcasting on 2 November 1982. She asked if I would be interested in designing a research project which would use my research techniques of interviewing and conducting ethnographic research with programme-makers, broadcasting executives and audiences. Stoessl had previously been head of research at LWT, where she was interested in research which asked audiences what they thought about programmers and explored the concept of targeted programmes. These were ideas and methods which she bought to Channel 4 where the idea of programmes which were targeted at specific audiences was integral to its scheduling.

Stoessl knew of my research at the CCCS and of my ethnographic research with audiences and broadcasters and she wanted the same approach to be used to record the early years of Channel 4. Of course, I accepted the commission and for the next six years I worked on an ethnographic research project about the channel. During the years of this research I met a number of people who had been influenced directly or indirectly by the work of the CCCS and learnt of the way that the theories and methodologies of cultural studies were part of their working lives and professional thoughts. I was also involved in discussions at every level and wrote papers for Jeremy Isaacs, the founding chief executive of Channel 4, about audience reception of their programmes. He always wanted to know what audiences were thinking and he wanted feedback from the viewers I was interviewing. He was particularly interested in their views on areas of contention. He also wanted to understand why viewers did not like bad language and why it caused offence. This was always from a cultural studies perspective and my views were appreciated and discussed in meetings.

ENCOUNTERING CHANNEL 4 – FEELING AT HOME

The first time I went to the Channel 4 building at 60 Charlotte Street, London, was to attend a Programme Review Meeting – a weekly meeting and one which subsequently I regularly attended – where I met the newly appointed commissioning editors. This was potentially a nerve-racking experience for an academic ethnographer. It had been confirmed by Jeremy Isaacs that I would look at the work which the commissioning editors were doing and write the story of Channel 4. Academia and the media were not the most natural combination and while broadcasters were used to looking at other people's working practices in documentaries they were not used to being the subject of such studies. Only the work of Schlesinger (1978) – the first ethnography of BBC newsrooms – was seen as a fair encounter with a broadcasting organization.[6] I was conscious that they might be wary of my attendance at meetings and knowledge of their working practices. However, this did not present any problems.

This was a group of people and a meeting which might well have been seen as an outreach branch of the CCCS. They knew the work of the Centre – particularly Stuart's work but also other work on youth cultures and audiences. Discussions in this and other meetings about programmes, commissions, and programme reviews were usually from an intellectual perspective and the notion of the philosophical ideas behind the programmes was as important as discussions about the resultant programmes. As with the CCCS political commitment was part of the philosophy of those who worked at the channel. The notion of a collective responsibility for the channel as well as your own programmes and the fierce arguments about the content and the execution of programmes was so much like the collectivity of the CCCS that I felt completely at home there. Meetings had a similarity to Centre meetings in many ways. There was fierce argument and debate. There was anger and sometimes even tears; passions I had seen at the Centre General Meeting or perhaps closer to the end-of-year Group Presentations. An endless battle of ideas and positions were the fuel which drove the engine of the channel. All these editors had different backgrounds. Some were experienced television professionals and some had no experience of television at all and they were all selected for various qualities and attributes which they had and which Jeremy believed would enable him to achieve the channel that he wanted to develop.

PEOPLE AND PROGRAMMES

While institutions are important I have always held the view that individuals and groups of individuals are as important in the development and ideologies of organizations. Their drive through their ideas and philosophies and their ability to lead and, more importantly, to enable others to achieve their ambitions is the hallmark of good leadership and ultimately of successful organizations. Among the list of people connected with Channel 4 as commissioning editors were many who shared beliefs in the underlying theories and developing themes of the work of the CCCS. As he was beginning with a clean slate, Jeremy Isaacs was able to create the notion of commissioning editors and to decide what would be the genres which they would introduce for the channel.

Commissioning editors included Liz Forgan, who was formerly women's editor at the *Guardian* and who did not have any prior experience of television but had a track record of news and a commitment to women's issues. Naomi McIntosh was senior commissioning editor for education and joined Channel 4 from the Open University. Her academic experience and interests were committed to extending access to education. She was not a television producer, although she had experience of television production at the Open University.

McIntosh adopted a philosophy of defining education across a wide range of areas and making accessibility the template for her commissions. The editor for multicultural programmes was Sue Woodford, an experienced documentary producer who came from Granada Television. Sue was instrumental in bringing the first programmes which were targeted at multicultural viewers, including *Black on Black* and *Eastern Eye* which alternated each week.[7] Michael Kustow, the commissioning editor for arts, was an ex-head of ICA and welcomed me as I first entered the meeting and immediately started talking about the work of the CCCS. There were other connections. Carol Haslem was an experienced BBC documentary producer who had worked on various Open University documentary programmes alongside Stuart Hall and was appointed commissioning editor for documentaries; Alan Fountain was appointed as commissioning editor for independent film and community. Alan's commissions many were from the Independent Filmmakers' Association which was founded in 1974. Channel 4 was committed to supporting film and video workshops and gave them financial support as well as commissioning programmes for them to transition.[8]

Outside Channel 4 there were others who subscribed to the theories and ideas which had emanated from cultural studies and who embraced the project in their own companies. As important as the commissioning editors were in determining the output of the channel, there were a vast number of creative writers, producers and directors who pitched and then created new programmes for Channel 4. The coming of the new channel meant that the early years was a period when ideas for programmes which ITV producers had nurtured were able to seek an outlet. Channel 4 was charged by Parliament to commission from independent producers but also from the existing ITV companies and they offered programmes which were more political and less popular than they could have shown on their main ITV channels. They saw Channel 4 as an opportunity to widen their own output. One example of this was Granada which made *Union World* for Channel 4, presented by Gus MacDonald.[9] Another programme which was part of the intellectual and multicultural programming on Channel 4 was *Bandung File*.[10] This was co-produced by Darcus Howe, a black activist and co-editor of *Race Today*.[11] Howe was initially suspicious of the channel but towards the end of Jeremy's time as Chief Executive, Howe told me 'I am a channel person, and Jeremy Isaacs somehow managed to do that. To take the most sceptical, the most cynical about British broadcasting, and he has made me a channel person.'[12]

Another programme commissioned by Channel 4 was *After Dark*, a late-night chat show which was open-ended in terms of its time. It lasted as long as the participants continued their discussions.[13] It consisted of groups of academics, intellectuals, experts and people who had knowledge of and interest in the topic of a given week. It did not begin until 1987 but it discussed a

wide range of topics, often controversial, always engaging. As Paul Willis, a contemporary of mine at the CCCS, told me at the time:

> I love that programme. You come in from the pub and you switch it on and you start squirming that you are going to have to make some contribution to the debate. And then you remember it is Channel 4 and you can just enjoy others arguing and you don't have to do a thing!

Overall the connections between the CCCS and Channel 4 were both obvious and tacit. The coming of Channel 4 opened the floodgates for many independent producers who wanted to make programmes which would not have been seen on television previously. Not only them but the producers within the ITV system also wanted to make programmes which could be seen as reflecting the intellectual developments which had not been able to find a broadcasting home.

CCCS AND CHANNEL 4 – A MEETING OF MINDS – CONCEIVED IN THE 1960s – BORN IN THE 1980s

Widening access and commissioning and transmitting new programmes was the driving force behind Channel 4. Looking at the first set of commissioning editors and areas of programming, it was plain to see where the vision had a connection with the ideas of Richard Hoggart, Stuart Hall and cultural studies and the principles that lay behind the ideas for the Centre. While the CCCS was established in 1964 the idea for Channel 4 also began in that period and there were many arguments about the form it would take. Eventually it had its own form and character. During my research at Channel 4 I interviewed a number of ITV executives about the channel. One executive was Sir Denis Forman, chairman of Granada Television and a leading member of the ITV television hierarchy who was hugely knowledgeable about the formation of Channel 4 and the forces and factions that had been involved in its establishment. He clearly articulated the battle for control of the new channel before it was awarded. The decisions of who would control the new channel verged between the role of the ITV companies and the push for an open broadcasting system. This was eventually resolved by the channel being controlled by the Independent Broadcasting Authority (IBA), the regulator for ITV and a forerunner of the communications regulator, OFCOM. Apart from the wishes of ITV to have control of another channel there was a very strong contingent of whom Sir Denis Forman defined thus:

> Now to go to the other end of the pole, the other polarization, was a group of people, fair to say I think, mainly on the Left; intellectual rather than political

Left, who formed the concept of the free publishing house rather the way that Holland has operated its radio and television . . . the same as the Dutch idea that any citizen has the right to broadcast.[14]

We discussed the way that Channel 4 might have been formulated and he confirmed that in the end there was a compromise and the new channel was to be controlled by the IBA and paid for by the ITV companies. The influence of those who wanted open access was incorporated into the charge that it should 'serve new audiences', 'be distinctive', 'serve minorities'. But it was never the open broadcast channel any more than the CCCS could stand alone outside the university system.

Eventually being launched in November 1982 the channel had been twenty years in gestation. Born in the early years of Thatcher's premiership, the channel had its own supporter in Lord William Whitelaw, a Conservative grandee who protected the channel and convinced Thatcher that here was an enterprise which would create hundreds of small businesses that she could take credit for. The ideologies of the companies or their programmes did not matter; it was the creation of small independent companies which delighted Mrs Thatcher. William Whitelaw was supportive of the work which Jeremy Isaacs was doing. And when he ceased to be home secretary Channel 4 invited him to a farewell lunch to express their thanks to him for the legislation which he had overseen and which had set the channel up.[15]

The shared history with the CCCS was evident – a new venture which was set for a huge struggle to become established against critics from every side. But intellectually it was a shared belief in change and new representations.

1960s TO 1980s

While there does not seem an immediate synergy between the founding of the CCCS in 1964 and the establishment of Channel 4 in 1982 there is a connection in the time of their conception. Conceived in the 1960s when ideas and change was prevalent, Channel 4 actually began transmitting in the years of the Thatcher government when the left-wing ideas had been changed to the new ideas of Thatcherism. A concept for a television company which addressed audiences who had not been catered for on British television, and the influence of theories which saw the need to explore the culture of working-class people found an intellectual and creative relationship which was evident in the early years of the channel.

It was the ethos of Channel 4 to provide the space for a voice for groups and individuals who had not had a voice on television before. There was a

massive constituency who were all eager to make programmes. They were women, independent film-makers, young people, emerging television produc- ers, black and Asian film-makers and hundreds of people who wanted to make documentaries, at that time the media equivalent of an academic thesis. There were also established ITV programme controllers and makers who wanted to make programmes which could not be shown on the mainstream ITV channel. Many of these individuals and organizations became the programme-makers for the new channel. Innovation was the hallmark of the commissioning in those early years. In fact, the terms of the 1981 Broadcasting Act specified that Channel 4 was 'to encourage innovation and experiment in the form and content of programmes, and generally to give the Fourth Channel a distinctive character of its own'.[16]

The creation of Channel 4 signifies the moment when a political idea for extending access and widening ideas within British television came to fruition. The new channel enabled independent producers to offer ideas for programmes which had not been part of the output of ITV. Remember that Channel 4 was only charged by Parliament to extend the programmes which had been offered by ITV. They were not responsible for extending the range of the BBC. The ideas which came forward included an outpouring for single documentaries, the subjects of which were often political in the philosophical sense as well as wishing to extend access to under-represented groups. New dramas, new programmes for and by young people were part of the output of the channel. Like the political changes that were happening in the CCCS, changes were reflected in the newly created Channel 4. A sense of a belief of what might be possible was the overriding philosophy which determined the work of colleagues at both institutions. They both came from debates and beliefs in the 1960s and their existence in the 1980s was evidence that such changes and innovations could be achieved.

Individuals and organizations were important in establishing and enabling the work of both the CCCS and Channel 4 Television at a significant moment in political, cultural and television history. Each began as new and small organizations with committed and enabling leaders, the CCCS with Richard Hoggart and Stuart Hall and Channel 4 with Jeremy Isaacs.

Channel 4 has continued to broadcast and has widened its areas of program- ming. It has majored on digital expansion and addressed many audiences. Like academia, television productions have also changed. Both encounter challenges and threats which they have to endure to survive. The ongoing relationship between the two is something that warrants further research particularly as the Conservative government has made repeated attacks on both public service broadcasters (in my opinion and experience, moves which are not a part of their remit). In 2015 the BBC faced challenges from the Department of Culture, Media and Sport as it approached charter renewal

and was forced to downsize its production and channels. The department also suggested that Channel 4 should be privatized – a threat that was met with rejection from the channel and many supporters. The different approach by government to the media organizations is a sad change from the time when the Conservative government supported the growth of Channel 4.

NOTES AND REFERENCES

1. Raymond Williams, *The Long Revolution* (London: Harmondsworth, Penguin 1961), p. 64.

2. This would become Dorothy Hobson, *Channel 4 The Early Years and the Jeremy Isaacs Legacy,* (London: I.B. Tauris, 2007).

3. *Butterflies* BBC Television for BBC 1 1978–82

4. See Dorothy Hobson, *Crossroads: The Drama of a Soap Opera* (London: Methuen, 1982) and *Start The Week* BBC Radio 4 (1970-present).

5. *Rocky II* United Artists/MGM 1982.

6. See Philip Schlesinger, *Putting Reality Together* (London: Constable, 1978).

7. *Black on Black* (London Weekend Television for Channel 4 1982–85) & *Eastern Eye* (London Weekend Television for Chananel 4 1982–85).

8. For a good analysis of the film and television workshops, see Paul Long, Yasmeen Baig-Clifford & Roger Shannon, 'What We're Trying to Do is Make a Popular Politics', in *Historical Journal of Film, Radio and Television* 33, 3 (2013), pp. 377–95.

9. *Union World* (Granada Television 1963–82 for ITV, 1982–98 for Channel 4).

10. *Bandung File* (Bandung Productions for Channel 4 1985–89).

11. For a recent biography of Howe, see Robin Bunce & Paul Field, *Darcus Howe: A Political Biography* (London: Bloomsbury Academia, 2013).

12. D. Howe, cited in Hobson, *Channel 4 The Early Years*, pp. 154–5.

13. *After Dark* (Open Media for Channel 4 1987 -97 for BBC 2003).

14. Unpublished interview with Sir Denis Foreman by author.

15. Jeremy Isaacs, *Storm Over* (London: Weidenfeld and Nicolson, 1989), p. 184.

16. Broadcasting Act (London: HMSO, 1980) Section 11.1.(c).

Chapter 19

Cultural Studies Conquered the Midwest and Took Me to London Fashion

Becky Conekin

Without my training in British cultural studies at the University of Michigan, Ann Arbor, in the 1990s, the directions my career has taken simply would not have been possible. Thanks initially to a generous US Social Science Research Council fellowship for research in UK archives, and then personal decisions I made while finishing my PhD at Michigan, I was surprised to find myself applying for lectureships in and nearby London in the later 1990s. While writing my PhD dissertation (or thesis, as it is called in the United Kingdom), I had supervised undergraduates in history at the University of Cambridge and done replacement teaching in modern British social and cultural history at what is now Anglia Ruskin University. I landed some interviews for postdoctoral fellowships and lectureships, but the job I was eventually offered was a lectureship in cultural studies at the London College of Fashion, the University of the Arts, London. Thanks to my coursework and oral examination preparation for a field in British cultural studies at the University of Michigan, I had read Antonio Gramsci, Raymond Williams, Stuart Hall, Michel Foucault, Paul Gilroy, Laura Mulvey, Jackie Stacey, Angela McRobbie, Raphael Samuel, Dick Hebdige, Carolyn Steedman, David Harvey, Frederic Jameson, all of *Universities and Left Review*, as well as the relatively recent tomes to come out of the Urbana-Champaign conferences on cultural studies, *Marxism and the Interpretation of Culture* (1988) and *Cultural Studies* (1992). (The latter were routinely referred to as 'the Old Testament' and 'the New Testament' by the co-chair of my PhD committee, Geoff Eley.)

These diverse and often complicated works provided me with the background necessary to convince the interview panel at the London College of Fashion that I could teach cultural studies on a wide-ranging portfolio of courses at varying levels, as well as eventually assist in designing their

master's courses and supervising PhDs. As is true in many art and design col-
leges, cultural studies was the required academic subject across the London
College of Fashion's majors and the place where final year BA dissertations
were carried out and supervised. Much of what we taught was about ways of
seeing and issues of representation, along with a lot of high theory, generally
broken down into smaller and more accessible chunks. The goal was to pro-
vide students with the tools to intelligently discuss fashion in all its guises – in
terms of consumption and production, embodiment, image, representation, on
the street and on the runway, etc. Traditional (post)graduate education in most
Anglo-American history departments would have not have offered such train-
ing in British cultural studies as my time at the University of Michigan did.[1]

Having arrived in (post)graduate school as a feminist and most recently
an activist in Boston, it now seems rather inevitable that I would have been
drawn into the contentious, creative, exciting debates around the 'cultural' or
'linguistic' turn in the field of history in the United States. Yet, the specificity
of pursuing a PhD in modern European history at the University of Michigan
in Ann Arbor in the early 1990s meant that I was fortunate to encounter
Geoff Eley and his near-evangelical enthusiasm for British cultural studies.
As cultural studies expanded and travelled in the 1980s and 1990s, its local
contexts, of course, influenced how it was taught and what concepts and ques-
tions were prioritized. At the University of Michigan, cultural studies was
institutionally fostered by the Programme in the Comparative Study of Social
Transformation or CSST. In addition to international guest speakers and
conferences, (post)graduate courses, and a faculty reading group, the CSST
spawned large edited collections. Eley, along with Nick Dirks and Sherry
Ortner, explained in the first of these, their volume *Culture/Power/History:
A Reader in Contemporary Social Theory*, that the CSST had created

> a new and distinctive intellectual space, which [was] not so much 'interdis-
> ciplinary' in the established meanings of university-based cross departmental
> negotiation, as adisciplinary, in the sense that the preserving of secure disciplin-
> ary foundations has receded further and further behind the exploring of common
> problems, and the ground of current innovation – as, for example, in work on
> race and gender or, in a different sense, on film and other popular media – lies
> across and beyond established boundaries of disciplinary discussion.[2]

Culture/Power/History was published in 1994 and represented the cul-
mination of the CSST's intellectual explorations across the 1980s and early
nineties. Dirks, Eley and Ortner announced that they saw themselves 'as
contributing to an emerging politics of knowledge in this respect, in a time
of exciting and contentious intellectual flux'.[3] With many of the luminaries of
British cultural studies, including Stuart Hall, coming to lecture at Michigan,

and with a few, such as Bill Schwartz, Carolyn Steedman and Frank Mort, arriving to teach for an entire semester, it clearly felt like an institution actively engaging in dynamic debates about 'culture, power and History.'

(Post)graduate students involved with the CSST at the University of Michigan were encouraged and listened to as equals in debates and discussions over the future of the field of history and its opening up to new notions of appropriate archives and available topics. In his book *A Crooked Line: From Cultural History to the History of Society* Eley enumerated these new historical subjects as

> fashion, shopping, and all aspects of taste, style and consumption; art, photography, iconography, and visual culture; architecture, landscape, and the environment; drinking, eating, and cigarette smoking; music, dancing, and popular entertainment; histories of gender, tilted more and more toward masculinity; all aspects of the history of sexuality; travel and tourism; clothing, furniture, toys, and other objects of commodification, usefulness, and pleasure; collecting and museums; hobbies and enthusiasms; occultism, psychology, psychiatry, and all areas of medical practice; histories of the body, and histories of emotions.[4]

It strikes me that for a younger generation Eley's enumeration reads rather like a list of all the most influential book topics of the past decade and a half or so. But these subjects were not always considered serious or scholarly or even feasible within the field of history.

The (post)graduate seminar offered in the early 1990s and co-taught by Eley and Dirks, which I was lucky enough to be a part of, proved pivotal to my scholarly life. The readings and discussions in that course prompted me to change my major focus from the Victorian era of British history to the immediate post-war period. How exciting I found it to concentrate on an historical period, which until then, had been primarily dominated by high political narratives. And cultural studies provided me with the conceptual and theoretical tools to think about post-Second World War society and culture in new ways.

As I have said, Eley was the key proponent and catalyst behind cultural studies at the University of Michigan. He has said that the way that cultural studies 'evolved' in the 1980s offered 'a really exciting way of convening the range of knowledges and purposes, intellectually and politically, that seemed to provide escapes from the materialist cul de sacs that Left thinking and practice had been finding themselves in by the end of the 1970s'.[5] He explains that for him

> it was hugely about feminism and about the popular, each of which led through film, TV, popular culture genres of all kinds including music and video, in a way that made the latter okay for the first time in a non-furtive and non-embarrassed

kind of way. Suddenly it was right to admit that you watched and enjoyed certain things while simultaneously accepting a commitment to thinking seriously about how the pleasures worked. Desire became a category not just of theory and analysis but also of politics and everyday life, and from there you traveled easily to an idea of the politics of the everyday . . . All of this happened very slowly and unevenly during the course of the 1980s'.[6]

In the United States, the first big important conference took place at the University of Illinois, Urbana-Champaign in 1983, which culminated in the hugely influential, *Marxism and the Interpretation of Culture* (1988) edited by Cary Nelson, with an introduction by Lawrence Grosberg. And Stuart Hall spoke at Eley's invitation at the University of Michigan for the first time in 1990 on theories of power from Althusser through Gramsci and feminist theory to Foucault.[7]

From a British perspective, Elizabeth Wilson has described a very similar process. In 2003 in her new foreword to her seminal book, *Adorned in Dreams: Fashion and Modernity* (1985), Wilson explained how the 1980s had seen scholars developing 'new ways of understanding culture and cultural artefacts', which focused on 'the hidden injuries of class, race and gender'.[8] In what she sees as a 'parallel move', Wilson described how cultural studies began at the same time to emphasize

> the audience and the use groups and individuals make of cultural artefacts, not passively receiving them but actively re-appropriating and even 'subverting' their intended purposes . . . Pleasures previously despised as 'feminine' – the reading of pulp romances, the watching of television soaps, the enjoyment of 'women's melodrama' in film – were now differently evaluated. Female pleasure was promoted, in the cultural as in the erotic sphere.[9]

Wilson contends that fashion played a 'crucial role . . . since it stood on the cusp of the feminine and the erotic, the cultural and the social'. Thus, fashion studies 'exploded', in her words. The clearest indication of this growth in the field was the founding of *Fashion Theory: A Journal of Dress, Body and Culture* in 1997 by Valerie Steele of New York's Fashion Institute of Technology.[10] In her inaugural introduction, Steele, as editor-in-chief, wrote that the journal approached fashion 'as the cultural construction of the embodied identity'.[11]

A very brief look at my own specialty of fashion history provides some further insights into these changes. The art historian Christopher Reed, best known for his work on the Bloomsbury Group, argued in the 2006, 10th anniversary issue of *Fashion Theory* that 1920s British Vogue had: 'slipped from critical view, overlooked altogether or obscured in condescending stereotypes about fashion magazines' because it had been perceived as 'too

posh for social historians', while 'too popular for specialists in literature and art'.[12] Two decades ago, we could have easily extended Reed's contention to fashion history generally. With a few key exceptions, notably Valerie Steele and Christopher Breward, now principal of Edinburgh College of Art, serious fashion scholarship was primarily in the hands of curators at major museums and a few dress historians at art and design colleges, who tended towards the meticulous examination of seams, rather than the unpacking of the meanings of garments and their multiple representations. Of course, there were the very rare birds like Elizabeth Hawes, an American fashion designer and fashion critic of the first half of the twentieth century, who took fashion seriously in a socio-logical way and wrote about its economics, culture and ethics, as well as its psychological aspects, memorably asserting in the 1950s that being perfectly dressed 'contributes directly to that personal peace which religion is ultimately supposed to bestow'.[13] But, for the most part, only in the past 15 or so years has fashion history become a legitimate field, something to be taken seriously. And the role of cultural studies cannot be downplayed here. Simon During in his *Cultural Studies: A Critical Introduction*, published in 2005, explained that 'in countries such as Australia and the UK, cultural studies is providing the basic understanding and interpretation of contemporary culture and society in art, design, and even fashion schools'.[14] In terms of fashion studies, the only field I can speak of with any knowledge, this is true in the United States today as well. Most of the people currently calling themselves fashion historians were educated in art and design colleges and museum MA programmes where interdisciplinarity and cultural studies were emphasized and provided the conceptual framework for researching and writing about fashion in the past.

Cultural studies has also helped to legitimate oral history within the broader field, providing what Eley calls 'the main framing and impetus for the growth of memory as an intellectual priority', treating memory 'as a complex construct shaped within and by the public field of representations, which needs to be approached via forms of interdisciplinary collaboration'.[15] Oral history and new forms of biography are key to the work I have done for the past decade on model-turned-photographer-turned-war-correspondent-turned-gourmet, Lee Miller; on the Free French, British *Vogue* photographer, Gene Vernier; and on all of the fashion models, editors, and photographers I have interviewed for my next book on professional modelling in London between the end of the Second World War and 1968. This latest project is an attempt to analyse early professional fashion modelling as women's work – and hard work – while also asserting the degree of agency many of those women had and the role that their creativity and talent had in the making of the 'Swinging Sixties'.

In conclusion, the organizers of the 50th anniversary conference asked those on my panel to discuss any cons to working in an interdisciplinary way. I have

to say that my only negative experiences in relation to my interdiscplinarity or my cultural studies–inspired history have been the occasional reactions of senior faculty at particular US East Coast institutions who look at my CV and say things like, 'Well, what you do is cultural studies, not really History', in a rather dismissive tone. But, I feel certain that the same individuals would find ways to relegate my work to the sidelines of their estimations because it is too contemporary or too oriented in fashion, if they didn't have the option of referring to it derisively as 'cultural studies'. Students at the same institutions seek me out to work from the undergraduate to the postgraduate level on fashion studies and recently on food history, as well. Cultural studies opened up new topics and approaches for me in the early 1990s that have served me well, offering fascinating research and teaching experiences for decades now. I am indebted to the Centre for Contemporary Cultural Studies (CCCS) at the University of Birmingham and to the CSST at the University of Michigan for pioneering and proliferating the conceptual tools that have so enriched my scholarly career.

NOTES AND REFERENCES

1. I offer an anecdote here. Sometime in the first few months I was in London conducting archival research, I met a student from an East coast university at the Institute of Historical Research. He said, 'Oh, you are part of the "Michigan School", you all swept the fellowship competitions this year'. Not knowing this to be true regarding the annual national fellowships and certainly not thinking of myself as part of a 'school', I was taken aback and asked him to say more. He said rather dismissively 'You all work on representations'. It transpired he worked on theatre but in some way that he perceived as very different from the 'Michigan School'. Although never overtly articulated, this had something to do with our exposure to British cultural studies and our cultivated interests in grappling with the big epistemological and theoretical questions of the day over the value of history and how best to pursue it. Eley's 'appeal' to 'fellow historians' in *The Crooked Line* lays out many of the lessons he instilled in his students through his teaching and his own practice and promiscuous intellectual engagement. There he wrote:

'Practice the historian's classic virtues, of course. Ground yourself in the most imaginative, meticulous, and exhaustive archival research, in all the most expansive and unexpected ways the last four decades have made available. Embrace the historian's craft and the historian's epistemologies. But never be satisfied with these alone. Be self-conscious about your presuppositions. Do the hard work of abstraction. Converse with neighboring disciplines. Be alive to the meanings of politics. History is nothing if not sutured to pedagogy, to political ethics, and to a belief in the future.' Geoff Eley, *A Crooked Line: From Cultural History to the History of Society* (Ann Arbor, MI: University of Michigan Press, 2005), p. xvii.

2. Nicholas B. Dirks, Geoff Eley and Sherry B. Ortner (eds.), *Culture/Power/ History: A Reader in Contemporary Social Theory* (Princeton: Princeton University Press, 1994), p. ix.

3. Ibid.

4. Eley, *A Crooked* Line, p. 167.

5. Geoff Eley, e-mail interview with the author, 11 August 2015.

6. Ibid.

7. Ibid.

8. Elizabeth Wilson, *Adorned in Dreams: Fashion and Modernity* (New Brunswick, NJ: Rutgers University Press, 2003), p. vii.

9. Ibid., p. ix.

10. Ibid.

11. Valerie Steele, 'Letter from the Editor', *Fashion Theory: A Journal of Dress, Body and Culture*, 1, 1 (1997), p. 1.

12. Christopher Reed, 'A *Vogue* that Dare not speak its name: Sexual Subculture During the Editorship of Dorothy Todd, 1922–26', *Fashion Theory*, 10, 1/2 (2006), p. 40.

13. Hawes quoted in Alice Gregory, 'The Most Brilliant American Fashion Designer, *T Magazine*, 12 June 2014. Hawes published nine books including *Fashion is Spinach*, (1938) and *It's Still Spinach* (1954).

14. Simon During, *Cultural Studies: A Critical Introduction* (Oxford: Routledge Press, 2005), pp. 9–10.

15. Eley, *A Crooked Line*, p. 153.

Chapter 20

On Not Being at the CCCS

Jo Littler

I wasn't a student at Birmingham, and I've never had an official institutional affiliation with a department solely named 'cultural studies'. But ever since I discovered what cultural studies *is,* at its best, rather than its pale populist imitations, it has always been the academic area I have been drawn to, and have identified with, most. I found out that it didn't just *allow* you to think about the relationship between contemporary culture and politics, it positively encouraged it! It said, *that's the point of your work.* That can be its purpose. It allowed you to put that dynamic right on the centre stage, and explore it with an openness to theoretical and methodological experimentation: with an openness to finding interesting new tools that fit the task rather than being servile to disciplinary boundaries. All this was for me made possible by the work people did in the Centre for Contemporary Cultural Studies (CCCS) in Birmingham. This chapter discusses some of those legacies from the particular standpoint of someone who was never at the CCCS, but who nonetheless kept finding out, with irritating regularity, that the most interesting academic roads seemed to lead back to it.

There are for me two particularly important features of cultural studies it is worth highlighting: first, its political investment in conjunctural analysis and second, its radical interdisciplinarity.[1] Some prefer the term 'multidisciplinarity' to 'interdisciplinarity' to indicate the range of disciplines cultural studies has drawn on; others prefer the more combative or disruptive terms trans- or anti-disciplinarity. As John Clarke has said in the excellent issue of *Cultural Studies* on the CCCS, 'I think the multi- and interdisciplinary formulation doesn't touch the *strangeness* of what was being done.' (Or as he put it another way: at CCCS 'they let you mess around'.)[2] In its CCCS formation, cultural studies tended to cross-disciplinary boundaries with energetic disregard to take whatever it needed, its anti-disciplinary ethos disrupting the

great tradition of elite conservatism. The range of disciplines that were drawn on – or raided – to produce work in cultural studies was wide, and often had knock-on effects by enlivening the areas it drew from.

Anti-or transdisciplinary 'messing around' does of course have longer histories. As I have discussed elsewhere, 'no-one could accuse Raymond Williams, for example, of being stuck in one single, unitary disciplinary rut'; but at the CCCS.

> the degree to which people working under the sign of cultural studies felt able to rip up the disciplinary rulebook, and the collective energy with which they pursued these enquiries, was to prove profoundly influential in humanities and social sciences from the last few decades of the twentieth century onwards, where it helped propagate a wider interdisciplinary ethos in research, even if the siloed nature of teaching programmes often remained the same. For instance, cultural studies helped (and was part of the wider currents which helped) history become more open to cultural history, and more open to considerations of the psycho-social (e.g. Eley 2005); literature become more open to theoretical, sociological and historical contextualisations and interpretation (e.g. Dollimore and Sinfield 2012); and sociology become more inventive in its qualitative analysis (e.g. Skeggs 2004).[3]

Like anyone else affected by it, I experienced the legacies of that interdisciplinary, conjunctural work from a very partial perspective or situated knowledge. My 'English and Related Literature' undergraduate degree in the early 1990s was predominantly conservative with experimental fringes. This meant that while it was often fairly dull, enough cultural studies had percolated through from Birmingham for me to find it. I was able to come across the early edited collections on cultural studies – *Cultural Studies* and *The Cultural Studies Reader* – in the bookshop;[4] to hear about the interesting modules friends with better taste than me at that moment had taken (on lesbian and gay literature, e.g.); to find work by cultural studies' literary cousin, cultural materialism; and to meet postgraduates who talked of how you could do more of 'this cultural studies stuff' at Sussex. So I went there to do an MA and PhD. That was where one of my several long-suffering supervisors Janice Winship, who had been a student and a producer of work at the CCCS, let me 'mess around' and explore a variety of disciplines, much more than a lot of other PhD supervisors and institutions would today.[5] The most significant part of this academic journey wasn't so much my PhD as the process of finding out about cultural studies and figuring out ways, within particular institutional spaces, to be able to do it.

On the way I found out just how many roads led *to* the CCCS at Birmingham (such as from the workers' education movement, and the New Left) as well as beside it (Handel Wright makes a persuasive case for the

Kamiriithu Centre in Kenya) and through, and beyond it (through those who left it to do innovative work in polytechnics, developed it in journalism, or translated it into/alongside national contexts outside the United Kingdom).[6] And I found out more about how the work that had fermented in Birmingham at the CCCS had opened up and helped reconfigure disciplines like history, art and design, as well as helping spawn new ways of understanding the relationship between politics and culture as the terrain of lived experience and the space of possibility.

To mention this latter feature is to refer to that key characteristic of cultural studies, conjunctural analysis. Understanding 'the conjuncture' means understanding the particular power dynamics and character of a particular moment. What is specific about the moment we inhabit? What common-sense understandings, what economic decisions, power dynamics, what vested interests and collaborative terrains work to shape its contours? What does this constellation of forces look like? How are these power configurations different from before?

> When a conjuncture unrolls, there is no 'going back'. History shifts gears. The terrain changes. You are in a new moment. You have to attend, 'violently', with all the 'pessimism of the intellect' at your command, to the 'discipline of the conjuncture'.[7]

Continually evoked and often maddeningly methodologically elusive, the analysis of the conjuncture has always been the central contribution of it as an (anti/trans)discipline and for many is its key project.[8] Borrowed from the then-recently translated texts by Antonio Gramsci, 'the conjuncture' was a means of describing the specificity of economic, political and cultural forces at a given moment, in which both long-term organic and short-term changes in power relations are present, and as the place where political and cultural struggles are fought: a space where both established interests might defend themselves and 'the terrain upon which the forces of opposition organise'.[9] This 1970s reuse of conjunctural analysis became a fairly open process in which a variety of additional theoretical tools were drawn upon as and when required.

Understanding 'the conjuncture' therefore became a malleable practice which tended to rely on some key cultural studies resources and influences. These have usually included: a strong commitment to the more equitable pooling of power and resources; a Gramscian understanding of cultural hegemony, of the importance of culture in political persuasion, and of Gramsci's ideas of wars of position; a commitment to anti-essentialism, which refuses the reification of essentialist identity subject-positions (considering, e.g. what a man/woman/white/old/young person 'is' as historically specific and

formed through culturally processes); a post-structuralist understanding of discourse which can be 'articulated' or connected in various different directions (so, e.g. environmental discourse can be funnelled through capitalism or anarchism); and an understanding of tendencies as dominant, residual or emergent.[10] On top of these tools, a wider range of theories are drawn from, created or sought for, depending on the subject and the people doing the work. Therefore, some cultural studies work which seeks to be 'conjunctural' in character might draw from the psychosocial; some on feminist activism; some on literary analysis; others on philosophy. All would try to use this multifaceted investigation to consider the configurations of power which constitute contemporary life.[11]

At the CCCS and elsewhere, conjunctural analysis in cultural studies formation therefore often used particular theoretical resources, insisted on interdisciplinary borrowing and emphasized the importance of thinking through the cultural and the political together (indeed, so much so that in many regards, a better term for 'cultural studies' might well be 'cultural politics'). One of the outcomes of this kaleidoscopic approach to theory and practice, filtered through a focus on the character of the conjuncture, and questioning how the shape of political-cultural terrains could be changed was the development of extracurricular projects outside the university. These spanned a wide range from club nights to art practice and community projects. One of the many vitalizing joys of the 2014 CCCS 50 conference was how these extracurricular activities were entertainingly revisited through anecdotes about local community activism, excerpts from Isaac Julien's film *Capital*, and Dick Hebdidge's flamboyant performance art.[12]

Where might we look right now – in this quite different climate – to find other forms of conjunctural analysis, political commitment and theoretical and methodological experimentation that resonate with those which characterized the CCCS, in order to find some resources of hope? What is the legacy of these forms of transdisciplinarity and experimental conjunctural analysis today?

I think we all know the contours of neo-liberal constraints that work on and through the universities now – institutions pitted against each other through the utter snobbery and savage social distinction of league tables, compulsory careerist individualism and atomization, marketization, an elite cadre of tutors and an army of perma-temps, and increasingly socially polarized and massively indebted students.[13] In fact, when I typed 'CCCS' into Google, the first listing that came up was not the Birmingham Centre, but a debt management organization, the 'Consumer Credit Counselling Service'.[14]

In Britain departments and degrees in cultural studies are thin on the ground; even more so after the University of Birmingham axed the CCCS.[15] Cultural studies' influence spread through research while it contracted as a

university discipline (not that it was ever huge in terms of student numbers in the first place). But I think we shouldn't forget how, in different ways, such practices were *always* hard, however easy they may look in retrospect. For instance, I was interested to come across a quote in the Centre's 1969 report stating how 'we are poorly staffed and funded for such an ambitious project. Interdisciplinary work in the centre, in particular, is poorly placed and supported'.[16] The report also raises the issue that while interdisciplinarity was paid ritual observance, in practice it was also very difficult: because it ran against defensive boundaries, established divisions of labour, deference and status between staff and students, even good manners.[17] Reading this, I thought: some things don't change so much. But the stark differences are equally important. When reading about the CCCS, one of the strikingly different characteristics today is what would now be called the 'horizontalism' of much of its organization; like, for example, its practice of students sitting on admissions panels.[18] Such practices have been made much more difficult through today's deadening hierarchical bureaucratic managerialism.[19]

But while cultural studies as a discipline perhaps has less institutional space in terms of named degree courses, there are other ways it is being practised. Cultural studies involves the establishment of spaces where culture and power – where the nature of the conjuncture – can be explored through interdisciplinary openness and experimental methodologies and connected to actions and movements for progressive social and cultural change. Events and connections and courses – and networks and assemblages – can be created in all kinds of ways, wherever there is a crack of possibility, wherever we can. There are initiatives here that give me hope; not the false hope of 'cruel optimism', but instead the potential of existing practice to supply what Williams called 'resources of hope'.[20] My list is short, partial, subjective and culturally and geographically limited. Other people's lists would be different.

For instance, ten years ago when I went to conferences and mentioned neo-liberalism and popular culture, people would look at me like I was a freak from a strange political sect. Now at many conferences you cannot move for papers on neo-liberal culture! Even taking into account criticisms of it being thrown in as a buzzword, or with the necessary provisos about the diverse quality that entails, there simply is a much more widespread and strong awareness of the extent to which rampant corporate capitalism attempts to bulldoze over contemporary life. Plus, there is now such exciting work around unpacking 'neo-liberalism' and its workings.[21] This encourages me. It encourages me that there is a renewed emergent academic engagement with activism: in several media departments there's a rash of new undergraduate and postgraduate courses on media, activism and social change; and that there's a new 'activism in sociology' forum in the British Sociology Association.

Cultural studies never made a lot of headway connecting to politics departments; but at Brighton University in the United Kingdom there's a centre for PPE which stands for politics, philosophy and *ethics,* rather than the traditional technocratic politician's training ground of politics, philosophy and economics; and in 2015 they ran a large conference on neo-liberal culture. It encourages me that there's widespread student discontent with the way economics is being taught. In 2014, after economics students at the University of Manchester created the *Post-Crash Economics Society* to protest the narrow curriculum which they saw to be failing to address global financial instability and climate change, they joined forces with like-minded students from nineteen different countries.[22] It encourages me that there are networks like the New Economy Organiser's Network (NEON) connecting activists with each other and with academics. It encourages me that in the United Kingdom, students have set up their own free art MA, *The School of the Damned,* overseen by a board of academic advisers, in protest against unaffordable education 'and a plutocratic state'.[23]

The CCCS demonstrated that cultural studies needed to reach beyond the academy. Today it encourages me that alongside established networks and publications and journals – which for me include spaces like *Crossroads in Cultural Studies, Cultural Studies, New Formations* and *Soundings* – there are newer media outlets like Zero and Repeater Books, which publish long pamphlets/short books mixing polemic, politics and a vibrant use of theory; and the burgeoning zone of podcasts on cultural politics, including Novara FM, *The Cultural Studies Podcast* and *Left Business Observer.* It encourages me that there's been a popular revival of interest in 'Left' philosophy and that there are journalists like Gary Younge, Christopher Hayes and Aditya Chakrabortty who dialogue so effectively with academic work. It encourages me that after being repeatedly flung into the wilderness feminism is resurgent and in good academic and popular health (the regular international *Consoleing Passions* media and feminism conference being an inspiring example) and a zone of renewed popular 'fourth wave' visibility (*The F Word, Feministing, Jezebel, The Vagenda*). It encourages me that, despite the wave of new racisms, there are simultaneously anti-racist initiatives that flourish, including the Black Lives Matter movement in the United States, the opening of the Black Cultural Archives in Brixton, United Kingdom and the *darkmatter* online journal. It encourages me that there is an urgent engagement with the ramifications of and activisms against advancing and ongoing environmental collapse.[24]

Of course there are not enough initiatives, and there are plenty of problems, but I spend most of the time when I am writing, writing about the problems, and here it seems more appropriate and productive to focus on the glimmers and offers of hope. Most of these projects, like any project, have their own

issues, shortcomings and weaknesses. Some may not even last as long as it takes for this book to be published. But these are just a few of the zones where interesting possibilities for anti-disciplinarity are opening up and could be extended. There are, and will, of course be many others.[25]

Sometimes, in the rush to interrogate neo-liberal politics, its synthesis with the cultural dimension, which the CCCS always foregrounded as the terrain of lived experience and the space of possibility, can be neglected. This is why cultural studies is important. It is also why the initiative from which this book springs – to discuss the heritage of the CCCS and to archive the stencilled papers for people who *weren't* there as well as those who were – is important. Not because we should fetishize the CCCS, but because we should celebrate its political spirit, and learn from it as a formative victory for intellectual emancipation, even though other transdisciplinary victories will today have to take different shapes and forms.

NOTES AND REFERENCES

1. I have written about this recently in Jo Littler 'Consumer culture and cultural studies', in Deirdre Shaw et al (ed.), *Ethics and Morality in Consumer Culture: Interdisciplinary Perspectives* (London: Routledge, 2016).

2. John Clarke and Hudson Vincent 'An interview with John Clarke', *Cultural Studies* 27, 5 (2013), p. 734.

3. Jo Littler, 'Cultural studies and consumer culture', in M. Carrington, A. Chatzidakis, T. Newholm and D. Shaw (eds.), *Ethics and Morality in Consumption: Interdisciplinary Perspectives* (London: Routledge, 2016).

4. Lawrence Grossberg, Cary Nelson, Paula Treichler (eds.), *Cultural Studies* (London: Routledge, 1992); Simon During (ed.), *The Cultural Studies Reader* (London: Routledge, 1993).

5. Janice Winship, 'Woman Becomes an Individual—Femininity and Consumption in Women's Magazines 1954–1969', CCCS Stencilled Occasional Papers, Birmingham: University of Birmingham. http://www.birmingham.ac.uk/schools/historycultures/departments/history/research/projects/cccs/publications/stencilled-occasional-papers.aspx. Accessed July 2015.

Many thanks to my other PhD supervisors: Rachel Bowlby, Craig Clunas and Roger Silverstone.

6. Ackbar Abbas and John Erni, *Internationalizing Cultural Studies: An Anthology* (Oxford: Blackwell, 2004); *Block* journal; Lawrence Grossberg, *Cultural Studies in the Future Tense* (Durham: Duke, 2010); *Marxism Today*; Suzanne Moore, *Head over Heels* (London: Viking, 1996); Gilbert Rodman, *Why Cultural Studies?* (Oxford: Wiley, 2014); Tom Steele, *The Emergence of Cultural Studies 1945–1965: Cultural Politics, Adult Education and the English Question* (London: Lawrence & Wishart, 1997); Jeremy Gilbert, *Anticapitalism and Culture: Radical theory and popular politics* (London: Berg, 2008); Judith Williamson, *Deadline at Dawn: Film Writings*

1980–1990 (London: Marion Boyars, 1992); Handel K. Wright, 'Dare we de-centre Birmingham? troubling the origin and trajectories of cultural studies', *European Journal of Cultural Studies,* 1, 1 (1998), pp. 33–56.

7. Stuart Hall, 'Gramsci and Us', *Marxism Today*, June 1987, p. 17.

8. Stuart Hall, Chas Critcher, Tony Jefferson, Jon Clarke, and Brian Roberts, *Policing the Crisis* (London: Macmillan, 1978); Jeremy Gilbert, *Anticapitalism and Culture* (London: Berg, 2008); Lawrence Grossberg, *Bringing It all Back Home* (Durham: Duke, 1997); Grossberg, *Cultural Studies in the Future Tense* (Durham: Duke, 2010).

9. Antonio Gramsci, *Selections from the Prison Notebooks*, translated Quintin Hoare and Geoffrey Nowell-Smith (London: Lawrence & Wishart, 2005).

10. Articulation as developed by Ernesto Laclau and Chantal Mouffe in their book *Hegemony and Socialist Strategy* (2nd edn, London: Verso, 2001); the dominant, residual and emergent as developed by Raymond Williams, *Marxism and Literature* (Oxford: Oxford University Press, 1977).

11. This paragraph draws from Littler 2016, given that the subjects of these chapters – while looking in different directions – overlap in their shared concern to define practices of cultural studies.

12. CCCS at 50 conference, audio recording. http://www.birmingham.ac.uk/schools/historycultures/departments/history/research/projects/cccs/conference/conference-programme.aspx. Accessed July 2015.

13. Brett de Bary (ed.), *Universities in Translation: The Mental Labour of Globalization* (Aberdeen: Hong Kong University Press, 2010); Ros Gill, 'Breaking the silence: The hidden injuries of neo-liberal academia' in Roisin Ryan-Flood and Ros Gill (eds.), *Secrecy and Silence in the Research Process: Feminist Reflections* (London: Routledge 2009); Andrew Ross, *Creditocracy* (New York: OR Books, 2014); Marina Warner, 'Learning my Lesson', *London Review of Books*, 37, 6 (2015), pp. 8–14.

14. This alternative CCCS is currently in the process of being renamed 'Step Change', according to its website as of April 30 2015: http://www.stepchange.org/?WT.srch=1&WT.mc_id=270000&WT.seg_1=cccs&gclid=CMCB0IKZnsUCFa_LtAodSGwA3g.

15. See Ann Gray's chapter in this volume.

16. *Centre for Contemporary Cultural Studies, University of Birmingham, Sixth Report 1969–1971*, p. 6. Online at http://www.birmingham.ac.uk/schools/historycultures/departments/history/research/projects/cccs/publications/annual-reports.aspx. Accessed July 2015.

17. *Centre for Contemporary Cultural Studies, University of Birmingham, Sixth Report 1969–1971*, p. 6. Online at http://www.birmingham.ac.uk/schools/historycultures/departments/history/research/projects/cccs/publications/annual-reports.aspx. Accessed July 2015.

18. Hudson Vincent, 'space for cultural studies: conversations with the centre', in *Cultural Studies*, 27, 5 (2013), pp. 671.

19. David Graeber, *The Utopia of Rules: On Technology, Stupidity and the Secret Joys of Bureaucracy* (Brooklyn: Melville House, 2015).

20. Lauren Berlant, *Cruel Optimism* (Durham: Duke University Press, 2011); Raymond Williams, *Resources of Hope* (London: Verso, 1988).

21. For example, Wendy Brown, *Undoing the Demos* (Cambridge: MA, Zone Books, MIT Press 2015); Michel Foucault, *The Birth of Biopolitics: Lectures at the College de France, 1978–9* translated by Graham Burchell (Basingstoke: Palgrave MacMillan, 2010); Rosalind Gill and Christina Scharff (eds.), *New Femininities: Postfeminism, Neoliberalism and Subjectivity* (Basingstoke: Palgrave, 2011); Jeremy Gilbert (ed.), 'Neoliberal Cultures', special issue of *New Formations,* 80/81, 2013, pp. 5–6; David Theo Goldberg, *Threat of Race: Reflections on Racial Neoliberalism* (Oxford: Wiley, 2008); Stuart Hall, Doreen Massey and Michael Rustin, *The Kilburn Manifesto* (London: Lawrence & Wishart, 2014). I apologize in advance to the authors of all the texts I left out.

22. Philip Inman, 'Economics students call for shake-up of the way their subject is taught', *The Guardian*, 4 May 2014. http://www.theguardian.com/education/2014/may/04/economics-students-overhaul-subject-teaching. Accessed July 2015.

23. http://schoolofthedamned.tumblr.com/. Accessed July 2015.

24. Richard Maxwell and Toby Miller, *Greening the Media* (Oxford: Oxford University Press, 2012); Phaedra C. Pezzullo (ed.), *Cultural Studies and the Environment, Revisited* (London: Routledge, 2010); Carmen Rojas, 'At the forefront of a new field of study: Petrocultures', http://www.woablog.com/2014/09/at-the-forefront-of-a-new-field-of-study/. 25 September 2014. Accessed July 2015.

25. Given that it is now keen on reclaiming the legacy of cultural studies, perhaps the University of Birmingham could open a centre for cultural politics, which I often think is a more accurate name for cultural studies.

Part VI

INTERVIEW WITH STUART HALL

Chapter 21

Stuart Hall

Interviewed by Kieran Connell

What follows is a transcript of an interview with Stuart Hall conducted by Kieran Connell in late-summer 2013. The interview was planned as a way of Hall contributing to the conference on which this volume is based. He was aware that it was unlikely that his health would allow him to make the trip up from London to Birmingham, so the interview was to be filmed and screened at the conference. Connell used the interview to ask Hall about some of the key issues that were to be discussed at the conference – the evolution of cultural studies at Birmingham, the nature of the field today, regional variations as it has been taken up globally – as well some of the themes that had begun to emerge from the establishment of the Centre's Archive. This included Hall's role in a student 'sit-in' at the University of Birmingham in 1968, and a 1971 internal document titled 'The Missed Moment' in which Hall bemoaned what he saw as the Centre's lack of political drive. As the interview developed it progressed into a wider conversation about Hall's life, career and political development. Hall talked about his relationship with feminism, for example, including what would become his infamous characterization of feminism's 'break in' to the Centre in the 1970s. Hall made these remarks at a major cultural studies conference at the University of Illinois in 1990, but in this interview associated them with his decision to leave the Centre over a decade earlier. It is indicative of Hall's generosity that, in the context of increasingly severe health problems and low energy levels, he talked openly for well over an hour about such sensitive moments and in response to archival documents he had not seen for the best part of five decades. Hall's death a matter of months after the interview was conducted made the screening of it – in front of over 200 friends, colleagues, former students, political comrades and intellectual fellow travellers – a remarkably poignant moment.

Kieran Connell: Stuart, I want to start by taking you back to 1963–1964, when Richard Hoggart makes his invitation to you to come to Birmingham. Can you remember the reasons behind accepting the invitation? Was it solely for intellectual reasons or was there a political dimension too?

Stuart Hall: Well I think there were both but it was principally an intellectual question. I mean, I had written *The Popular Arts* which seemed to be in some of the areas that Hoggart was interested in. In *The Uses of Literacy*. I was involved in the New Left; Hoggart wasn't directly involved at all, organizationally. His sympathies were on the Left but he wouldn't have invited me for political reasons directly. But remember that we're talking about a period which constituted a political milieu and the political milieu was principally defined by us as a question about 'What has happened to the working class culture which has underpinned Labour, the Welfare State etc.? What is happening to it as a consequence of the new forms of competitive, corporate capitalism?' So if you put it that way, we were both interested in the same question and *The Uses of Literacy*, though it doesn't address that directly, is addressed to that. 'Has affluence undermined, unbent the springs of working class action?' was one of Hoggart's phrases. So I think I was known to him as somebody interested in television and the media. I was known to him as someone who was asking these kinds of cultural questions about politics. And I was kind of at a loose end because I was teaching general studies in London. Hoggart had got this money to start up and I guess he thought I was a good person to take on. But he wouldn't have come to me because we were politically aligned, though we did share many political perspectives of course.

Connell: But you were also the product of quite different formations . . .

Hall: Oh yes we couldn't have been more different, but that was true about me and most of the people in the New Left. I mean someone once said, 'They never, ever saw you as a racial subject.' They couldn't and that wasn't a common category – they were all people on the Left so they were all anti-imperialists, etc. But they couldn't understand how being a colonial had shaped my formation. A lot of people don't understand even now.

Connell: I guess the two of you also had a very different relationship to popular culture too.

Hall: Well a different relationship to popular culture, although, you know, I mean Richard I suppose in some ways, some distant ways, belonged to the Leavis School in the sense that they thought that popular culture when commercialized in the American form – the new mass culture would shift and reshape working-class culture. They did think that and they thought not necessarily in a good way. And I guess I thought that too . . . we were influenced by Leavis, though many of us didn't share the political project, but we were very interested in it. But I think that Richard saw himself as engaged in this argument. Remember what the argument was – an argument which came to be known as the argument about affluence, 'Has the working class become bourgeoisified?'

What was interesting about that is that the question of the culture had never been a political issue. You know, people just took it for granted that that's how working-class people lived in these specific forms. But they didn't see it as contributory to the culture. So the cultural question is suddenly plum in the middle of the politics. So that's why everybody suddenly begins to address it. And one of the things that's distinctive about the New Left, which is the sort of antecedent in many ways to the Centre, is that it named cultures of great and equal importance to economics and politics in shaping our position to the drift towards a kind of consumer capitalism. So it's very much tuned in to the atmosphere – the question raging around the political elite at that time: 'Has the coming of the telly, the fridge, the small car, you know all these things, undermined permanently Labour's chance of winning ever again?' Well that's a pretty big question!

Connell: Did you ever have any hesitations about accepting the invitation to come to Birmingham?

Hall: I had only one; my relationship with Catherine had recently started, so I wasn't anxious to move in this direction, the Birmingham direction. But also, she was going to Sussex and I was going to Birmingham. We'd both been living in London until then, so it looked an unlikely proposition. It looked like an unlikely proposition in many respects but in the particular respect that we were going in the opposite directions. Apart from that I wasn't wedded to London. I was active in all sorts of things in London, especially around the New Left Club and so on, but I wasn't wedded to London and I thought, 'This is a great opportunity to work with Hoggart;' I'd been very impressed by *The Uses of Literacy*. Hoggart had never met Raymond Williams and it was the *New Left Review* that introduced Williams to Hoggart. We were all circling around the same questions, circling around the same issues.

Connell: So you arrived in Birmingham in 1964. Do you have any recollection of the early days? Setting the Centre up and how you went about broaching this new terrain?

Hall: Before we moved to Birmingham we got married. We decided that was the solution to the distance problem, and she changed to Birmingham. She was doing history. So we were in Birmingham, trying to find a place to stay, which was not pleasant, not easy. A mixed couple, lots of shouts and jeers and obscenities on the buses and things like that. But we eventually found a Jewish couple that rented us a place and we were there for a while before moving closer to the university. So it was an unsettling time because neither of us had a world in Birmingham. Before that, Catherine had done a year in Sussex and I used to leave Birmingham on a Thursday evening, stop off in London where my books still were, go down to Sussex, spend the weekend with her, come up on the Sunday night, back to Birmingham. I thought you know, 'What is one doing in this city? It's a bizarre place, you don't know anything about it and the first thought you have is getting out of it!' That's not very good – so it was an odd place to

choose to go to, but Hoggart was there as a professor, he'd raised the money which enabled him to open the Centre, he wanted me to come. He had very firm views that the Centre should not go to one of the trendy new universities, yes, where it would be part of the trendiness, the sort of upcoming wave; it should stay in one of the old universities like Birmingham or Manchester, etc. So there it was and there we were, so we moved to it, rather than trying to get it to move to us. And then he and I engaged in a long conversation. We had a long conversation, until we took our first students in September, about what we were doing, what would it be called? What was the programme? How would we recruit students? What sort of students did we want? I mean for instance, there's no first degree in cultural studies, so how do you take sociologists, historians, people in English studies, anthropologists and prepare them to do research in a field which is not yet defined? So it was a bit like swimming in treacle, but we got settled and we got a few students opting to come to us, one or two adult students who didn't care – I mean wanted to pursue a topic and didn't mind the fact that it wasn't an established discipline which could further their careers – and we opened.

Connell: It must have been an incredibly exciting time in a sense – swimming through treacle, but also remarkably fresh I imagine?

Hall: All extremely exciting, but, you know, because we were making it up ourselves, so there was a real sense of, 'You go wherever you want'. It's compounded by the fact that this is an early period in English universities organizing graduate studies. So there wasn't really a place into which we could easily fit, but that equally meant that they didn't keep a tight grip on how those students were prepared, so in a way the Centre had an open field as to what they did. Did they do seminars? Did they have tutorials? Did they do individual work and reports, etc.? We could make it up ourselves. I served as the deputy director, I was the liaison person between the university and the Centre and I said, you know, 'I will help Hoggart to prepare these students to do a thesis of a traditional kind, you'll recognise it, we'll get external examiners. If they say it's okay, it's okay. Just leave us alone apart from that.' And in the early days, they did. So that part of it was fairly exciting. It was threatening because we'd all come from very strong disciplinary backgrounds. Both Hoggart and I were in the literature field, sort of New Criticism, the *Scrutiny* tendency as it were. We didn't have many other people there with a very strong background. I knew practically no sociology at all at that stage, as a formal discipline.

Connell: To move on slightly to 1968 – one of the things that we found in the archive is this issue of *Mermaid*, the university's student magazine, from May of 1968. It's all about the nature of the university: What should it be? What should it look like? And you had an article in it as well as various other people connected to the Centre. You wrote of the 'current of anxiety about the place, purpose, function and meaning of the university in society' and six months after that, the University of Birmingham had its own student sit-in. What are your recollections of that time?

Hall: Well my recollection of that time is that first of all the Centre was much larger than when it started – not much, but I mean it had a grouping of 20 students or something like that. Secondly, that universities were breaking out all over, as there was a huge student movement developing and that had already begun in the States, occupations and sit-ins and so on and I think many of the students in Birmingham at the Centre thought, 'Well how do those questions relate to us?' I started to read things and we got embroiled in the debate about Birmingham and we got asked to do an issue of *Mermaid* in which we addressed the vice-chancellor about it. 'To Sir with Love' it was called and it was a very interesting document because it wasn't sharp and bitter as those sorts of rows became, it was gentle but questioning, you know, 'What sort of university is this? What does it teach? Why do students play such an obedient and negative and quiet role in it?' and so on. Well, by the time it came to that Christmas, Birmingham had its sit-in and the occupation was in that case motivated by the rise in student fees for external students. And we thought this is a sign of a very backward place, that is not welcoming outside students and using the fees to deter their entry rather than encourage it, and this is a sign of a kind of bureaucratized management of the system, which was not open to student influences. The Centre was very influenced by '68 in the sense that we began to think of ourselves as a collective. In those days everybody was in a collective – we thought the Centre was a kind of collective too.

Connell: Did you have a role in the sit-in? Were you speaking or did you have more a distant position?

Hall: Well remember, because of the way in which the Centre was organized, students and staff were very much together. We couldn't be very separate because we didn't profess a discipline that we could tell them about, you know? We were sort of two weeks behind the next text we suggested they read for the general theory course, so that ruptured the normal relationships between teachers and students. But as well as that, wanting to make the place more collectively organized and collectively run meant that we were in constant discussions, continuous discussion with one another. Every Centre meeting was another sort of opening enquiry into, 'Where's the university going? What is the politics of Cultural Studies? How does it affect students? How should we organise our work so it makes sense more in those terms?' etc. So all of that is well in play around us, before Birmingham students decided that Birmingham owes itself an occupation.

Connell: And where was Hoggart within this? Because at that point he was still director. Was he treading quite a fine line?

Hall: Yes he's treading a fine line, so am I, but I'm mainly attached to the Centre, whereas he's a professor of English. What's more, he was on the Senate Committee, so he was discussing what to do about the troublesome students who were sitting in the Great Hall while coming back from the Centre where clearly two or three of the malcontents would be easily identified. So he had a

very rough time I think and the rest of the university gave him a very uncomfortable time. I think in a way too uncomfortable for him to stay. They didn't put him out or – it wasn't a decision like that, but I just think they asked him to operate in an atmosphere, which he found so uncomfortable, he couldn't go with. There was a lot of pressure on me too, but then I belonged to the Centre and I was thought to be more political and I'd edited the *Mermaid* edition so they knew my sympathies at any rate. I wasn't organizing the sit-in, but my sympathies were on the side of students who were demanding change and who were not only demanding organizational change in the university, but also arguing about the organization's social knowledge, 'Who gets it? Do you get it by standing still? Do you get it by reading books? Or do you get it by engaging with it?' and so on. So it bore down on both of us rather separately and that's when Richard got his invitation to go to UNESCO for a short time and decided to go. And he's never told me, but I've just assumed that he thought it was time for him to be out of the Centre, of those cross pressures.

Connell: So first Hoggart's departure and then the 1968 moment more generally – how did those two things impact on the Centre's organization and working practices? Did it lead to a further democratization of the Centre?

Hall: Well that's an embarrassing question. I was made director, acting director, while Hoggart was away for four years. But four years is four years you know? So the place inevitably took on my intellectual and political and critical interests. I was much more theoretical than Hoggart was; we began the Theory Seminar in that period. So it did – it was influenced and shaped by the fact that Richard was in Paris and I was in place, as it were. I went to see him, reported to him, etc., and I think he could clearly pick up that, not through any doing of me against him, or anything like that, but the drift was just going away from an old literary critical cultural interest in *The Uses of Literacy*. It just wasn't that any more. What we call 'the cultural turn' was beginning; that's really what was happening here. This is the impact of culture and its disorganizing effects on a whole range of disciplines; on English, on sociology, on anthropology, on history, on architecture, on history of art and so on. So it's a big moment in that sense. So the '68 question also led us to initiate more things in the Centre, so by the time Hoggart was considering whether he was coming back or not, there were things like weekly general meetings, at which everything about the Centre was discussed; every single facet of it, people could raise whatever they liked and because it was a collective, we didn't take particular positions of leadership, so people got more of a say going on. I remember a very important decision I took too – we used to use cyclostyle machines, you know Gestetner machines – and I got some money and I bought a second machine; one for the office and one for the students and they could write what they liked, what they thought and distribute it and put it in the pigeon holes, without my say-so. So for right or wrong, good or bad, I have negated a kind of particular form of academic leadership. I wasn't into it; I didn't think it was right. So by the time Hoggart did consider his time was up and he either had to stay for a while on a more prominent basis

and give up the Centre, or come back, the Centre had sort of changed out of all recognition. There were many more discussion groups and that was important because the numbers of students had expanded, so there were more disciplines represented in the student body and more interests. So we had to cater for that. Groupings of interest came together and formed their own working groups. So there was a general meeting for the Centre for organizational purposes. Then there's a General Theory Seminar which everybody's going to. Then there are the group meetings and discussions where people are reading more in a more specialist way. The question is how did anybody get time to do any research? And the truth is, they didn't all that much. But that's what they wanted to do and that's how the tendency went.

Connell: What was the relationship between that increasing democratization of the Centre and then yourself and the students? I want to ask you a little bit more about that – was being acting director and then director difficult in this context? Did you have to try to unlearn all sorts of unconsciously dominant ways of talking, acting and feeling, etc.? How did that process take place?

Hall: Well I'll give you one instance. What were we going to read in the theory course? Well there had been a course before that, a sort of Teaching Group which Richard Hoggart ran and Richard made them read Orwell's 'Shooting an Elephant', DH Lawrence, Tyger Tyger, etc. Really a literary curriculum. When we came to the Theory Seminar, 'General Seminar' it was called, what did they read? Well they read *The Uses of Literacy*, they read Raymond on *Culture and Society*, they read a bit of Leavis because they had to understand what that's about and there were all sorts of other things. They're beginning to talk about the relationship between literature, culture and society, but they don't know anything about society. So perhaps we ought to give them some Max Weber, perhaps we ought to give them *The Protestant Ethic*, but you can't teach Weber without teaching Durkheim. So all of a sudden, the intellectual breadth covered in the Centre expanded exponentially and we were trying to give a collective introduction to these bits of these different fields to everybody. Then there was a specialist group where they could pursue their own interests more fully. So say the group on media studies was reading Roland Barthes and 'mass communication studies', but they were also coming to the Centre which was reading Hoggart and Williams and Max Weber and Durkheim. So it created a phenomenally unique intellectual milieu; I don't know any other milieu like that. I sometimes think – people sometimes talk about the 'Birmingham School', modelling the phrase out of the 'Frankfurt School', but it was nothing like the Frankfurt School, you know. The Frankfurt School was Adorno and other illustrious philosophical figures. We didn't have any grand philosophical figures, we were just part of the *hoi polloi* trying to find out and to get some useful ideas, workable ideas with which we could analyse the trends in contemporary culture. That's what we were trying to do. Well, you asked the question about my position in that, because as you can see, I am playing two roles. As far as the Centre is concerned and the university is concerned, I am a Research Centre director;

I'm responsible to them, for the students, for their supervision, their theses, for the organization of their studies. As far as the Centre is concerned, I'm in the general meetings speaking like everybody else. I mean inevitably because I'm the director, I guess my words may have carried more weight, but it was not so led by the more experienced of us, not by any means. So the pressures between these two positions began to be very difficult to sustain, yes? I could not be a student among students and I didn't want to be a research director looking after his students. But these are two roles which are very difficult to sustain. I think people in the Centre found it difficult; I think they were very sympathetic because they understood that this was emotionally rather testing and they gave me an easy time of it, though they also didn't give me an easy time when they wanted to.

Connell: But in a sense, if you made an intervention, that would be seen as being 'the director's intervention', and if you didn't make an intervention, it would be seen as being, 'Why is Stuart being so quiet?' In a sense you couldn't win . . .

Hall: . . . You couldn't, there was no path. You were constantly confronted by two ways of doing it. For instance, let me give you an example which is a telling one. The students said at one stage, when we announced the theory readings for the next semester, 'Why isn't there any Feminism?' 'Yeah indeed you're quite right. Well, what shall we read?' 'Juliet Mitchell.' 'Okay we'll put Juliet Mitchell, who else?' 'Well some of the French theorists.' 'French theorists? Who are they?' 'Well let's put them on.' 'Well I can't introduce that and that's not my choice.' So gradually they're intervening in the very core of the seminar; they are rewriting the curriculum of the seminar. It's hard to take, you know when you're ten, 15 years older than them, you don't know a lot more about cultural studies, but you sort of feel, well you know those ancient, ancient feelings assail you, 'Well I am a bit more experienced. I've read a few more books than you. Why don't you listen to what I have to say on this subject rather than just make up your own mind?' So I felt a tug – I was constantly tugged between the two poles and there was a particular area of concern in which that manifested itself and that was in relation to the political tendencies in the Centre, because when it grew, there were people from all over the political compass. We had a couple of Conservatives, we certainly had people from the Labour Left, we had Communists, we had Trotskyists, we had the Far Left, etc. And I wanted all of these tendencies to be perfectly free and open to express their views; hence the cyclostyling machine. But I opposed the idea that the Centre itself should belong to, or be colonized by any one tendency; it was not a communist centre, not a Trotskyist centre, not a Social Democratic centre. The politics was in the intellectual work, not in the colonization by a tendency outside itself. So you had to bring the critique into the work itself and show justification for why it's there, why it matters, why you're asking that question. You're not asking that question because Communist Headquarters or somebody else has told you to ask the question, not because you're trying to capture the Centre. Well, to be honest, my recollection of it is that most people eventually agreed with that, because they

didn't want the Centre to deteriorate into just a slap bang confrontation between the forces of the Left. On the other hand, individual people did think we should be rather more Communist, or rather more Social Democratic, or rather more Liberal than we were. So there was a debate going on.

Connell: I was going to ask you a bit more about the relationship between the politics of intellectual work and also with external politics. Again, something that has come out of the archive is a document called 'The Missed Moment' which I think was written in 1971. In it, you say that you were never able to accept that the Centre could provide a self-justifying political alternative in itself. So what exactly was the relationship between the Centre and the broader political milieu?

Hall: Yes, yes – no you must understand that these are slightly different things. There was no embargo on people being political and no embargo about people joining political groupings and being active in them in the outside world. But there was an embargo against thinking that the purpose of the Centre was to advance a particular political position which was formulated far away from the intellectual work. And in a way, you know, it's very early to call myself a Gramscian, but it was Gramsci's idea, namely pessimism of the intellect; you have to think the thing through – what matters is the quality of the intellectual thought. What matters is to confront reality as it really is, not as you'd like it to be, not as it's written in the by Lenin, Trotsky or somebody else, as it really is. And you can't intervene until you know what the situation is. So it has to be inside the intellectual project, not grafted on to the intellectual project from outside. And my sense was that people were relieved, although they didn't want to necessarily defend that position openly, they were relieved that that was the sort of position I took, though other people have memories of rather more bitter struggles going on below my visual threshold, as to this particular position of the Centre in relation to politics. But, you know, people were positively encouraged to go into arts associations and anti-racist work, community politics, etc., but don't tell me I must now think this, because you're involved in that. That's the link I didn't want to have.

Connell: What are your memories of these 'Missed Moment' debates in the Centre? I know it is rather cheeky to throw it at you considering it was 40 years ago but as I understand it, was it like the transition from this notion of a relatively tight collective to a looser collective?

Hall: Yes, there's a transition from a tighter collective to a looser collective. You can't recruit students from all over Britain by a normal process of recruitment and expect them to form a tight collective. The days of tight collectives belong with five students, Richard and me in a room. The moment of 20 students in a room and lots of people coming to the Centre who didn't formally belong at all, but slipped up to Birmingham to hear one seminar or another, forming a tight collective was not on. So we did loosen the notion of the collective. One of the ways in which we did that was to give more power to the individual groupings;

they could have projects of their own as it were, and therefore to take a bit of the weight away from the General Centre Meeting and the Theory Seminar. Those were the sort of central collective points of organization in the week, but people could get more and more involved in the literature around their particular areas of concern. So gradually the idea of a tight collective couldn't be sustained and I didn't want it really – as far as I'm accurate in thinking about what I wanted at that time . . . on the other hand, this did mean that there were many tendencies going in the Centre and I thought in some respects, opportunities were being missed and that was what I thought the 'missed moment' was.

Connell: Does that relate to this notion of the creation of an 'advanced base' within the university where territory could be reclaimed from the dominant mode of knowledge and authority? Was that what was being missed?

Hall: Yeah I mean that's the moment when that was reinforced. I think from the moment we knew we were opening a Centre in a field which was not a discipline and had no curriculum, we were engaged in an exercise counter to the current organizational knowledge and the link between knowledge and power would shape the university material. We were obviously at odds with that, working in a different kind of way, in a different direction. And by the time you get to the moment you are talking about, that's perfectly obvious and so the question is, 'How are we to assess exactly how we should behave in such a situation?' you know, 'What were we to do, if we were trying to challenge the map of knowledge which universities were there to transmit?' That's their formal purpose, transmit knowledge; usually the knowledge of the traditional scholars. But now you're not transmitting that, you're forming a kind of breakaway group inside that and I thought that needed a lot more thought. Because you couldn't declare a Republic – the 'Republic of the Centre of Cultural Studies'! But we clearly were not going along the groove of other fields. I mean I don't know – I think you must know that when the Centre first opened, two sociologists wrote to the weekly student paper to say, 'I see Hoggart's Centre is opening, we don't know what this is going to do but as traditionalist Sociologists, we are warning them against thinking that what they're doing is Sociology.'

Connell: Looking back, do you think that you succeeded in the creation of this notion of the advanced base? Do you think that was a success?

Hall: You know there was a lot of talk in those days about establishing a 'red base'; ours was not a red base like that. But if you asked me, 'Did it establish a bridgehead and work out some of the modes of organisation and study and writing?' It did; yes, it did. And the fact that after that, cultural studies took fire all over the world, you know, is the sense that its very counter properties were what other people were looking for. Because there was a crisis of traditional knowledge in the social sciences and the humanities. And we later came to call that 'the cultural turn'. But the Centre is one of the first examples of trying to organize the cultural turn as a sort of quasi-institution, inside a university hostile to its overall purposes.

Connell: When do you think identity politics arrived within the Centre?

Hall: Well, I would say identity politics, you know they were sort of on the agenda earlier on, because there was a lot of movement towards community politics; politics from below. People had lost their faith in political parties, political tendencies, but they wanted to engage ordinary folk in taking command of their own lives or thinking out what sort of things they wanted to do. But I think it's really with two factors that identity politics comes into existence; one is around race and the other is around feminism. Because this is a claim made in relation to a category of social being, yes? It doesn't say, 'You must do this because that's my political programme'. You're saying, 'You must do this because this is what I am. I make this claim in the name of being Black, which is a category which has been despised etc. overruled by the West for centuries.' Or, 'I do this in the name of the Women's Cause, whom patriarchy has bossed throughout the centuries.' I think that's when the question of, 'Who are you?' gradually comes to the fore. And it begins to intervene in the more traditional field of politics, so that it becomes the organizing centre of a number of political movements; rather than they being given by the old political agendas. Well I'll say one thing that might be of interest to you at this point. I was in a very particular place in relation to that, because I didn't – well I didn't think that identity could be all of it, because there are lots of un-progressive, reactionary black people. Secondly, I was myself in a quandary about the question, because my whole social formation had led me exactly to this unresolved point: 'Who are you? Where are you from?' I was born into a middle-class Jamaican family. My mother belonged to a small planter class; I was adopted into it. My father was a lower – middle-class boy. They wanted me to be a good, middle-class Jamaican boy. They wanted me to be clever, win the plaudits, go into law, you know – when the colonial regime eventually would go, we would be the bosses, as has indeed happened. I couldn't stand it in there; in that milieu I could not bear it. I didn't like their attitudes, I didn't identify with who they wanted me to be, I didn't identify with how they saw me, you know. I was darker than most of them. I thought, 'Why should that matter?' It *does* matter, because they despised, or certainly looked down on the broad mass of ordinary black Jamaicans. So I gradually distanced myself from that social location. When you distance yourself from a social location, where do you go? I'm still a schoolboy, I'm still living there. Well, where do you turn? Well of course you turn to the people that are being left out. But how does a young brown middle-class Jamaican boy take on the black Jamaican vernacular? I know about it because Jamaica is a small place. I know lots about it; I know everything about it. But I'm not one of it either. So, who am I? And I resolved that problem partly by leaving. I decided not to stay at home and study, but to come abroad to study, because I thought, 'Jamaica is a very provincial place; you are not going to solve this question of where you stand in it, in a very easy way. Go somewhere else, encounter new things and think about it.' Well I decided eventually not to go home. I say that only because I wanted you to know that when identity politics arose at the Centre I was sort of waiting for this question to come up in a broader way. I had already

confronted it, because when I came to England, brought by my mother in August 1951 to go to Merton College, Oxford, with a huge steamer trunk, which I never went into after she'd placed it in the basement of Merton College, I walked round the corner from where we're staying, past Paddington Station and there were all these ordinary Jamaicans; perfectly ordinary, working-class Jamaican men and women in their felt hats, dressed up to the nines and shivering in their cottons and their straw baskets and I thought, 'Where are they from?' I thought I'd safely left them all behind! Now they're going to come and trouble me here! I could not help thinking 'What is their prospect? Are they going to make a life? Are the English going to accept them? Will they retain the old culture? Will they take on a new culture?' So the identity question arises for me long before the Centre for Cultural Studies or feminism or the black movement.

Connell: But it's also happening outside of the Centre, before it arises in the Centre as well. I mean the Women's Movement, Women's Liberation comes out of 1968, but it takes a while for it to come in to the Centre, even though people like Rosalind Brunt were active in various women's groups in the early 1970s.

Hall: Yes, well they were active and we approved of that. It comes in partly as a result of that in terms of recruitment and you know, we wanted to get somebody in who could take charge of this area more. We thought, 'Get a feminist academic.' We didn't have any money to pay them, but they might be willing to help us decide how to build this into the Centre. But we couldn't – we didn't manage it. But not long after that we started to recruit women who were active feminists; an active feminist element came into the Centre. So it's really through recruitment, rather than through our individual activities. Some people were in both places, but a lot of people began to come – drift towards the Centre, because it seemed to be asking relevant questions about their political and identity problems. So then it's another phase – the phase now is how to represent this new set of interests, within the field that we'd been defining as 'cultural studies' and that's when a lot of the tensions arose.

Connell: So given what you've just said about your own formations and identity and those questions that are of course already very much at the forefront of your mind. In a sense it was an open door for . . .

Hall: . . . Yes, it was very much at the forefront of my mind and very much an open door. On the other hand, I don't know that I understood how deep those questions went into the political heart of the project, yes? It's only afterwards, a bit later that I understood that we were not just adding on – you know, adding on Juliet Mitchell to Raymond and Marx and so on, but we were really rejigging, reconfiguring the intellectual project, so that those questions became central. If you discuss the question of identity, you're discussing the question of identification, which is a process, not a thing. I took the position from the very beginning that I didn't believe in identities as stable things, because my own identity changed. So I couldn't think it was stable; it's clearly a position which is moving; it's a process. You identify a thing, you take up a position; that doesn't

last for very long, other things come to challenge it, you reconsider it. So I was very interested in the process of identification, but not in just 'The Black Project', 'The Feminist Project', 'The X Project'. So at that stage you just realise that cultural studies, when it was picked up elsewhere, was going to include a range of other social interests, political positions, people from different backgrounds and so on. The field was proliferating, yes? And was bound to and we should welcome it. And in the '80s and early '90s, all the other places in Britain started doing cultural studies – North East London Polytechnic started, Portsmouth polytechnic, Middlesex started introducing cultural studies courses into their traditional field. So it's a long route by which the cultural turn takes place.

I should add one more thing – identification is a subjective process, as well as a social one. Things are social identities, but unless you invest something in them, they don't matter. You have to invest feelings or you know, you have to commit to them in some way, to bear them and take the brunt of them and get sworn at because of them, really for them to matter, otherwise they just float around and you choose to be a 'Mod' one day and a 'Bike Boy' the next. So if you're interested in that deeper process, you're interested in psychoanalysis, because psychoanalysis, as opposed to traditional sociology, has a much richer account of how identification takes place in the social region and in language, as much as just in the psyche. When I hear myself explaining this to you, it's as if something is going on out there, something real is happening in here and this is mirroring that and that is influencing that. But it's very hard to say, 'Identity was my problem and I brought it into the Centre.' I didn't at all; I certainly didn't. Identity is a problem out there which I'm reflecting; I didn't do that either. I just knew that knowledge about society and culture could not get very much further without taking on more actively, both the social and the psychic and personal subjective sides of the process.

Connell: I was going to ask a bit more about the implications that the arrival of identity politics within the Centre – feminism, but also race . . .

Hall: . . . I mean they're different; Race – we always knew we should have dealt with race. But we couldn't recruit any bloody students, before Paul Gilroy's generation, because there were so few black students in higher education, doing our kind of work or taking our kind of interest, who had got good enough results in their undergraduate degrees, to get money to study as an undergraduate or at a postgraduate level. So we couldn't do it. So they were not just available to us. So what you see is the moment when that cohort becomes available. Errol Lawrence, Paul [Gilroy], Hazel Carby and so on. You will see it's actually a cohort who were all recruited somewhere around the same time. They become interested in the Centre, it seems like a place where they can continue with their interest, and the Centre becomes interested in them as the social, cultural phenomenon it ought to have at the centre of its project.

Connell: I was going to ask you more generally now about kind of taking it up to 1979 and your decision to leave and take up a position at the Open University.

What were the reasons behind that and did you think that by that point the Centre was safe enough to leave?

Hall: By the time I left in '79, I did think it was safe enough just – *just*. But what had happened was that that conflict of roles which I spoke about earlier was really becoming untenable; I couldn't manage the transition between being their director, their supervisor, their friend, their political ally, their intellectual interlocutor; it was too much for me. And I began to grow resentful, you know, 'I'm not adding another text that you just thought of from French structuralism or French feminism, because you heard of it' yes? 'So stop tinkering – I'm not going to face another term or year in which we entirely revise the reading list, come on! I've done it five times! This must come to a stop! It must settle somewhere.' So I felt unsettled about it and I made a very serious mistake, which showed me how untenable it was. I spoke at a conference in the States about cultural studies and I said, 'It's been constantly interrupted by new things'; its progress and development depends on interruptions, whereas normally you think traditional knowledge evolves smoothly from one paradigm to another, cultural studies has broken it down. And I said, 'Race and feminism have broken in to the Centre in that way and reconfigured it.' And in other words, my attitude towards this was very positive; I was warning people in the States who thought they could take up cultural studies, you know, it wouldn't create a lot of mess and problems, 'Just hold on! It's not an easy subject to get hold of.' But I used a metaphor; I said, 'Feminism had broken in like a thief in the night' and I used an American colloquialism which I will not bring myself to use, you know, which seemed to be hostile. You can imagine when that news hit the Centre when I returned from my time teaching at Illinois, the Centre was in uproar. I of course tried to explain myself: I was aligning myself with these interruptions; I thought it was a good thing; I was trying to recommend it, speak in favour of it. But that terrible trip of the tongue – as Freud said, it betrayed more than it said. And it just told me that, 'You are finding this very difficult. You are finding this *very* difficult. You've always been in favour of women's rights, but when it comes to authority and power, you are not as transformed as you think you are or as you ought to be.' Practice is stronger than conviction in the head. I wasn't a convinced feminist, because I don't believe men can be feminists to tell you the truth, that's like a slave owners' trade union! But I can understand feminism and try to change my behaviour in that direction. But somehow residues of something else were still inside me and getting expressed. And though I didn't decide to leave at that point, I thought, 'This is finished. It's not on. The Centre needs somebody with another vision of how it hangs together without trailing the long history that I brought into it. It needs to test whether the University will allow it to go on or not.' And I didn't start to look around but I began to think, 'Well what are you going to do? You can't be Head of the Centre forever.' So I began to look around to see where else I might go. One or two universities expressed an interest; I didn't suit them and they didn't suit me and it wasn't a serious proposition at all. But then came an offer from the Open University. I knew the Open University because Catherine taught at the Open University

in the very early days. And it was an offer of a job, it wasn't sort of, 'Would you like to apply?' The job had been offered and they didn't like people who had applied and they decided to offer it to me. And I thought, 'Well this is the right thing, not to go to Essex or Sussex or Brighton or something like that, but to go to a place like this, like the Open University – which is attached to social purposes that you identify with, which is attempting to enhance the opportunities of people who've been starved.' Its social purposes suited me and I liked the fact that it was teaching adults. It was helping adults to go back to study and remedying a fault – a gross fault of our education system which is such a selective system in Britain. So it had intrinsically reformist airs and ambitions. But because it wasn't so tightly organized, I could take a lot of cultural studies things into being professor of sociology. I very much remember when the vice-chancellor said, 'But you're not a Sociologist of any kind.' I said, 'No and I'm willing to profess anything that will get me the right job!' This wasn't quite true because of course by then I'd read a hell of a lot of sociology, but not of a traditional American sociological kind. I'd read the European tradition, I read Marx, I read Gramsci, etc. I'd done a lot of – I'd read a lot of social theory, but I had not done American-style functionalist sociology. So he was right in that sense. But I didn't think that my Open University students needed that either. I didn't need it; I don't see why they need it. And it wasn't a sociology degree – it was a social science degree, so I felt free to assemble a grouping in the Open University that would sort of rethink the social sciences in that direction and what's important about the courses that we produced then was that it was sort of the first time that anybody tried to produce a series of teaching materials to kind of acknowledge the cultural turn within the social sciences.

Connell: As you know, there's going to be a lot of people, former colleagues, friends, watching this interview at the conference we are organizing in Birmingham. I wanted to end by asking you about some of the things we are hoping to pick apart at the conference. How would you reflect on the legacies of the Centre, both its intellectual legacies and with respect to the broader social milieu?

Hall: I've never had a problem with leaving places. I know I've left, I'm not going to be in charge, they're going to say, 'We don't know what we're going to do without you' but within a term they will know. I didn't want to go back to the Centre very much, but I didn't feel you know in any way affronted by the fact that it was taking its own direction; not at all. That's what I expected. Not all of them approved of my brand of cultural studies, but it was going to be different; always going to be different. Some part of it became closer to media studies, but that was already going in the Media Studies Group in Birmingham in the Centre well before '68. So it just changed direction and I thought that was right. It became much more theoretical; French theory zapped it from behind. I was very interested and very influenced by French theory, but I thought the notion that the Centre's purpose was to develop a cultural theory was absolutely wrong. We were never about a cultural theory; we were about developing intellectual

tools for understanding the distinctive nature of culture and its relation to other practices; how culture and society, culture and economics, you know related to one another. So I've never supported the idea of a cultural theory. Well a lot of the people who took the cultural turn into theory sort of then never left it. I mean, you know, they've ventriloquized Derrida, Levi-Strauss and Althusser, etc. It sounds strange for me to say so, because I was very influenced by all of them, but I was influenced by them because they gave us tools to think with, yes?

Connell: Do you think that sort of ethnographic, almost empirical side of the Centre's work is something that gets a bit overlooked at times?

Hall: Yes, that does happen too – the importance of Paul Willis's and others' work is that they were more attentive to the concrete, yes? And I was always interested in using the intellectual tools to analyse the concrete. So I wanted to understand a particular conjuncture of events and relationships, but I wanted more than observation or you know observers' evidence; I wanted some tools to break into it. You know Marx once said, 'A theory is like a concept is like a microscope; you can't see the structure, you have to break into it, then you see the structure.' And I wanted something which would break the carapace and reveal what was lying beneath that. So I was influenced in that way by a whole series of theorists, but I didn't think producing a theory which combined them all was ever our business.

Connell: So in a sense, I guess *Policing the Crisis* would be one example of a more concrete work . . .

Hall: Yes, although *Policing the Crisis* was not a separate group as you know; it arose within the Centre, it just wasn't a formal reading group. We had a group on deviancy, we had a group which produced an issue of the journal – a book called *Resistance through Rituals*. One of those people Chas Critcher was working also in community politics and learnt about the case that underlay *Policing the Crisis*, brought it to us and we said, 'Let's do some work on it.' So a number of people came together. So it was neither a formal working group, nor was it outside the Centre. It didn't have a formal recognition in the Centre. It did have a rather distinctive flavour because it was me plus four students, but lots of other people in the Centre contributed to it, lots of others. So it was kind of a fulcrum of interest. Secondly, it was researched over seven years. I couldn't let it go! We did masses of spin-offs of it, deviancy conferences and seminar papers and interim publications, but actually the book didn't get published until 1978. So you know it wasn't a separate enterprise really. What was odd about it was that there was me and these four graduate students who became the researchers and the main authors, but there wasn't a black person among them. But there wasn't a black person in the Centre, so what would have stopped us in our tracks now, 'What are you lot doing when you were the only person who represents the minority?' Still, I felt in a group of this kind, we could identify the problems quite clearly and make a contribution towards understanding them. And in the

course of doing so, I think we did. And we could afford to be more openly political. We could afford for the study to become in effect a sort of – a kind of critique – a sort of sustained critique of contemporary capitalism.

Connell: Stuart, I want to end by asking you about Cultural Studies today. First, I was going to ask do you think that there should be a discipline of cultural studies today? And if so, what should that discipline look like?

Hall: Well I'll let you off the hook because I don't! I mean I don't want it to be a discipline; I think its looseness is what is attractive about it. I think people find it easier to appropriate things in cultural studies and to take a kind of cultural studies path towards project, if it does not remain a discipline like every other. Now that's easy for me to say. It becomes a discipline in many places and the result of that is it becomes much more established, it gets funded, it makes academic appointments, it develops traditions of its own and there's nothing wrong with that. That's one way to go. And I'm not opposed to that, but it wasn't the way that I think cultural studies should go. It did have the effect of launching cultural studies more or less globally in some funny kind of way; it was taken up in so many different places. But think about Britain. Cultural Studies inserted itself into other fields. So there's cultural history, there's cultural geography, there's cultural accounting – Foulcauldian accounting! It's all over the place and partly by hiding out, it's made itself tougher because it has constantly to argue against its other colleagues who want to attack it; traditional historians who say, 'We don't know what "cultural history" is. What's all this fuss about? Representations and language and nonsense!' So it toughens it up, but it doesn't get anybody an annual salary. So in our own backyard, it has not become a discipline in that way, whereas in say Australia it is a discipline. In other places I can think of, in the States, well, it's become a discipline in some places and in others not. So it hangs ambivalently between becoming a discipline in its own right, with all the problems that that involves and remaining like what I think you can plainly see from how I talk about it, as a moving target; constantly moving target – you want to criticize it? Come over here and read some things with me and just explain to me how that doesn't require a tending to the sort of things that cultural studies is about. So it takes its place eventually in a long line of turns; the postcolonial turn, the linguistic turn, the psychoanalytic turn and finally the cultural turn.

Connell: Just finally then, do you have a message for friends, former colleagues and others who will be watching this?

Hall: Bob Marley said, 'Don't give up the fight.' But don't expect to find the fight lodged fully accomplished and outlined in some book; you've got to use your bloody heads! You have to use your critical faculties to make intellectual use of the ideas, concepts and knowledge of the concrete studies you are doing, to make some sense of it. So it's not coming already packaged. So don't think 'the work has been done in the first generation, that Birmingham School did it all and we are just tagging along'. Not at all; not at all. I would say something

else though which is rather new. Cultural studies worked against the grain of a certain kind of economism. The idea in classical Marxism, is that eventually ideas are determined in the last instance by the economic. Cultural studies does not hold that position; never held that position. It constantly fought against a reduction of ideas to the economy. What that has meant for a lot of the period [during which] cultural studies was operating was virtually to forget that the economy existed. You know, so we drifted off into the cultural institutions and discourses and discursive analyses etc., as if the economy didn't exist. And I notice – I have to say I notice that since capitalism started, since the global capitalism started to go down the drain, everybody wants to know about economics! All the cultural studies students are talking about the labour theory of value. They've discovered what I said to you early on, the vocation of cultural studies – the role of culture in relation to and in articulation with other areas of practice; the economy, society, the psychic. And if you go that way, you don't give in to economism, but you don't forget that you know there is such a thing as the economy and if you look like a society like Britain today, almost every feature of the culture – public culture, every feature of social life and I sometimes think every aspect of the inside of a lot of people's heads are influenced, shaped by what I would call the 'economic'. Not in the narrow sense, but by the economic. By the fact that we live in a consumer society, that we live in an individualist society, that we live in a property-oriented society and so on, you know? So it's not just the economy, but you can't leave that dimension out. Never leave a dimension out. In one of the best definitions of cultural studies that I know, which is in the second chapter of Raymond's *Long Revolution* – it's kind of my early bible and I still stick to it – he says a very famous sentence, where he says, 'The Arts' – by which I take it he means culture as well – 'The Arts are there alongside the trading, the bringing up of families, the organisation of political government' and that's the notion of an articulate whole, not of one element setting forward and saying, 'Follow me, I'm the one determining you.' In that sense, 'The last instance never comes'; There is no such moment; the economy is always entangled in these other things which construct it as part of a social formation and I would say to people who are thinking about using culture to understand the current crisis of global capitalism, that they should not be put off that they're drifting back into an economic determinism. That's not what it is at all; but it requires thinking, how it can influence all these things without becoming determining in the last instance. And I think that in some ways, the struggle against an economistic reduction of culture and thus of cultural studies is still on the agenda today.

Index

About the Contributors

Kieran Connell is a lecturer in contemporary British history at Queen's University Belfast. He has published on subjects including race, immigration, photography and the New Left in post-war Britain and has co-curated exhibitions on the Centre for Contemporary Cultural Studies (CCCS) and photographs of Janet Mendelsohn. Previously, he worked at the Open University and the University of Birmingham.

Matthew Hilton is professor of social history at Queen Mary University of London. He is the author of several books including *Smoking in British Popular Culture* (Manchester, 2000), *Prosperity for All: Consumer Activism in an Era of Globalisation* (Cornell, 2009) and *The Politics of Expertise: How NGOs Shaped Modern Britain* (Oxford, 2013). He is an editor of *Past and Present* and is currently researching the history of humanitarianism and international aid and development.

Dennis Dworkin has a PhD from the University of Chicago. He is currently professor of history at the University of Nevada, Reno, where he teaches courses in historical and cultural theory, British and Irish history, modern Jewish history and modern Italian history. Among his published works are *Cultural Marxism in Postwar Britain: History, the New Left and the Origins of Cultural Studies* (Durham, NC: Duke University Press, 1997); *Class Struggles* (London: Longman, 2007); and *Ireland and Britain, 1798–1922: An Anthology of Sources* (Cambridge, MA: Hackett Publishing, 2012. He is also the co-editor of *Views beyond the Border Country: Raymond Williams and Cultural Politics* (London: Routledge, Chapman and Hall, 1993). He has published essays on Paul Gilroy, Stuart Hall, Eric Hobsbawm, C. L. R. James,

the Irish philosopher Richard Kearney, Sonya Rose and E. P. Thompson. His work has been translated into Chinese, Portuguese and Turkish.

Geoff Eley teaches at the University of Michigan. His earliest works were *Reshaping the German Right* (1980, 1991) and (with David Blackbourn) *The Peculiarities of German History* (1980, 1984). Most recently he published *Forging Democracy: A History of the Left in Europe. 1850–2000* (2002), *A Crooked Line: From Cultural History to the History of Society* (2005), (with Keith Nield) *The Future of Class in History* (2007), and *Nazism as Fascism: Violence, Ideology, and the Ground of Consent in Germany, 1930–1945* (2013). He is co-editor of *German Colonialism in a Global Age* (2014).

Ann Gray is emerita professor of cultural studies at the University of Lincoln and co-editor of the *European Journal of Cultural Studies*. Publications include *History on Television* (Routledge 2013) and *Research Practice for Cultural Studies* (2003). Ann was lead editor of *CCCS Selected Working Papers*, volumes I and II (Routledge 2007) and worked at the Department of Cultural Studies and Sociology between1989 and 2002.

Rosalind Brunt was a postgraduate student at Birmingham University's CCCS between 1968 and 1973. She is currently visiting research fellow in media studies at Sheffield Hallam University. She was vice-chair of the United Kingdom's professional association for communication and cultural studies, MeCCSA, and the founding chair of its Women's Media Studies Network.

John Clarke is emeritus professor of social policy at the Open University and visiting professor at Central European University. Recent books include (with Dave Bainton, Noémi Lendvai and Paul Stubbs) *Making Policy Move: Towards a Politics of Translation and Assemblage* (Policy Press, 2015) and (with Kathy Coll, Evelina Dagnino and Catherine Neveu) *Disputing Citizenship* (Policy Press, 2014).

Tony Jefferson is currently professor emeritus at Keele University and adjunct professor at Queensland University of Technology in Brisbane, Australia. He has also held visiting professorships in Sweden, Denmark, Australia and the USA. He has researched and published widely on questions to do with youth subcultures, the media, policing, race and crime, masculinity, fear of crime and racial violence. His recent books include: (with Stuart Hall et al.) *Policing the Crisis* (2nd edn., 2013); (with Wendy Hollway) *Doing Qualitative Research Differently* (2nd edn., 2013); (with Dave Gadd) *Psychosocial Criminology* (2007); and (edited with Stuart Hall) *Resistance through*

Rituals (2nd edn., 2006). Between 1999 and 2002 he was the British editor of the journal *Theoretical Criminology*.

Lawrence Grossberg is the Morris Davis Distinguished Professor of Communication and Cultural Studies at the University of North Carolina at Chapel Hill. He has written about popular music and politics, the state of youth/youth culture, US political culture (new conservatisms, countercultures and progressive opposition), value theory and multiple modernities. His books include *We Gotta Get Out of This Place: Popular Conservatism and Postmodern Culture* (1992); *Caught in the Crossfire: Kids, Politics and America's Future* (2005); and *Cultural Studies in the Future Tense* (2010). He has also co-edited volumes including *Marxism and the Interpretation of Culture, Cultural Studies* and *New Keywords*. His books and essays have been translated into over a dozen languages. He is editor of the international journal *Cultural Studies*. His newest book *We All Want to Change the World* is available free online.

Gregor McLennan is professor of sociology at the University of Bristol. He was part of the cohort of the first 'taught MA' in cultural studies in 1975, going on to complete a PhD thesis at the CCCS in 1980. Of the CCCS volumes of papers, he contributed to *On Ideology* and *Making Histories*. Greg worked alongside Stuart Hall at the Open University through the 1980s, before moving to New Zealand in 1991, and then on/back to Bristol in 1998. He is the co-editor of a number of collections in social and political theory, and his sole-authored books are *Marxism and the Methodologies of History* (1981), *Marxism, Pluralism and Beyond* (1981), *Pluralism* (1995), *Sociological Cultural Studies: Positivity and Reflexivity in the Human Sciences* (2006) and *Story of Sociology* (2011). He is currently working on theoretical issues around post-secularism.

Maureen McNeil is professor emeritus of women's studies and cultural studies at Lancaster University. She was lecturer/senior lecturer in women's studies at the Centre for Contemporary Cultural Studies, University of Birmingham from 1980 to 1996. Her publications include: *Feminist Cultural Studies of Science and Technology* (2008) and (with Joan Haran, Jenny Kitzinger, Kate O'Riordan) *Human Cloning in the Media* (2014).

Jackie Stacey is professor of media and cultural studies at the University of Manchester where she is currently co-director of the Centre for the Study of Sexuality and Culture. Her publications include: *Star Gazing: Female Spectators and Hollywood Cinema* (1994), *Teratologies: A Cultural Study of Cancer* (1997), *The Cinematic Life of the Gene* (2010) and the co-edited

collections *Queer Screen* (2007) and *Writing Otherwise: Experiments in Cultural Criticism* (2013). She has just started a new research project titled: Crossing over with Tilda Swinton.

Richard Johnson taught social history at the University of Birmingham from 1966 to 1974 and then cultural studies at the same university until he left the Centre for Contemporary Cultural Studies (CCCS) in 1993. A second 'retirement' was from the Faculty of Humanities at Nottingham Trent University where with others he started new postgraduate programmes in cultural studies and research practice. Since 2004 he has taught adult education courses, worked in a group on masculinity and ageing and is active in the Campaign for Nuclear Disarmament (CND) and other campaigns. A further retirement is contemplated to finish some early work on the history and current state of schooling. He enjoys the cultural diversity of Leicester, his large and complex family and the company of six grandchildren.

Iain Chambers teaches cultural, postcolonial and Mediterranean studies at the University of Naples, 'Orientale'. He is the author of many books and articles on these arguments; among the most recent are *Mediterranean Crossings. The Politics of an Interrupted Modernity* (2008) and *Mediterraneo blues. Musiche, malinconia postcoloniale, pensieri marittimi* (2012).

Lidia Curti is honorary professor of English in the same university (University of Naples, 'Orientale') and author of *Female Bodies, Female Stories* (1996) and *La voce dell'altra, Scritture ibride tra femminismo e postcoloniale* (2006).

Mikko Lehtonen is professor of media culture at the University of Tampere, Finland. He served as the bursar of the Association for Cultural Studies in 2002–2010 and was the chair of the organizing committee of the 10th Crossroads in Cultural Studies conference in Tampere in July 2014. Lehtonen has published numerous books in Finnish, one in English (*Cultural Analysis of Text*, Sage 2000) and is currently working on an English version of his monograph on materialist cultural studies.

Keyan Tomaselli is distinguished professor at the University of Johannesburg and professor emeritus at the University of KwaZulu-Natal (UKZN). He is editor of the journal *Critical Arts: South-North Cultural and Media Studies* and co-editor of the *Journal of African Cinemas*. He was director of the Centre for Communication, Media and Society, UKZN for 29 years.

Huang Zhuo-yue is a professor in Beijing Language and Culture University, whose work primarily focuses on international cultural studies, comparative

study of Eastern and Western literature, literary theory and criticism, etc. Huang is one of the first scholars introducing and researching cultural studies in China and has offered the course Introduction to Cultural Studies to postgraduate students in his university for 15 years. Huang is also well known as the founder of BLCU International Cultural Studies Forum which has been held 5 times in Beijing. At his invitation many former members of the Centre for Contemporary Cultural Studies (CCCS) and famous scholars from the United Kingdom and other countries joined the forum and gave speeches. Huang has written and published several papers and books on cultural studies since the 1990s.

Chas Critcher joined the Centre for Contemporary Cultural Studies (CCCS) in 1969 where he stayed three years full-time and eight years part-time. He subsequently studied and taught media, leisure and community studies at Sheffield Hallam University. One of the co-authors of *Policing the Crisis* (Macmillan, 1979), he reprised some of its themes in *Moral Panics and the Media* (Open University Press, 2003). He is currently visiting professor in media and communications at Swansea University.

Dorothy Hobson is a writer, academic and television historian. She was at the Centre for Contemporary Cultural Studies (CCCS) from 1975 to 1982. She has written for newspapers and broadcast on radio and television for British and international media. She is an expert on soap operas, audience studies, popular television and contemporary media. Her publications include *Crossroads: The Drama of a Soap Opera* (1982) and *Channel 4: The Early Years and the Jeremy Isaacs' Legacy* (2008). Hobson is a fellow of the Royal Television Society (RTS) and vice-chair of RTS Midland Centre. She is currently writing a new book 'Television that Changed Everything' and is also writing her first novel.

Becky Conekin has taught at Yale since 2009. Prior to that she taught at the London College of Fashion, University of the Arts, where for many years she was the course director of their MA in the history and culture of fashion. She is a fellow of the Royal Historical Society and author of numerous publications including: *Lee Miller in Fashion (2013)*; *The Autobiography of a Nation: The 1951 Festival of Britain (2003)*; *Vernier: Fashion, Femininity & Form (2012)* with Robin Muir: and as co-editor, The Englishness of English Dress (2002) and Moments of Modernity: Reconstructing Britain, 1945–1964, (1999) as well as the 10th anniversary issue of Fashion Theory dedicated to Vogue magazine (2006).

Jo Littler teaches in the Centre for Culture and Creative Industries in the Department of Sociology at City University London. Her work includes

the books *Radical Consumption? Shopping for Change in Contemporary Culture* (Open University Press, 2009) and (with Roshi Naidoo [eds]) *The Politics of Heritage: The Legacies of 'Race'* (Routledge, 2005). She is currently writing a book called *Against Meritocracy: Culture, Power and Myths of Mobility.*